GREAT GALLERIES OF THE WORLD

The PRADO

of Madrid and Its Paintings

Edited by
MIA CINOTTI

With a foreword by
XAVIER DE SALAS Y BOSCH

JOHN BARTHOLOMEW & SON LIMITED: Edinburgh

Great Galleries of the World

Collection directed by
ETTORE CAMESASCA

Editorial secretary
CARLA VIAZZOLI

Editing and Graphics
CLAUDIA GIAN FERRARI
MARCELLO ZOFFILI
SERGIO TRAGNI
GIANFRANCO CHIMINELLO

Secretary
MARISA CINGOLANI

Graphic and Technical Adviser
PIERO RAGGI

Printing and Binding
ALEX CAMBISSA
CARLO PRADA
LUCIO FOSSATI

Color editing
PIETRO VOLONTÈ

Foreign editions
FRANCA SIRONI
ENRICO MAYER

Editorial Committee
MILTON GLADSTONE
DAVID GOODNOUGH
JOHN SHILLINGFORD
ANDREA RIZZOLI
MARIO SPAGNOL
J.A. NOGUER
JOSÉ PARDO

Contents

Photographic sources

Color plates: Archivio Rizzoli, Milan; Domínguez, Madrid; Nimatallah, Milan.
Black and white illustrations: Prado Museum, Madrid.

First published in Great Britain 1973 by
JOHN BARTHOLOMEW AND SON LTD.
12 Duncan Street, Edinburgh, EH9 1TA
and at 216 High Street, Bromley, BR1 1PW
Copyright © by Rizzoli Editore, Milano, 1973

PRINTED IN ITALY

Prado
a Multitude of Masterpieces

The taste for art collecting is a tradition of Spanish kings dating from the thirteenth century and affecting all royal houses, from the Castilian to the Hapsburgs and the Bourbons. It was a kind of art collecting, though, that was cultivated with the loving care of a tradition and was always careful and attentive not so much to the art of the past as to the art of the present — the social, historical and political age in which the connoisseur was living. This made it possible for the Spanish royal collections, the nucleus of this museum, to be shaped along the lines of an artistical-historical reading of the centuries in which they were born. Furthermore, they have value not just for the Spanish sphere, but also for the European, since the acquisitions and the commissions reached the painters of all the western world. The passion for art that marked the Spanish royal house was unique in that the selections were quite exceptional in regard to the artistic scope of four centuries. In fact these selections, although guided by the particular taste of each monarch (Philip II was fascinated by the critical and surrealistic phantasy of Bosch and by the portraits and the "poems" of Titian, while Philip IV had Velázquez as his private painter and Charles III admired most highly an artist such as Mengs), brought forth those artists who turned out to be leading figures in the history of art, and those works that are still today considered masterpieces. When Ferdinand VII decided that the Prado building, damaged by war before even being used for the purpose for which it was built, should be restored and given over to the exhibition of the royal collections, he offered to his people a patrimony of works of unmeasurable value, not just artistic, as we have said, but also historical. The direct commissions to the painters who lived at the Spanish court transmitted to us, with their portraits, battle scenes or general works, a lively and often critical reading of the political events and of the costumes and manners of the different epochs.

With his decision also Ferdinand VII fulfilled the wish that already in the middle of the seventeenth century had been growing among Spanish men of culture for the unification and transformation of the royal collections into a public museum, realizing the cultural ideals of the Enlightenment. In order to appreciate the importance of the Prado museum, not only for the art enthusiast but also for the simple visitor, it suffices to consider that all Spanish painting, from el Greco to Goya, from Velázquez and Ribera to Murillo, is represented with the most meaningful works. Next to the masters one finds examples of schools of painting which give a wider dimension to the development of taste and of the socio-historical background of the artists, allowing a fuller understanding of their work.

No less important is the Italian presence; in fact, one cannot claim to know Titian or Veronese without having seen, admired, and studied their works exhibited in the Prado, not to mention those of Tintoretto, Raphael and many more. Ample space is devoted also to Flemish painting, one of the most cultivated passions of Spanish monarchs. The works of Van der Weyden, of the Master of Flémalle, of Bosch and of the Brueghels, as well as of Rubens, are among the most meaningful of the art of the Flanders, and have exceptional presentation in the Prado.

I believe that all praise for the museum should be based on the extremely high quality of the pictures that are displayed in it; there is hardly a room without a masterpiece, and many are crowded with them. For one hundred and fifty years this has been one of the most beautiful and important art collections of the western world.

XAVIER DE SALAS Y BOSCH
Director of the Prado Museum

History of the Museum and Its Paintings

The Prado Gallery was originally formed from royal collections which had been assembled through intelligent purchases and direct commissions by three Hapsburg kings (Charles V, Philip II and Philip IV) during the sixteenth and seventeenth centuries, and by three Bourbon kings (Philip V, Charles III and Charles IV) in the eighteenth and early nineteenth centuries. The first great art collector of the Spanish royal house had been Queen Isabella, but nothing of her late fifteenth century collection was left in the royal palaces.

At the time the Gallery first came into being, the collections reflected the taste of the Spanish kings. Their taste had developed along with the international vogue for the Italian High Renaissance, dominated by the figures of Raphael and Titian. At the same time they were much attracted by Flemish art from Van der Weyden and Bosch to Rubens and Van Dyck. They also accepted the latest classical, naturalist and baroque styles of seventeenth century painting from Bologna, Rome and Naples, as represented by artists ranging from the Carracci, Reni and Guercino to Poussin, Claude and Luca Giordano. They likewise responded with immediate enthusiasm to the work of outstanding Spanish masters such as Velazquez and Goya, and to the work of a German neo-classical painter like Mengs, who reacted against the rococo taste of the royal court in the eighteenth century. But they were disinclined to broaden their horizons to embrace other important kinds of painting. Thus they paid no attention to Rembrandt, or to such important Spanish primitives as Berruguete, Bermejo and Gallego, or the great British painters of the eighteenth century.

1516-58. The first nucleus of masterpieces entered the royal palaces thanks to Charles V and his sister Maria of Hungary, both of whom were patrons of Titian but also admirers of Anthonis Mor, Jacopo Bassano and Cranach. It was Charles V who commissioned from Titian such masterpieces as the *Portrait of the Emperor Charles V*, the *Portrait of the Emperor Charles V on Horseback at Mühlberg* and *The Madonna of Sorrows* (with hands together). It was his sister who on her death in 1558 bequeathed another group of Titians (twenty odd portraits, *The Madonna of Sorrows* (with hands apart), *Sisyphus* and *Tityus*, the last two of which were part of a commission for paintings of "condemned men" or "furies), as well as Van der Weyden's glorious *The Deposition of Christ*, the two scenes of *Hunting at Torgau Castle in Honor of the Emperor Charles V* by Cranach the Elder, and various works by Mor.

1556-98. Philip II's favorite painter was also Titian, whom he commissioned to paint not only sacred pictures and large compositions to celebrate his glories, but also "indecent" paintings (i.e. nudes, which were defined at that time as "poems"), such as *Venus and Adonis* and *Danae and the Shower of Gold*. Philip II was also particularly fond of the mystical demoniacal art of Bosch, and hence obtained for himself such masterpieces as the panel of *The Table of the Seven Deadly Sins*, *The Haywain Triptych*, *The Garden of Delights Triptych* and *The Adoration of the Magi Altarpiece*.

1598-1621. Philip III was not an art collector. It was during his reign that a great many paintings were destroyed or severely damaged in a fire at the Pardo Palace on March 13, 1604. Nevertheless, it was during this same period that the king's favorite, the Duke of Lerma, first commissioned Rubens. Rubens painted for him *Heraclitus*, *Democritus* and the series of paintings of *The Apostles*, as well as the splendid equestrian portrait of the Duke of Lerma himself.

1621-65. Philip IV and his minister, the Count Duke of Olivares, were responsible for giving art patronage a fresh and unsurpassed impetus. Philip IV kept his two favorite painters, Velázquez and Rubens, hard at work. Furthermore, Philip IV sought other opportunities for making his collection of paintings unique. When the paintings owned by Rubens were auctioned in Antwerp in 1640, he secured 32 of them (18 by Rubens himself, including *The Three Graces*, *The Garden of Love*, the *Portrait of Marie de' Medici* and the *Portrait of the Cardinal Infante Don Ferdinand of Austria at the Battle of Nordlingen*, and 14 by other artists, including Titian's *Self-portrait* and Van Dyck's *The Crowning of Christ with Thorns* and *The Betrayal of Christ*). When the Puritan government auctioned the property of Charles I of England after his execution in 1649, Philip arranged to purchase such masterpieces as Mantegna's *The Death of the Virgin*, *The Holy Family*, known as *La Perla*, by Raphael and assistants, Tintoretto's *Christ Washing the Apostles' Feet*, Dürer's *Self-portrait*, Andrea del Sarto's *The Madonna della Scala*, works by Veronese and Palma Giovane, four Titians (*St. Margaret and the Dragon*, *The Marchese del Vasto addressing his Troops*, *Venus with an Organist and a Small Dog* and the *Portrait of the Emperor Charles V*, which had been given to Charles I by the Spanish court). At the same auction, the Duke of Medina de las Torres bought Correggio's *Noli me tangere* and gave it to the Spanish king. Immediately afterwards (1650) Philip sent Velázquez to Italy to purchase works of art, thus acquiring Veronese's *Venus and Adonis*, various paintings by Tintoretto (*Scene of Battle between Turks and Christians*, *Paradise* and seven ceiling paintings with scenes from the Old Testament) plus a number of pieces of sculpture (see p.).

Other masterpieces were presented to the king as gifts. Queen Christina of Sweden gave him Dürer's *Adam* and *Eve*. Don Fernando de Fonseca, Count of Ayala and Viceroy of Sicily, gave him *The Fall on the Road to Calvary* by Raphael and assistants. Niccolò Ludovisi (nephew of Pope Gregory XV and Viceroy of Aragon) gave him Titian's *Bacchanal of the Andrians* and *The Worship of Venus* through the Count of Monterrey, Viceroy of Naples. Monterrey's successor as Viceroy, the Duke of Medina de las Torres, gave him Raphael's *The Madonna del pesce*. The Marquis of Leganés gave him Van Dyck's *Portrait of the Cardinal Infante Don Ferdinand of Austria*.

This passion for collecting works of art was intensified by the need to furnish the new royal palaces. In Madrid there was now not only the old Alcázar palace, but also the Buen Retiro (the ancient retreat for penitents), which the Duke of Olivares had completely rebuilt for the king between 1631 and 1637. And around the city were the other "royal seats" (Aranjuez, the Escorial and the Pardo Palace, rebuilt since the fire), including the Torre de la Parada, a hunting lodge built by Philip IV in the Pardo forest. It was decorated with splendid mythological paintings (the 112 "Metamorphoses") commissioned from Rubens for this purpose, and executed by him or by his assistants.

The Buen Retiro Palace in Madrid became a magnificent gallery of seventeenth century Italian and Spanish paintings, all devoted to the single theme or royal splendor.

As with the Buen Retiro Palace, the Alcázar Palace also gained from Philip's enthusiasm for seventeenth century Italian art. In this case, however, it was not a question of a series of paintings being commissioned, but of individual masterpieces arriving as gifts or purchases. There was the *David with the Head of Goliath*, attributed to Caravaggio, Annibale Carracci's *Venus, Adonis and Cupid*, Guido Reni's *Hippomenes and Atalanta* (similar to the one in the gallery at Naples, and quite as magnificent), the young Guercino's *Susanna and the Elders* (a gift to the king from Cardinal Ludovico Ludovisi), and Orazio Gentileschi's *The Finding of Moses*. Other works by Reni, together with Annibale Carracci's *The Assumption of the Virgin*, went to embellish the Escorial.

1665-1700. When Philip IV died, the royal collection of paintings was one of the richest in Europe, but Charles II added little to it. Nevertheless, the royal palace regained Rubens' unfinished series of paintings *The Apotheosis of the Eucharist*, which was purchased in 1687 at the auction of the property of the Marquis of Eliche, Viceroy of Naples (to whose father it had formerly been given), and his *The Holy Family with St. Anne* was purchased in 1687 at the auction of the property of the Marquis of Carpio. And at the same time, still lifes by the Neapolitan artist Recco and flowerpieces by the Roman artist Nuzzi were bought by the king for the Buen Retiro Palace. By the time Charles II died, the number of paintings in the royal collections had reached 5539.

1700-46. The age of the Bourbon Kings of Spain was characterized by a new interest in French art. This reflected the personal taste of Philip V, the first of the Bourbon kings, who was the son of the Grand Dauphin, and a nephew of Louis XIV of France, and of Philip's first wife, Maria Luisa of Savoy. Consequently, new paintings by Poussin (including the famous *Parnassus*) were added to the royal collection, and French artists like Rigaud, Largillière, Houasse, Ranc and Louis-Michel Van Loo were employed at court. However, when Elisabetta Farnese became the king's second wife in 1714, her intelligent influence was responsible for a striking increase in the number of paintings by Italian artists or artists familiar with Italian art, such as Van Dyck. It was she who purchased five of Van Dyck's paintings, including the *Portrait of Sir Endymion Porter and Van Dyck* and the *Portrait of Mary Ruthven, the Artist's Wife*.

While the War of the Spanish Succession was being waged, and Cardinal Alberoni of Piacenza, Philip's new minister, was directing the struggle against Austria for control of Italy, the king and queen of Spain were busy adding to the great art collection established by their Hapsburg predecessors. The most important additions resulted from the purchase in Rome in 1722 of the art collection of the painter Carlo Maratta. His collection provided a magnificent cross-section of seventeenth century Italian painting, including works by Annibale Carracci (*Landscape*), Ludovico Carracci (*Christ in the Garden of Gethsemane*), Domenichino, Andrea Sacchi and

Maratta (various works), the Genoese artist Castiglione and other lesser artists. Among non-Italians represented were Poussin (*The Triumph of David*, *Bacchic Scene* and landscapes) and Dughet. Other important royal purchases were two paintings by Watteau, *Venice, from the Island of San Giorgio* by Van Wittel, who created an interest in views of the Venetian lagoon, more than sixty works by David Teniers II, and more than thirty paintings by Murillo, which the queen discovered in Seville. Until then, Murillo had been poorly represented in the royal collection, but now there were added such masterpieces as *The Holy Family with a Bird*, *The Virgin and St. Anne*, *The Good Shepherd*, *St. John the Baptist as a Child* and *Rebecca and Eleazar*. All these paintings went to decorate both the new palace at La Granja de San Ildefonso — the "Versailles" which Philip V had built near Segovia in 1721-23 — and the Aranjuez palace, which had been rebuilt after the fires of the previous century. But the huge art collection now owned by Philip V and Elisabetta Farnese suffered a severe blow in 1734 when a fire at the Alcázar Palace in Madrid destroyed 537 paintings.

1746-59. Few changes occurred during the reign of Ferdinand VI, whose chief artistic enthusiasm was for music. Paintings by Amigoni and Giaquinto were among the few new additions to the royal collection, but an important artistic event was the founding of the Academy of Fine Art of San Fernando.

1759-ff. Charles III of Bourbon became king of Spain after twenty years on the throne of Naples, and like his mother, Elisabetta Farnese, he was a keen art collector, with the result that he arranged for a number of new collections to be purchased. The most outstanding of them consisted of twenty-nine paintings belonging to the Marquis de la Ensenada, including works such as Rembrandt's *Queen Artemisia*, Velázquez's *Portrait of the Count Duke of Olivares on Horseback* and Tintoretto's *Judith and Holofernes* 391.

1785. In this year Charles III commissioned the great neoclassical architect Juan de Villanueva to design an impressive building for use as a museum in the "prado de San Jerónimo" (the gardens of the Monastery of St. Jerome). This was a large expanse of meadows and trees next to the park belonging to the Buen Retiro Palace at the eastern edge of Madrid. Villanueva had already designed the magnificent Botanical Gardens in this same "prado" in accordance with the king's wishes; now he was required to build a museum in the northern part of the park. In accordance with the scientific enthusiasm of the eighteenth century — the century of Enlightenment and the Encyclopédie — this museum was to house the royal collections in the natural sciences, but it was also intended for the royal works of art.

The idea of allowing the public to see the royal masterpieces was within the best traditions of the Spanish monarchy. It had been possible to visit the royal picture galleries ever since the days of Philip II and Philip IV. As early as this the kings of Spain had been collecting major works of art not just to decorate their palaces but with the specific idea — often stated but not yet put into practice — of creating an art gallery as such. The man responsible for suggesting the setting up of a royal art gallery during Charles III's reign, but before the specific plan for the "Prado" museum came into being, was Mengs, the king's favorite artist. But he died more than six years before May 30, 1785, the date

Villanueva presented the king with his first design for a new museum of the sciences and arts in the "prado".

1787. Villanueva now presented to the king his final plans for the museum, and construction was begun. The magnificent entrance rotunda is reminiscent of the Pantheon in Rome. And with the long gallery forming the main axis of the building and the majestic hall placed across this axis (with its deep apse and a Doric entrance portico opening onto the Paseo del Prado, the park avenue), it presents the fundamentals of ancient architecture: the round mausoleum, the judicial basilica with its apse, and the temple with its portico. This noble and harmonious structure is a distillation of Villanueva's memories of his journey to Rome as a young student of architecture, of the tenets of the newly developed neoclassical culture, and of the particular requirements of the museum.

1788-ff. Charles III died in December 1788, before his museum was completed. Spain was now dragged into the European conflict resulting from the French Revolution, and the monarchs of Europe feared for their thrones. Political events thus slowed down progress on the museum. For political reasons, the new king, Charles IV was able to devote little attention to the museum project.

This is not to say, however, that Charles IV did not make important additions to the royal collections. He had begun to purchase paintings before he came to the throne, acquiring Raphael's masterly *Portrait of a Cardinal* as well as various works by seventeenth century Italian artists (Cavedone, Domenichino and Turchi) and others, for his "casita" at the Escorial and at the Pardo Palace. He was also responsible for the acquisition of Andrea del Sarto's *The Sacrifice of Isaac* and the Master of Flémalle's *St. John the Baptist and Heinrich of Werl* and *St. Barbara* — two of his most important works. But Charles IV's chief merit lies in his patronage of Goya. Most of the 119 Goyas in the Prado (the tapestry cartoons and the portraits) go back to the reign of Charles IV.

1800. The king's minister, Mariano Luis de Urquijo, arranged for paintings by Murillo then in Seville to be moved to Madrid, and he mentioned that it would be advisable to adopt the custom which had grown up in other civilized nations "of setting up schools and museums at court" in order to rescue culture from the somnolence of the provinces. The order concerning the Murillos was cancelled three years later by the Prime Minister, Manuel Godoy. Apart from being the queen's favorite and Prince of Peace (peace with France, that is) he was a keen collector of works by Goya (*The Naked Maja* and *The Clothed Maja*) and by Velázquez (*The Toilet of Venus*, now in the National Gallery in London). On this occasion he, too, spoke repeatedly of a "royal museum."

1808. This was the year of Charles IV's abdication and the flight of his son Ferdinand VII. The Napoleonic occupation of Spain began, and there occurred that heroic War of Independence against the invaders which was later immortalized by Goya in his large canvases depicting the violent episodes of May 2 and May 3. Though surrounded by all these troubles, the new king, Joseph Bonaparte (1808-13), adhered to the Napoleonic cultural policy. He decided to set up an Art Gallery (to be named after himself) and to this effect issued two decrees in 1809 and 1810, which were countersigned by Urquijo, who continued to

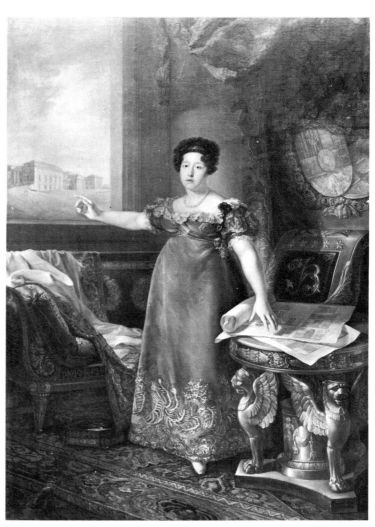

Bernardo López Piquer, Portrait of Maria Isabella of Braganza, second wife of Ferdinand VII of Spain (*Prado*). She encouraged the founding of the Prado. The Prado building can be seen on the left through the window. Plans for hanging the pictures are lying on the table to the right.

serve as Prime Minister. This gallery was to be situated in the Buenavista Palace, now confiscated from Godoy, and was to contain the former owner's masterpieces, together with those removed from recently dissolved monasteries and from public buildings and, if possible, those from the royal collections. The gallery, however, never came into being. Meanwhile, the Prado building was nearly complete but, alas, it was being used as an armory and stables by the French army.

1811. In a letter to Paris, Napoleon's ambassador in Madrid, Count de la Forest, mentioned disparagingly a meeting of the Council of State at which the "Museo Josephino" and the Prado had been discussed, but he scorned the idea of setting up a gallery at the Prado because of the deplorable state to which Villanueva's building had been reduced.

1813. Fifty paintings from the royal collections were selected by the French experts Vivant Denon and Frédéric Quilliet and sent to the Musée Napoleon in Paris. They included some of the most outstanding works which later became part of the Prado, such as a number of Raphaels (*The Madonna del pesce*, *The Fall on the Road to Calvary*, *The Visitation*, *The Holy Family* ("*La Perla*") and *The Holy Family with St. John under an Oaktree*, Maino's *The Recapture of the Port of Bahia in Brazil* and Murillo's *The Adoration of the Shepherds*.

1814. This was the year of Napoleon's fall. In Spain, the War of Independence waged by the Spanish patriots came to an unexpected end with restoration of the Bourbons. Ferdinand VII reentered Madrid in May and began once again his plans to establish an art gallery to house paintings confiscated from the monasteries and at that time held by the Academy of San Fernando. The monasteries successfully claimed them back, however. Others to be housed in the new gallery were to include works from the royal collections, the treasures carried off by the French during their retreat and those sent to the Musée Napoleon, which Ferdinand hoped to recover. It was intended to call this art gallery the "Museo Ferdinandino," and it was to be housed in the Buenavista Palace. But on December 26, the king accepted a proposal by the Council of Castile that the famous but ill-starred building constructed as an art gallery by his father and grandfather should now be used for that purpose. The building they were referring to was the Prado.

Ferdinand VII continued his father's patronage of the arts and commissioned Goya to paint scenes celebrating the rising of 1808 against the French (these were the two famous pictures of *May 2* and *May 3*), as well as some portraits. But by now the king was not so much concerned with collecting paintings as with transfering his own treasures to the gallery.

The golden age of the royal collections had now come to an end, and

we are approaching the time when they were to be enjoyed by the public and so transformed into an active cultural force.

1815. In this year, Maino's *The Recapture of the port of Bahia in Brazil* (see the year 1813) was returned from Paris and deposited at the Academy of San Fernando. The splendid vases belonging to the 'Dauphin's Treasure' (see the year 1839) were also returned to the Museum of Natural History from which they had been removed.

1816. Maria Isabella of Braganza, Infanta of Portugal, arrived in Madrid to become a keen supporter of the gallery, as well as the king's second wife. There is a painting of her in the Prado by Bernardo López.

1818. Restoration work on the building continued. In March, the Marquis of Santa Cruz, who was now to all intents and purposes the director of the Gallery (he was officially appointed the following year), hurriedly used a monthly allowance from the king "to prevent the rain from falling on a ruin." On November 22 the Raphaels and the Murillo arrived back (see the year 1813) — but *The Madonna del pesce* went to the Escorial. Murillo's *The Holy Family with a Bird*, which Joseph Bonaparte had carried off to Orleans, was also returned. On December 26 Maria Isabella, the great patron of the gallery, died in childbirth. 850 paintings from the Royal Palace and Aranjuez had also reached the Prado by this year.

1819. About 600 more paintings reached the Prado. On November 19 the "Real Museo del Prado" was at last officially opened in the presence of Ferdinand VII and his third wife, Maria Josepha Amalia of Saxony. Contrary to what usually happens in the history of museums, it had taken thirty years to put into use rooms which had been specifically designed for this purpose. The Prado was a quarter of a century behind the Louvre, the model which inspired the creators of the Prado, but it was four years ahead of another of the great galleries of Europe, the National Gallery in London.

In its first two years of life, the Prado exhibited only Spanish works, though by recent or even living artists, and they were set out in the three rooms around the rotunda on the first floor. Goya stood out with his *Portrait of Charles IV on Horseback* and *Portrait of Maria Luisa on Horseback* (the famous *The Family of Charles IV of Spain* came into the Gallery later — see the year 1827), but it was Velázquez who took pride of place with the paintings commissioned by Philip IV, including *The Surrender of Breda* and *Las Meninas.* Luis Eusebi, a modest honorary painter of Italian origin, acted as "custodian" of the Gallery, and for the inauguration he drew up the first catalogue of 311 paintings (but there were already 1510 in the building).

1820. After the "Pronunciamiento de Cabezas de San Juan," the king revived the liberal constitution of 1812, and the Prado acquired a new director in the Prince of Anglona. The tradition that the director of the Prado should be of noble blood continued for twenty years. The "king's gallery' had to be in charge of someone with a position at court.

1821. The paintings now also occupied the first central gallery and included Italian and Flemish works. Eusebi's second catalogue listed 512 works, including (among 195 Italian

paintings) Titian's *Portrait of the Emperor Charles V on Horseback at Mühlberg*, and Rubens' *Portrait of the Cardinal Infante Don Ferdinand of Austria at the Battle of Nordlingen*. The Gallery was open to the public on Wednesdays and was heated in winter by means of three large braziers. Permanent stoves were subsequently installed.

1823. Absolute rule was reinstated by French troops sent by the Holy Alliance, and there is an echo of these political events in the fact that Eusebi's third catalogue, similar to the one published in 1821, was issued in French. On December 20, Ferdinand VII appointed the Duke of Ariza as the new director, with Vicente López, a court painter, as his assistant.

1826. Another 99 paintings reached the Prado from the Royal Palace on March 20. On March 31 the Gallery was temporarily closed so that the arrangement of the various schools of painting could be reorganized. López wanted to put the Italian and Spanish schools in the large gallery and the Northern schools in the side rooms, but the director and his nephew, the Duke of Híjar, were opposed to this, as they wished to devote the central gallery to Italian art, house the Spanish and French schools in the large room with the apse, and put the Flemish and Dutch schools in the south block, opposite the entrance rotunda. The Duke of Híjar was appointed as the new director in June, and he rearranged the Gallery in accordance with his own views on the subject. He succeeded in obtaining more pictures from the royal palaces and from the royal collections deposited at the Academy of San Fernando. The renown of the Prado was increased in 1826 by the publication of the first volume of the monumental "Colección lithographica" which, by permission of the king, illustrated works from the Prado and the Royal Palace.

1827. April, May and June saw the arrival from the Academy of San Fernando of Ribera's *Jacob's Dream*, Velázquez's *Portrait of Pablo de Valladolid* and *Portrait of the Jester known as Don John of Austria*, Maino's *The Recapture of the Port of Bahia in Brazil* and a number of "indecent" paintings (i.e. nudes) which were put in a reserved room at the wish of the king. (His predecessors, Charles III and Charles IV, had actually wanted to have such pictures burned.) Among the "indecent" pictures were Dürer's *Adam* and *Eve*, Titian's *Danae and the Shower of Gold* and three paintings of *Venus*, Rubens' *The Judgement of Paris* 1669, *The Three Graces* and *Diana and Callisto*. From Aranjuez came two triptych wings by the Master of Flémalle depicting *St. John the Baptist* and *St. Barbara*, from the Palace of La Granja de San Ildefonso came Pieter Brueghel the Elder's *The Triumph of Death*, and from the Royal Palace came Goya's *The Family of Charles IV of Spain*, which was to dominate the room reserved for the king and his household. And in the same year Ferdinand VII purchased El Greco's *The Holy Trinity*.

1828. The Gallery was reopened on January 27. The public was to be admitted on Wednesdays and Saturdays from 8.00 a.m. until 2.00 p.m. (from 9.00 a.m. until 2.00 p.m. in winter). Spanish, Italian, French and German works were on view, as well as the prohibited nudes, some of which got into Eusebi's new catalogue (the fifth), which was published in Italian and French as well as in Spanish. 757 works are listed in the catalogue. It was in this year that the Scottish artist David Wilkie

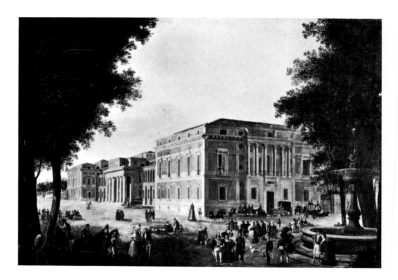

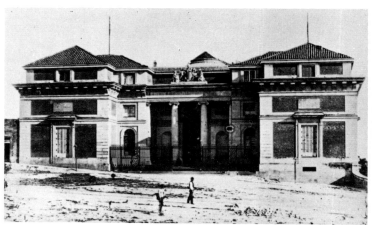

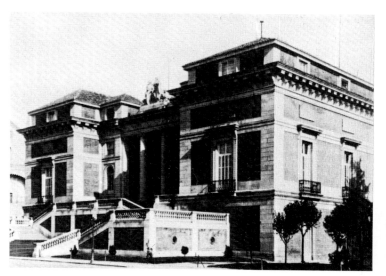

(Top) *Picturesque view of the Prado (Madrid, Collection of the Marquis of Santo Domingo) as it was in 1828, showing the short south side and the long west side facing the Paseo del Prado, with its Doric portico. (Center) The main façade on the north side before construction of the flight of steps. (Bottom) The same façade with the double flight of steps built in 1882 by the architect Francisco Jareño (replaced by the present steps in 1945).*

visited the Prado and was much impressed by it.

1829. Velázquez's masterpiece *Christ on the Cross* 1167 was given to the Prado as a gift to Ferdinand VII from one of the heirs of the Duchess of Chinchon, wife of the minister Godoy, who had just died. A number of pieces of sculpture from the royal collections were also given to the Prado, inclu-

ding bronzes by Leone Leoni. The king purchased José Antolínez's *The Ecstasy of the Magdalene* for the Prado.

1830. New rooms of works by Flemish and Dutch artists were opened, as a sculpture hall on the ground floor. At about this time the Duke of Híjar arranged for the west front of the gallery building to be decorated with portrait medallions, allegorical statues

and a bas-relief on the attic (not put into position until 1842), which showed Ferdinand as a patron of the sciences and the arts.

1831. The French writer Prosper Mérimée visited the Prado and wrote an article about its wonders in "L'Artiste."

1832. The second and third volumes of the "Colección lithographica" were published (see the year 1826). 198 paintings were illustrated, but the series was discontinued.

1833. Ferdinand VII died on September 29 and was succeeded by his small daughter Isabella under the regency of his fourth wife, Maria Christina of Bourbon-Naples. The Prado was now in continual danger as a result of the Carlist civil war, fought until 1839 by the king's brother Don Carlos, who claimed the throne under the Salic law. The Prado Gallery was in even greater danger of dismemberment as a result of the sharing out of the king's property among his widow and daughters. Velàzquez's *Las Meninas* and *The Spinners* were now valued at 400,0000 and 120,000 reals respectively, Goya's *The Family of Charles IV of Spain* was valued at only 80,000 reals and Rubens' *The Three Graces* at 10,000 reals, as against 4,000,000 reals for *The Fall on the Road to Calvary*, which was then thought to be by Raphael working entirely alone. Fortunately, negotiations were protracted, and in 1845 the danger was avoided when the whole of the Prado was assigned to Isabella.

1836. A Committee of Management was appointed to assist the director, thus foreshadowing the modern "Patronato" (see the year 1912).

1837. The Carlist war proved of benefit to the Prado in that a number of major works were evacuated to there from the Escorial, which was in some danger. In this way the Prado acquired, between 1837 and 1839, three Raphaels (*The Madonna del pesce*, *The Holy Family* and *The Madonna della rosa*), Bosch's *The Adoration of the Magi Altarpiece*, a *Madonna and Child* attributed to Giorgione, *The Marriage of the Virgin* and *The Annunciation* by the Master of Flémalle, Mabuse's *Christ with the Virgin and St. John the Baptist* and *The Madonna of Louvain*, Andrea del Sarto's *The Holy Family*, Titian's two paintings of *The Entombment of Christ* and his two paintings of *The Madonna of Sorrows*, Rubens' *The Supper at Emmaus*, Patinir's *The Rest on the Flight to Egypt* 1611 and a number of others. They were to remain the property of the Prado.

1839. The Prado passed out of the jurisdiction of a palace functionary into that of the Patrimonio Real, thus bringing to an end the directorship of the Duke of Híjar — the last director to be a nobleman. Now began the period when directors were court painters, and the Madrazo Family was well to the fore. The first was José de Madrazo, Director of the Academy of San Fernando and founder of a whole dynasty of artists which has continued up to the present day. He arranged for the Prado to be open to the public only on Sundays instead of twice a week, in order to give greater access to colleagues and pupils from the Academy who wanted to make copies there during the week. He reorganized the Prado on the model of the Louvre, and entrusted the revision of the catalogue to his son Pedro.

By a decree of December 29, 1838, the famous "Dauphin's Treasure" was transferred to the Prado from the Mu-

seum of Natural History. On April 27 six new rooms of paintings were opened to celebrate the birthday of the Regent, Maria Christina.

1843. Pedro de Madrazo's new catalogue was published. It went through thirteen editions and, with additions by his successors, another six editions. It lasted until 1920 — twenty-two years after the author's death. The Prado was now called the *Real Museo de Pintura y Escultura*. 1949 paintings were on exhibition, while 1833 appeared in the catalogue.

1847. Memling's triptych of *The Adoration of the Magi*, which had once belonged to Charles V, came to the Prado from the Castle of Aceca near Toledo.

1848. Approval of regulations for the Gallery, drawn up by José de Madrazo.

1857. After the 1854 revolution and a reduction in contributions to the Prado, José de Madrazo resigned as director and his place was taken by the painter Juan Antonio Ribera, who set about improving the condition of the pictures (restoration work, rebacking canvases, purchase of chemicals for the laboratory), and drying out that part of the Paseo del Prado whose humidity was affecting the Prado building. In this years Edgar Quinet published *Mes vacances en Espagne*. He had visited the Prado in 1840, and declared it to be the richest art gallery he knew.

1860. Federico de Madrazo became Director of the Prado. He was the eldest son of José, who had died the previous year, and was a court painter and well-known portrait artist. In the next year, the Gallery acquired another masterpiece in the form of Fra Angelico's *The Annunciation* — which resulted from a skilful exchange of "Annunciations" arranged by Federico de Madrazo with the Descalzas Reales nuns.

1865. Napoleon III and the Empress Eugenie presented to Isabella II a large Sèvres vase by Schilt (1852), which joined the "Dauphin's Treasure" in the Prado. Jan Van Kessel the Elder's strange triptych of forty small paintings of *Animals* was given to the Prado by Count Hugo. This was the first time that a gift had been made directly to the Gallery. Its enrichment was now no longer the exclusive privilege of the crown. The reproduction of paintings now no longer depended on royal permission. As a result of the advent of photography many more private individuals were granted permission to make reproductions. In September of the same year a huge allegorical painting by Vicente López was set in the ceiling of the Sala de Descanso (the "Hall of Rest" — now called the "Sala del Tiepolo," XXXIX on the first floor).

1866. Restoration work on the "Dauphin's Treasure" was carried out by Pedro Zaldos, a goldsmith. The "Treasure" was put on view the following year in two glass cases in the central gallery.

1868. In June the Gallery purchased El Greco's *The Annunciation* for 150 escudos. The Director of the Gallery, Madrazo, opened negotiations for the transfer to the Prado of the famous tapestry cartoons which Goya had painted as a young man for the royal tapestry workshops of Santa Barbara. They were at present rotting in the cellars of the Royal Palace. The September revolution brought about the

fall of the Bourbons, and so the Prado was nationalized, thus protecting it from the uncertainties of the royal succession. It was given the title Museo Nacional de Pintura y Escultura. The liberal painter Antonio Gisbert was appointed director.

1870. This year saw a great increase in the fortunes of the Prado, for Goya's tapestry cartoons arrived, together with others by Ramón Bayeu and José del Castillo (25 in all). Their transfer from the Royal Palace was hastened as a result of a theft of six cartoons the previous year, including Goya's *The Guitar Player, Dogs and Hunting Gear* and *Children Playing at Giants*. They were recovered later, however (see the years 1895 and 1914). On November 25 a first decree was issued dissolving the Museo Nacional de la Trinidad, which had been created in 1840 to house the art collections of recently suppressed monasteries. It was decided to merge the Prado and the Museo Nacional de la Trinidad.

1871. A monument to Murillo was unveiled at the back of the Prado, looking on to the Botanical Gardens. It was a copy of the monument erected at Seville in 1863, and was the first of a series of monuments to great Spanish artists which were to be set up around the Prado.

1872. A final decree for the dissolution of the Museo Nacional de la Trinidad was issued on March 22. As a result, a number of masterpieces came to the Prado, including Berruguete's panels from the *St. Dominic* and *St. Peter Martyr* polyptychs, *The Fountain of Grace* (school of Van Eyck), and Van der Weyden's *Triptych of the Redemption*, to be followed by Goya's *Self-portrait* and his *Portrait of Josefa Bayeu* and some El Grecos — notably *The Resurrection of Christ, The Descent of the Holy Ghost* and *Christ Carrying the Cross*. Some frescoes by Annibale Carracci were also received. They had been taken down from the church of San Giacomo degli Spagnoli in Rome, and were not exhibited in the Prado until recently. Pedro de Madrazo's monumental *Catálogo descriptivo e histórico* (713 pages) was also published in 1872, giving the Gallery its new title of "Museo Nacional." The first 154 pages of this catalogue had in fact been printed during the reign of Isabella II. It covered only the Italian and Spanish schools, and no more was to be published. The director set aside a room in the Prado as his private painting studio — a much criticized innovation which continued until 1918.

1873. Gisbert continued as director during the brief reign of Amedeo I of Aosta (1870-3), but with the advent of the First Republic in 1873 he was replaced by Francisco Sans y Cabot, a painter who remained as director even when the Bourbon restoration brought Alfonso XII to the throne in 1875. Except for another hundred or so paintings which came to the Prado up to 1877, the rest of the valuable collection at the Museo Nacional de la Trinidad was dispersed (for lack of space at the Prado) to provincial museums, small churches and village halls as well as to private institutions, where they often ended up by being destroyed. It is only recently that the difficult work of recovering them has been started.

1880. Valdés Leal's *Christ among the Doctors* was acquired.

1881. Federico de Madrazo was reappointed Director of the Prado and continued to hold the office until his death in 1894. The German banker Baron Emile

d'Erlanger gave the Prado Goya's fourteen amazing "Black Paintings" which had decorated the artist's house on the banks of the Manzanares, known as the "House of the Deaf." Erlanger had bought the House of the Deaf in 1873 in order to rescue these wall paintings from the destruction with which they were threatened, and he had the paintings transferred to canvas. They were thought so revolutionary that it was twenty years before they were put on exhibition.

1882. Francisco Jareño was commissioned to design a new entrance for the Prado. It was to have a fine double stairway to take the place of the flight of steps leading from ground level to the first floor rotunda.

1884. Francisco de Palafox, Duke of Saragossa, gave the Prado Goya's portrait of his father: *Portrait of General Don José de Palafox on Horseback.*

1889. The Duchess of Pastrana gave her splendid collection of paintings to the Prado. It included Rubens' 12 sketches for the mythological paintings for the Torre de la Parada, and as many as 200 other works, including Rubens' three *Scenes from the Life de Achilles*, portraits of Madame de Pompadour and Madame Du Barry, attributed to Drouais, and that strange work by John Francis Rigaud entitled *The Three Favorite Balloonists*, which celebrates the first balloon ascent by an Englishwoman in 1785.

1891. Two fires broke out in the Prado, on the 18th and 21st of July, and were extinguished with difficulty by the gallery staff. The lack of care exercised in protecting the Gallery led a journalist named Mariano de Cavia to write a sensational article in the November 25 issue of "El Liberal" in which he imagined that the Prado had burned down during the night. He imagined the arrival of the Minister of National Economy and his criticisms of the safety precautions which had failed to prevent the fire. The next day, the Minister did indeed visit the Prado and ordered the removal of all the wood stored in the cellars and the departure of the families of gallery staff who were living in the building without permission.

1894. Federico de Madrazo died in June and was succeeded as Director of the Prado by Vicente Palmaroli, a pupil of his, who was officially appointed to the position in 1895. The dowager Marchioness of Cabriñana gave four paintings to the Prado, including Paulus Potter's *Animals in a Meadow* and Memling's delightful *Madonna and Child with Two Angels.*

1895. The artist Raimundo de Madrazo gave the Prado two of the cartoons by Goya which had been stolen from the Royal Palace in 1869, namely: *The Guitar Player* and *Dogs and Hunting Gear.*

1896. Palmaroli died in January and was succeeded as director by another painter, Francisco Pradilla. When the estate of the Duke of Osuna was put up for auction, the Prado bought Goya's *Portrait of General Urrutia* for 50,000 *pesetas*, and his *The Meadow of St. Isidore* for 10,000 *pesetas*, while a further 15,000 *pesetas* procured Carreño de Miranda's fine *Portrait of the Duke of Pastrana*. Goya's magnificent *Portrait of Doña Tadea Arias de Enriquez* was given to the Prado by the sitter's grandchildren, and Morales' *St. John of Ribera* was bequeathed by Maria Enríquez de Valdés.

1897. Goya's magnificent *Portrait of the Duke and Duchess of Osuna and*

9

their children was donated to the Prado by their descendants. Pablo Picasso, still only a youth at this time, frequented the Prado and made copies, especially of paintings by El Greco, who was not yet very highly regarded.

1898. Goya's "Black Paintings" (see the year 1881) were at last put on exhibition, as a result of a protest from a son of the donor. The magazine "Ilustración Española y Americana" published the new piece of sculpture, representing *The Apotheosis of Apollo*, which now had pride of place at the top of the north façade, in place of an earlier modest work. On July 29, the director, Pradilla, resigned as a result of the theft of Murillo's beautiful sketch for *The Virgin and St. Anne*. The new director was another painter: Luis Álvarez Catalá. Meanwhile, Spain was at war with the United States and was to lose her last colonies: Cuba, Puerto Rico and the Philippines. On August 1 the Museo de Arte Moderno was opened in Madrid and the works of a number of contemporary artists were transferred there from the Prado. On December 10 a peace treaty was signed with the United States. Political events had in fact put the Prado in a very dangerous position, for its works had been valued, perhaps with a view to war reparations or the purchase of currency towards the cost of the war. The works of Velázquez were valued at 18,600,000 francs, those of Rubens at 4,000,000 francs, and the Goyas at 3,000,000 francs. The American collector Havemeyer actually declared that the United States should have exchanged the Philippines for the Prado. But fortunately the masterpieces in the Prado were not touched.

1899. The tercentenary of the birth of Velázquez was celebrated. The preceding year Aurelio de Beruete y Moret had published an important monograph on him. On June 6 there was an official commemoration in the presence of the Regent, Maria Christina, in the Sala Velázquez, now officially inaugurated (see the year 1889). On June 14 a monument to Velázquez was unveiled in front of the entrance at the long side of the Gallery.

1901. On the death of Álvarez, the painter José Villegas became director of the Prado. Goya's *The Naked Maja* and *The Clothed Maja* were transferred from the Academy of San Fernando.

1902. Alfonso XIII came to the throne. An El Greco exhibition began a tradition of large-scale exhibitions at the Prado.

1904. 25 modern works, including some by Mariano Fortuny, were bequeathed to the Prado by Ramón de Errazu.

1905. A large Zurbarán exhibition was held. Velázquez's *Portrait of Don Diego de Corral y Arellano* and his *Portrait of Doña Antonia de Ipeñarrieta y Galdós and her son Luis* were bequeathed to the Prado by the Duchess of Villahermosa.

1908. Publication of the first catalogue of the Prado's 400 sculptures, edited by Eduardo Barrón, keeper of the sculptures. At this time the statues occupied a large part of the ground floor: the oval room, the large gallery beyond it, and the "rotunda of Ariadne" at the back.

1912. Alfonso XIII signed a royal decree creating a "Patronato" (Board of Management) for the Gallery. It was to have nine members (the number was increased to twelve in 1913), and the Inspector of Fine Arts and the Director of the Gallery were members *ex officio*. The Duke of Alba was the first chairman. The Board aimed to modernize the Gallery, to gather together the collection from the Museo Nacional de la Trinidad, which was at present scattered in various storage places, and to enlarge the Gallery, since its thirty-one rooms (thirteen on the ground floor, fourteen on the first floor and four on the second floor) were now insufficient. The Hungarian art collector Marzel de Nemes donated Antonio Pereda's *The Relief of Genoa by the Second Marquis of Santa Cruz*, which had been removed by General Sebastiani during the French occupation. Its arrival in the Prado meant that the group of great historical works painted for the Salon de Reinos in the Buen Retiro Palace to extol the glories of Philip IV (Velázquez's *The Surrender of Breda* is the most outstanding of them) was now complete. Francisco Bayeu's *Portrait of Feliciana Bayeu* and Goya's *The Execution* and *The Pyre* were bequeathed to the Prado by Cristóbal Ferriz.

1914. In January the Gallery failed to purchase Van der Goes' *The Adoration of the Magi*. The magazine "Por el Arte" had launched a public appeal fund which had raised the sum of 76,000 *pesetas* (more than two million *pesetas* of today's money), as against the 1,268,000 *pesetas* paid by the Kaiser. On the other hand, the Prado acquired Goya's cartoon *Children Playing at Giants*, which had been stolen from the Royal Palace in 1869 and was now given to the king by Baron Herzog of Budapest. Work on the enlargement of the gallery building was begun in accordance with plans drawn up by the architect Fernando Arbós. It was proposed to join together the two outer blocks of the building and the projecting apse of the oval hall. In this way it would be possible to create about twenty new rooms on two floors along the east side of the building. They would be separated from the central gallery by two courtyards.

1915. Vinierga, the deputy director, died, and his place was taken by José Garnelo, a painter, who discovered Giambattista Tiepolo's *St. Francis of Assisi Receiving the Stigmata* in one of the Gallery's storerooms. The painting was in extremely poor condition, but was restored, and joined another work from the same series already in the Gallery, namely *The Immaculate Conception* from the church of San Pascual at Aranjuez. Other paintings from the same series were acquired in 1926, 1933 and 1959. In this same year, the heirs of the Countess of Castañeda gave the Prado Morales' *St. Stephen*, and the very large Pablo Bosch bequest brought in 89 paintings, 946 coins and 852 medals. The paintings included Alonso Cano's *The Dead Christ* 2637, Cima da Conegliano's *Madonna and Child*, Gerard David's *The Rest on the Flight to Egypt*, Fernando Gallego's splendid *Christ Enthroned*, El Greco's powerful *A Trinitarian or Dominican Friar*, Morales' masterly *Madonna and Child* 2656, Marinus Van Roemerswaele's *St. Jerome* 2653 and Bernard Van Orley's *The Holy Family*.

1917. A Morales exhibition was held. Vincenzo Campi's *The Crucifixion* was bequeathed to the Prado by José Maria d'Estoup. Since the beginning of the century, about 150 pictures had been donated, bequeathed or returned to the Gallery.

1918. On September 20, it was discovered that 11 objects belonging to the "Dauphin's Treasure" and exhibited in two glass cases in the gallery leading to the Sala Velázquez had been stolen many months earlier. Jewels and cameos which had been taken from precious vases were traced on the antiquarian market, while one object was found at a pawnbroker's. Rafael Coba, a temporary member of the gallery staff, was found to have carried out the theft with the aid of three custodians. Journalists and intellectuals criticized both the failure of those responsible for the Gallery to take sufficient security measures, and the danger to the Gallery of allowing unchecked entry and exit ever since the director's private studio had been inside the building. In December, a distinguished art historian, Aureliano de Beruete y Moret, was appointed director, with Fernando Álvarez de Sotomayor, a court painter, as deputy director. Beruete made it his task to revise the catalogue entries and to increase the number of paintings on exhibition.

1919. The centenary of the foundation of the Prado occurred on November 19, but went by without celebration.

1920. The room devoted to El Greco was reopened after renovation, as were also the two rooms containing Velázquez's *Christ on the Cross* 1167 and the views of *The Gardens of the Villa Medici in Rome*. In this year the Gallery's name was changed from Museo Nacional de Pintura y Escultura to Museo del Prado. Work on the extension to the Gallery was completed (see the year 1914). The purchase by public subscription of *The Madonna of the Knight of Montesa* by an unknown artist from Valencia, caused heated debate. Three works were transferred from the Museo Arqueológico Nacional, namely: Bartolomé Bermejo's masterly *St. Dominic of Silos*, the Master of Arguis' polyptych of *The Legend of St. Michael*, and the *St. Vincent, Deacon and Martyr* by the Master of Archbishop Dalmau de Mur. The trial of those responsible for the theft from the "Dauphin's Treasure" was held from November 15 to 20. As a result the principal thief was released from prison, having already spent the period of his sentence there. His associates were acquitted. A strong protest against the verdict was signed by writers and intellectuals.

1921. El Greco's *St. John the Evangelist* was given to the Prado by César Cabañas.

1922. Beruete, the director of the Gallery, died in June and was succeeded by Fernando Álvarez de Sotomayor (see the year 1918). The new deputy director was an art historian, Professor Francisco Javier Sánchez Cantón.

1923. Andrea del Sarto's *St. John the Baptist with the Lamb* was purchased.

1924. Giambattista Tiepolo's magnificent *Abraham and the Three Angels* was given to the Gallery by the Sainz y Hernando family, and a *St. Michael* by an anonymous fifteenth century artist of the Hispano-Flemish school was bought from the Hospital of San Miguel de Zafra.

(From the left) Pedro de Madrazo, editor of the basic catalogue of paintings published from 1843 to 1920 (editions from 1900 onward were posthumous), in a portrait by his brother Federico, who was one of the most important Directors of the Prado. Fernando Álvarez de Sotomayor, who was Director of the Prado from 1922 to 1931 and after the Civil War from 1939 to 1960. Francisco Javier Sánchez Cantón, director of the Prado from 1960 to 1968.

1925. Herrera the Elder's *St. Bonaventura received into the Franciscan Order* was given to the Prado by Joaquín Carvallo, and Adriaen Isenbrandt's tiny panel of the *Madonna and Child with St. John and Three Angels* was bequeathed by Luis de Castro y Solís. Van der Weyden's *Pietà* was purchased. On September 20 the fine central staircase in the Gallery was officially opened. It was designed by the architect Pedro Muguruza and led from the central gallery to the smaller rooms containing works by Velázquez.

1926. The Luis de Errazu bequest brought to the Prado Tiepolo's *St. Paschal Baylón* (see the year 1915), El Greco's *Portrait of Julián Romero de las Azañas with St. Julian*, and three other paintings. A bequest by the Marquis of Niebla brought three Goyas (the portraits of the two Marchionesses of Villafranca and that of the Duke of Alba), and Van Dyck's *Portrait of the Earl of Arundel and his Grandson*. Alonso Sánchez Coello's supposed *Self-portrait* and Mateo Cerezo's *St. Augustine* were purchased for the Gallery.

1927. Raimundo de Madrazo's *Portrait of the Marchioness of Manzanedo* was bequeathed to the Prado by the sitter, who had died in 1924. Feus Bartolomeus' *Madonna and Child* and the *Self-portrait* by Murillo (school of) were purchased. On December 12 the central gallery was reopened, with its new reinforced concrete roof in place of the old false roof of lathwork.

1928. The widow of General Mille bequeathed Francisco Bayeu's sketch of *St. Theresa in Glory* to the Gallery. Purchases were: Juan de Sevilla's *The Rich Man and Lazarus*, Jan Van Kessel II's *A Family in a Garden* and the *Pietà* by the Master of the Virgo inter Virgines. On the occasion of the centenary of the death of Goya, the ground floor rooms were reorganized for an exhibition of his tapestry cartoons, and a large exhibition, with catalogue, was held in April and May. The first volume of a catalogue of Goya's drawings (*Goya: I, Cien dibujos inéditos*) was published, edited by Félix Boix andI F. J. Sánchez Cantón.

1929. Enrique Puncel gave the Gallery Mariano Salvador Maella's *A Vision of St. Sebastian and Aparicio*. Purchases were: Bernini's *Self-portrait*, Yáñez de la Almedina's *St. Damian* (he had not hitherto been represented in the Prado) and the *Polyptych of Archbishop Don Sancho de Rojas* by an unknown artist. To celebrate the one hundred and fiftieth anniversary of the death of Mengs, a large exhibition of his work, with catalogue, was held.

1930. The extremely important Pedro Fernández Durán bequest brought in almost one thousand paintings, as well as tapestries, embroidery, furniture, armor, ceramics, miniatures and drawings. The paintings included five masterpieces by Goya (*The Colossus or Panic, Blind Man's Buff 2781, The Drunken Stonemason, The Hermitage of St. Isidore on a Festival Day* and the *Portrait of General Don Antonio Ricardos*), Van der Weyden's *Madonna and Child*, Adriaen Brouwer's *Three Men Searching for Lice*, David Teniers II's *The Smokers*, three still lifes by Willem Claesz. Heda, Valentin Boullogne's *St. Peter Denying Christ*, an *Ecce Homo* by Morales, Battistello Caracciolo's *St. Cosmas and St. Damian*, three sketches for royal portraits by Luca Giordano and twelve paintings

by Frans Franck the Younger. The Xavier Lafitte bequest brough another sixteen paintings, including three Canalettos, Ribera's *An Elderly Money Lender*, and Morales' *The Annunciation*. Purchases were: Pieter Brueghel the Elder's *The Adoration of the Magi*, the Master of Sigüenza's *Polyptych of St. John the Baptist and St. Catherine*, Miguel Ximénez's predella of *The Resurrection of Christ with Scenes from the Legend of St. Michael and from the Martyrdom of St. Catherine*, and six panels by the Master of La Sisla. Four scenes from the lives of Carthusians by Vicencio Carducho were transferred from the Museo Nacional de la Trinidad. The second floor of the north block of the Prado was enlarged in the period 1929-30 in order to make room for the Fernández Durán bequest. In addition, the beautiful rotunda at the north end of the ground floor, below the Ionic rotunda, was "rediscovered".

1931. Ramón Pérez de Ayala, a writer, became director of the Prado. New acquisitions included the two panels of *The Legend of St. Lucy* by the Master of Estimariú and Goya's *Portrait of Don Manuel Silvela*. The Fernández Durán bequest was housed in the new rooms on the second floor, with Goya's drawings displayed in the furthest of these.

1932. Goya's three tondos, *Trade, Agriculture and Industry* came from the Admiralty, which now occupied the palace formerly belonging to the minister Godoy, for whom Goya had painted them. The Gallery purchased Zurbarán's *St. Diego of Alcalá* and Nicolas Francés' polyptych depicting *Scenes from the Life of the Virgin and St. Francis*.

1933. Antonio Pereda's *The Annunciation* was bequeathed to the Prado by Count de Pradere and Anders Zorn's *Portrait of Christine Morphy* was bequeathed by the dowager Countess of Morphy. Fernando del Rincón's *St. Cosmas and St. Damian performing Miracles* was loaned from the fortress of Guadalajara. Purchases were: the *Triptych of the Nativity* by the Master of the Half Figures, the *Triptych of the Annunciation* by the Master of the Holy Blood, G. B. Tiepolo's *An Angel with a Crown of Lilies* (see the year 1915), and Luis Paret y Alcázar's *Charles III of Spain at Table Before his Courtiers*. F. J. Sánchez Cantón's new catalogue was published. It grouped works according to the artist's country and for the first time included all the exhibited sculptures as well as the paintings.

1934. The Duke of Tarifa bequeathed to the Prado: Marinus Van Roemerswaele's *The Money Changer and his Wife*, Pantoja de la Cruz's *Portrait of Philip III of Spain* and *Portrait of Queen Margaret of Spain*, and Mengs' delightful sketch for the *Portrait of Maria Luisa of Parma 2568*. Purchases were: Juan Bautista del Mazo's *A Hunting Scene at Aranjuez* and thirteen small sketches for tapestry cartoons by Francisco Bayeu.

1935. The Duke of Arcos bequeathed to the Prado: Romney's *Portrait of an English Gentleman*, Greuze's *A Young Woman Seen From Behind*, Nattier's *Portrait of Marie Leszczynski* (the identity of the sitter is not certain) and seven other pictures. Purchases were: Pedro Machuca's *The Virgin and the Souls in Purgatory*, Jan Van Scorel's *Portrait of a Humanist*, Claudio Coello's *The Christ Child at the Temple Door* and Valdés Leal's *A Martyr of the Hieronymite Order*. An

exhibition of the treasures of the "Cámara Santa" at Oviedo was held.

1936. The last purchases before the Civil War were: Zurbarán's magnificent *St. Luke Dressed as a Painter* and Valdés Leal's *St. Jerome*. The civil war between Republicans and Nationalists caused the Prado to be closed on August 30, and since there was a danger of bombing, the most important pictures (including the entire contents of the Sala Velázquez) were taken down to the cellars and protected with sandbags. In September the director of the Gallery left Spain. On November 5, the Minister of Education decided to transfer the principal paintings from the Prado (and the other galleries) to Valencia. On November 16, a high relief by Bambaja fell as the result of a bomb explosion and was severely damaged. On November 20, Pablo Picasso was appointed director of the Gallery. However he never took up the position. Work began on moving the paintings to Valencia, to be housed in the Torre de Serranos, a very strong building which had been reinforced with a series of protective ceilings. Special precautions against vibration and dampness were taken, and the first paintings to be evacuated were Velázquez's *Las Meninas* and Titian's *Portrait of the Emperor Charles V on Horseback at Mühlberg*.

1937. A number of major paintings were removed to Valencia, including four by Velázquez (*The Surrender of Breda, The Forge of Vulcan, The Topers* and *The Spinners*), Rubens' *The Three Graces* and Goya's *The Family of Charles IV of Spain*. The "Dauphin's Treasure" was also taken to Valencia. In February an exhibition in Brussels included Rubens' series of paintings known as *The Apotheosis of the Eucharist*.

1938. In January, Roberto Fernández Balbuena, architect and painter, became deputy director of the Prado. In view of the possibility of Spanish territory being split in two, the remaining paintings in the Prado were moved (late March and early April) to various places in Catalonia.

1939. In view of the Nationalist offensive in Catalonia, the treasures of the Prado were sent via France to the League of Nations in Switzerland on the understanding that they would be returned to the Spanish government after the war. When the Civil War came to an end on April 1st the new government reinstated Fernando Álvarez de Sotomayor as director and Francisco Javier Sánchez Cantón as deputy director. From June to August an important exhibition of the 152 masterpieces in the care of the League of Nations, plus 21 others, was held at the Musée d'Art et d'Histoire in Geneva, with the title "Exposition de Chefs-d'Oeuvre du Musée du Prado." 400,000 people visited the exhibition. Meanwhile, in Madrid, the damage to the Prado building was being repaired, and on July 7 an exhibition of paintings from Barnaba da Modena to Goya was opened, including works from the Prado itself and from other sources. The declaration of war on September 3 necessitated bringing back all the Prado pictures from Geneva as quickly as possible, and they were restored to the positions they had occupied in the Gallery in 1936. The treasures of the Prado had now finished their hazardous journeys and were back in place, unharmed. Additions to the collection began once more: Juan Carreño de Miranda's *The Naked "Giantess"* was given to the Gallery by Baron de Forna.

List of Catalogues of the Prado Museum

L. EUSEBI, Catálogo de los cuadros de Escuela Española que existen en el Real Museo del Prado, 1819

L. EUSEBI, Catálogo de los cuadros que existen colocados en el Real Museo del Prado, 1821

L. EUSEBI, Notice des Tableaux exposés jusqu'à présent dans le Musée Royal de Peinture au Prado, 1823

L. EUSEBI, Catálogo de los cuadros que existen colocados en el Real Museo de Pinturas del Prado, 1824

L. EUSEBI, Noticia de los cuadros que se hallan colocados en la Galería del Museo del Rey nuestro señor sito en el Prado de esta Corte, 1828

L. EUSEBI, Notice des Tableaux exposés jusqu'à présent dans la Galerie du Musée du Roi, 1828

L. EUSEBI, Notizia dei Quadri Esposti finora nella Galleria del Museo del Re, 1828

P. DE MADRAZO, Catálogo de los cuadros del Real Museo de Pintura y Escultura de S. M., 1843

P. DE MADRAZO, Catálogo de los cuadros del Real Museo de Pintura y Escultura de S. M., 1845

P. DE MADRAZO, Catálogo de los cuadros del Real Museo de Pintura y Escultura de S. M., 1850

P. DE MADRAZO, Catálogo de los cuadros del Real Museo de Pintura y Escultura de S. M., 1854

P. DE MADRAZO, Catálogo descriptivo e histórico del Museo del Prado de Madrid seguido de una sinópsis de las varias escuelas y los autores de éstos y de una noticia histórica sobre las colecciones de pintura de los Palacios Reales de España, y sobre la formación y progresos de este Establecimiento, 1872

P. DE MADRAZO, Catálogo de los cuadros del Museo del Prado de Madrid, 1873

P. DE MADRAZO, Catálogo de los cuadros del Museo del Prado de Madrid, 1876

P. DE MADRAZO, Catálogo de los cuadros del Museo del Prado de Madrid, 1878

P. DE MADRAZO, Catálogo de los cuadros del Museo del Prado de Madrid, 1882

P. DE MADRAZO, Catálogo de los cuadros del Museo del Prado de Madrid, 1885

P. DE MADRAZO, Catálogo de los cuadros del Museo del Prado de Madrid, 1889

P. DE MADRAZO, Catálogo de los cuadros del Museo del Prado de Madrid, 1893

P. DE MADRAZO, Catálogo de los cuadros del Museo del Prado de Madrid, 1900

P. DE MADRAZO, Catálogo de los cuadros del Museo Nacional de Pintura y Escultura, 1903

P. DE MADRAZO, Catálogo de los cuadros del Museo Nacional de Pintura y Escultura, 1907

P. DE MADRAZO, Catálogo de los cuadros del Museo del Prado (corrected by S. Viniegra), 1910

P. DE MADRAZO, Catálogo de los cuadros del Museo del Prado, 1910

P. DE MADRAZO, Catalogue des Tableaux du Musée du Prado, 1913

P. DE MADRAZO, Catálogo de los cuadros del Museo del Prado, 1920

F. J. SÁNCHEZ CANTÓN, Museo del Prado, Catálogo, 1933

F. J. SÁNCHEZ CANTÓN, Museo del Prado, Catálogo de los cuadros, 1942

F. J. SÁNCHEZ CANTÓN, Museo del Prado, Catálogo de los cuadros, 1949

F. J. SÁNCHEZ CANTÓN, Museo del Prado, Catálogo de los cuadros, 1952

F. J. SÁNCHEZ CANTÓN, Museo del Prado, Catálogo de los Cuadros, 1963

1940. The Prado acquired Quentin Massys' *Christ Before The People*, which had been bequeathed by Mariano Lanuza in 1936. In the same year, Francisco Cambó gave the following works: Botticelli's three magnificent panels of *The Story of Nastagio degli Onesti*, Taddeo Gaddi's two small panels of *Scenes from the Life of St. Eloy*, Melozzo da Forlì's *An Angel Playing a Musical Instrument*, Giovanni dal Ponte's *The Seven Liberal Arts* and Zurbarán's splendid *Still Life*. All these paintings passed into the Gallery the next year. Purchases were: Felipe Ramirez's *Still Life* and Francisco Ribalta's *Christ Embracing St. Bernard*.

1941. An exchange of works of art was arranged with the French government, as a result of which the Prado received: the *Lady of Elche*, a masterpiece of Iberian sculpture, Murillo's *The Immaculate Conception*, which Marshal Soult had taken from Seville in 1813, and Goya's tapestry cartoon *The Fight at the "Venta Nueva."* In exchange, Velázquez's replica of his *Portrait of Mariana of Austria, Queen of Spain* was given to the Louvre. In addition, Murillo's *St. Isabella of Hungary Healing Lepers* was restored to the Hospital de la Caridad in Seville, but at the same time one of his finest portraits, the *Portrait of a Gentleman Wearing a Ruff* was acquired. Other important purchases were: Alonso Cano's *The Miracle of the Well*, Yáñez de la Almedina's *St. Anne, the Virgin, St. Isabella, St. John and the Christ Child*, "Hell" Brueghel's *Snow Scene* and *A River Ford*, and Pedro Ruiz González's *Christ on the Night of the Passion*. The most important works to come to the Prado, however, were loaned from the Escorial by order of the government. They were: Bosch's *The Table of the Seven Deadly Sins* and *The Garden of Delights Triptych*, Van der Weyden's *The Deposition of Christ* and Tintoretto's *Christ Washing the Apostles' Feet*. The second volume of Goya's drawings, again edited by Sánchez Cantón, was published *Goya: II, Ochenta y cuatro dibujos inéditos y no coleccionados*. (For the first volume, see the year 1928.)

1942. Purchases were: El Greco's *St. Andrew and St. Francis*, two small heads of weeping female saints by Luis Tristán from the Yepes polyptych, two paintings of *Cupids* (overdoors) attributed to Boucher. Work began on replacing the old wooden floors of the Gallery with new fireproof ones.

1943. Purchases were: Reynolds' *Portrait of a Clergyman*, and David Roberts' two Spanish landscapes, *The Castle of Alcalá on the River Guadaira* and *The Torre del Oro*.

1944. Mario de Zayas, a Mexican, gave the Prado an outstanding collection of antique sculptures. Count de la Cimera bequeathed twelve paintings, including the *Portrait of the First Count of Vilches* and the *Portrait of the Countess of Vilches* by José and Federico de Madrazo respectively, Agustíne Esteve's *Portrait of the Count Consort de la Cimera* and a view of *The Coloseum* by Hubert Robert. Important purchases were: El Greco's *The Veil of St. Veronica* and one of Velázquez's rare early works, *Portrait of the Venerable Mother Jerónima de la Fuente*, as well as Luis Paret's delightful *A Masked Ball* and Hobbema's *Landscape*. The 'Dauphin's Treasure', which had been put back into the central gallery in 1939, was now moved into the small rotunda at the west end of the southern section of the ground floor which corresponded

to another rotunda containing the *Lady of Elche*. The four original niches in this rooms were provided with original gesso shelves, supported on brackets, taken from the room where the *Lady of Elche* was on exhibition (and where the shelves were still preserved). It may be that Villanueva had originally intended these shelves to be used for the "Treasure," for it belonged at that time to the Museum of Natural History which was to have been housed in the Prado building (see the year 1785). A catalogue of the "Treasure," edited by Diego Angulo Iñiguez, was also published in this year.

1945. The fine flight of steps on the north side of the building (see the year 1882) was replaced by a double flight designed by Pedro Muguruza.

1946. Goya's *Portrait of Don Juan Bautista de Muguiro* and *The Milkmaid of Bordeaux* were bequeathed to the Prado by Fermín de Muguiro, and a recently rediscovered Velázquez, *Christ on the Cross* was given by the Bernardas del Sacramento Convent in Madrid, through the Minister of Education. Purchases were: the four surviving paintings of El Greco's 'Apostolado' from Almadrones, Yáñez de la Almedina's lovely *St. Catherine* and Zurbarán's *A Vase of Flowers*. In this year the monument to Goya, which had been erected in 1902, was moved from the intersection of the Calle de Velázquez and the Calle de Goya to a position facing the north side of the Prado Gallery.

1947. León Picardo's two panels *The Annunciation* and *The Purification of the Virgin* were purchased.

1949. The first volume of a catalogue of sculptures, edited by Elías Tormo, was published with the title: *Catálogo de las Esculturas: I, La Sala de las Musas*.

1950. Fortuny's *Portrait of the Artist's Children, Maria Luisa and Mariano* was bequeathed to the Prado by the artist's son Mariano. Amigoni's *Portrait of the Marquis of the Ensenada* was purchased. The wall paintings from the Hermitage of the Cross at Maderuelo by an unknown Spanish artist of the XII century were transferred to a small ground floor room which had been set out as a chapel for this purpose. These paintings had been purchased and put on canvas in 1947.

1952. Luis de Madrazo's *Portrait of a Lady* was bequeathed to the Prado by María Cuesta. Ignacio Iriarte's *Landscape with Shepherds* was given by Frederick Mont. Purchases were: Murillo's magnificent *Landscape 3008* and four of the six panels which Juan de Flandes painted for the church of San Lázaro at Valencia. (The other two went to America.) A two-volume work illustrating Goya's 480 drawings in the Prado was also published.

1953. Bertram M. Newhouse gave the Prado Thomas Gainsborough's *Portrait of Dr. Isaac Henrique Sequeira*. Purchases were: a *Pietà* by Luis Tristán, Salomon Koninck's *A Philosopher*, Van Goyen's *Landscape* and Michiel Van Miereveld's fine *Portrait of a Lady* and *Portrait of a Gentleman*.

1954. Zuloaga's *Portrait of Mrs. Alice Lolita Muth Ben Maacha* was bequeathed to the Prado by the sitter, and Joshua Reynolds' *Portrait of Mr. James Bourdieu* was donated by Bertram M. Newhouse. A late masterpiece by El Greco, *The Adoration of the Shepherds*, was purchased for more than one and a half million *pesetas*. Other

interesting purchases were Simon Vouet's *Time Defeated by Youth and Beauty* and Benjamin Cuyp's *The Adoration of the Shepherds*.

1955. Gainsborough's fine *Portrait of Mr. Robert Butcher of Walttamstan* and Luca Giordano's *St. Charles Borromeo* were both purchased. Work on a further extension of the east side of the Gallery was begun this year. At the rear of the two sets of rooms linking the central rooms to the square end blocks (see the year 1914), seven rooms were added on the ground floor and eight on the first floor. The extension was designed by Lorent and Chueca and the work was supervised by Muguruza.

1956. A delightful early work by Zurbarán, *The Immaculate Conception* was purchased. The new rooms in the Gallery, devoted to the work of Rubens and Van Dyck, were opened on June 9. Rafael Alberti's short play *Noche de guerra en el Museo del Prado* was published in this year.

1957. An exchange arranged with the Metropolitan Museum in New York brought to the Prado the fragmentary wall paintings from San Baudelio de Casillas de Berlanga by an unknown Spanish artist. Goya's *Portrait of Don Joaquin Company* was purchased, as well as José Moreno's *The Visitation* and Sir Martin Archer Shee's *Portrait of Anthony Gilbert Storer Esq.* Antonio Blanco's important *Catálogo de la Escultura* was published. It dealt only with antique sculpture and modern copies.

1958. Zurbarán's *Portrait of Fray Diego de Deza* and *St. Anthony of Padua with the Christ Child* were purchased, as well as a *St. Clare* which may possibly also be by him. More British paintings arrived. Manuel de Arpe y Retamino gave Sir John Watson Gordon's *Portrait of a English Gentleman*, while Lawrence's *Portrait of John Vane, Tenth Earl of Westmoreland* and Sir Martin Archer Shee's *Portrait of Mr. Storer* were purchased. Hence it was now possible to devote a basement room to the British school of painting.

1959. The following works were given to the Prado: El Greco's magnificent late painting *St. Sebastian* was given by the Marchioness of Casa-Riera, John Hoppner's *Portrait of Mrs. Thornton* was given by a Mr. Appleby of London, and the *Portrait of the Artist's Mother*, attributed to Antonio Puga, was given by Frederick Mont of New York. Purchases were equally important. They included two masterpieces by Fernando Gallego, *Calvary* and *Pietà*, another painting by Giambattista Tiepolo for the church of San Pascual at Aranjuez, namely *St. Anthony of Padua with the Christ Child* (see the year 1915) and two paintings by Lawrence: *Portrait of Miss Marthe Carr* and *Portrait of a Lady of the Storer Family*.

1960. Francisco Javier Sánchez Cantón was appointed Director of the Prado (see the year 1922) in April, on the death of Sotomayor. Poussin's *Parnassus* was sent on loan to the large Poussin exhibition in Paris.

1961. The new Deputy Director of the Gallery was Professor Xavier de Sala y Bosch, critic and museologist, who had previously been Director of Museums in Barcelona and of the Spanish Institute in London. Purchases included: Alonso Cano's sketch of *The Virgin appearing to St. Anthony of Padua*, Ribalta's *St. John the Evangelist*, Machuca's monumental painting of *The

Deposition of Christ*, and a *St. Catherine* attributed to Gallego. Mantegna's *The Death of the Virgin* was loaned to an exhibition of his work in Mantua.

1962. Thomas Harris gave Goya's little *The Bull Fight*, and the Countess de las Infantas gave El Greco's two polychrome wood sculptures *Epimetheus* and *Pandora*. Purchases included Goya's delightful *The Wandering Players* and Escalante's *The Communion of St. Rosa of Viterbo*. The *Resurrection of Christ* by Berruguete, Juan Rizi's *St. Benedict and St. Maurus*, and other paintings were purchased and lent to the Cerralbo Museum, but were not exhibited until 1966. On February 16 a number of new rooms were officially opened. They were the renovated ground floor rooms, devoted to Goya's tapestry cartoons (see the year 1928) and to sixteenth century Spanish painting. The latter were in the rooms in the east wing which had previously housed the French school of painting.

1963. Purchases included the early fourteenth century altarfrontal from Guills by an unknown Spanish artist, and Herrera the Elder's *The Head of a Decapitated Saint*. Reni's masterpiece *Hippomenes and Atalanta* was returned to the Prado by the University of Granada, to which it had been loaned. Work began on the construction of additional rooms, to be created by eliminating the two internal courtyards between the large gallery on the first and second floors and the east rooms (see the year 1914).

1964. Federico de Madrazo's *Portrait of the Duchess of Castro Enriquez* was bequeathed to the Prado by Maria Paz García. Purchases included: Murillo's magnificent *Portrait of Nicolas Omazur*, Quentin Massys' *An Old Woman Tearing her Hair*, Yáñez de la Almedina's *Madonna and Child*, Zacarías Gonzáles Velázquez's *Portrait of a Young Woman* and a sixteenth century Brussels tapestry. Six new rooms were opened on the two floors in the north wing, where there had previously been a courtyard. Those on the first floor housed Titians, Zurbaráns and seventeenth century Spanish painting, while those on the ground floor housed fifteenth century Spanish painting.

1965. *The Temptation of St. Anthony* 3085, attributed to Bosch, was given to the Prado by Mrs. D.M. Van Buuren of Brussels. Purchases included *The Dead Christ*, a rare work by Antonello da Messina and two polyptych panels of *Scenes from the Life of St. John the Baptist and St. Mary Magdalene* from the studio of Jaime and Pedro Serra.

1966. Juan Antonio Escalante's *Ecce Homo* was given to the Prado by Florencio Milicua. Purchases included Goya's striking sketch of *The Betrayal of Christ*, Luis Gonzáles Velázquez *Celebrations at the Porziuncola* and Raeburn's magnificent *Portrait of Mrs. MacLean of Kinlochaline*. Three other works, purchased in 1962, were brought out of storage and put on exhibition. An exchange arranged with the Mauritshuis in The Hague allowed Frans Hals' *The Gypsy* to be put on show temporarily.

1967. A collection of 82 eighteenth century glass objects from the factory at La Granja was bequeathed to the Prado by the Marquis de Fontana. Purchases included: Jacinto Jerónimo Espinosa's *St. Raymond Nonnatus*, Carreño de Miranda's *The Feast of Herod* and Magnasco's masterpiece *Christ Accompanied by Angels*.

1968. Adolfo de Arenaza gave the Prado a fragment of an altarpiece attributed to Jaume Huguet. Purchases included: Alonso Cano's masterpiece *St. Bernard and the Virgin* and Andrés de la Calleja's fine *Portrait of a Knight of St. James*. The second stage of extension work was completed this year (see the years 1963 and 1964), so that there were now three rooms on the ground floor and one large room on the first floor in place of the internal courtyard at the south wing of the Gallery building. On August 15, Professor Diego Argulo Íñiguez, an art historian, was appointed director of the Prado and Sánchez Cantón became honorary director. On September 25, five paintings, including Van der Weyden's *Madonna and Child*, were damaged by a mentally deranged man, but were successfully restored.

1969. The one hundred and fiftieth anniversary of the Prado was celebrated this year. The occasion was marked by an exhibition of the "Principales adquisiciones de los últimos diez años (1958-68)," with a catalogue listing 59 paintings, four pieces of sculpture and three pieces of decorative art. The most striking acquisitions were the painting by Antonello da Messina (see the year 1965) and the most recent purchase of all, Rubens' *Portrait of the Duke of Lerma*. A room was set aside for the works of Luca Giordano (no. 85), while seventeenth century Italian painting, now restored and reexamined, was housed in six rooms on the second floor at the north end of the building. A new catalogue of sculpture was published. It was edited by Antonio Blanco and Manuel Lorente and included medieval and modern as well as antique sculpture (see the year 1957). Purchases included Mattia Preti's *Christ in Glory with Saints and* (in December) two works by Cavallino: *Tobit cured of his Blindness* and *The Marriage of Tobit*. An important gift from Countess de los Moriles included two flowerpieces by Arellano, *St. Joseph* and *St. Peter* by Maella, the Master of Flémalle's *Madonna and Child*, a *St. Jerome* by an unknown sixteenth century Flemish artist, and a *Portrait of Isabella Farnese* by an unknown Eighteenth Century French artist.

1970. Celebrations for the one hundred and fiftieth anniversary of the Prado were continued in April and May of this year when a major exhibition entitled "Pintura italiana del siglo XVII" (with a critical catalogue) was held in the Casón of the Buen Retiro Palace. 198 works were shown, including 111 from the Prado. n December, Professor Xavier de Salas y Bosch, who had already been in the service of the Prado for ten years, was appointed its director. More works were added to the Gallery's collections: a *Still Life* by an unknown seventeenth century artist from Madrid was purchased, and two flowerpieces, both seventeenth century Spanish works belonging to the Prado, were transferred to the University of Madrid. An important donation came from Jiménez Díaz: Morales' *The Holy Family*, Zurbarán's *St. Euphemia* and Valdés Leal's *St. Michael*. Two further acquisitions were the *St. Christopher Altarpiece* by an unknown Spanish artist of the late thirteenth century (presented by Varez Visa), and Morazzone's *The Marriage of the Virgin* (presented by Mv. Milicua).

1971. On June 16 it was discovered that a small painting by Jan van Kassel had been stolen. It belonged to a triptych made up of forty small paintings and it represented some birds on a river.

GENERAL INFORMATION

Staff – The Museum is directed by the Ministry of Education and Science, and is headed by a general director and by a committee that oversees its interests.

Connected institutions – The Museum is endowed with a photographic laboratory including negatives files, and with a restoration shop.

Lighting – The exhibition rooms are oriented in north-south and east-west directions and are lighted by fluorescent and incandescent lamps, in addition to natural light.

Security services – There are guards in the rooms during visiting hours, and a watch, inside and outside, during the night. The fire-prevention services are provided with extinguishers which throw a compound of dust and carbon dioxide that doesn't harm the paintings and the other works of art.

Visiting hours – The Museum visiting hours vary according to the differences in daylight periods, namely: in June, July, August and September, 10:00 A.M. to 6:00 P.M.; in October, February, March, April and May, 10:00 A.M. to 5:30 P.M.; and in November, December and January, 10.00 A.M. to 5:00 P.M. The Museum is partially closed on Sundays, visiting hours being 10:00 A.M. to 2:00 P.M., and is closed each Monday, January 1, Good Friday, November 1, and Christmas. Entrance is free on Saturdays and after 2:00 P.M. Visits to the deposits are allowed on special application only.

Cultural services for the public – Visitors can attend the library and avail themselves of the museum photo files. Catalogues and guides, color and black and white postcards, large reproductions, and other publications are on sale. In spring and wintertime the museum organizes cycles of lectures.

Public comforts – The Museum operates a restaurant with self-service.

Complementary exhibitions – The Museum organizes periodically exhibitions of paintings, prints, and drawings.
Exhibits: 2,500 works.
Visitors: about 1,100,000 per year.

CHARACTERISTIC

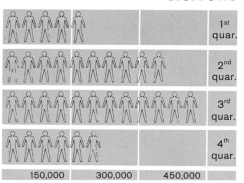

4,000 drawings
2,400 paintings
1,800 coins and medals
500 sculptures

VISITORS

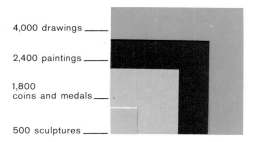

| | 1st quar. |
| 2nd quar. |
| 3rd quar. |
| 4th quar. |

150,000 300,000 450,000

RELATIVE IMPORTANCE OF THE SCHOOLS REPRESENTED IN THE MUSEUM

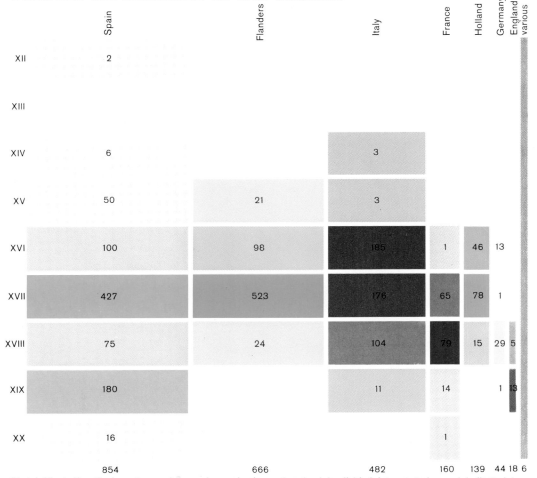

	Spain	Flanders	Italy	France	Holland	Germany	England	various
XII	2							
XIII								
XIV	6		3					
XV	50	21	3					
XVI	100	98	185	1	46	13		
XVII	427	523	176	65	78	1		
XVIII	75	24	104	79	15	29	5	
XIX	180		11	14		1	13	
XX	16			1				
	854	666	482	160	139	44	18	6

Sketch illustrating the importance of the various schools: each school is divided into centuries and indicated by a different color; the length of the strips is proportional to the number of paintings belonging to each school with regard to the other schools; the color intensity is proportional, within each school, to the importance of the paintings for each century. The figures referring to the paintings have been indicated with the nearest possible approximation.

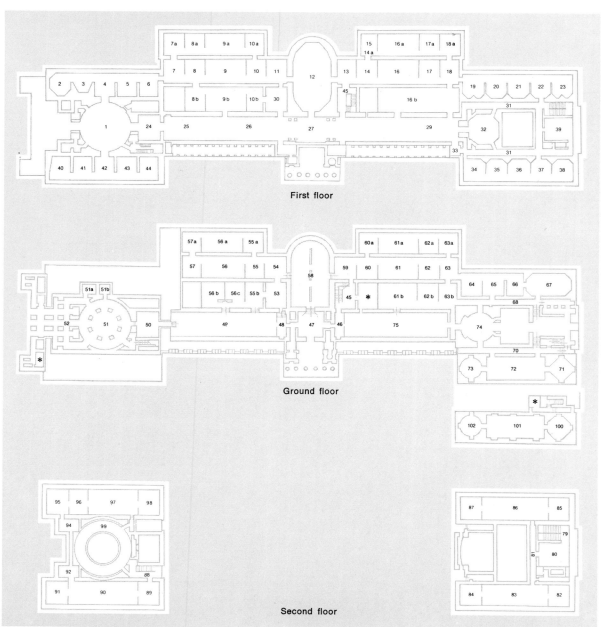

1	Paintings and sculptures of the Salón de Reinos del Buen Retiro
2	Raphael
3	Botticelli, Antonello, and Mantegna
4	Italian paintings of the Fifteenth Century and Angelico
5	Correggio and Andrea del Sarto
6	Italian paintings of the Sixteenth Century
7	Giorgione, Bellini, Lotto, and Titian
7A	Veronese and Venetian masters
8-9	Titian
8a	Veronese, Tintoretto, and Venetian masters
8b	Venetian masters
9a	Tintoretto
9b	Zurbarán
10-11	Greco
10a	Bassano and Venetian masters
10b	Spanish paintings of the early Seventeenth Century

12-15	Velázquez
16, 17, 18, 18a, 19	Rubens and his circle
16a, 17a	Van Dyck and other Flemish painters
16b	Flemish paintings
20-21	Circle of Rubens
22-23	Dutch paintings
24	Spanish paintings of the Sixteenth Century
25-29	Spanish paintings of the Sixteenth and Seventeenth Centuries
30	Greco
31	(left) Spanish paintings of the Eighteenth Century (right) French paintings
33-38	French paintings of the Seventeenth and Eighteenth Centuries
39	Tiepolo and Giaquinto
40-44	Flemish paintings of the Fifteenth and Sixteenth Centuries
45	Ribera and Luca Giordano
46	Flemish paintings of the Seventeenth Century
48	Goya
49	Spanish paintings of the Sixteenth Century
50	Spanish paintings of the Fourteenth and Fifteenth Centuries
51	Classical sculpture; Snayers
51a, 51b	Spanish frescoes of the Twelfth Century
52	Classical sculpture
53	Goya's drawings
54-57a	Goya
58	Goya and Spanish paintings of the Eighteenth Century (in preparation)
59-60a	Spanish paintings of the Seventeenth Century
61, 62	Murillo and his circle
61a	Ribera
61b	Rubens and his circle; classical sculpture
62a	Spanish paintings of the Seventeenth Century
62b, 63b	Flemish paintings of the Seventeenth Century
63-63b	Flemish paintings of the Fifteenth and Sixteenth Centuries
64	Antonio Moro
65	Floris and other Flemish Romanists
66-68	Flemish paintings of the Seventeenth Century
70-72	Classical sculpture and medals
73	"Treasure of the Dauphin"
74	Classical sculpture
75	Rubens and his circle; classical sculpture
79	Luca Giordano paintings
80	Mengs
81-82	Spanish paintings of the Eighteenth Century
83	Spanish paintings of the Seventeenth Century
84	English school
85	Luca Giordano
88-91, 93, 96-99	Italian paintings of the Seventeenth Century (in preparation)
92, 94, 95	Fernández Durán donation
100	History and records of the museum
101	Spanish paintings of the Nineteenth Century
102	Errazu donation

First floor

Ground floor

Second floor

Description
of the Museum

The Prado Gallery is located in the southeastern part of Madrid, and is one of the finest examples of Spanish neoclassical architecture. It was designed by Juan de Villanueva, and was embellished and enlarged throughout the nineteenth century and on up to the present day. Its plan is a long rectangle measuring 36×182 metres, its main north-south axis being parallel to the charming Paseo del Prado, which passes along the west side of the building. To the south are the Botanical Gardens, to the north is the Calle Felipe IV, to the east is the Calle de Alarcón and the church of San Jerónimo.

The principal façades are on the short north side and the long west side. Entry is usually gained on the north side. The north side has a fine peristyle with two Ionic columns at first floor level (this is the Gallery's main floor), which is reached by means of recently built twin flights of steps, one on each side. From there, access is gained to the large Ionic rotunda inside the building, while below are three identical doors giving access to the building at ground floor level. The façade is crowned by Jerónimo Suñol's marble sculpture representing *Apollo and the Muses*. The west façade has a massive central entrance with a six-column Doric propylaeum between two very long wings with an Ionic colonna-

de at first floor level and alternating arches and niches at ground floor level. The niches contain allegorical statues of female figures relating to the arts by Valeriano Salvatierra. Above the statues is a series of portrait medallions by Ramón Barba in square recesses, representing the most important Spanish painters and sculptors. In the attic above the propylaeum is a bas-relief by Ramón Barba and assistants representing Minerva and the Fine Arts paying homage to *Ferdinand VII*. This grandiose entrance, in imposing classical style, leads through an internal atrium into the room which constitutes the heart of the building, namely the large oval hall, rising through two stories, at right angles to the large gallery running along the main axis of the building. The third façade, on the short south side, has a portal at ground floor level and a colonnade of six Corinthian columns at first floor level.

In front of the south, west and north façades are monuments to Murillo (by Sabino de Medina), Velázquez (by Aniceto Marinas) and Goya (by Mariano Benlliure) respectively, each one consisting of a large bronze statue on a stone plinth. In the case of the monument to Goya, *The Naked Maja* and the demoniacal figures of the *Caprichos* are represented in sculpture on the plinth.

The Prado building consists of a

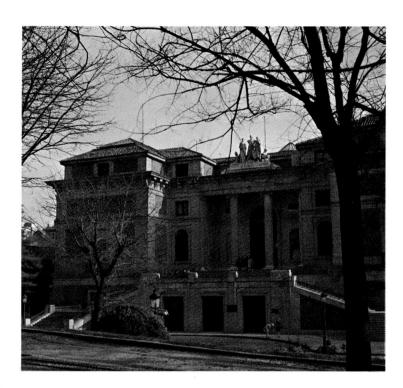

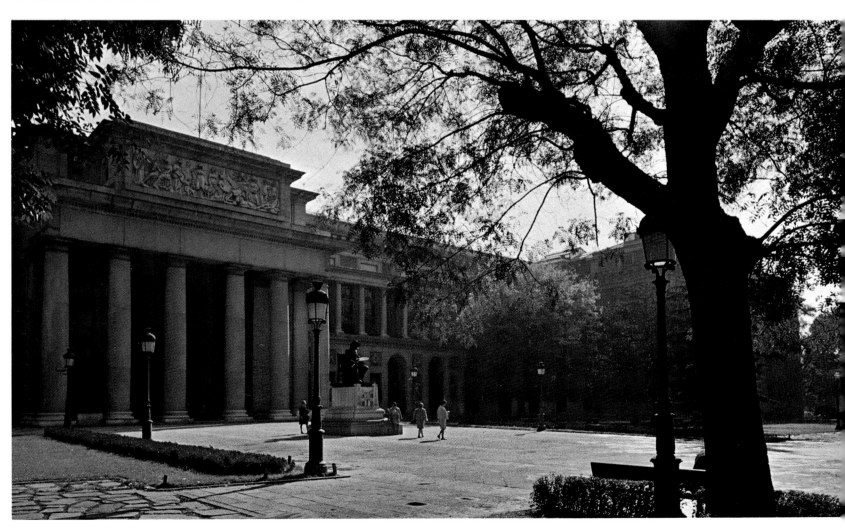

long gallery on two floors with symmetrical rectangular blocks at the north and south ends on three floors. In the middle, towards the east side, is the transversal room already mentioned, which is oval at first floor level and a truncated oval at ground floor level. The long gallery on the first floor has a concrete barrel-vault roof with skylights and a series of lateral groins. The central section, facing the Sala Velázquez, has a massive arch on twin columns at either end and there is a circular opening at the top of the coffered roof. In this way as much light as possible is allowed to penetrate from above so that the paintings may be easily seen.

The north pavilion has two superimposed rotundas, one on the ground floor (see the *History of the Prado Gallery and Its Paintings*, 1930) and one at first floor level. The latter is the fine Ionic entrance rotunda and has exhibition rooms on three sides.

Around the cupola on the second floor are more exhibition rooms. The south pavilion was originally intended for the use of the royal family, and is built round a central courtyard. At first floor level there is a polygonal room (originally known as the "Sala de descanso" or rest room) at the end of the long gallery, while in a corresponding position on the ground floor is the lovely circular room known as "Ariadne's room" after the Roman Hellenistic statue of Ariadne placed at the far end of it. To the west of this rotunda is a rectangular room with a small rotunda at either end. There are three identical rooms underneath these at basement level, and more rooms above them on the second floor. Internal communications throughout the building are made possible by a number of elevators, a staircase in the north and south pavilions and a third staircase at the south end of the oval room. The total number of rooms in the

building, including large and small exhibition rooms, galleries, rotundas, corridors and the wells of staircases is about one hundred, and in addition to those used for exhibiting works of art, there are others for various services, a restaurant, administrative offices and a library. The part of the building specifically devoted to the exhibition of works of art is arranged as follows:

1) Painting

a) Spanish School

12th Century Frescoes	Rooms 51A-B
15th Century	Rooms 50, 53A, 55B, 56B-C
16th Century	Rooms 24-29, 49, 53A, 55B, 56C
El Greco	Rooms 10-11, 30
17th Century	Rooms 1, 10B, 25-29, 45, 59-69A, 62A, 83, 86-87
Zurbarán	Room 9B
Velázquez	Rooms 12-15
Murillo	Rooms 61 and 62
Ribera	Rooms 45 and 61A
18th Century	Rooms 31, 58 (in preparation), 81-82
Goya	Rooms 32, 48, 53-57A, 58 (in preparation)
19th Century	Rooms 101-102

b) Italian School

15th Century	Rooms 3-4
16th Century	Rooms 5-6
Raphael	Room 2
Artists of the Veneto	Rooms 7-7A, 8A-B, 9A, 10A, 39
Tintoretto	Rooms 9A, 8A
Titian	Rooms 7-9
17th and 18th Century	Rooms 39, 45, 88-91, 93, 96-99 (88 to 99 are in prep.)
Luca Giordano	Rooms 79, 85

c) Dutch and Flemish School

15th and 16th Century	Rooms 40-44, 63-63B, 65
Antonio Moro	Room 64
17th Century	Rooms 16B, 17A, 22-23, 46, 51, 62B, 63B, 66-68
Rubens	Rooms 16, 17, 18-21, 61B, 75
Van Dyck	Rooms 16A, 17A

d) French School	Rooms 31, 33-38
e) German School	Room 44
Mengs	Room 80
f) British School	Room 84
2) Sculpture	Rooms 1, 51, 52, 61B, 70-72, 74, 75
3) 'Dauphin's Treasure'	Room 73
4) Medals and Applied Arts	Rooms 56B, 72
5) Drawings	Room 53
6) History and Records of the Prado Gallery	Room 100

The Prado is essentially a gallery of paintings, and it is hence to these that the *History of the Prado Gallery and Its Paintings* (beginning on page 6) and the subsequent parts of this book are primarily devoted. Nevertheless, the other art collections in the Prado deserve some individual consideration.

Sculpture

The sculpture collection comprises about 500 pieces of sculpture, and can be divided into three groups. The first of these consists of Greek and Roman sculpture (statues, busts, reliefs, and also vases, columns and other fragments), and is based mainly on the collection which Queen Christina of Sweden gathered together in Rome about 1664. This collection subsequently passed to Prince Odescalchi, and was bought from his heirs in the eighteenth century by Philip V of Spain to please his Italian wife Isabella Farnese. It was set up in the Palace of La Granja de San Ildefonso and from there passed to the Prado. The classical section has been added to by minor acquisitions (e.g. those made by Velázquez during his visit to Italy — see below) and by donations. Thus certain Popes gave the Hapsburg kings of Spain a series of busts of Roman emperors; and Nicolás de Azara, Spanish ambassador in Rome, had excavations carried out at Tivoli in 1779 and bought sculptures in Rome in order to make a present of the items thus acquired to Charles IV of

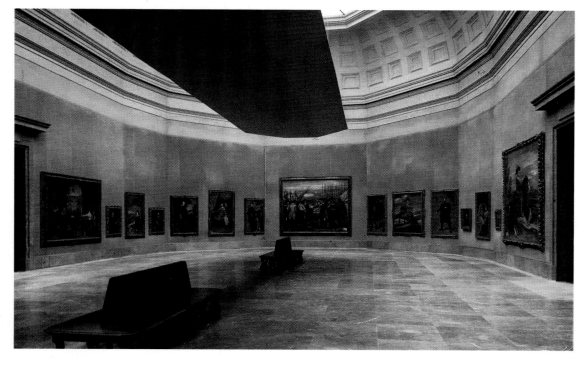

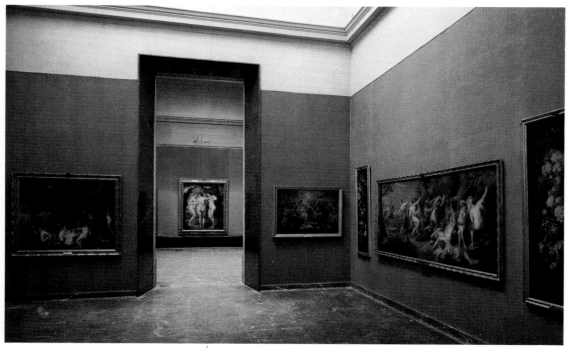

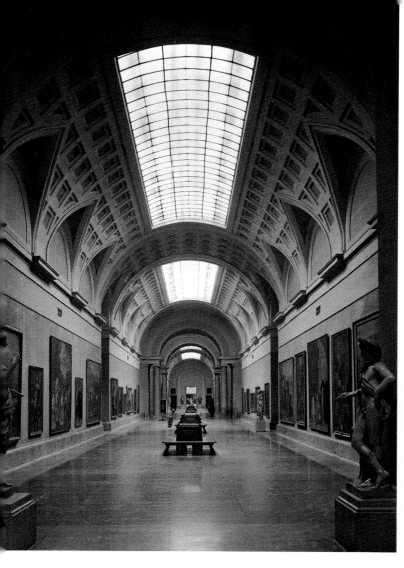

Spain. A recent gift to the Prado was a collection which included a Sumerian head dating to 2300 B.C., as well as pieces of classical sculpture.

The most interesting items are: group known as the *San Ildefonso Group* (two naked youths making a sacrifice on an altar) — a Hellenistic work belonging to the first century B.C., the fine *Bronze Head* (3rd century B.C.), formerly thought to represent Alexander the Great, the Hellenistic copies of the *Diadumenus* of Polyclitus and of the *Resting Satyr* of Praxiteles (the latter restored by Bernini in the baroque manner), and the Roman statues of *The Sleeping Ariadne, A Faun with a Kid, Venus and a Dolphin, Venus and a Shell, The Muses from* the Villa Adriana at Tivoli and *The Apotheosis of Claudius.*

The second group of sculptures consists of Renaissance copies or imitations of famous antique sculptures. Apart from the busts of Roman emperors given by Popes (see above), most of them were purchased by Velázquez in Rome in the period 1649-50 on orders from Philip IV of Spain. They include *The Boy with a Thorn in his Foot, The Sleeping Hermaphrodite* and *The Belvedere Antinous.* The finest work in this group is the bronze *Venus* made by the Florentine sculptor Bartolomeo Ammannati in 1558-9 and purchased by Philip IV of Spain with another seven bronzes from an Antwerp dealer. It holds this pre-eminent position in spite of the fact that nineteenth century restoration of the arms has undermined its original charm; but that charm remains intact in the gesso version of the same work now in Vasari's house at Arezzo.

The third group of sculptures consists of medieval and modern works, and bears witness to the fact that the Spanish monarchs appreciated the art of contemporary sculptors as well as that of antiquity. The most important items in this group are the statues and portrait busts of the royal family which Charles V and Philip II commissioned from the famous Milanese sculptor and goldsmith, Leone Leoni, whom Charles V appointed artist to the Imperial court, and who was assisted in this work by his son Pompeo. The finest of Leoni's bronzes is the great statue of *Charles V Defeating Fury* (1564) — an outstanding example of the most refined and exquisite sixteenth century mannerism. The highly ornate breastplate worn by Charles V can be removed, thereby leaving him in that sublime state of nudity reserved for gods and ancient heroes. Other works in this third group deserving mention are: a relief of *The Four Seasons* attributed to the Italo-Flemish sculptor Giambologna (1529-1608), a recently (February 1968) acquired Flemish late Gothic *Madonna* in polychrome wood and a marble bust of *Christ the Redeemer,* a recent (1955) gift to the Prado which is sometimes held to be a Sixteenth Century Italian work and sometimes attributed to a Spanish sculptor working in the Italian style, such as Gaspar Becerra (1520-70); the statue of *Louis XIV, on Horseback* attributed to François Girardon.

Apart from a few typically Spanish statues of Christ and saints in polychrome wood, Spanish sculpture is scarcely represented, but two unusual examples of Spanish work are the polychrome wood statuettes of *Epimetheus* and *Pandora.* They are in fact two rare original sculptures by El Greco, and demonstrate his interest in the nude. Also worthy of mention are the bronze busts of *The Count Duke of Olivares* (1643) and *Don John Joseph of Austria* (1648) by Juan Melchor Pérez, a Spaniard who worked in Naples. Of

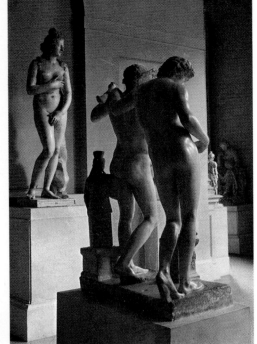

(Top, from the left) The Sleeping Ariadne; *sculpture in white marble, 256 cm. long; Roman Hellenistic.*
In the foreground, seen from behind, the
San Ildefonso Group, *Hellenistic sculpture in white marble with traces of color, overall height 161 cm., first century B.C.*
(Left) Venus and a Dolphin, *Hellenistic-Roman sculpture in white marble, 200 cm. high.*
(Immediate right) A dioritic Sumerian head, *24 cm. high, dating to 2300 B.C.*
(Bottom) Round sculpture hall: in the center:
The Apotheosis of Claudius, *Roman sculpture in white marble, 99 cm. high (excluding the plinth, which was added in the 17th century), second Century A.C.*

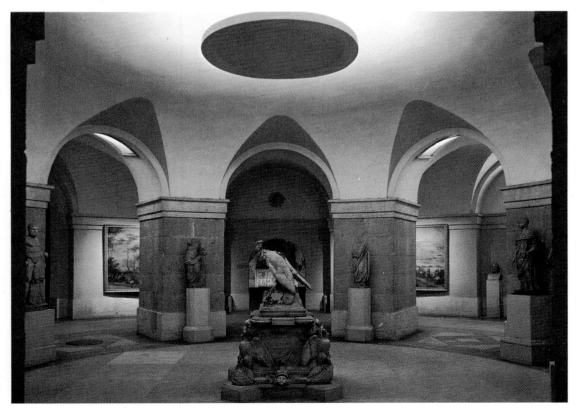

iconographical interest are the neo-classical statue of *Isabella of Braganza,* patron of the Prado by José Álvarez Cubero (1768-1827), the bust of *Juan de Villanueva,* the architect who designed the Prado, by José Grajera (d. 1858), and the bust of Goya by Mariano Benlliure (1862-1947), who was also responsible, as already mentioned, for the monument now in front of the north façade of the Prado building.

The Dauphin's Treasure

The "Dauphin's Treasure" or "las Alhajas del Delfín" is one of the world's most valuable collections of vases and other gemstone and rock crystal objects of the late Renaissance. It belonged to the "Grand Dauphin," son of Louis XIV of France and father of Philip V of Spain, who inherited part of this magnificent collection on his father's death in 1711. (The remainder went to one of his brothers in France, and is now in the Louvre.) The "Treasure" was first kept in its own caskets in the Palace of La Granja, but in 1776, during the reign of Charles III, it was deposited at the Museum of Natural History which he had founded. In 1813 it was sent to Paris by the French, but returned to the Museum of Natural History two years later — though minus twelve objects and with others badly damaged. Subsequently, having regard rather to its artistic beauty than to the natural properties of the materials of which it was made, the "Treasure" was transferred from the Museum of Natural History to the Prado where, alas, eleven more objects were stolen and a number of others were damaged in 1918.

In spite of these vicissitudes, the "Treasure" has not lost its original splendor. All the vases are mounted in ornamented precious metals. Half a dozen of those made of gemstone (agate, jasper, jade and lapis lazuli) are decorated with cameos, most of which are of onyx, though some are of Sicilian jasper or lapis lazuli. Master jewelers of the Renaissance from Milan were largely responsible for the delicate engraving of profile busts in the classical manner, or scenes which were also inspired by classical gem work. Of particular interest among the various vessels are an onyx salt-cellar supported by a gold siren, a lapis lazuli goblet with handles in the form of two large enameled dragons, a bell-shaped agate vase with cameos, and two fine caskets dating to about 1600, one rectangular and one octagonal, both decorated with a profusion of cameos, including portraits, on the rectangular casket, of Francis I, Henry IV, Richelieu and St. Charles Borromeo.

These vases stand out for the magnificence of their colors, but the most strikingly refined engraving is to be found in a group of rock crystal vases, dating mostly to the second half of the sixteenth century and the early seventeenth century (though one of the finest early objects is a lovely cylindrical tankard belonging to the second quarter of the thirteenth century). They are largely the work of Milanese engravers of the period of the Saracchi family and Annibale Fontana, a master in the art of engraving jewellery. Outstanding individual objects are a spheroidal vase mounted in gold enamel and diamonds, vases with hunting and grape harvesting scenes, a topaz goblet with emeralds, and containers in the shape of boats or animals. (There is one delightful one in the form a peacock.) All of these are a striking testimony to the genius and skill of the Renaissance in reviving the techniques and themes of classical antiquity, and applying to them its own standards of splendor and magnificence.

The Collection of Drawings

The unique series of Goya drawings would in itself be sufficient to justify the high reputation enjoyed by the Prado's whole drawing collection. Of the 448 drawings, most belong to two groups which reached the Prado in 1866 and 1886 and have been catalogued. Another five reached the Prado very recently and are as yet unpublished. All of these drawings show the artist's technique to be rich and varied (he used sanguine, black chalk, watercolor sepia, red and brown), and they provide impressive confirmation of the many-sided genius of an artist who was a unique interpreter of the life of his own age and country. They constitute a magnificently unique corpus of ideas expressed at an early stage of development — at the moment of their birth even — and yet they are perfect and complete in themselves. They depict scenes of ordinary and aristocratic life in Madrid, as well as the political drama which enveloped Spain as the eighteenth century gave way to the nineteenth (a bitter social drama which gave wings to the artist's satire and invective, and a visionary intuition of a "different" world — a devil-ridden counterpart of a divinely transcendental world, which shows Goya as a master of the hallucinatory vision and nightmare, and which makes him a precursor of modern surrealism. Of particular interest within this broad range of subject matter is the series of drawings which are in fact the early and later sketches for his series of engravings, for they allow us to follow step by step the genesis of the Caprichos, the Desastres de la Guerra and the Disparates, and so offer a unique experience to the public and to the scholar and connoisseur.

The Prado possesses two other groups of drawings in addition to those by Goya. One is numerically small and consists of the drawings from the Royal Palace which formed the original nucleus of the Prado collection. Most of them are the work of court painters who had a studio in the Palace. The artists represented are largely seventeenth and eighteenth century Spaniards who worked at court or were involved in court commissions (e.g. Alonso Cano, the Bayeu brothers and Mengs), or Italians, such as Luca Giordano and Giambattista Tiepolo and his sons, who were deeply involved in work for the kings of Spain and left a rich series of drawings in Madrid. (Of special interest are the striking pastel portraits by Lorenzo Tiepolo, who is known particularly for his work in Madrid.) Most of these drawings are by painters, but there are a few striking architectural drawings, such as Juan Guas's design for the presbytery of the church of San Juan de los Reyes at Toledo (built 1477-1503), Cano's design for the altar in the church of San Andrés in Madrid (it includes the architecture of the whole building), and a rare drawing by Gian Lorenzo Bernini for a sculpture group (which he never made) on the subject of The Truth Revealed by Time.

The third group of drawings consists of about three thousand items of various periods and schools which were bequeathed to the Prado in 1930 by Pedro Fernández Durán. They include some very interesting studies by Spanish artists such as Carreño de Miranda, Claudio Coello, Herrera the Elder, Murillo, Alonso Cano and other lesser artists of the seventeenth and eighteenth centuries, as well as French and Flemish drawings. Among those by Italian artists, seventeenth century Bolognese and Roman art and eighteenth century Neapolitan art are well represented. There is also a unique collection of drawings by Luca Cambiaso, the most famous sixteenth century artist from Genoa, who was called to Spain by Philip II to assist in the decoration of the Escorial. Other drawings have been acquired more recently by donation, bequest and purchase.

Medals

The art of the medal is represented at the Prado thanks to a bequest by Don Pablo Bosch y Barrau who left a "bargueño" (cabinet) containing 946 old Spanish coins, and a collection of 852 Italian and other cast and struck medals. The Italian series (which includes examples stretching from the fifteenth to the seventeenth century) bears witness to the birth of the medal in the early fifteenth century, thanks to the Veronese artist Pisanello, who was inspired by ancient Roman portrait medallions. Examples of this early type, cast in bronze from a wax model, like a piece of sculpture, are Pisanello's Iñigo d'Avalos, Marquis of Pescara and Alfonso V of Aragon, Sigismondo Pandolfo Malatesta by the equally famous Matteo de' Pasti, and medals of Charles the Bold, Mary of Burgundy and Maximilian of Austria by the Roman artist Candida, who worked a great deal in France. The collection also shows the change at the end of the fifteenth century from cast medals to smaller struck medals, in imitation of the magnificent coins of Greek and Roman times. Interesting examples are the famous medals which Leone Leoni made for Charles V, Philip II and Michelangelo, and those which the Lombard goldsmith and jewel engraver Jacopo da Trezzo (who worked a great deal in Spain) made for Philip II, Mary Tudor and Ippolito Gonzaga.

The Renaissance art of the medal was destined to spread from Italy to the rest of Europe. The Prado collection shows evidence of its existence in France in the sixteenth century work of Matteo del Nassaro and Bechot (medals of Francis I and Henry II) and in the work of refined seventeenth century artists like Guillaume Dupré, Marin, Cheron and Jan Roettiers. (The French section in fact comes up to the twentieth century with portraits of presidents of the Republic by Alphée Dubois.) Germany is represented by medals of Hermán Cortés, Charles V, Anne of Hungary (attributed to the famous Renaissance medallist Hagenauer) and Martin Luther (bearing Dürer's monogram). Of special interest among the English medals is John Croker's series of naval victories in the reign of Queen Anne; and amongst the many Netherlands medals of the sixteenth, seventeenth and eighteenth centuries is an unusual series in which the medals are made from two embossed plates, welded at the edges and hollow inside. Owing to the supremacy of the Italians, Spanish medal making did not come into its own until the eighteenth century when, for the first time, one finds medals of some originality, such as the fine series of Charles III made by Tomás Prieto and his pupil Gerónimo Antonio Gil, and those of Charles IV, also by Gil.

Among the other objets d'art in the Prado must be mentioned the tapestries, furniture, weapons and ceramics bequeathed by Fernández Durán in 1930; the two interesting tapestries by Willen Pannemaker of Brussels, from a series devoted to the story of Mercury and Herse (acquired through a bequest by the Duke of Tarifa in 1934) and a purchase made in 1964. Also to be cited is the magnificent collection of glassware from the factory at La Granja, bequeathed to the Prado in 1967. It includes 82 objects in crystal made between the late eighteenth and early nineteenth centuries.

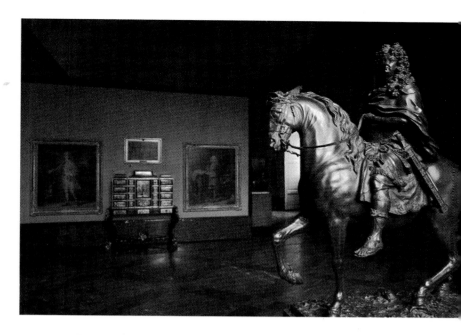

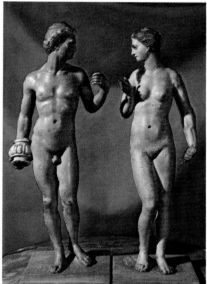

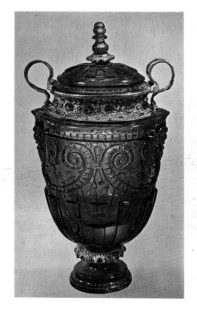

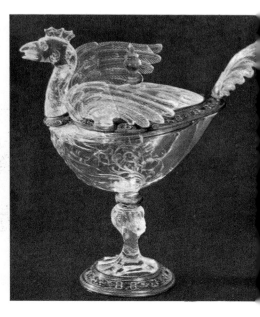

(Top) Louis XIV, on Horseback. A bronze statue attributed to François Girardon (1628-1715); 105 cm. high. *(Immediate left)* Epimetheus and Pandora. Statuettes in polychrome wood, 43 cm. high, by El Greco; c. 1600-10. *(Bottom)* Two precious vessels from the Dauphin's Treasure: topaz goblet dating to the second half of the sixteenth century, decorated with gold, enamel, emeralds and diamonds; rock crystal container in the shape of a bird, engraved by a Milanese artist, late 16th century.

Masterpieces
in the Prado Museum

SPANISH ARTISTS

The Prado Gallery provides an almost complete survey of Spanish painting from the fifteenth century "primitives" to Goya. Furthermore, the mounting on canvas and removal to the Gallery of a number of Romanesque frescoes has made it possible to provide a preliminary view of that post-tenth century stylistic revival in territory which had earlier formed part of the Roman Empire.

1 – 2. The two frescoes, *Hare Hunt* and *The Creation of Adam and the Original Sin*, come from hermitages in Old Castile and are striking examples of Spanish Romanesque. Their simplified forms derive from Italo-Byzantine art, but their considerable expressive intensity is typically Spanish. The first of these frescoes, by an anonymous artist from Berlanga, is one of a series devoted to the secular theme of hunting, while the second, by an anonymous artist from Maderuelo, belongs to a series of biblical scenes, and was painted about 1125. The Tree of Knowledge appears in both halves of the double scene in the lunette. On the right-hand side Adam and Eve have already tasted the fruit offered to Eve by the serpent, and since they have thus acquired a knowledge of good and evil, they conceal their nakedness with leaves. Adam and Eve are identified by abbreviated forms of their names: ATM (Atamos) and ATEV (ad Evam).

3 – 4. Fifteenth century Spanish painting is related to Flemish realism of the late Gothic period, and is also influenced to some extent by the early Italian Renaissance. Both these influences can be detected in *The Adoration of the Magi* and *St. Dominic and the Albigensians* by the Castilian artist Pedro **Berruguete**. These paintings were executed after his visit to the Court of Urbino in 1477, where the painter had the opportunity to learn the Renaissance science of perspective

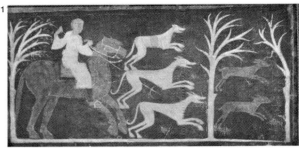

ANONYMOUS SPANISH ARTIST HARE HUNT

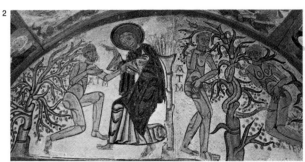

ANONYMOUS SPANISH ARTIST THE CREATION OF ADAM AND
THE ORIGINAL SIN

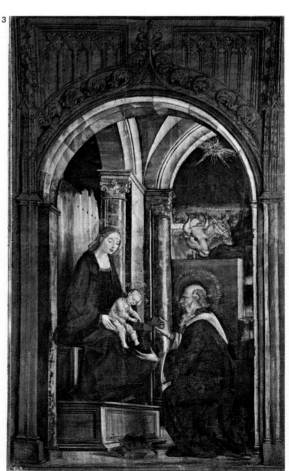

BERRUGUETE THE ADORATION OF THE MAGI

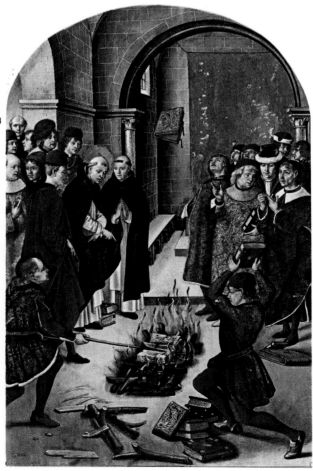

BERRUGUETE ST. DOMINIC AND THE ALBIGENSIANS

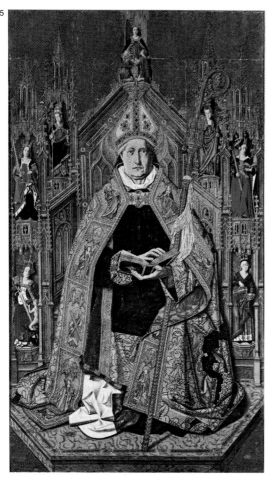

BERMEJO St. Dominic of Silos

GALLEGO Pietà

both from Laurana and Francesco di Giorgio, and from artists like Piero della Francesca and Melozzo da Forlì. In both paintings it is the architectural elements which provide a feeling of spatial depth, and in *The Adoration of the Magi*, the monumental quality of the Virgin and Balthazar also belongs to the Renaissance. But the mock carved frame is Gothic, and gives the scene something of the flavor of a medieval religious play. The panel of *St. Dominic and the Albigensians* shows clearer signs of Flemish influence, with its warm and lively, realistic details. The scene depicts St. Dominic in the act of demonstrating to the heretics of the French town of Albi, in 1207, that the books containing their false doctrines burn in the fire, whereas the Catholic books which he has brought float away unharmed.

5. Bartolomé **Bermejo** or Cardenas or Rubeus (all these names mean red and perhaps derive from the color of his hair) worked in Cordova, and his *St. Dominic of Silos*, the central panel of a triptych, reveals strong Gothic and Flemish influences. The saint's face is rendered with harsh realism, and he is resplendent in his ecclesiastical robes as he sits on a Gothic throne in the upper niches where sit the three theological virtues (Faith on the left, Hope on the right and Charity in the middle). The four cardinal virtues are in the lower niches – Justice and Fortitude on the left, and Prudence and Temperance on the right.

6. The *Pietà* is an early works by Fernand **Gallego**, who was active from 1466 to about 1507 at Salamanca, an important centre of Hispano-Flemish art. The harsh and pathetic realism of his figures derives from Van der Weyden, Bouts and German engravings, and he shows a predilection for broad landscapes in the background. In this particular case, the landscape horizon is obscured by a view of Jerusalem, represented as a Gothic city walls and towers. The two donors standing on the left are saying the prayer "Miserere mei D(omi)ne." At the bottom is the artist's signature in abbreviated form.

7. The **anonymous artist of the Hispano-Flemish school** who painted this *St. Michael* about 1475 was clearly inspired by late Gothic elegance and the medieval taste for two-dimensional "tapestry" compositions, as well as by Flemish realism. St. Michael is depicted in the act of slaying the dragon, a symbol of Satan. Choirs of angels are singing above him, and on either side good and rebellious angels are fighting, the latter being turned into devils at the bottom of the picture. Reflected in the center of St. Michael's shield is the figure of the donor, who kneels between his guardian angel and the devil who is trying to gain his soul.

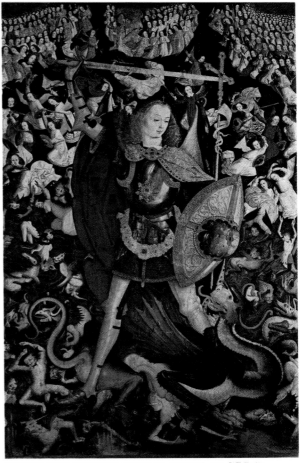

ANONYMOUS HISPANO-FLEMISH ARTIST St. Michael

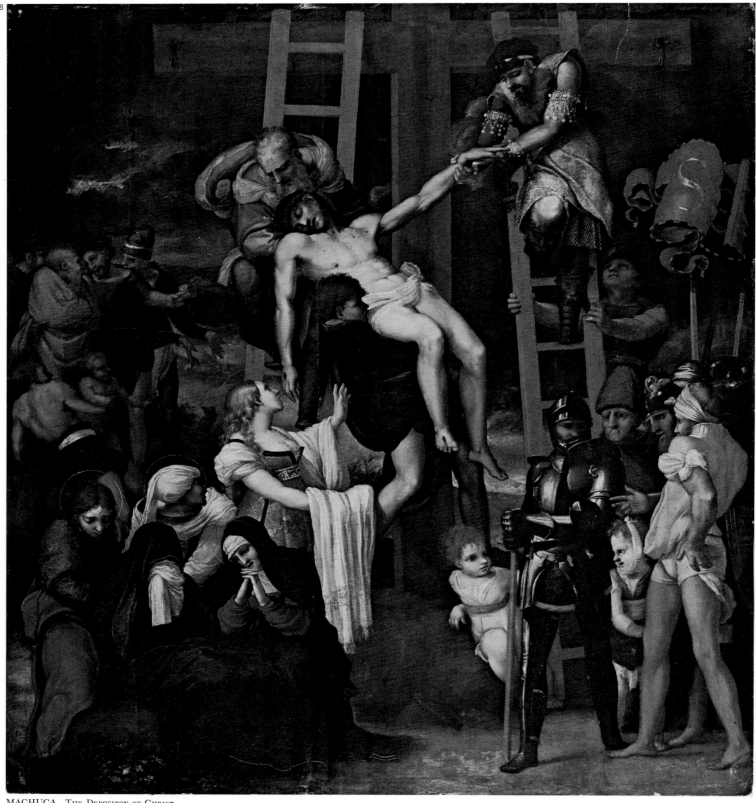

MACHUCA THE DEPOSITON OF CHRIST

8. Characteristic of sixteenth century Spanish painting is the close attention paid to the Italian Renaissance and to Raphael in particular. One of the first to introduce the style of Raphael into Spain was Pedro **Machuca** of Toledo, who studied in Italy from 1517 to 1520. From the "bella maniera" of the great sixteenth century painters he developed that greater pathos and intensity of style which is known as "mannerism." *The Deposition of Christ* was painted either during the period he spent in Italy or immediately after his return to Spain, when he worked as an architect at Granada. (It was he who designed Charles V's famous Alhambra palace.) Machuca's composition has the pyramidal form so common in Raphael's later works, but the numerous figures derive not only from Raphael himself, or from his assistant, Giulio Romano (the women, Christ and Joseph of Arimathea), but also from the expressive harshness of certain German engravings, as one can see in the group of soldiers on the right, the figure of Nicodemus on the second ladder, and the detail of the boy with a swollen, bandaged face, who has slipped between the soldiers in order to get a better view.

YÁÑEZ St. Catherine

JUANES The Burial of St. Stephen

23

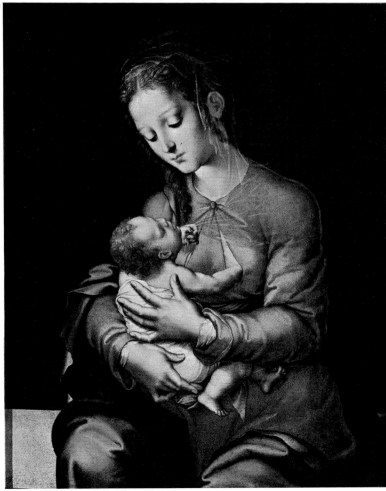

9 – 10. Two artists whose work at Valencia made it an active center of Renaissance art, and who reveal the influence of Raphael, though in a softer key, are Fernando **Yáñez** de la Almedina and Juan de **Juanes**. As a young man, Yáñes de la Almedina had visited Italy and paid attention to Giorgione and Leonardo da Vinci as well as Raphael. Reflections of their work can be seen in his gentle figure of *St. Catherine* of about 1520. St. Catherine rests a sword against the broken wheel of her martyrdom, having placed her royal crown and her martyr's palm on the elegant Renaissance balustrade behind her. Until his death in 1579, Juan de Juanes was, with his father, Juan Vicente Masip, chiefly responsible for spreading the influence of Raphael in Valencia. *The Burial of St. Stephen* is more mannerist than Yáñez's *St. Catherine*, and the man in a white collar who gazes out of the painting on the left hand side is thought to be a self-portrait.

11. The Spanish Renaissance is dominated by Luis de **Morales**, who was born and worked at Badajoz in the Estremadura, and died there at a ripe old age in 1586. The intense mysticism of his paintings gained him the title of "divine." But in spite of his mellow style, Morales was not a Spanish Raphael. His mystical vein and the upthrusting rhythms of his elongated figures make him rather a precursor of El Greco. Instead of the Raphaelesque myth of pagan beauty, one finds in his paintings a deep spirituality, reminiscent of the figures of Leonardo da Vinci, which is heightened by a refined use of color and a Flemish attention to realistic details. This *Madonna and Child* is the most famous of his many pictures of the Virgin Mary, and has something both divine and down-to-earth about it. Philip II, however, disliked his delicate style, with its avoidance of all courtly grandeur, for he considered it provincial by comparison with that of the great sixteenth century painters. Hence he refused to allow any work by Morales to be placed alongside those of his favorite painters in the Escorial.

MORALES Madonna and Child 2656

PANTOJA PORTRAIT OF A LADY

12. Portraiture in the sixteenth century was dominated by the work of the Dutch painter Antonio Moro, whose work was highly regarded at the Spanish court, and it also reached a high level of archievement in the work of Sánchez Coello and his pupil Pantoja de la Cruz. The *Portrait of a Lady*, with her sumptuous dress, stiff lace ruff and unusual comb with tiny teeth, is by Juan **Pantoja** de la Cruz, whose great merit has only recently been recognized. Pantoja worked as a portrait painter at the Spanish court at Madrid during the last years of the reign of Philip II, and remained there as court painter to Philip III until his death in 1609. His work is reminiscent not only of Moro, but also of the brilliance and clarity of Titian.

13 – 14. The favorite artist of Philip II and his family was Alonso **Sánchez Coello**, who inherited the position and prestige at court of Antonio Moro when the latter fell into disfavor. He painted this *Portrait of Philip II* about 1575, or at any rate before 1582, for we know that the king's beard was white by that time. The attribution to Sánchez Coello is not unanimous, but it is justified by the delicate grey tones which he was most skilful at using. The *Portrait of the Infantas Isabel Clara Eugenia and Catherine Micaela* was painted about 1571. The two little sisters were born in 1566 and 1567 to Philip II and his third wife Isabel of Valois, and they do not appear to be more than five or six years old in the painting. (The elder of the two later married the Archduke Albert of Austria, Governor of the Netherlands, and became a great patron of Rubens.) Both the pose and the ceremonial dress, enclosing the body like a sumptuous suit of armour, reflect the strict etiquette which governed the lives of members of the Spanish court from the day they were born.

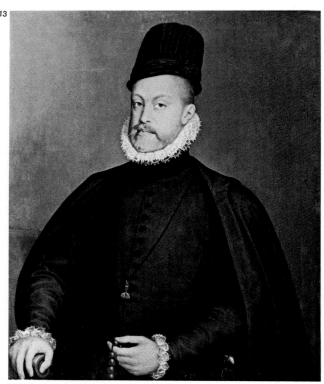

SÁNCHEZ COELLO PORTRAIT OF PHILIP II OF SPAIN

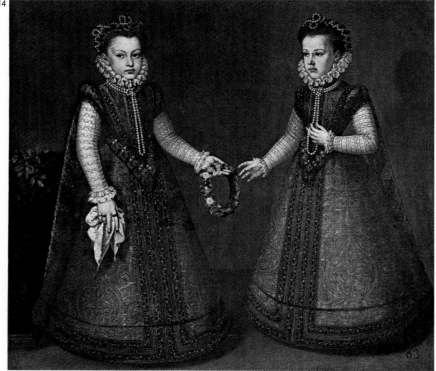

SÁNCHEZ COELLO PORTRAIT OF THE INFANTAS ISABEL CLARA EUGENIA AND CATHERINE MICAELA

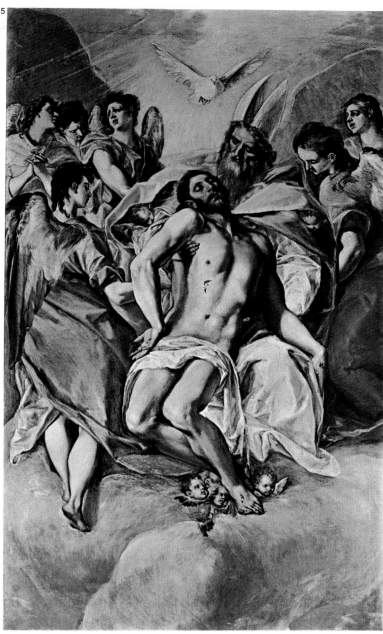

THE HOLY TRINITY

EL GRECO

Domenico Theotocopuli was called El Greco because he was a native of Crete, but in spite of this and in spite of his early training both in Venice (at Titian's studio and in contact with Tintoretto) and in Rome (among the mannerists), he is the most Spanish of all Spanish painters. He had a broad humanist culture, and could read ancient Greek and Latin authors in the original when seeking confirmation of the classical values reinstated by the Renaissance. At the same time he was a cultured and earnest Catholic, among whose favorite books were the Bible, the Early Fathers of the Church and the recent enactments of the Counter-Reformation. Therefore, he had a unique ability to interpret the complex and contradictory spirit of the old Spain as it entered a new century. This spirit embraced the mystical fervor of long tradition (its essence expressed with extreme poetic lyricism in the writings of El Greco's contemporary, St. Theresa of Avila), the new enthusiasm for Humanism, and a strict adherence to the discipline of the Counter-Reformation (the anti-Renaissance, in other words) as the sole remedy against the decay of Catholicism. El Greco worked entirely at Toledo, the ancient Spanish bastion against the Moors, and the favorite city of the Catholic monarchs and the Emperor Charles V, by contrast with the new capital at Madrid. He came to Toledo in 1577 at the age of thirty-seven, and remained there until his death in 1614, devoting his intense labors to the embellishment of local churches and monasteries and to commissions from the intellectual nobles of the city. His skilfully constructed compositions, with their strong colors, deriving from Renaissance and Mannerist painting, present ethereal, elongated figures which are drawn upwards toward Heaven in a powerful and mystical way.

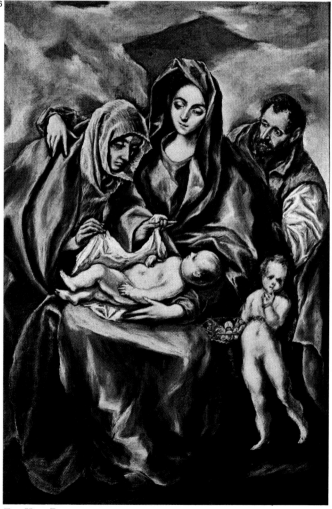

THE HOLY FAMILY

15. One of El Greco's earliest substantial commissions in Toledo was obtained in 1577, soon after his arrival there. It involved the decoration of the altars in the new church of Santo Domingo el Antiguo, and kept him busy until 1579. *The Holy Trinity* is one of the works which he produced for this church. It was to be the principal and uppermost part of an altarpiece for the high altar, and El Greco (who was also an architect and sculptor) was responsible for the design and sculptural decoration of the altar as well. One can still clearly discern Italian influences in this painting, especially from Venetian art and the work of Michelangelo, but there was also an influence from Dürer. (Michelangelo's last *Pietàs* are related to an engraving made by Dürer in 1511). This association between the Holy Trinity and the Pietà goes back to the fourteenth century, but was particularly popular during the Counter-Reformation because the spirit of religious devotion was identified with the great themes of suffering, compassion and penitence.

16. This painting of *The Holy Family* with St. Anne belongs to the later period of El Greco's maturity. St. John as a child with his basket of fruit is really a little pagan idol rendered in El Greco's typically ethereal way.

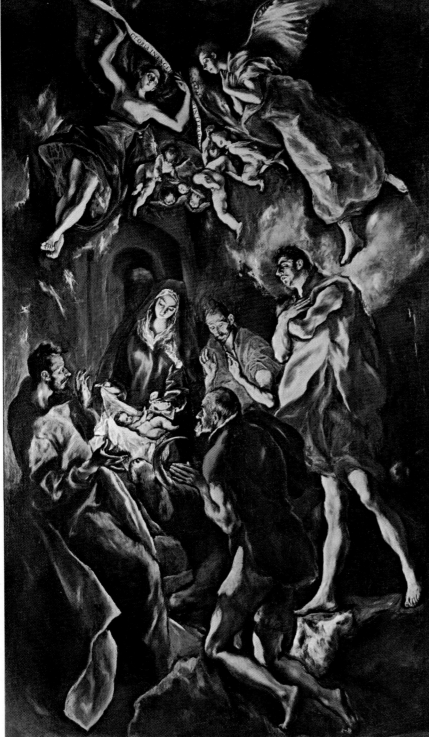

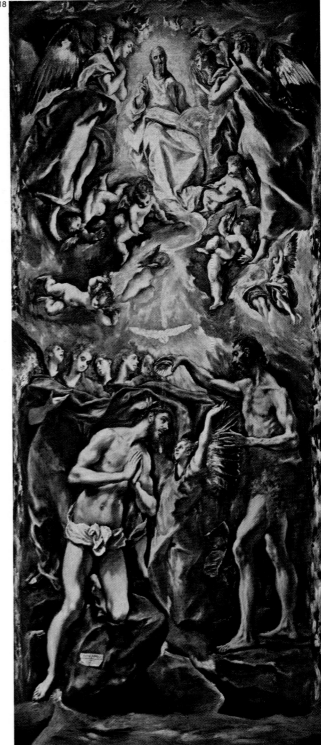

THE ADORATION OF THE SHEPHERDS

THE BAPTISM OF CHRIST

17. **El Greco**'s interpretations of the principal episodes in the life of Christ always contain a powerful element of transfiguration, as can be seen in *The Adoration of the Shepherds*. The scene, with Jesus in the manger, faithfully follows the account given in St. Luke's Gospel, with an angel holding up the words sung to the shepherds by the heavenly host: "Gloria in excelsis Deo et pax in terra hominibus bonae voluntatis." At the same time, however, the subject is treated with tremendous power, and the artist's imagination has given an awesome intensity to an intimate episode. This is the manner of El Greco's later years. The altarpiece was in fact painted only a few years before his death, and was apparently intended for the chapel where he was to be buried in the church of Santo Domingo el Antiguo.

18. *The Baptism of Christ* is one of the small number of paintings by **El Greco** to be commissioned by a body connected with the Spanish royal family, for it was painted between 1597 and 1600 at the request of the Royal Council of Castile for a college founded in Madrid by one of the queen's ladies-in-waiting. It is a mature work. Reminiscences of Italian art have now been completely absorbed into an ethereal vision, bringing together the figures of human and divine beings in an upsurge which is tempered by the skilful composition, based on harmonizing oval shapes. The supernatural quality of the scene is offset by a number of realistic details, such as the small angel in the middle of the painting who raises his arms as a sign of rejoicing, or the angels' wings, which look like those of farmyard fowls.

19. *The Crucifixion, with the Virgin, St. Mary Magdalene, St. John the Evangelist and Angels* also belongs to the period of **El Greco's** full maturity. The figures are extremely elongated and very freely constructed, while the Virgin has the pointed, pallid face typical of El

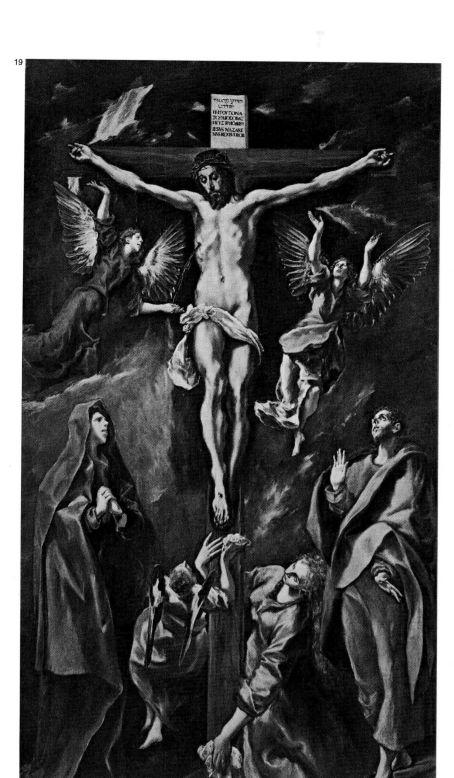

THE CRUCIFIXION, WITH THE VIRGIN, ST. MARY MAGDALENE, ST. JOHN THE EVANGELIST AND ANGELS

PORTRAIT OF A GENTLEMAN WITH HIS HAND AT HIS BREAST

PORTRAIT OF A DOCTOR (RODRIGO DE LA FUENTE?)

Greco's later Madonnas. There are certain harshly realistic details, such as St. Mary Magdalene and the angel wiping away Christ's blood as it drips on the wooden cross, but they are wholly integrated into the atmosphere of spiritual tension and intense suffering, which provides a supreme expression of the spirit of the Counter-Reformation.

20 – 21. The striking simplicity of method and the expressive intensity of **El Greco**'s portraits give him a unique position in that genre. *The Portrait of a Gentleman with his Hand at his Breast*, belongs to El Greco's earliest years at Toledo, and is thought to depict Juan de Silva, Marquis of Montemayor, a senior notary of Madrid and a Knight of the Order of St. James. The influence of Tintoretto can still be detected here, but the subject is already transfigured in El Greco's inimitable way. The *Portrait of a Doctor* is a somewhat later work and is thought to depict Rodrigo de la Fuente, a famous doctor and a friend of El Greco, who was immortalized by his great contemporary and acquaintance, in a story entitled "The Illustrious Serving Girl."

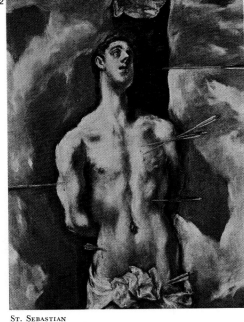

ST. SEBASTIAN

22. The *St. Sebastian* shows the saint pierced by arrows and surrounded by swirling and darkly mysterious clouds. It is a fragment of a larger painting which must have included St. Sebastian's legs. The intensity of expression and tones of red demonstrate that this is a late work.

23 – 24. *The Resurrection of Christ* and *The Descent of the Holy Ghost* form a pair and are late works. The figures have an ethereal, ghostly appearance, the artist's technique is bold and varied, and his most characteristic colors shine out from the canvas: yellow, orange and lapis lazuli blue as well as that particular purplish red of the Virgin's dress which immediately reveals the hand of **El Greco**, and which is supposed to have been made up from strange ingredients, including pigeon's blood. The descent of the Holy Ghost during the Jewish Feast of Pentecost follows the text of the Acts of the Apostles, but there is an original element in the representation of the Resurrection, in that the soldiers on guard at the tomb are shown attemping to prevent Christ's ascent.

25. By contrast with this late example of **El Greco**'s visionary art, the *St. Andrew and St. Francis*, which he painted in his maturity, before 1600, has an elevated and classical calm. Nevertheless, the painting is dominated by the very elongated figures of the saints, who seem literally to absorb the landscape in which they are placed. This painting remained unrecognized for centuries in the Real Monasterio de la Encarnación in Madrid, where it was discovered during the Civil War of 1936-39. The two saints (St. Andrew has the X-shaped cross of his martyrdom and St. Francis has the stigmata) are splendid examples of the endless series of paintings of apostles and of St. Francis which the religious houses of Toledo continuously requested from El Greco.

28

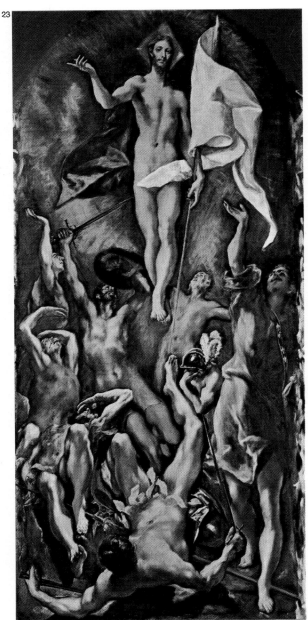

THE RESURRECTION OF CHRIST

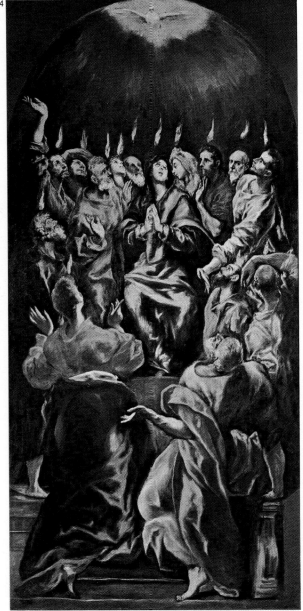

THE DESCENT OF THE HOLY GHOST

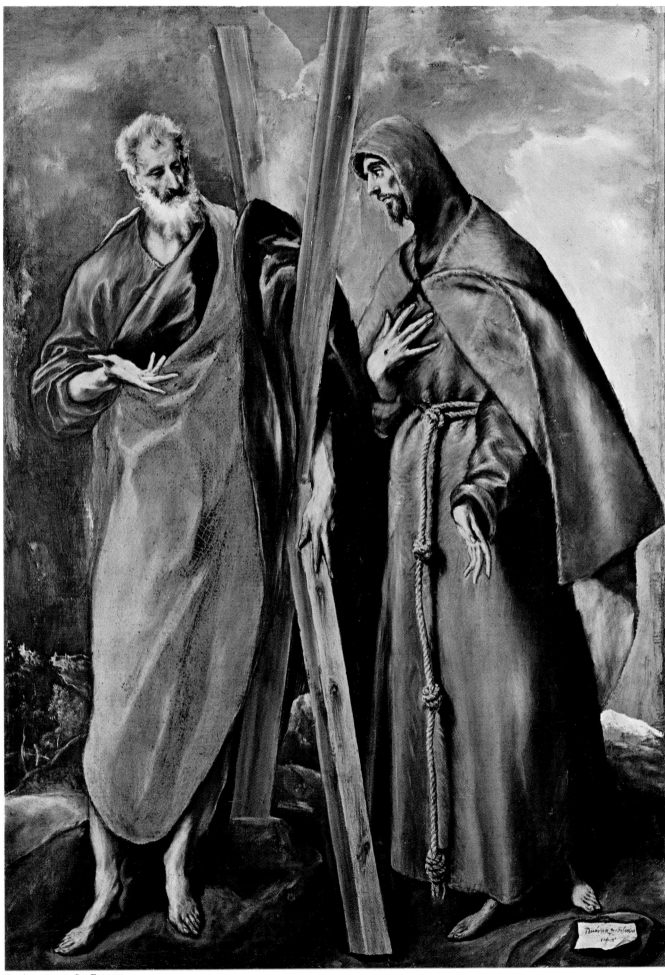

ST. ANDREW AND ST. FRANCIS

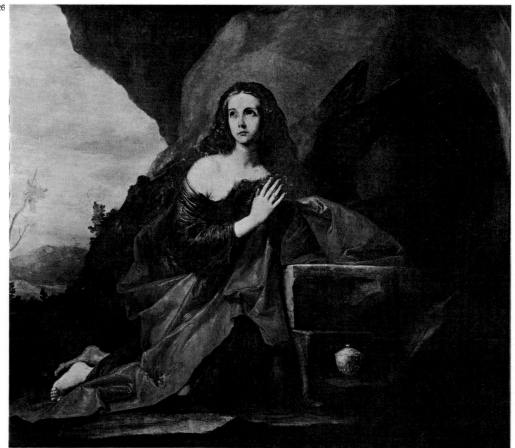

RIBERA THE PENITENT MAGDALENE 1103

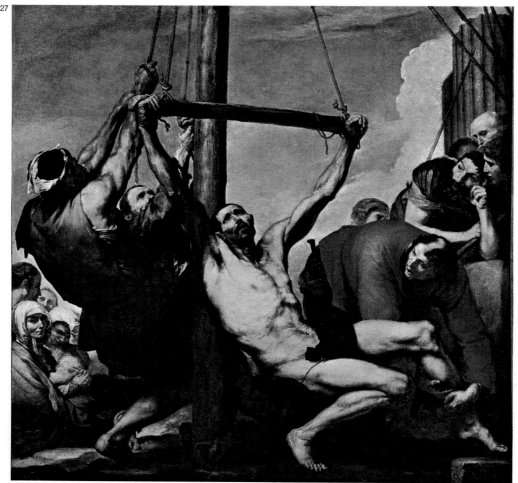

RIBERA THE MARTYRDOM OF ST. BARTHOLOMEW

The golden age of Spanish painting was the seventeenth century. It was a time of moral and political upheaval, when Spain's dream of world dominion on both sides of the Atlantic faded, as the Thirty Years' War dragged on and the Inquisition imposed its rigorous discipline. Yet it was now that Spanish art came to splendid fruition. Spanish mysticism, and the classicism and naturalism derived from fruitful contacts with neighboring Italy, where Caravaggio's style was in full bloom, produced the splendors of Spanish realist painting in all its variations, from the use of artificial light in the vigorous construction of the human figure (Caravaggio's great contribution to European art) to a striking synthesis of the real world, or its exhaltation in distorted baroque forms.

26 – 27. One of the greatest artists of the Spanish realist school was José de **Ribera**, a native of Valencia and known to the Italians as "Lo Spagnoletto." From 1616 until his death he worked at Naples. *The Penitent Magdalene* was painted about 1644-47, and the artist's daughter was his model for the figure of the saint. Ribera had learned how to use light by studying the work of Caravaggio, and here it acquired soft tones imbued with color-as-light and mysticism. *The Martyrdom of St. Bartholomew* is one of Ribera's masterpieces and belongs to the earlier years of his maturity. It dates to 1630 or 1639, the date being inscribed on the piece of stone in the bottom right-hand corner of the painting. The work is striking for the brilliance of the colors, which even penetrate the areas in shadow, and for the extraordinary, baroque vigor of the composition. The arrangement of St. Bartholomew's arms and legs is an example of hyperbole, that rhetorical figure so dear to the baroque mind, and it here takes the form of two infinitely divergent ellipses, symbolizing exaggeration.

28. The striking representation of *St. Bonaventura Received into the Franciscan Order* was painted in 1628 by Francisco de **Herrera** the Elder, a native of Seville and one of the first exponents of the new realist art in Spain. Velázquez was among his pupils, and until Zurbarán's time he dominated the Seville school of painting with his harsh and forceful realism expressed by means of a dynamic technique and conveying an earthy freshness.

29. The *Portrait of the Empress Margaret Theresa of Austria* was painted by Juan Bautista del **Mazo**, who became Velázquez's son-in-law and worked with him. The portrait depicts the daughter of Philip IV and Mariana of Austria, who appears as a small child in Velázquez's *Las Meninas* (see no. 49). Now she is a fifteen-year-old princess in mourning for the recent death of her father. In the background is the small figure of Charles II, already a king at the age of five, and beside him is the court dwarf Maribárbola.

30. *The Recapture of the Port of*

Bahia in Brazil shows the city's recapture from the Dutch in 1625, and it is one of the large canvases commissioned by the Duke of Olivares, Philip IV's prime minister, to celebrate the king's victories against the English and the Dutch (see also no. 39). It was painted ten years after the event by Juan Bautista **Maino**, an artist born in Milan who was also a friar. The fresh realism of the painting derives not so much from Caravaggio as from Orazio Gentileschi. Don Fadrique de Toledo, the hero of the engagement, is shown before his troops with a tapestry depicting Philip IV, his minister Olivares and the figure of Victory, all of whom stand over the corpses of Heresy, Anger and War. The real subject of the painting, however, is the Port of Bahia.

HERRERA THE ELDER St. Bonaventura received into the Franciscan Order

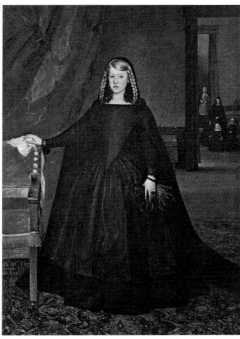

MAZO Portrait of the Empress Margaret Theresa of Austria

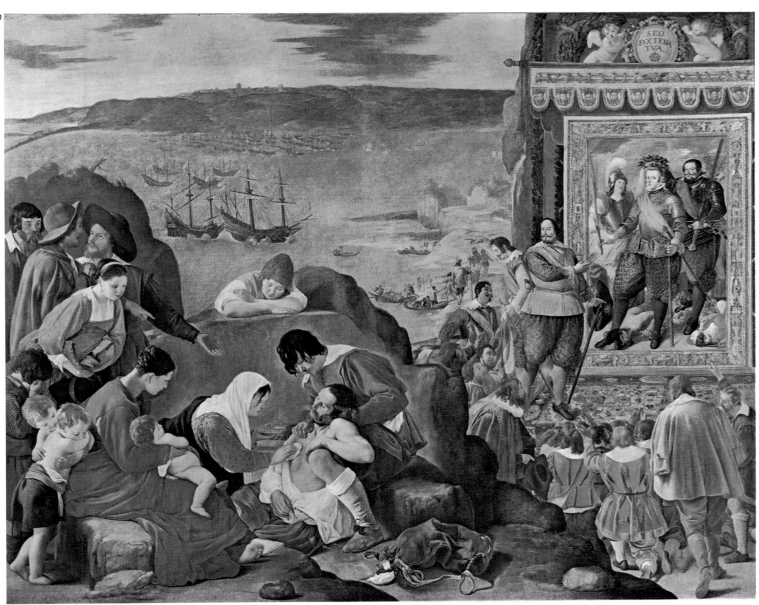

MAINO The Recapture of the Port of Bahia in Brazil

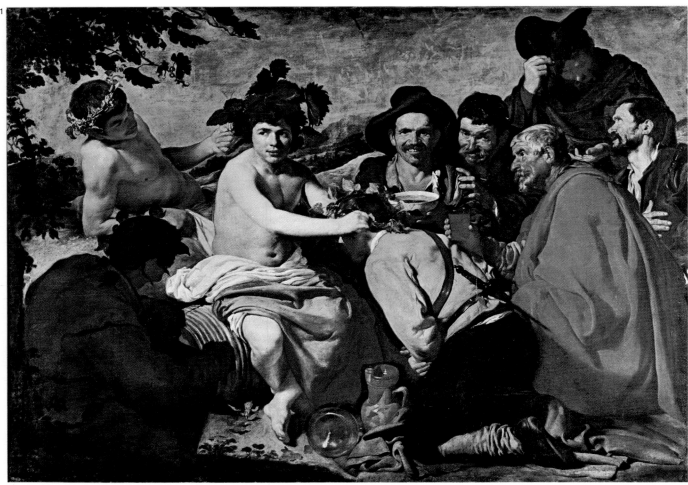

THE TOPERS

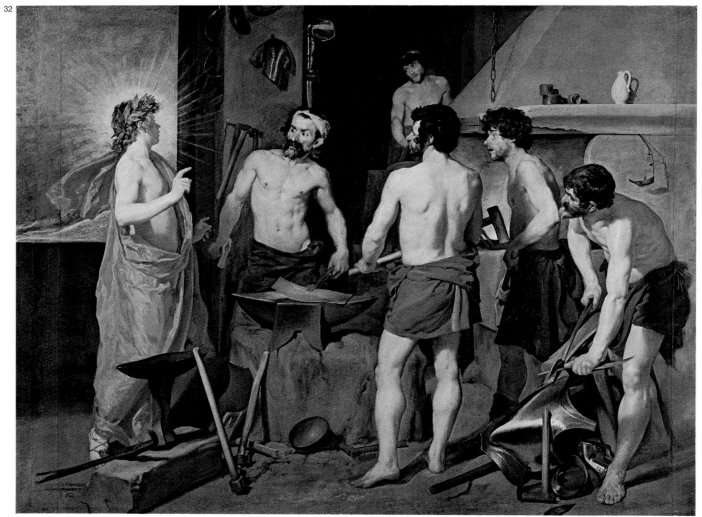

THE FORGE OF VULCAN

VELÁZQUEZ

The art of Diego Rodríguez de Silva y Velázquez, a native of Seville, dominates Spanish painting in the seventeenth century. Although his painting falls under the general heading of realism, it is characterized by independence of vision and an instinctive revolutionary talent, as well as a thoughtful melancholy in its day-to-day contact with the realities of life, and a capacity for making penetrating judgments on men and objects. And yet his supreme gifts as an artist, as expressed in his works, are strikingly dissimilar to the tenor of his personal life, which was entirely spent in Madrid court circles and in the service of Philip IV. Velázquez first met Philip IV and painted his portrait when he was twenty-four. Philip was then barely eighteen. He became painter to the king that same year (1623) and took up palace employment in 1627, faithfully persevering in both tasks until his death in 1660. These were troubled times for the Spanish spirit. Cervantes was now completing the creation of that poetic and bitter figure, the generous-hearted and deluded Don Quixote; the friar Tirso de Molina was creating the characters of a non-conformist theatre dominated by Don Juan, the "Burlador de Sevilla"; the soldier-poet Calderón de la Barca was turning his attention, between battles, to plays which declare reality to be an illusion; and Velázquez was placing his dreamlike pictures of dwarfs and sybils, noblemen and humble working people, kings and gods within the limited confines of the royal palaces. These may be dreams, but they have a genuine reality, and they are expressed in a highly personal style which brings to fruition what Velázquez had learned from other painters. He had also made splendid use of his study of perspective, symmetry and architecture.

31 – 32. Velázquez's early works combine realism with a deep feeling for classicism. In *The Topers*, which he painted in 1628, Bacchus is seen crowning one of his devotees. In *The Forge of Vulcan*, Apollo is seen warning Vulcan of the infidelity of his wife Venus with Mars. This second painting was executed in Rome in 1630.

33 – 34. These two figures, from the ancient world but dressed in everyday clothes, are in fact two portraits. *A Sybil* probably represents Juana Pacheco, the artist's wife, but it is not known who the model was for *Aesop*.

35 – 36. Velázquez painted the *Portrait of the Venerable Mother Jerónima de la Fuente* in 1620 at Seville, where the nun in question paused on her way to found a convent in the Philippines, as a long inscription explains. The painting has all the uncompromising realism of Velázquez's early manner, which he developed in Seville under the influence of Herrera and the severe classicism of Pacheco. On the other hand, the *Portrait of Doña Antonia de Ipeñarrieta y Galdós and her Son Luis* was painted a few years later, after Velázquez's arrival in Madrid, and it shows a more controlled kind of realism.

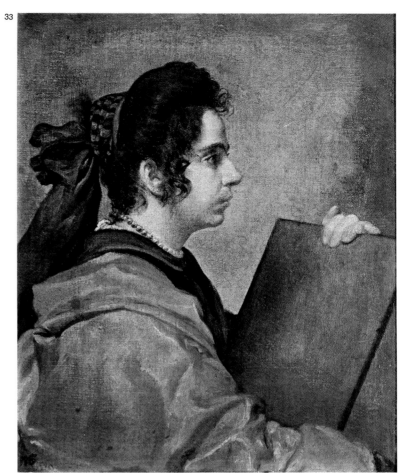

A SIBYL

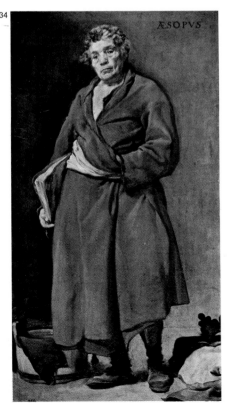

AESOP

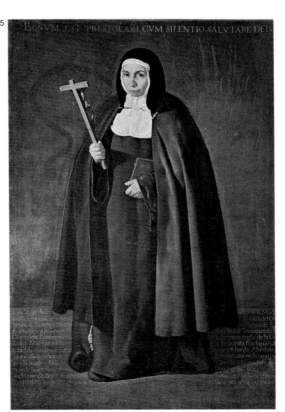

PORTRAIT OF THE VENERABLE MOTHER JERÓNIMA DE LA FUENTE

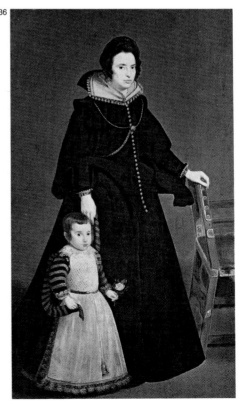

PORTRAIT OF DOÑA ANTONIA DE IPEÑARRIETA Y GALDÓS AND HER SON LUIS

34

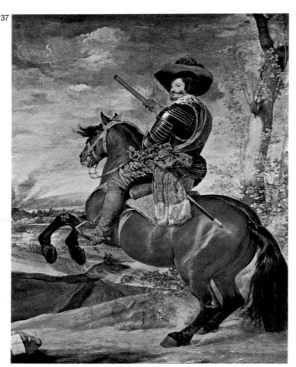

PORTRAIT OF GASPAR DE GUZMÁN, COUNT-DUKE OF OLIVARES,
ON HORSEBACK

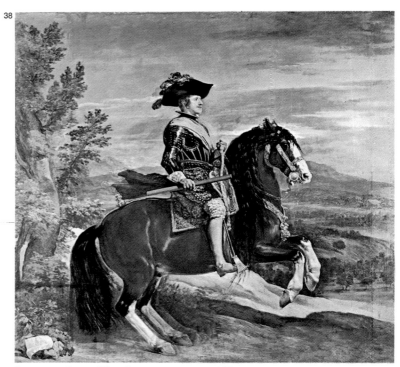

PORTRAIT OF PHILIP IV OF SPAIN ON HORSEBACK 1178

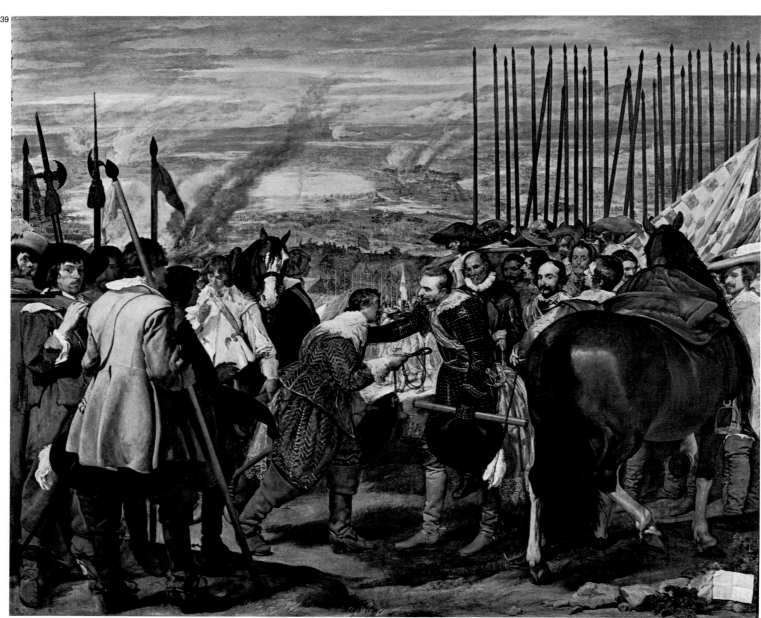

THE SURRENDER OF BREDA

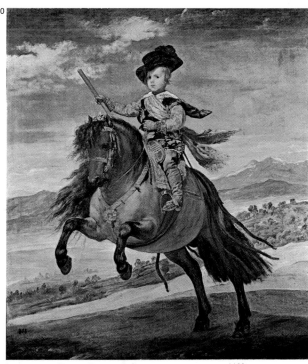

PORTRAIT OF PRINCE BALTASAR CARLOS ON HORSEBACK 1180

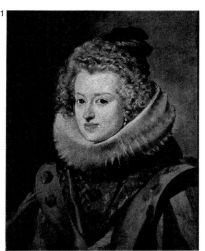

PORTRAIT OF MARIA OF AUSTRIA

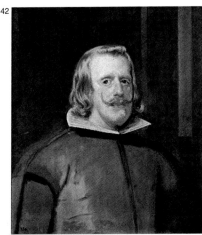

PORTRAIT OF PHILIP IV OF SPAIN 1185

37 – 39. These are three mature works, painted in the years 1634-36 to celebrate the glories of Philip IV. The *Portrait of Philip IV of Spain on Horseback* and the *Portrait of Gaspar de Guzman, Count-Duke of Olivares on Horseback* display a baroque intensity which is influenced by the work of Rubens. *The Surrender of Breda* (also known as *The Lances*, on account of the thirty prominent lances on the right hand side of the painting) celebrates a victory of ten years earlier with great penetration of human character and considerable forcefulness of construction. The Flemish fortress of Breda had surrendered after an eight months' seige, and we see here the Genoese commander-in-chief of the Spanish army, Ambrogio Spinola, receiving the keys of the fortress from Justin of Nassau, illegitimate brother of the Statholder of Holland, who has shown great prowess at arms. **Velázquez** had met Spinola in 1629 when they both travelled on the same ship on the occasion of Velázquez's first visit to Italy. This is deservedly the most famous of the pictures commissioned by the king's minister Olivares (see also no. 30) (which celebrates the glories of his master) in the Salón de Reinos in the Buen Retiro Palace, where the equestrian portrait of the king, also illustrated here, enjoyed a prominent position.

40 – 42. Among the collection of portraits of members of the royal family, three paintings by **Velázquez** stand out. They are the *Portrait of Prince Baltasar Carlos on Horseback*, also painted for the Salón de Reinos; the *Portrait of Maria of Austria, Queen of Hungary*, painted in Naples in 1630 when the Infanta was on her way to marry Ferdinand III; and the *Portrait of Philip IV of Spain*, painted about 1660 with all the impressionistic vigour of Velázquez's later manner.

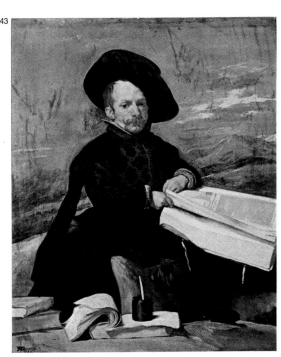

PORTRAIT OF THE JESTER DON DIEGO DE ACEDO
(THE ARTIST'S 'COUSIN')

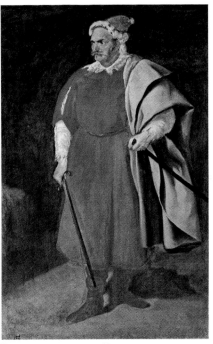

PORTRAIT OF THE JESTER BARBARROJA

43 – 44. Velázquez found inexhaustible inspiration in the court jesters. The *Portrait of the Jester Don Diego de Acedo* shows the dwarf – known as "el Primo" because he claimed to be Velázquez's cousin – surrounded by the instruments of his office at the king's privy seal, against a landscape background which is rendered in rapid impressionistic style. It was painted at Fraga in 1640 during a royal visit to Catalonia and Aragon. The *Portrait of the Jester Barbarossa* shows Don Cristóbal de Castañeda y Pernia dressed in Turkish style with a sword in his hand. In spite of his diminutive figure, Don Cristóbal did indeed have military pretensions, and was brave enough to face bulls in the bullring.

45. The *Portrait of Mariana of Austria, Queen of Spain* shows Philip IV's niece and second wife. She has the typical Hapsburg features to be found in many European royal families as a result of the network of family intermarriages. Velázquez painted her here dressed in the elaborate fashion of the day, four years before she appeared again in *Las Meninas* (see n° 49).

46 – 47. The *Portrait of the Cardinal-Infante Don Ferdinand of Austria* (brother of Philip IV) and the *Portrait of Prince Baltasar Carlos* show both men in hunting dress. **Velázquez** painted them about 1635 with a sober realism and steady brushwork which are characteristic of his early maturity.

48. The *Portrait of the Infanta Margaret of Austria* should show the princess at the age of nine – five years older than in *Las Meninas* (see no. 49) – but in fact her face suggests that she was twelve or thirteen. Hence it is thought that **Velázquez** began the portrait shortly before his death in 1660, and that is was subsequently altered and finished by his son-in-law del Mazo (see also no. 29). Nevertheless, the dress, veil and bunch of violets show all the vigor and skill of Velázquez's later years.

49. The romantic title *Las Meninas* (The Maids of Honor) was given to **Velázquez**'s famous painting in the nineteenth century. It was originally called *The Empress* (i.e. the Infanta Margaret - see no. 29 and 48) *with her Ladies-Waiting and a Dwarf*, while in the eighteenth century it was known as *The Family* (i.e. the royal family). Tradition states that the figure of the Infanta, rendered with extreme lightness of touch and brilliant effect, shows her at the age of four (the year is 1656), when she has come to the artist's studio in the royal palace to find her parents, who have been sitting for their portrait. The figures of Philip IV and Queen Mariana are in fact reflected in the small mirror on the far wall, while Velázquez has shown himself on the left, busy at the portrait of the royal couple on a huge canvas. The spatial depth of the room is rendered by means of strict geometrical perspective, and the figures stand out within it like actors on a stage, facing the public – that is to say facing Philip and Mariana, ghostly spectators who are given only a semblance of solid reality by their reflection in the mirror. It is as though the artist had seen the Infanta and her companions (who have their backs to him now that they are in the rooms) in a mirror which provided him with a frontal view of them. In fact, in the Prado Gallery a real mirror has been placed in front of the painting in order to reverse the image again, and hence show the spectator how the group of people must have looked in reality. However, since the canvas in front of Velázquez seems excessively large for a portrait, but roughly corresponds in size to that of *Las Meninas*, it may be that Velázquez was depicting himself in the act of painting not one of the many royal portraits but *Las Meninas* – the most demanding work in his whole career as an artist. Goya studied this painting carefully and made an engraving from it, and one hundred and fifty years after the creation of *Las Meninas* he painted the equally famous *The Family of Charles IV of Spain* (see no. 80), which makes use of the same idea of the artist at work inside the scene he is painting. It is as though the artist were using his own figure as a kind of signature – an imaginative and proud gesture on the part of a genuine artist. But perhaps the romantic tradition of the double portrait will have to be abandoned. Perhaps the plain truth about *Las Meninas* is that Velázquez is painting the Infanta and her companions, while her parents watch over her and are set down as reflections

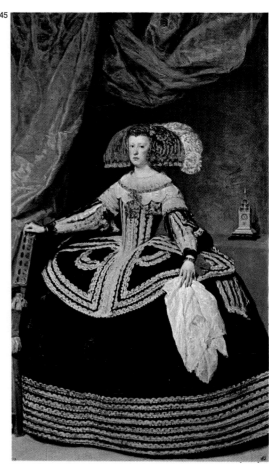

PORTRAIT OF MARIANA OF AUSTRIA, QUEEN OF SPAIN

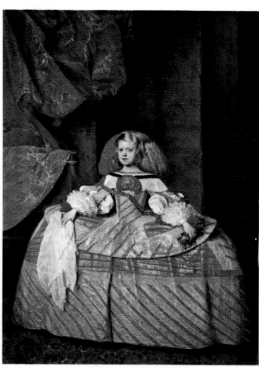

PORTRAIT OF THE INFANTA MARGARET OF AUSTRIA

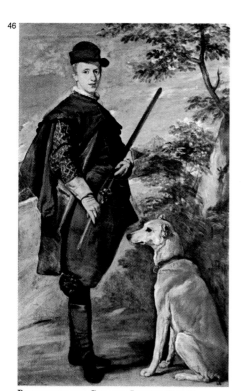

PORTRAIT OF THE CARDINAL-INFANTE DON FERDINANDO OF AUSTRIA

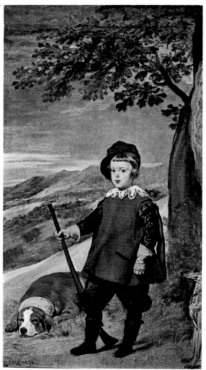

PORTRAIT OF PRINCE BALTASAR CARLOS 1189

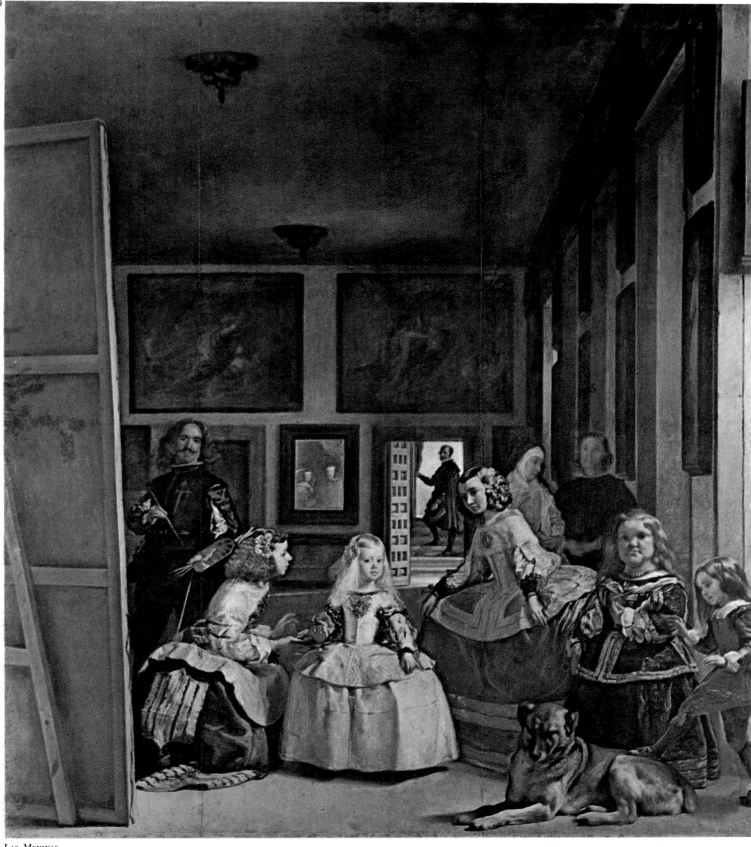

LAS MENINAS

in the mirror; and then he depicts himself beside his sitters. The little princess is surrounded by her maids-of-honor. Standing in the doorway is Don José Nieto Velázquez, the palace chamberlain. On the walls are copies of masterpieces from the royal art collections. The cross of St. James worn by the artist is a later addition, for he became a Knight of St. James only the year before he died. This painting is the most famous work in the Prado (like *The Night Watch* in the Rijksmuseum), and its magic has surprised and appealed to all kinds of men at all times. As early as 1692 Luca Giordano described *Las Meninas* as "the theology of painting"; and two hundred years later Théophile Gautier was so obsessed by its "magical realism" that he asked himself "Where is the painting?", for he wondered whether its essence was to be found within the painting itself as an object, or whether it lay rather in the reality of life.

THE GARDENS OF THE VILLA MEDICI IN ROME 1210

THE GARDENS OF THE VILLA MEDICI IN ROME 1211

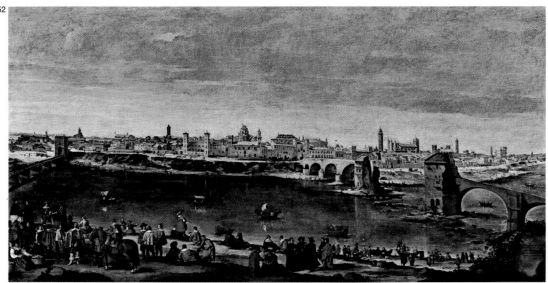

A VIEW OF SARAGOSSA

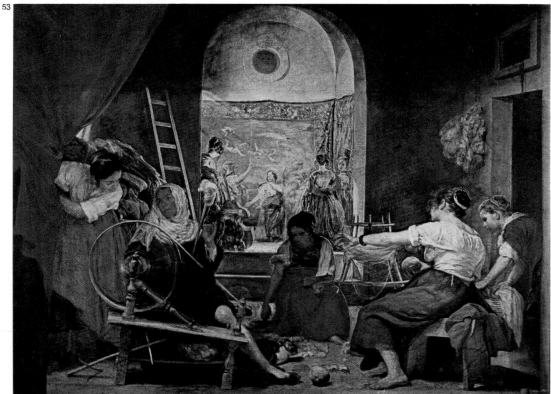

THE SPINNERS

50 – 52. There is first-hand testimony of **Velázquez**'s two visits to Italy in the two paintings of *The Gardens of the Villa Medici in Rome*, one of which shows the entrance to the Grotto and the other the Pavilion of Ariadne. The attention paid by the artist to changes of light as the time of day changes is such that the paintings have even been entitled *Noonday* and *Day*, and they anticipate the 'plein air' painting of modern times. On the other hand, *A View of Saragossa* is a much more tranquil piece of work. Velázquez may have had a hand in it, but it is largely the work of his son-in-law Juan Bautista del Mazo, whose signature it bears, together with the date 1674. In accordance with the wishes of Prince Baltasar Carlos, who commissioned the painting, the city is seen from a room in the San Lázaro Palace, in which the Prince died when he was barely seventeen years old, before he could see the finished painting.

53. Velázquez's responsibility for providing the decorations at court festivities often took him to the royal tapestry workshops where he saw the women at work, and this provided him in later years with the inspiration for *The Spinners*. As in *Las Meninas* (see no. 49), so also here he combines a profound understanding of composition and perspective with a modern sense of light and color. Some maintain that he has blended fact and fiction here by representing the story of Arachne. The scene in the background is taken to be the first part of the story: the ladies represent the women of Lydia who have come to admire the wonderful cloths woven by Arachne with the assistance of the goddess Athena, the inventor of the loom (seen here wearing a helmet). The well-known story relates how Arachne dared to challenge the goddess to a trial of skill in weaving and was changed into a spider as punishment; but this part of the myth does not appear in the painting.

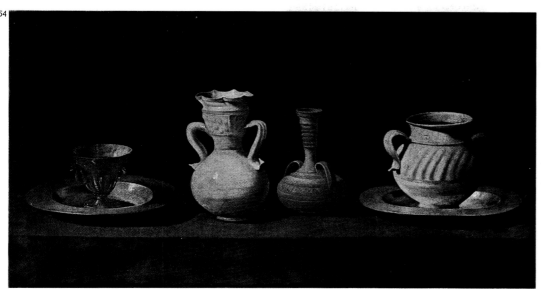

ZURBARÁN STILL LIFE

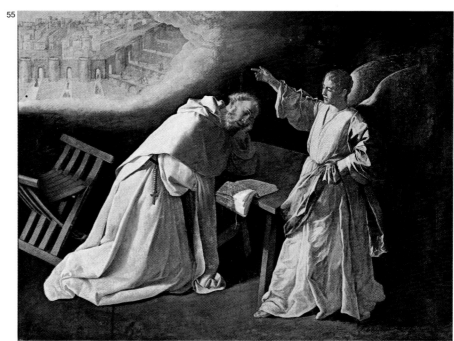

ZURBARÁN ST. PETER NOLASCO DREAMING OF THE HEAVENLY JERUSALEM

54 – 56. The *Still life, St. Peter Nolasco Dreaming of the Heavenly Jerusalem* and *St. Peter the Apostle Appearing to St. Peter Nolasco* were all painted by Francisco **Zurbarán**. The objects in the first of these are seen as abstract shapes formed out of light and placed in a timeless setting, while the other two blend intense mysticism with intense realism. In fact Zurbarán was known as "the realist of the other world," and he held sway in the Seville school of painters before Murillo. He was born in the Estremadura in 1598, but settled at an early age in Seville, where that great artist Herrera the Elder (see no. 28) took him on as assistant for a series of canvases intended for the Colegio de San Buenaventura. Henceforward, Zurbarán specialized in paintings illustrating the lives of monks, and he worked in Seville and Madrid, where he died in 1664. These two paintings of St. Peter Nolasco were executed for the Mercedarian monastery in Seville, shortly after the canonization of St. Peter Nolasco, who, four hundred years earlier, had founded the lay order of Our Lady of Mercy in order to ransom Christians who had been enslaved by the Moors. In the first painting St. Peter Nolasco is seen wearing the white habit of his Order, as he dreams of the New Jerusalem, which is pointed out to him by an angel. (This is the same vision that St. John had in the Apocalypse, but here the heavenly city seems to be a real view of Avila with its walls and towers.) In the second painting, he sees his patron saint, the apostle Peter, who was crucified head downward at his own request, because he said he was unworthy to die in the same manner as Christ. In order to give reality to this ascetic vision, Zurbarán has abandoned the seventeenth century taste for dark tones. His figures have a harsh reality, but they glow with the abstract light of a supernatural world — the only true world for the holy monks who commissioned the paintings.

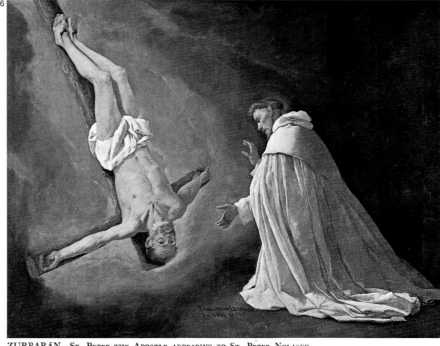

ZURBARÁN ST. PETER THE APOSTLE APPEARING TO ST. PETER NOLASCO

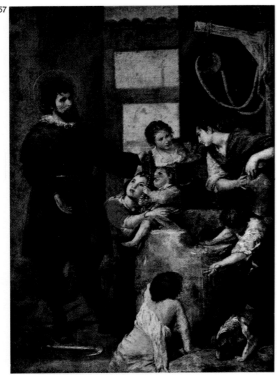

CANO The Miracle of the Well

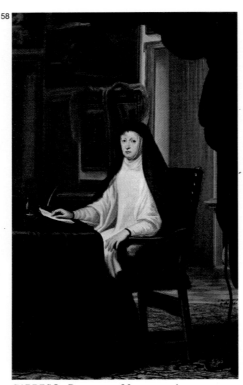

CARREÑO Portrait of Mariana of Austria,
Queen of Spain

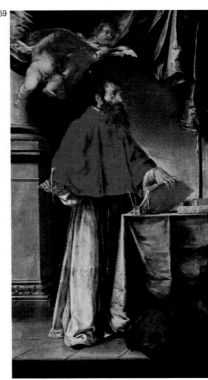

VALDÉS LEAL St. Jerome

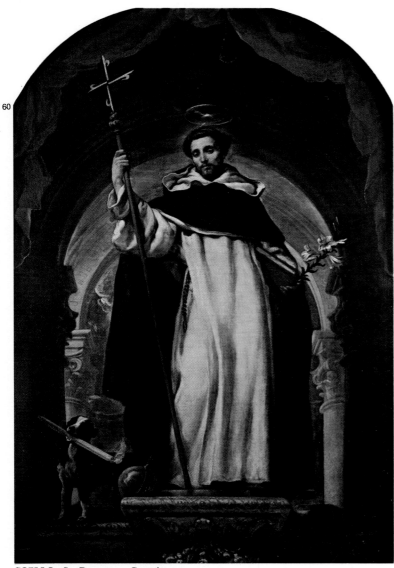

COELLO St. Dominic of Guzmán

57 – 58. Alonso **Cano** (1601-1661) was a native of Granada. He painted *The Miracle of the Well* when he was thirty-six, and he treats the subject of the child saved by St. Isidore of Madrid as a brightly-lit scene of working-class life. In his *Portrait of Mariana of Austria, Queen of Spain* (see no. 45), Juan **Carreño** de Miranda continues the tradition of Velázquez and presents a spiritual image of the queen, now a widow, as she sits in the Salón de los espejos in the Alcázar Palace at Madrid. The picture may have been painted in 1669, the year when the Queen appointed Carreño court painter.

59 – 61. The sumptuous *St. Jerome* in cardinal's robes is by Juan de **Valdés Leal**, and is a typical example of the work of the realist school of painting at Seville. Valdés Leal and Murillo both worked in Seville and together founded an academy of painting there. Valdés Leal died there in 1690. On the other hand, Claudio

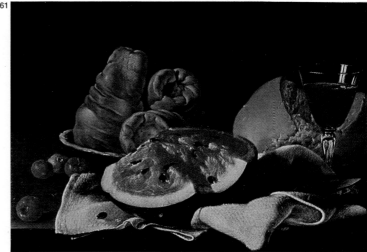

L. MELÉNDEZ Still Life

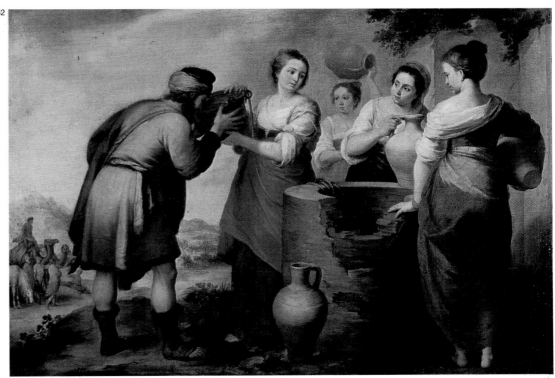

MURILLO Rebecca and Eleazar

Coello's *St. Dominic of Guzmán* continues the ascetic realism of Zurbarán (see nos. 55 and 56), while at the same time revealing Flemish influence, as well as that of the baroque movement which Rubens brought to Madrid. Coello was born in Madrid in 1642, and worked there until his death in 1693. Luis Eugenio **Meléndez** also lived and worked in Madrid until his death in 1780, having moved there from Naples in 1717. His *Still Life* with melon, bread and buns is a mid-eighteenth century work which still echoes the poetry of Flemish realism.

62 – 64. The golden age of Spanish painting in the seventeenth century comes to a close with the vigorous, down-to-earth realism of Bartolomé Esteban **Murillo**, the most famous representative of the Seville school of painting. He was born in Seville in 1618 and died there in 1682. The two great themes of Spanish art, mysticism and melancholy, are blended in his figures to produce a warm, sympathetic understanding of the spirit of ordinary people. He apparently went to Madrid in his youth and studied the works of Titian, Rubens and Van Dyck in the royal collections, and indeed his knowledge of their art is reflected in the warm colors and the elegant, flowing forms of his *Rebecca and Eleazar*. Both this work and *The Holy Family with a Bird* were painted when Murillo was about thirty, but the latter painting is closer in style to the purely Spanish realism of Ribera (see nos. 26 and 27) and to the taste for flowing robes that one finds in the work of Zurbarán (see nos. 55 and 56). There is nothing religious about this family group: it is just a working-class family from Seville. *The Good Shepherd* shows Christ as a child. It belongs to his mature period, and is a famous example of his skill at painting children. By this stage in his career his children are unmistakable, with their gentle but forceful features expressed with controlled emotion by means of a broad technique.

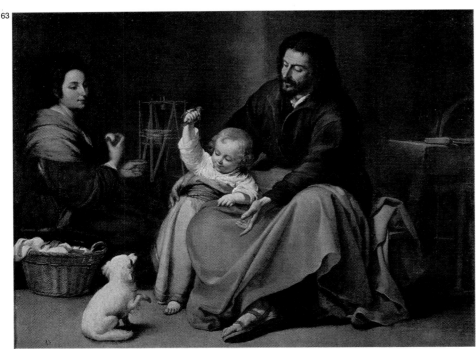

MURILLO The Holy Family with a Bird

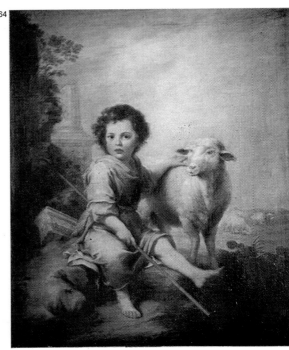

MURILLO The Good Shepherd

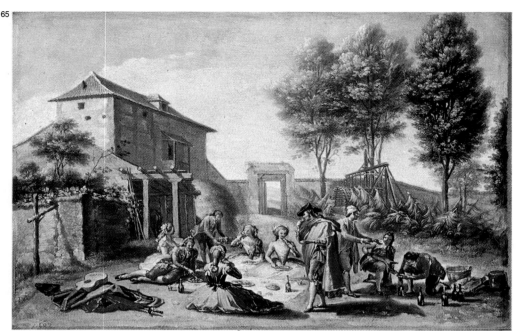

F. BAYEU A PICNIC IN THE COUNTRY

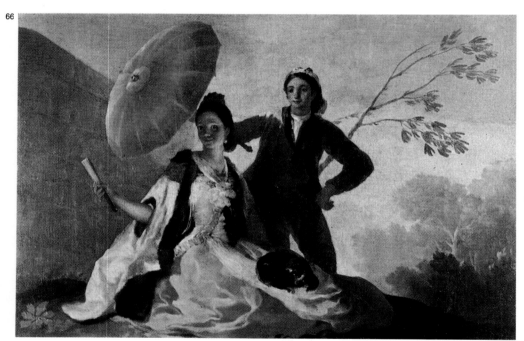

THE PARASOL

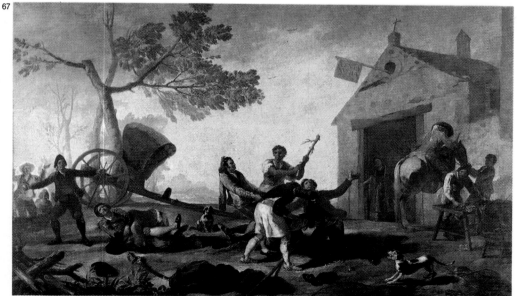

THE FIGHT AT THE 'VENTA NUEVA'

65. *A Picnic in the Country* is a tapestry cartoon by Francisco **Bayeu**, Goya's brother-in-law and predecessor at the Madrid tapestry works. The scene reflects the eighteenth century aristocratic taste for pastoral scenes.

GOYA

With the deeply disturbing art of Francisco Goya y Lucientes, the world of calm convictions created in the Renaissance now crumbles, and we enter the age of modern art. Goya was born not far from at Saragossa in 1746 and died at Bordeaux in 1828. Thus, from a strictly chronological point of view, he belongs to the age of transition from the eighteenth to the nineteenth century, when the ideal of pagan serenity offered by neoclassicism was already being attacked by the Romantics in the name of imagination and feeling. Nevertheless, his work projects him much further forward in time. The nightmarish quality of his witches' sabbaths is surrealistic rather than Romantic. His paintings in fact have the immediacy of a flash of lightning: a rapid impression of reality is re-expressed in a manner which scorns all the canons of beauty and so anticipates both Impressionism and Expressionism. He is a child of his age, and yet outside it at the same time. The tapestry cartoons of his early maturity have an essentially eighteenth century charm and whimsicality, but they are also neoclassical in their abstract search for an ideal world of joy — and modern, too, in their bold choice of lower class subjects. His history paintings go beyond Romantic patriotism. The French firing squad (see no. 86) conveys the inevitable consequences of violence, and the death of the Madrid patriots becomes a universal tragedy. His portraits do not just bear witness to a particular society. Although his subjects seem to gaze at the spectator, they are in fact gazing anxiously at themselves, in an invisible inner mirror. Because of the complexity of his art, Goya is a solitary and disturbing figure, standing at the gateway to our modern, troubled times. All painting that comes after him derives from him.

66 – 69. Over a period of seventeen years, that is to say between the ages of twenty-nine and forty-six, Goya produced at least sixty-three tapestry cartoons on canvas for the royal tapestry workshops, where he had been summoned to work at the request of the neoclassical painter Mengs (see no. 169), who was much in favour at court. The four cartoons illustrated here are among the best of those produced in the earlier part of this period. Their subject matter is drawn from the leisure pursuits of humble people, and they are full of joy, conveyed in a fresh and rapid style which is somewhat reminiscent of the frescoes by Tiepolo which Goya admired in the Royal Palace at Madrid. But Goya's tapestries brought the life of ordinary people into the royal palaces. Life is still full of elegance in *The Parasol*, but it is unruly in *The Fight at the "Venta Nueva."* (Both of these were painted in 1777.) It has the joy of sport in *Flying a Kite* and is full of gossip in *The Crockery Selles*, where the salesman displays to the ladies his wares from the well-known factory at Alcora.

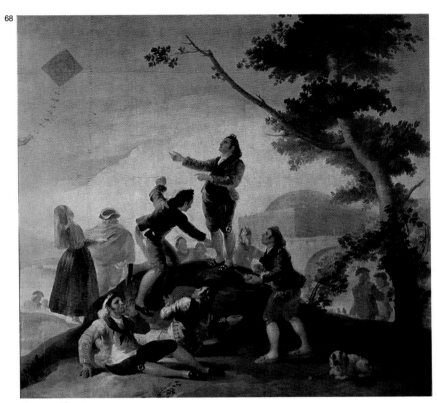

FLYING A KITE

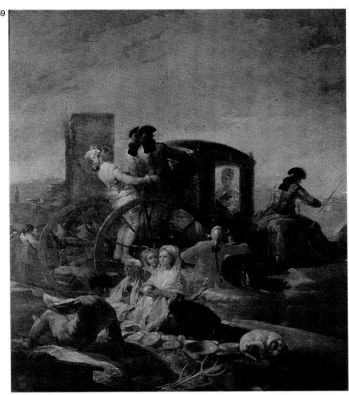

THE CROCKERY SELLER

70 – 72. In *The Flower Girls,* a girl is offering freshly gathered flowers to a young woman, while a mischievous servant tries to frighten her with a little rabbit. Like *The Grape Harvest,* in which **Goya** adopts a new broad technique, it was painted in 1786, the year in which Goya was appointed painter to the king. For six years he had given up supplying the tapestry workshops with cartoons, for he was upset at having to wait so long for this royal appointment. *The Injured Stonemason* belongs to the same period. Its unusual subject matter is evidence of new social interests on the part of Goya, and may perhaps constitute a tribute to Charles III, who issued a decree to assist those who were injured at their work.

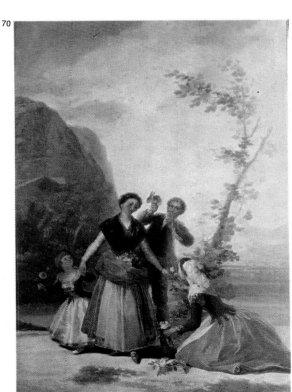

THE FLOWER GIRLS

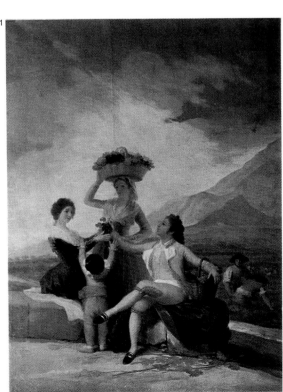

THE GRAPE HARVEST

THE INJURED STONEMASON

73

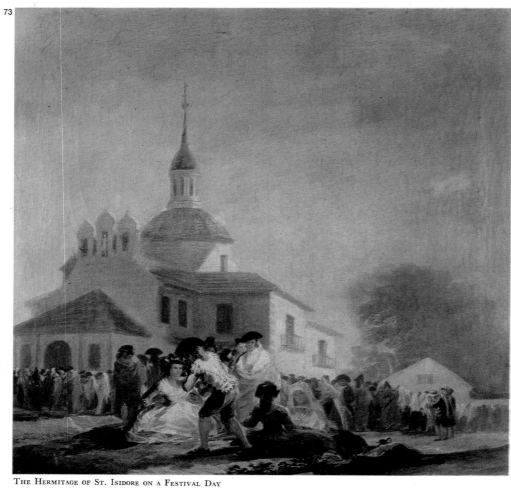

THE HERMITAGE OF ST. ISIDORE ON A FESTIVAL DAY

44

74

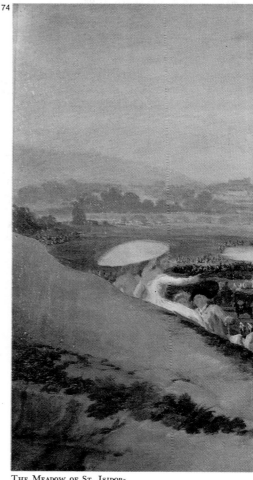

THE MEADOW OF ST. ISIDORE

75

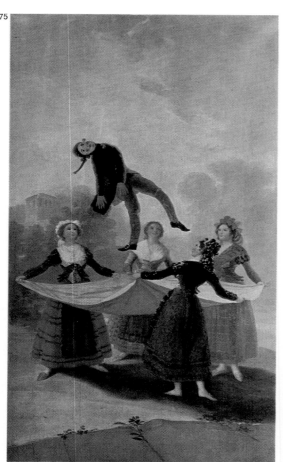

THE PUPPET

76

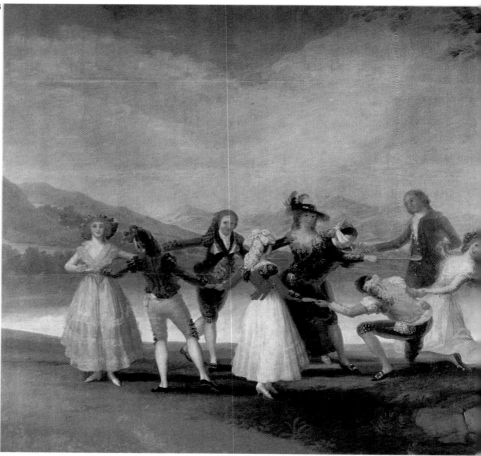

BLIND MAN'S BUFF 804

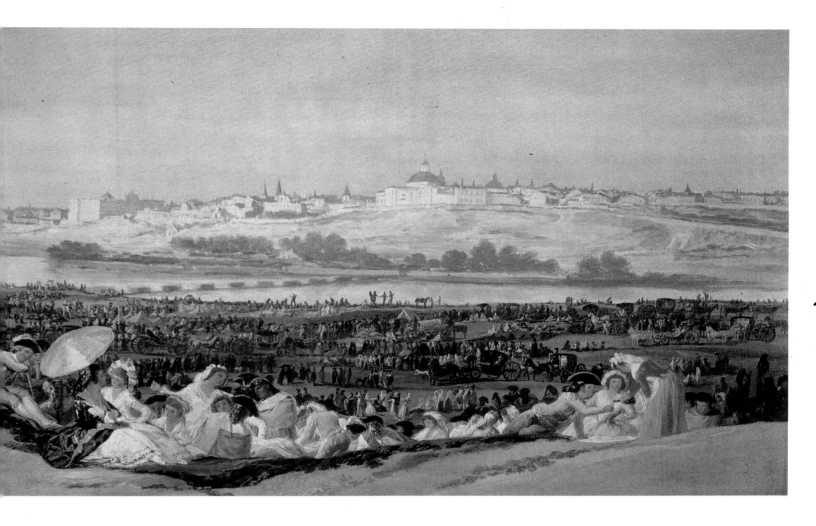

73 – 74. *The Hermitage of St. Isidore on a Festival Day* and *The Meadow of St. Isidore* were both painted in 1788 as tapestry sketches, but were never turned into cartoons from which the tapestry weavers would work. Both depict events on May 15, the feast day of St. Isidore, the patron saint of Madrid. The first is concerned with the pleasures of humble people, but the impetuous figures have all the dash of those painted by Watteau; the second goes beyond the picnic theme by presenting the first modern light-filled landscape, with a background which takes us beyond the River Manzanares to Madrid, with the Royal Palace on the left and the huge dome of the new church of San Francisco el Grande in the center. The painting is completely bathed in light. **Goya** foreshadows the experiments of the Impressionists by using a mixture of the pure colors of sunlight—those colors which were to play so important a part in modern "plein air" painting.

75 – 76. These two paintings belong to the years 1791-92, and are **Goya**'s last tapestry cartoons. In *The Puppet*, four young women are throwing a large straw doll up into the air; in *Blind Man's Buff*, some adults are playing a children's game. In this late stage of development of Goya's representation of gaiety, a note of irony creps: in eighteenth-century whimsicality and neoclassical elegance are crumbling as satire begins to bite.

77. *The Wandering Players* was painted before the end of the eighteenth century, and shows **Goya**'s interest in the sparkling improvisation of the "commedia dell'arte," which he may have encountered during an early visit to Italy. In this kind of theatrical performance, the actors made use of themes from the great Greek writer of comedies Menander, to whom reference is made here in the placard with the words "Aleg [oria] men [andrea]," held up by three little deformed creatures at the front of the stage. The performance is in the open air and includes the typical characters of the Italian "commedia dell'arte": Harlequin, Columbine, Pantaloon, the Doctor and a Dwarf.

77

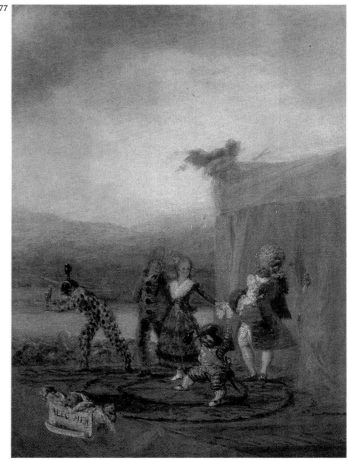

THE WANDERING PLAYERS

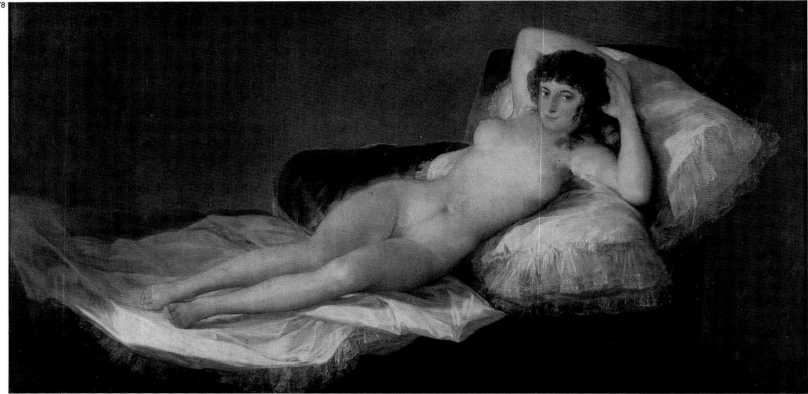

THE NAKED MAJA

78 – 79. According to legend, the model for *The Naked Maja* and *The Clothed Maja* (a "maja" is a lower-class girl of Madrid) was the Duchess of Alba, who was a patron of **Goya**, and with whom he is said to have been in love. But the lady who appears in these two famous paintings does not look at all like the Duchess of Alba. In any case, she died in 1802, whereas the paintings reflect the rich technique used by Goya in works of about 1805 – a time when other paintings of reclining beauties appear among his works. The maja's pose is reminiscent of that of Venus in Velázquez's *The Toilet of Venus*, then the property of the Duchess of Alba and now in the National Gallery in London. Since

nudes were prohibited in those days, it is likely that the unknown gallant who commissioned the two paintings intended to keep them in a common kind of double, hinged frame, whit the clothed figure in front and the nude figure behind, the latter to be revealed on appropriate occasions. Both are the same size (we know at least that they found their way into the collection of Manuel Godoy, the extremely powerful minister of Charles IV, who is not necessarily to be regarded as the commissioner.

80. **Goya** began painting portraits when he was about thirty-seven. He was fifty-four when he painted *The Family of Charles IV of Spain.*

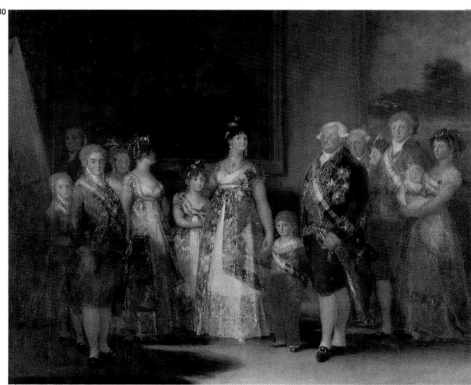

THE FAMILY OF CHARLES IV OF SPAIN

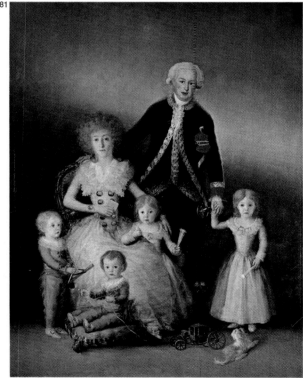

PORTRAIT OF THE DUKE AND DUCHESS OF OSUNA AND THEIR CHILDREN



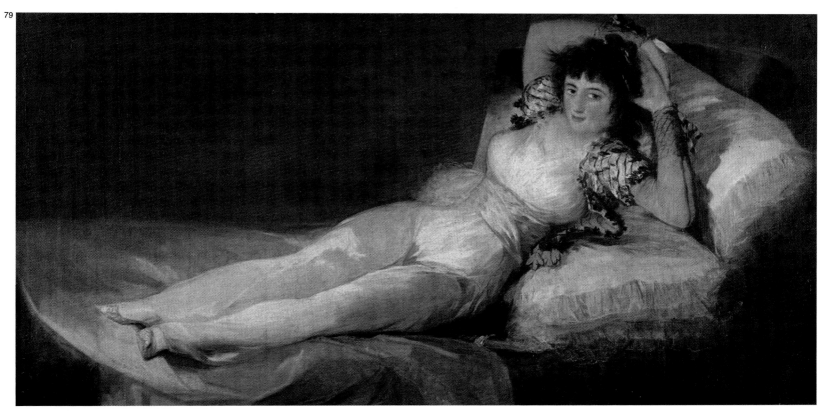

THE CLOTHED MAJA

Various sketches for his great painting are preserved in the Prado. At the center stand King Charles IV and Queen Maria Luisa, surrounded by their children, grandchildren and other relatives. On the left is their eldest son Ferdinand, later to become Ferdinand VII, with his wife at his side, but the latter has her head turned so that her features cannot be distinguished, for when the portrait was painted no bride had yet been chosen for the heir to the throne. Behind these two Goya has placed himself. In spite of the forceful realism of the painting, Goya has depicted the faces of his subjects as disturbing, enigmatic masks by superimposing a number of very thin layers of paint.

81 – 82. The elegant and delicate style of the *Portrait of the Duke and Duchess of Osuna* and *Their Children* and of the *Portrait of Doña Tadea Arias de Enríquez*, painted by **Goya** in 1790 and 1794, is reminiscent of the tapestry cartoons of the same period (see nos. 75 and 76).

83 – 84. This powerful *Self-Portrait* shows **Goya** at the age of about seventy. When he painted *The Milkmaid of Bordeaux* he was over eighty and had been living in voluntary exile in France since 1824. The painting may be a fragment, for it is probable that the whole canvas showed the milkmaid on a horse. It is a striking picture of a humble girl with her jug of milk, and shows a revival of Goya's early interest in people of the classes, while its ability to seize an impression and compose a single image out of many elements make it a precursor of the Impressionism of fifty years later.

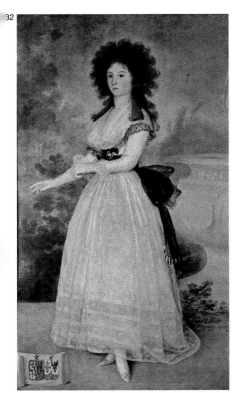

PORTRAIT OF DOÑA TADEA ARIAS DE ENRÍQUEZ

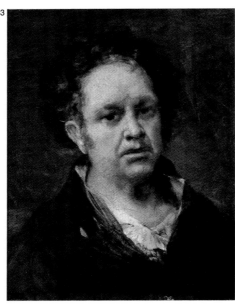

SELF-PORTRAIT

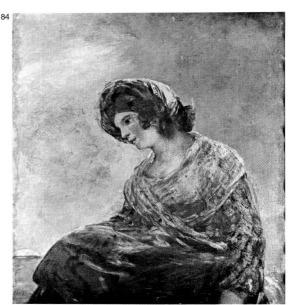

THE MILKMAID OF BORDEAUX

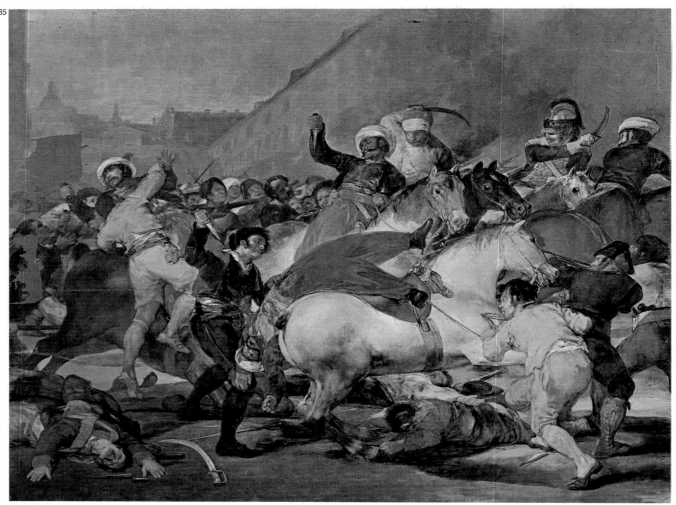

THE CITIZENS OF MADRID FIGHTING MURAT'S CAVALRY, 2nd MAY 1808

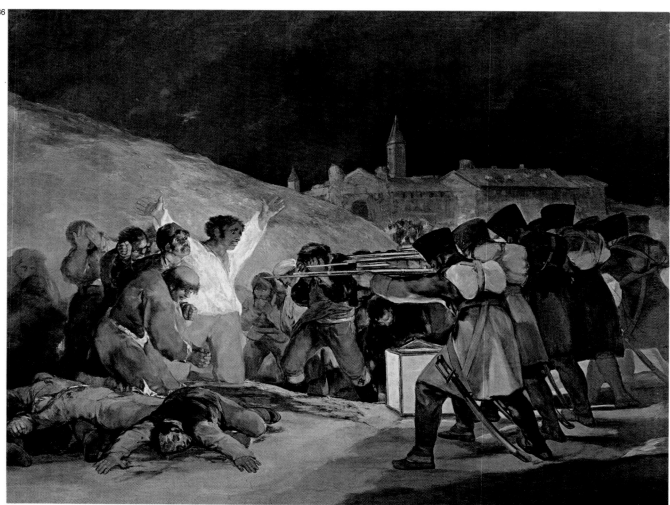

THE EXECUTIONS OF 3rd MAY 1808

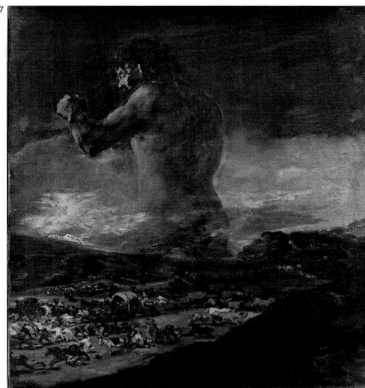

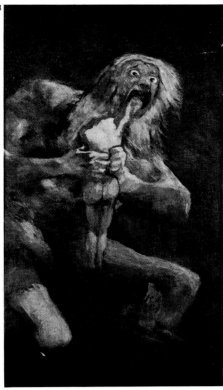

THE COLOSSUS

SATURN DEVOURING ONE OF HIS SONS

85 – 86. These two paintings were commissioned from **Goya** in 1814 by Ferdinand VII after the French had been driven out of Spain and the House of Bourbon had been restored to the throne. They constitue a powerful and harshly impressive re-evocation of the heroic struggle against Napoleon's troops in Madrid six years earlier. In *The Citizens of Madrid Fighting Murat's Cavalry, 2nd May 1808*, we see the ordinary people of the city fighting against troops which the French had recruited in Egypt, and the figure of a cavalryman of the Imperial Guard can be distinguished among them. *The Executions of 3rd May 1808* shows the patriots who had been arrested during the previous day's fighting being shot by the French. It is one of the most powerful achievements in the history of painting.

87 – 89. In these disturbing paintings **Goya** is probing not the real world, but an unseen world from which he derives ambiguous and troubled images. *The Colossus*, also known as *Panic*, may perhaps refer to the bewilderment of the Spanish people as a result of the events of 1808. It shows a crowd of people fleeing in terror at the sight of a terrible giant who looms up from amid the mountains. The other two works belong to a group known as the "Black Paint-

ings" because of their dark colors and the sinister nature of their subject matter. The group consists of fourteen wall paintings (now on canvas) which Goya, now a sick and disillusioned man, painted over a period of four years to decorate the country house on the banks of the Manzanares which he had bought in 1819. The house was commonly known as the "quinta del sordo" (the house of the deaf man), but this name may well have nothing to do with the fact that Goya had become deaf at the age of forty-six. The painting of *Saturn Devouring One of his Sons* is similar in subject matter to a painting by Rubens which Goya saw in the Royal Palace and which is now in the Prado. It illustrates the grim myth of Saturn or Kronos (Time) devouring his children (the Days). *The Witches' Sabbath* shows Asmodeus, the demon of marital incontinence (represented as a woman), carrying off a terrified man into the hills, while in the distance bands of armed men are fighting. The meaning of this and other paintings in the same group is not clear. However, what is clear is that the world represented in Goya's demoniac visions is not an infernal one but the macabre, "black" reality which nudges the shoulder of all men.

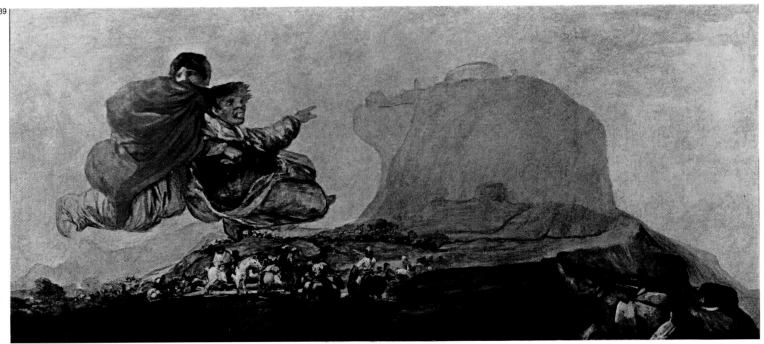

THE WITCHES' SABBATH

ITALIAN ARTISTS

90. The work of the Florentine artist **Fra Angelico** blends the freshness and naïveté of the "primitives" (with their sparking color and meadows like Gothic tapestries) with a Renaissance understanding of perspective and volume. Until his death in 1455, Fra Angelico was a friar and an active painter in the monastery of San Marco in Florence, and it is within the walls of the monastery that he sets the scenes of his religious paintings. *The Annunciation*, illustrated here, was painted for his fellow Dominicans at Fiesole when he was about thirty. The scene of the banishment of Adam and Eve from the Garden of Eden in the background is intended to remind man of his fall, which Christ will come to redeem. In the predella are a number of scenes from the life of the Virgin, namely: The Birth and Marriage of the Virgin, The Visitation, The Epiphany, The Purification in the Temple and The Death of the Virgin.

91 – 93. Sandro **Botticelli** was born in Florence in 1445 and died there in 1510. *The Story of Nastagio degli Onesti* is inspired by a well-known Fourteenth Century story from Boccaccio's *Decameron*. Lorenzo the Magnificent was Botticelli's patron, and he introduced into the Florence of Lorenzo's day a new kind of art in which the robust

FRA ANGELICO THE ANNUNCIATION

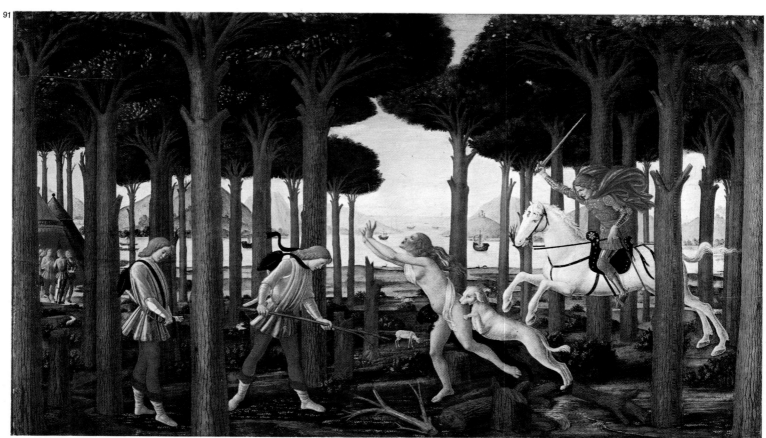

BOTTICELLI THE STORY OF NASTAGIO DEGLI ONESTI (Scene I)

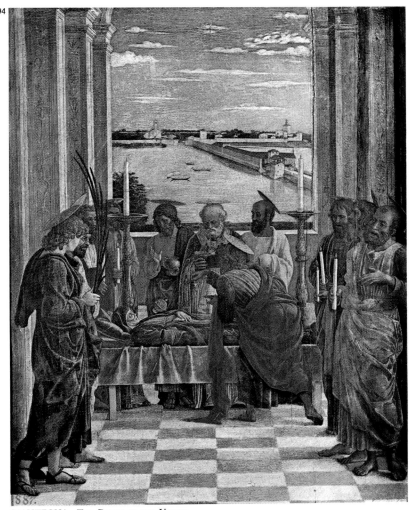

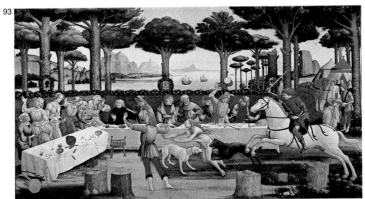

realism of the early fifteenth century has given way to elegant and sinuous forms with a rhythmic, musical vibrancy. In the first scene young Nastagio is seen wandering through the pine wood near Ravenna. He is sad because his love for his lady is unrequited, and he has a terrifying vision of a woman pursued by the lover whom she scorned: after the suicide of the lover and the death of the woman, they were condemned to come forth from Hell every Friday and enact the terrible scene which ends with the woman being torn apart. Thus the second scene shows the lover catching the woman, tearing out her heart and throwing it to the dogs. In the third scene Nastagio has invited his lady and her family to a banquet at the spot where he had seen the vision. The vision recurs and Nastagio explains its meaning. His lady is perturbed at this and sends a maidservant to him to say that she accepts his love (this episode is on the right in the background). A fourth scene showing the final wedding is in a colletion in London.

94. Andrea **Mantegna** was responsible for bringing Renaissance art to Padua, but when he painted *The Death of the Virgin* at the age of about thirty, he had recently moved to Mantua to take up service with the Gonzaga family. This painting was intended to be placed, along with others, in the chapel of the Castello di San Giorgio, and the scene is set in the castle itself. Mantegna was a keen student of antiquity, and his figures are draped like antique statues. Their hard, incisive and expressive faces are almost like pieces of sculpture, and the architecture recalls that of Greece and Rome. There is a wonderful sense of perspective in the painting, underlined by the regular pattern of the floor, the receding line of pilasters and the landscape with its very high horizon.

95. This expressionistic painting of *The Dead Christ* is related to the dramatic 'close-up' figures in the Pietàs of the Venetian artist Giambellino, and to the grief-stricken figures of Mantegna. It was painted in 1475-76 in Venice by **Antonello da Messina.** The strong colors, intense pathos and minute details echo the Flemish art which Antonello had admired in Sicily and Naples, and which inspired him to paint in oils.

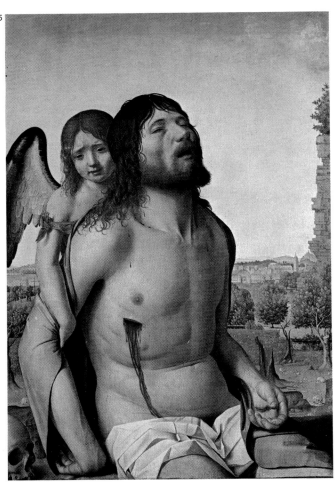

51

MANTEGNA The Death of the Virgin

BOTTICELLI The story of Nastagio degli Onesti (Scene II)

BOTTICELLI The story of Nastagio degli Onesti (Scene III)

ANTONELLO DA MESSINA The Dead Christ

96 – 97. In these two paintings **Raphael** conveys the ideals of Renaissance classicism. The groups of figures stand out strongly from the space within which they are situated, and while their solid and pure forms are derived from geometrical shapes (circles, ovals and pyramids), the gently rhythmic curves and harmonious colors lend them considerable human warmth. *The Holy Family* is an early work, painted in Umbria in 1507, and it conveys a strong sense of emotion, whereas in the *Madonna del pesce*, which was painted in Rome about eight years later (Raphael was to die in Rome in 1520 when he was just thirty-seven), the figures have a sublime and classical tranquility without losing their human warmth. One can see this not only in the Madonna and Child but also in the figure of St. Jerome with the Book of Tobit from his own translation of the Bible, and in that of young Tobias, who offers the Virgin a fish whose gall has medicinal properties. Tobias had caught the fish with the aid of the Archangel Raphael in order to cure the blindness of his father, Tobit. The painting may in fact be a votive offering for recovery from a disease of the eyes.

98. Late in 1508 **Raphael** moved from Florence to Rome to decorate Pope Julius II's new apartments in the Vatican, known as the "Stanze," and it was soon after his arrival in Rome that he painted this *Portrait of a Cardinal*. It offers a spiritual image with solid but soft forms and a harmonious pyramidal composition. The man represented has the typical aquiline nose of the Este family and may perhaps be Ippolito d'Este, son of Ercole I of Ferrara. On the other hand, he has a certain resemblance to Bandinello Sauli, a cardinal at the court of Julius II. Sauli was a turbulent man who contributed to the election of Pope Leo X, but later conspired against him and died in prison.

52

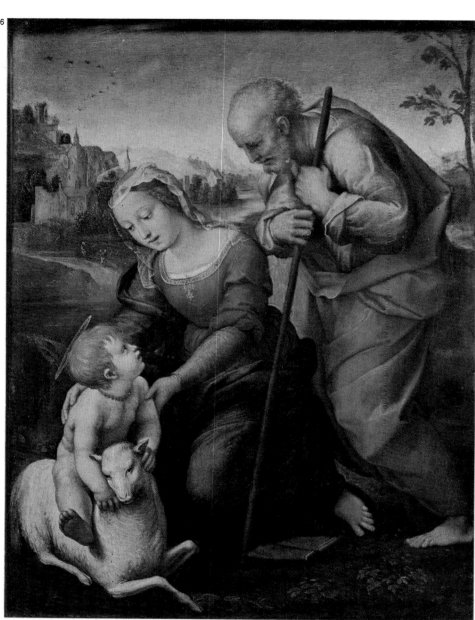

RAPHAEL THE HOLY FAMILY

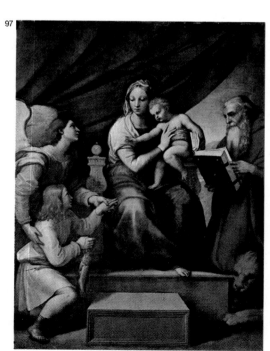

RAPHAEL THE MADONNA DEL PESCE

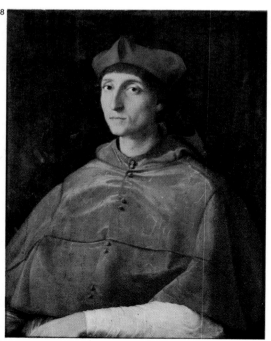

RAPHAEL PORTRAIT OF A CARDINAL

90 – 100. The *Portrait of Don García de' Medici* by the Florentine artist Agnolo **Bronzino**. It depicts the son of Cosimo I, Grand Duke of Tuscany, and Eleanor of Toledo as a boy of three or four (he was born in 1547). The calm and untroubled classical beauty of Raphael here acquires a more anxious and melancholy tone, as the "bella maniera" turns into "mannerism." On the other hand, *The Madonna della Scala* still has a sober classicism in the pyramidal group of figures, which acquire additional elegance from the delicate color tones, reminiscent of Leonardo da Vinci. The painting is by **Andrea del Sarto** (born 1486, died 1530), another Florentine artist, and the greatest successor to Raphael and Leonardo. He painted it when he was about thirty-six, and it is thought to allude to the confirmation by Christ of the authenticity (often denied) of the Book of Tobit. Tobit is sitting on the left, and the Archangel Raphael is on the right with the book.

101. The *Noli me tangere* tells the story, from St. John's Gospel, of Christ's meeting with Mary Magdalene after the Resurrection. She mistakes him for the gardener from the place where the tomb is situated, and Christ thereupon reveals his identity, commanding her not to touch him nor remain prostate at his feet, but to hurry to warn the Disciples of his coming ascent to the Father. The scene is intensely dramatic, making full use of the kind of solid, active figures that one finds in the work of Raphael and Michelangelo, as well as the subtle use of color to be found in Leonardo da Vinci. It was painted by Antonio Allegri, known as **Correggio** after the small town where he is thought to have been born in 1489 and where he died in 1534. He was about twenty-eight when this picture was painted. Correggio is the most important Renaissance artist from Emilia, and worked chiefly at Parma, being particularly skilful in portraying nobly expressive glances and gestures as well as softly modeled and delicate figures.

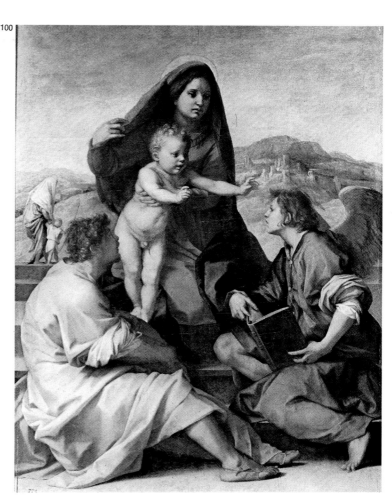

ANDREA DEL SARTO THE MADONNA DELLA SCALA

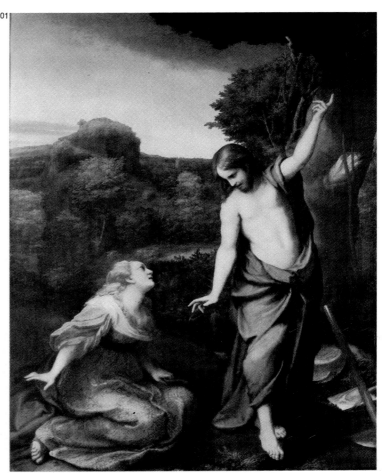

CORREGGIO NOLI ME TANGERE

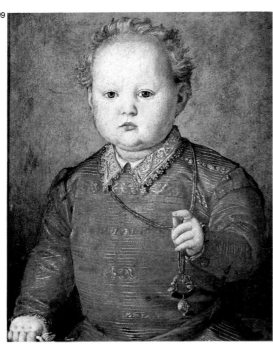

BRONZINO PORTRAIT OF DON GARCÍA DE' MEDICI

53

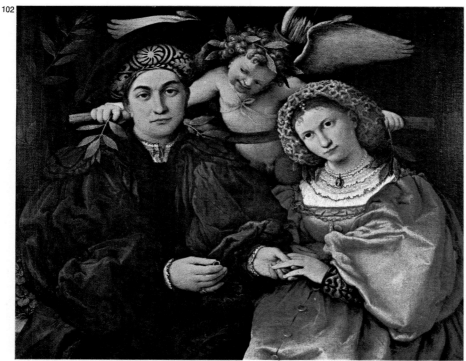

LOTTO PORTRAIT OF MESSER MARSILIO AND HIS WIFE

102. The *Portrait of Marsilio and his Wife*, in which a cupid imposes the yoke of matrimony upon the couple's shoulders, was painted by Lorenzo **Lotto** at Bergamo in 1523. It shows a typically Venetian brilliance of color, combined with a subtle psychological penetration of a kind which takes Lotto away from classicism. Since he could not compete successfully with Titian in Venice, he worked at Bergamo and in the Marche, and died at Loreto in 1556 at the age of seventy-six, having become a lay brother at the Holy House there.

TITIAN

Tiziano Vecellio became the favorite painter of the Venetian Republic and of Charles V and Philip II of Spain. He was born at Pieve di Cadore, but moved to Venice while still a child, and his contribution to Venetian art spans the whole of the sixteenth century up to the time of his death in 1576 at the age of about eighty-six. His painting is all color and light, and develops further the poetic tones of his predecessor Giorgione. He constructs his paintings in color and builds up his figures by blending color with light, thus creating a classically serene world, a sort of Venetian Olympus, in which the figures have a new kind of carnality. This new relationship between color and light created by Titian was to lead to the dramatic flashes of light in the work of Tintoretto and the bright color harmonies of Veronese.

103–105. These three noble but very human portraits were painted by Titian at Augsburg (where he had been invited by Charles V in 1548) at the time of the Imperial Diet, held a year after the victory over the Protestants at Mühlberg. He took six months to paint the *Portrait of the Emperor Charles V on Horseback*, and Charles V insisted on his painting a companion portrait of his wife, although she had died ten years earlier. Hence the *Portrait of the Empress Isabella of Portugal*. The *Portrait of Philip II of Spain* was painted in 1551, before Philip came to the throne, and

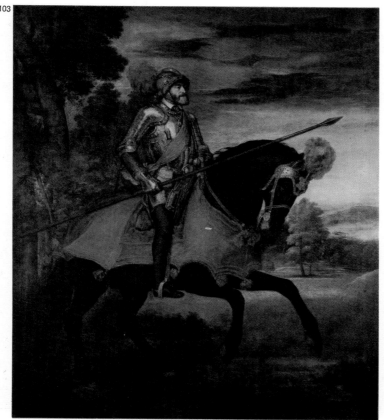

PORTRAIT OF THE EMPEROR CHARLES V ON HORSEBACK AT MÜHLBERG

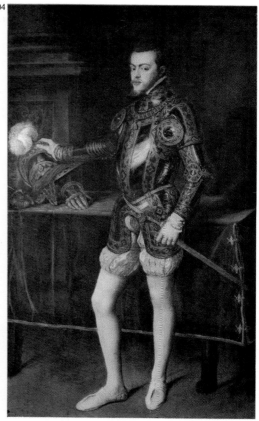

PORTRAIT OF PHILIP II OF SPAIN

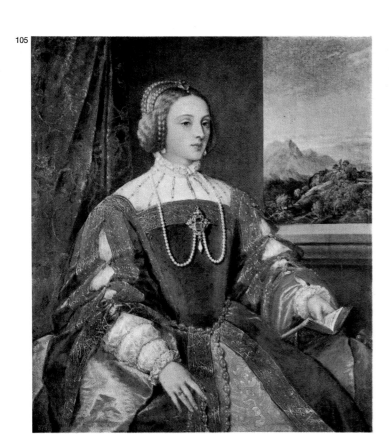

PORTRAIT OF THE EMPRESS ISABELLA OF PORTUGAL

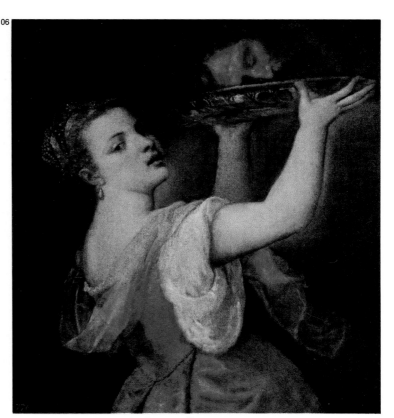

SALOME WITH THE HEAD OF ST. JOHN THE BAPTIST

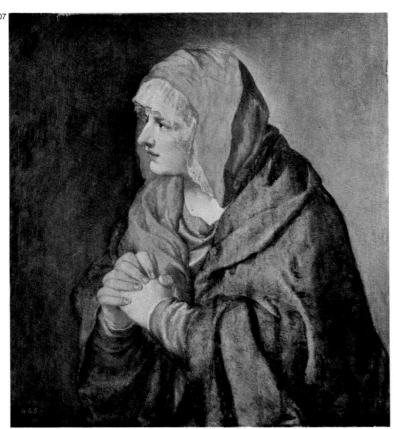

THE MADONNA OF SORROWS 443

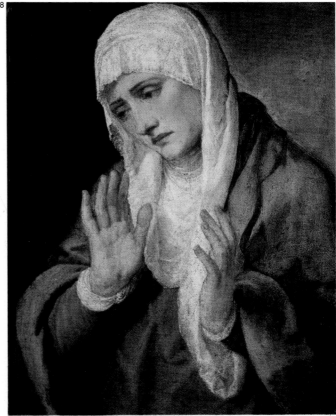

THE MADONNA OF SORROWS 444

was used to show Queen Mary of England the physical appearance of her husband-to-be. The armor which the two kings are wearing in the portraits is still preserved in the Royal Palace at Madrid.

106 – 108. These three powerful paintings are to all intents and purposes portraits, painted with all the vigorous impasto that one finds in Titian's mature works. *Salome with the Head of St. John*

the Baptist was finished when he was about seventy, and his daughter Lavinia is supposed to have acted as a model. Charles V received *The Madonna of Sorrows* (107) from Titian at Augsburg in 1550, and after his abdication he took it with him to his retreat at Yuste. *The Madonna of Sorrows* (108) was painted in 1554 for Maria of Hungary, Charles' sister.

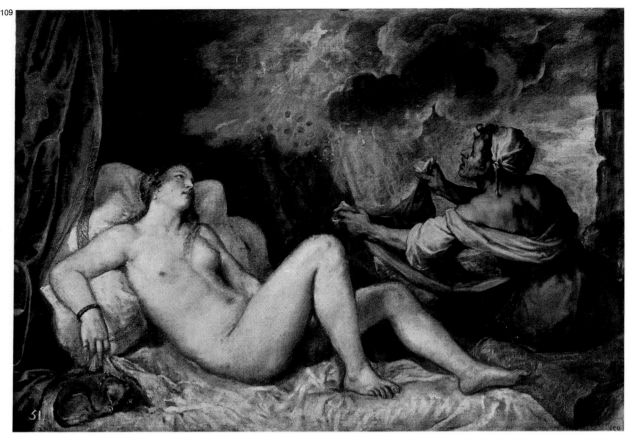

DANAE AND THE SHOWER OF GOLD

109 – 110. Almost all **Titian**'s mythological paintings and nudes were commissioned by Philip II, and they were called "poesie" ("poems") in order to distinguish them from portraits and religious paintings. In a letter of 1553, Titian promised Philip II that he would send without delay the two "poems" illustrated here, but Philip did not receive the second one until the next year. *Danae and the Shower of Gold* flashes with color and light throughout. Jupiter is hidden in the shower of gold, and the rich, fleshy figure of Danae is contrasted not with the usual Cupid, but with the realistic figure of an avaricious old serving woman who is trying to gather up some of the gold coins. *Venus and Adonis* is painted in broader areas and is full of dramatic con-

trasts. It illustrates the moment when Venus tries to prevent her young lover from setting off for the hunt during which he is to lose his life.

111. **Titian**'s *Adam and Eve* is a much later work than the two preceding paintings. It was painted when he was over seventy, but it may be that he was in fact finishing a work which had been started some years earlier, because the classical solidity of the figures recalls his early period. It is likely that he found inspiration in a well-known engraving by Dürer, which would help to explain a certain incisive hardness about the two figures. With a pagan refinement of imagination, Titian represents Lilith, Eve's tempter, as half serpent and half cupid.

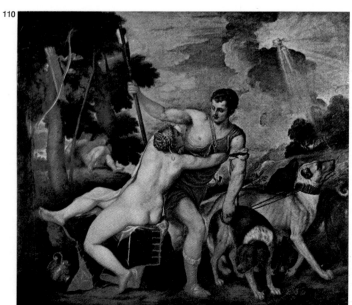

VENUS AND ADONIS

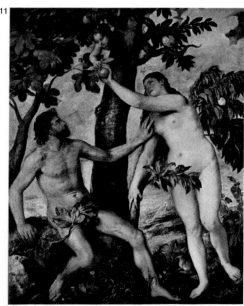

ADAM AND EVE

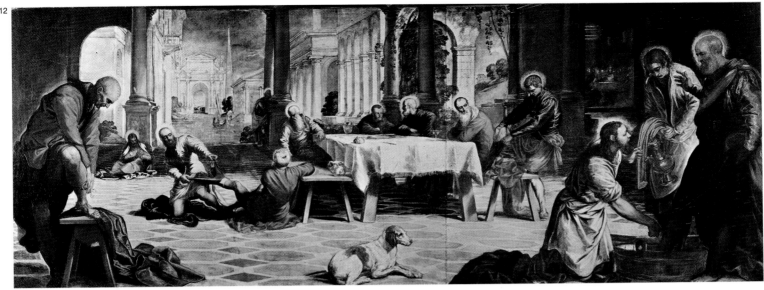

TINTORETTO Christ Washing the Apostles' Feet

TINTORETTO Susanna and the Elders

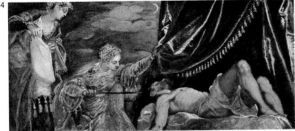

TINTORETTO Judith and Holofernes 389

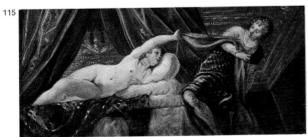

TINTORETTO Joseph and Potiphar's Wife

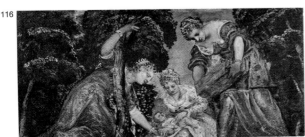

TINTORETTO The Finding of Moses

112. **Tintoretto** painted *Christ Washing the Apostles' Feet* in 1547, when he was twenty-nine. The nervous intensity of its use of light can be described as mannerist, but this is combined with an approach to architecture and perspective which is classical. The scene depicts Christ washing St. Peter's feet before the Last Supper as a sign of humility, while the other Apostles take off their stockings as they await their turn. Judas can be seen on the extreme left, without a halo.

113 – 116. **Tintoretto** was influenced by the delicate color tones of Veronese when at thirty-eight he painted these very foreshortened pictures of *Susanna and the Elders*, *Judith and Holofernes*, *Joseph and Potiphar's Wife* and *The Finding of Moses*. They were used to decorate a ceiling in Venice.

117. **Veronese** came to Venice from Verona in 1553 at the age of twenty-five, and brought with him a delightfully fresh style of painting. He was about forty when he painted *The Finding of Moses*, in which Pharaoh's daughter is rescuing the child from the water of the Nile. What we actually see, however, is a group of elegant Venetian ladies, complete with their maids, a Negro servant and a dwarf.

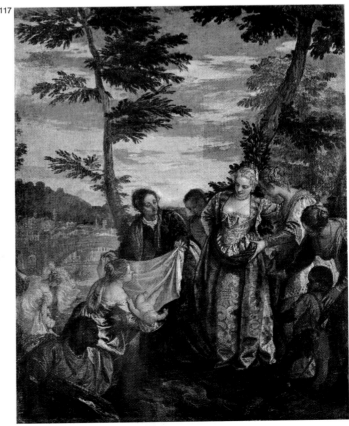

VERONESE The Finding of Moses

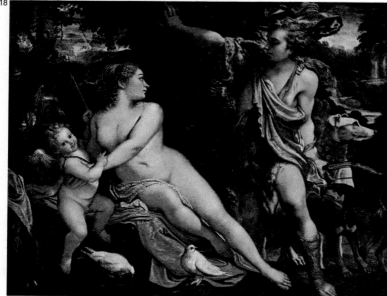

ANN. CARRACCI Venus, Adonis and Cupid

58

118. Once seventeenth century artists had abandoned mannerist pathos and Counter-Reformation piety, they began once again to examine the real world, at the same time making use of the lessons they had learned from the great classical artists of the Renaissance. This new art flourished chiefly in Bologna, Rome and Naples, and proved very popular with the kings of Spain. Its chief exponent in Bologna was Annibale **Carracci**, who was born there in 1557. He painted this *Venus, Adonis and Cupid* when he was about thirty-five, and one can see reflected in it the rich classical art of Venice, though now expressed with the darker tones typical of the seventeenth century.

119 – 120. *The Birth of St. John the Baptist* was painted in Naples about 1635 as Artemisia **Gentileschi**'s contribution to a series of scenes from the life of St. John the Baptist for the new Buen Retiro Palace in Madrid. The painting has sharply defined classical qualities, and the play of artificial light, which the artist had learned from Caravaggio, here acquired a more delicate touch. Caravaggio also influenced Artemisia's father, Orazio **Gentileschi**, who was born in Pisa and was particularly active in Rome. *The Finding of Moses* is a typical mature work of his, and the group of figures is depicted with Tuscan clarity and solidity. In 1633 he sent the picture to Philip IV from England, where he was employed at court and where he died in 1639 at the age of seventy-six.

121. The colorful and realistic *Portrait of a Lady with a Dove* was once thought to be a self-portrait of Artemisia Gentileschi, but it is now attributed to **Cecco del Caravaggio**, a French artist and imitator of Caravaggio. It may have been painted on the occasion of a marriage, and may be a companion piece to a portrait of a young man with a rabbit, painted in a similar style, which is now in the Royal Palace at Madrid. Both doves and rabbits were in fact used as symbols of love.

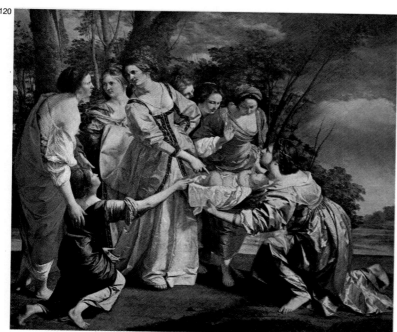

A. GENTILESCHI The Birth of St. John the Baptist

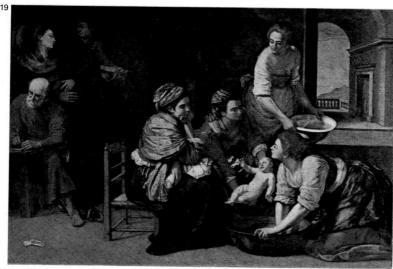

O. GENTILESCHI The Finding of Moses

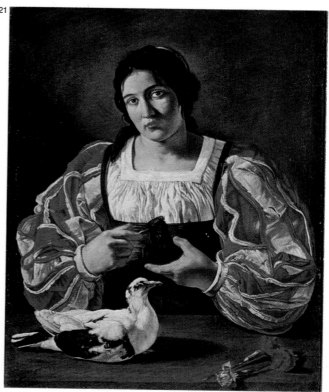

CECCO DEL CARAVAGGIO Portrait of a Lady with a Dove

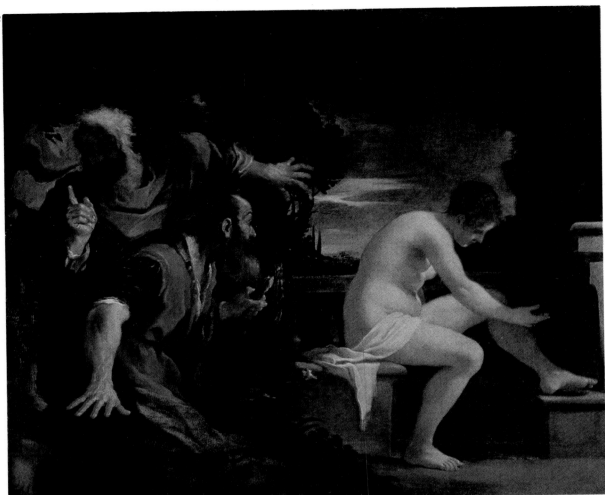

122 – 123. *Susanna and the Elders* is an excellent early work by **Guercino**, painted, when he was twenty-six (along with other biblical scenes) for the Bishop of Bologna. The painting is suffused with light, and is an example of a different kind of art from the consummate classicism of Guido Reni which then held sway in Bologna. It was only when Reni died in 1642 that Guercino, now fifty-one, could bring his dramatically light-drenched art from his native Cento to Bologna. Guido **Reni** was born in Bologna in 1575 and worked chiefly in Rome. *Hippomenes and Atalanta* is a typical work of his in its elegance of form. On the advice of Aphrodite, Hippomenes has thrown down some golden apples which Atalanta stops to pick up. She thereby loses the race and must marry Hippomenes. This painting was recently discovered in the Prado cellars. There is a version at the Capodimonte Gallery in Naples.

GUERCINO SUSANNA AND THE ELDERS

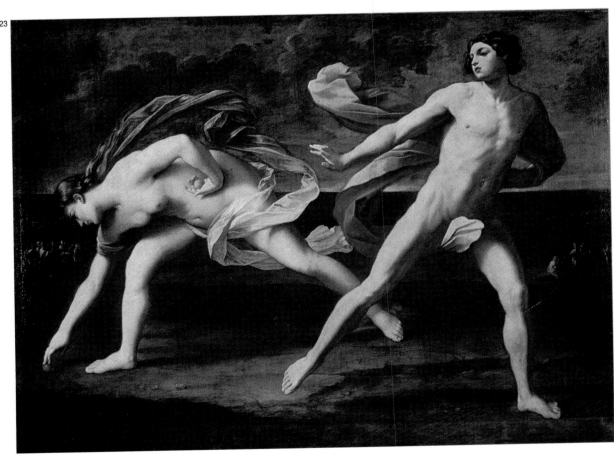

RENI HIPPOMENES AND ATALANTA

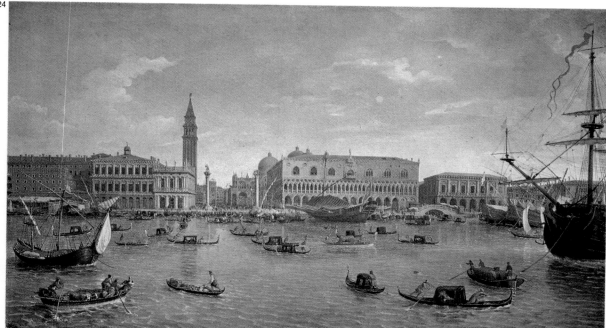

VAN WITTEL Venice, from the Island of San Giorgio

GIORDANO The Dream of Solomon

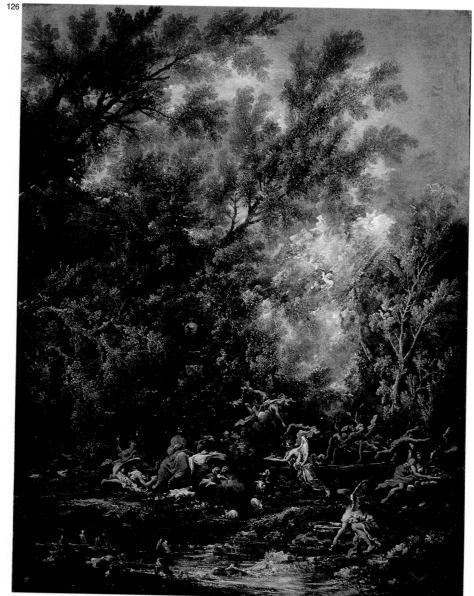

MAGNASCO Christ Accompanied by Angels

124. Eighteenth century Italian Painting is dominated by the serene and monumental vision of Tiepolo, and by those splendid views of Venice which proved so popular because every foreign visitor wanted to take away with him a souvenir of that fascinating city. *Venice, from the Island of San Giorgio*, with the expanse of the Bacino di San Marco in the foreground, can be rightly regarded as the masterpiece by Gaspar **Van Wittel**, a Dutch painter from Rome, who painted it in 1697, when he was forty-four. It was he who introduced the fashion for sweeping views of Venice and its lagoon, and his son Luigi, known by the Italianized name of Vanvitelli, became an important architect.

126. Alessandro **Magnasco** was a Genoese artist who introduced a disturbing note into eighteenth century art. The small flickering figures and the bristling forest in his *Christ Accompanied by Angels* are rococo in origin, but the whimsical charm and rhythm of the painting give it a strangely bizarre character. Magnasco was born in Genoa in 1667 and died there in 1749, but his own dark style, with its flashes of light, was developed when he was learning to be an artist in Milan, then a bastion of the Counter-Reformation and full of romantic gloom.

125. *The Dream of Solomon*, with its view of the Temple in Jerusalem, is a late seventeenth century work which still retains a rich baroque opulence. It was painted by that exuberant Neapolitan artist, Luca **Giordano**. He was born in 1634 and during the period 1692 – 1702 was in the service of Charles II of Spain, where he was known as Lucas Jordán. He was also known as "Luca fa presto" ("Lightning Luca") because of the speed at which he worked; and indeed there are thousands of square yards of frescoed ceilings by him in Italy and Spain. This painting and others in the same series include the same scenes from the life of Solomon and David as those in the frescoes which Luca Giordano painted in the Church of the Escorial; and tapestries still preserved in the Royal Palace were designed from them.

127 – 128. Giambattista **Tiepolo** was a Venetian artist whose work reflects the bright harmonies of Paolo Veronese, and he brings the eighteenth century to a close with grandeur and serenity. He knew how to blend the human and the divine. The infinite spaces he depicted are the timeless heaven of God, and at the same time the cloud-flecked sky to be sen any day over the Venetian lagoon. His divine characters take human form and walk on the clouds in a quite natural way. Thus in *The Immaculate Conception*, the Virgin stands upright on the earthly sphere and crushes the serpent of temptation with her foot. Tiepolo had arrived in Madrid in 1762 at the age of sixty-six to vie with the German painter Mengs over the frescoes for the new Royal Palace, and he painted this canvas there in 1769. It was one of a number of altarpieces for the church of San Pascual at Aranjuez, but immediately after Tiepolo's death in 1770, Mengs managed to have them removed, and some were subsequently lost. Tiepolo's *Abraham and the Three Angels* is set in a solitary landscape, and is characterized by a more familiar, intimate style and a greater warmth of emotion.

61

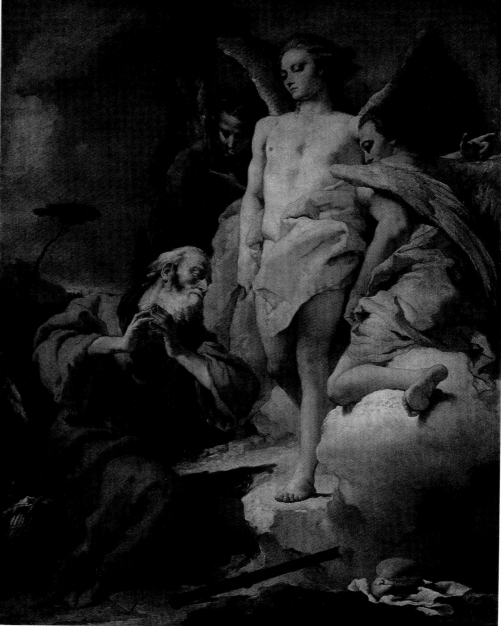

G. B. TIEPOLO THE IMMACULATE CONCEPTION

G. B. TIEPOLO ABRAHAM AND THE THREE ANGELS

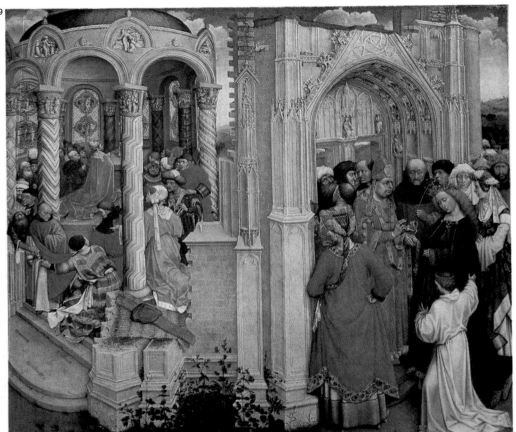

MASTER OF FLÉMALLE St. Barbara

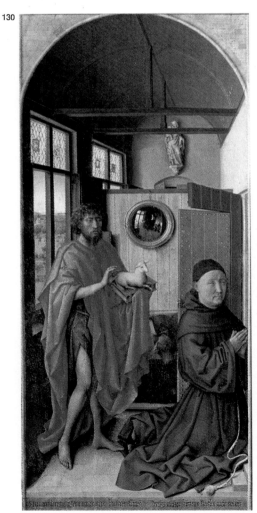

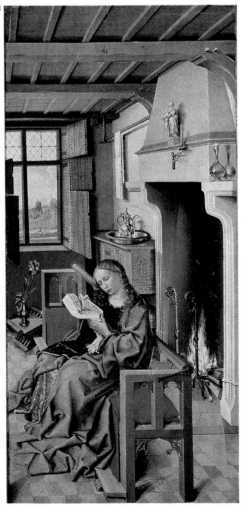

MASTER OF FLÉMALLE St. John the Baptist and
a Theologian

MASTER OF FLÉMALLE The Marriage
of the Virgin

FLEMISH AND DUTCH ARTISTS

129 – 131. The unidentified **Master of Flémalle** is the first great representative of the Flemish school. He is often identified with Robert Campin of Tournai and occasionally also with Van der Weyden in his early period, and on one hand he is a precursor of the Van Eyck brothers in his loving analysis of reality, and on the other of Van der Weyden in his intense expression of feeling. *The Marriage of the Virgin* is divided into two parts, each having its separate perspective. On the left is a round temple decorated with bas-reliefs in which a priest is seen praying, while the disappointed suitors whose twigs have failed to blossom stand all around him, and Joseph slips away, hiding from view the blossoming twig which designates him as the bridegroom. On the right is the wedding, set in the Gothic porch of Notre Dame du Sablon at Brussels, where all those present are wearing sumptuous contemporary costumes. The other two paintings, *St. John the Baptist and the Theologian Heinrich of Werl* and *St. Barbara*, are the wings of a triptych which was completed in 1438. Typical of the Master of Flémalle are the forceful, statuesque figures, and the interiors are rendered with striking efficacy and a profound sense of perspective. Heinrich of Werl was a theologian at Cologne; and the saint in the second picture has been identified as St. Barbara by the tower which can be seen through the window. This is the tower where, on account of her beauty, she was imprisoned by her father, who was subsequently responsible for her death and martyrdom. The iris and the jug of water with a bowl and towel are the symbols of her maiden's purity.

132 – 133. *The Deposition of Christ* and the *Triptych of the Redemption* are examples of the deep pathos to be found in the work of Roger **Van der Weyden**, born about 1399 at Tournai. His meticulous attention to detail, the careful Gothic folds of the draperies and the architectural elements in his paintings are accompanied by intensely expressive faces which introduce into Flemish art a dramatic note, destined to have a considerable following. No one has painted more expressively than he the tears flowing from the eyes of the women. *The Deposition of Christ* is one of Van der Weyden's most famous paintings and belongs to his early maturity, being painted, that is to say, when he was about thirty-five. The group of figures is set in a mock frame and gives the impression of being a piece of religious sculpture. The *Triptych of the Redemption* was painted during the period 1455 – 1459, five years before the artist's death. It is set in mock portals with statues in niches. The central panel depicts *The Crucifixion* and the scene is set at the entrance to a Gothic church.

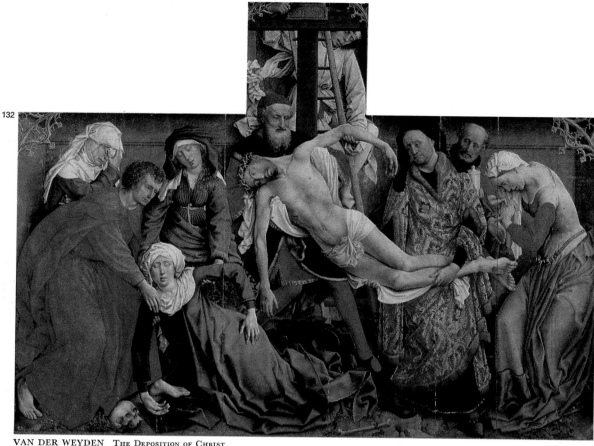

132

VAN DER WEYDEN The Deposition of Christ

Under baldacchini set alongside the Gothic arch are scenes from the Passion of Christ, while above the pilasters are represented the sacraments (Baptism, Confirmation and Ordination on one side, and Marriage, Penitence and Extreme Unction on the other), and at the altars behind St. John are Communion and the Elevation of the Host. The right-hand wing shows Adam and Eve expelled from the Garden of Eden. At the back is the Temptation, and along the Gothic arch are scenes from the Creation. In the top corners are God the Creator and the creation of Eve. The left-hand wing shows the Last Judgment; at the bottom can be seen the Resurrection of the Flesh and the Separation of the Just and the Wicked. Along the Gothic arch are six works of mercy. In the top corner is the seventh work of mercy.

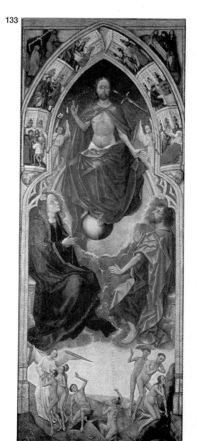

133

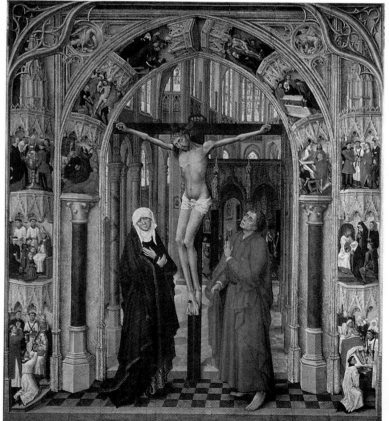

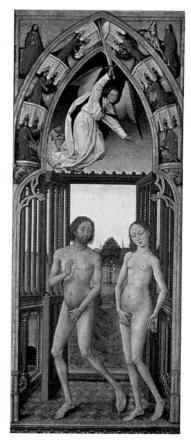

VAN DER WEYDEN Triptych of the Redemption

134

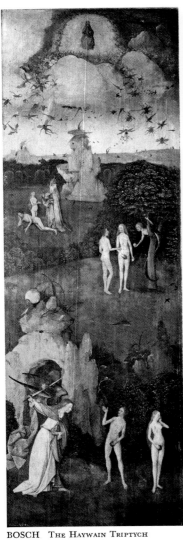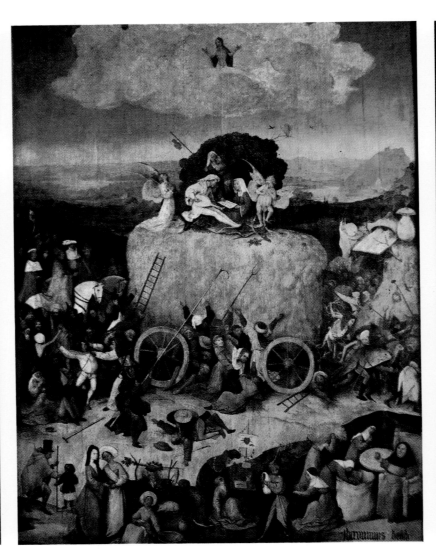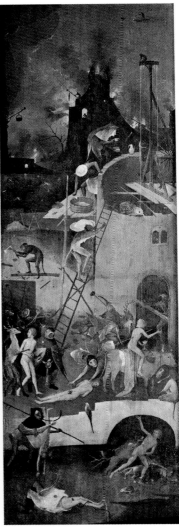

BOSCH The Haywain Triptych

135

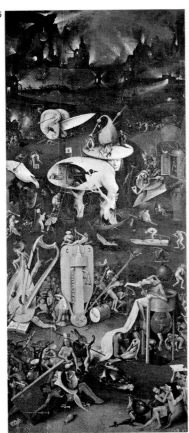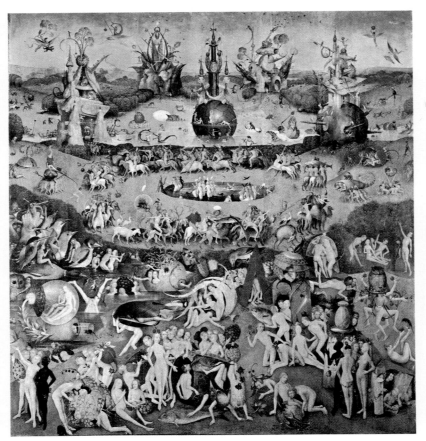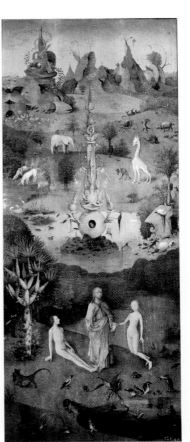

BOSCH The Garden of Delights Triptych

134 – 135. Hieronymus **Bosch** of s'Hertogenbosch (Bois-le-Duc) was active in his native town from the end of the fifteenth century until his death in 1516. In his triptychs he makes use of nightmarish medieval visions with both moral and satirical intent. His extraordinary imagination is evident in his portrayal of man's sins and the terrible transformations they cause in man, and at the same time his delicate painting makes these nightmares seem convincing. *The Haywain Triptych* is the first of his great triptychs and depicts three stages in man's insane greed for pleasure. In the left-hand wing we have a prelude in the form of the Garden of Eden and the Original Sin, leading to the attainment of pleasure in the central panel, where a crowd of sinners seek to seize all they can from the haywain, a traditional symbol of the transitory nature of worldly goods. Finally, in the right-hand panel, we see man's punishment, as the haywain, with its greedy throng, is dragged to Hell by animal-like devils, who represent the various sins. The crowd of sinners following the haywain is headed by the most powerful earthly leaders (king, emperor and Pope), while there is an allusion to the corruption of the clergy in the presence of priests and nuns among the secular figures. On top of the pile of hay are two pairs of lovers who are being fought over by a devil and an angel — perhaps to suggest that they alone are capable of salvation. *The Garden of Delights Triptych* was painted in the first decade of the sixteenth century, and in Spain was originally called *The Painting of Strawberries* or *Lust*, since strawberries are a symbol of lust. The left-hand and right-hand wings show a state of innocence and punishment respectively (the Garden of Eden and Hell), while the central panel between them shows lust — the sin which reduces man to an animal state (represented by the cavalcade round the fountain of youth in the middle distance), and then plunges him into a whirlpool of obsessive, perpetual transformations where he abandons his human nature and assumes attributes from the animal, vegetable and mineral worlds. The images derive from mystical works, books on the interpretation of dreams and manuals of alchemy, as well as from contemporary symbols and proverbs, thus bearing witness to the breadth of culture of the artist.

136 – 138. Hell and its torments play a large part in sixteenth century Flemish Painting, and Joachim **Patinir**, who died at Antwerp in 1524 and was a little younger than Bosch, uses them as a pretext for a magnificent riverside landscape in his *Crossing the Styx*, where Charon is seen ferrying the souls of the dead. Pieter **Brueghel** the Elder was born between 1520 and 1525, probably at Bruegel, and died at Brussels in 1569. He uses the theme of *The Triumph of Death* to portray a macabre and frenzied scene of popular festivity into which has been poured all the wild spirit and solid substance of his paintings of scenes of Flemish village life. Against a landscape background fit for a witches' sabbath, in which various sins are depicted, devils are seen pushing sinners into a Hell which is guarded by an army of skeletons. His eldest son, Pieter **Brueghel** the Younger (Brussels 1564 – Antwerp 1638), is known as "Hell Brueghel" because scenes of Hell were his speciality. *The Rape of Proserpine* is set in a fiery glow, as Pluto carries off Proserpine in his chariot down to his subterranean realms.

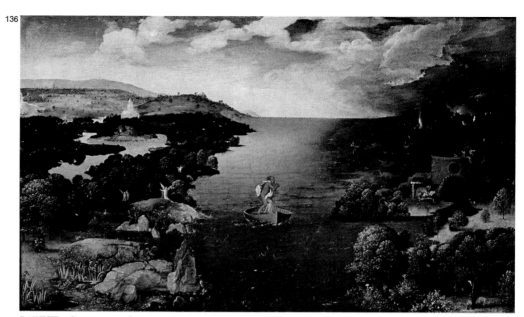

PATINIR CROSSING THE STYX

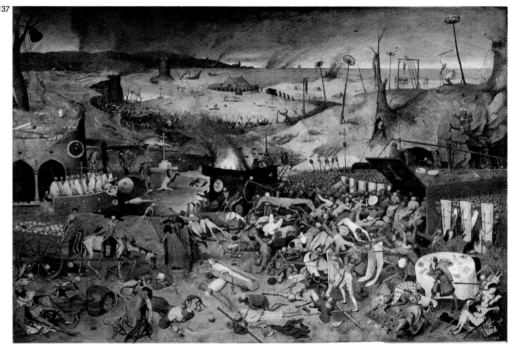

P. BRUEGHEL THE ELDER THE TRIUMPH OF DEATH

P. BRUEGHEL THE YOUNGER THE RAPE OF PROSERPINE

J. BRUEGHEL THE ELDER HEARING

139. Jan **Brueghel** the Elder (Brussels 1568 – Antwerp 1625) was the second son of Pieter Brueghel the Elder, and was known as "Velvet Brueghel," being famous for the loving care with which he painted velvets and other fine cloths and hangings. *Hearing* is one of his series of paintings of the five senses. Central to the painting is the naked nymph playing a lute, but she is only one element in a music lover's paradise, full of meticulous detail, with musical instruments and other objects (including clocks), and animals connected with hearing. On the table is a book of madrigals for six voices by Peter Philip, the English organist to the Archduke of Flanders. A concert is going on in the rooms in the background on the left, while through the elegant central arches one can make out, towards the right, the archduke's castle at Mariemont.

140 – 142. *The Nativity* is a triptych wing, painted by Hans **Memling** of Bruges about 1470. Its idealized poetic imagery is a fifteenth century derivation from the delicate religious style of the Flemish primitives, which is still influential in the sixteenth century, though now in combination with Renaissance elements, in Gerard **David**'s *The Rest on the Flight to Egypt*. (The scene of the flight is in the background, on the right, below the wood.) David was a pupil of Memling and died at Bruges in 1523. On the other hand, Jan Gossaert, known as **Mabuse**, is wholly an artist of the Renaissance. He died at Antwerp after 1534, and was the first of the Flemish artists to adopt an "Italianate" manner. This *Madonna and Child* of his is set in a classical niche which echoes the architecture which he saw during his visit to Italy.

MEMLING THE NATIVITY

DAVID THE REST ON THE FLIGHT TO EGYPT

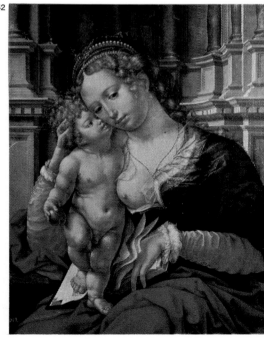

MABUSE MADONNA AND CHILD

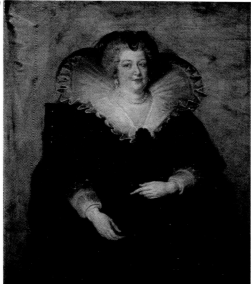

PORTRAIT OF MARIE DE' MEDICI, QUEEN OF FRANCE

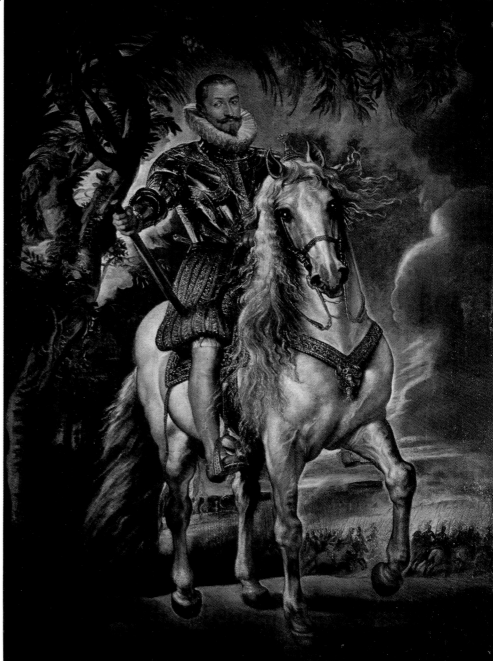

PORTRAIT OF THE DUKE OF LERMA

Love shows the garden of Rubens' house in Antwerp, but the fountain of Venus on the right, and that of the three Graces under the archway in the background, show that this is really a dwelling place for gods and goddesses dressed in fashionable contemporary costume. Among those present Rubens and his wife can be identified dancing on the left.

149 – 150. The delicate diplomatic missions which were entrusted to Rubens by the Governors of the Netherlands were carried out while he was painting portraits – an activity which he used as a cover for his diplomatic work. The *Portrait of Marie de' Medici* was painted in Paris about 1625. This sumptuous and convincing portrayal of the queen mother of France, dressed in mourning, is an example of the way in which Rubens probed the secret desires and innermost psychology of his subjects in order to create images of intense vitality, expressed in magnificent color harmonies. The *Portrait of the Duke of Lerma*, painted in 1603, shows Philip III's favorite – and Rubens' first Spanish patron – on horseback, with a battle scene in the background. The principal figure is perhaps, however, the horse rather than the man. This was one of a number of commissions which the Duke of Lerma gave to Rubens when he was only twenty-six and before he obtained official commissions from the court.

151 – 152. The two delightful *Concerts of Birds* are by Frans **Snijders**, a pupil and very active assistant of Rubens, who was responsible for a large number of the animals to be found in Rubens' paintings.

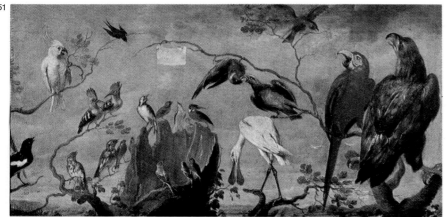

SNIJDERS A CONCERT OF BIRDS 1761

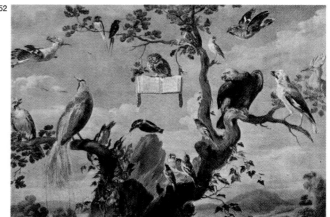

SNIJDERS A CONCERT OF BIRDS 1758

VAN DYCK Portrait of the one-handed Painter, Martin Ryckaert

VAN DYCK Portrait of Diana Cecil, Countess of Oxford

VAN DYCK Portrait of Charles I of England

153 – 155. Anthony **Van Dyck** was Rubens' most important follower and a highly accomplished portrait painter, in whose aristocratic and sober figures the baroque exuberance of his master is somewhat subdued. The *Portrait of the one-handed Painter, Martin Ryckaert*, the *Portrait of Diana Cecil, Countess of Oxford* and the *Portrait of Charles I of England on Horseback*, are examples of three kinds of portraiture which Van Dyck practiced: the intimate, the aristocratic and the courtly. All three were painted at the height of his career, in the decade preceding his death in London in 1641 at the age of forty-one. They are also evidence of his international reputation. After having been the favorite portraitist of the Genoese nobility and of the rulers of Antwerp (where his studio was no less a hive of activity than Rubens'), he was called to England by Charles I in 1632 and ended his career there.

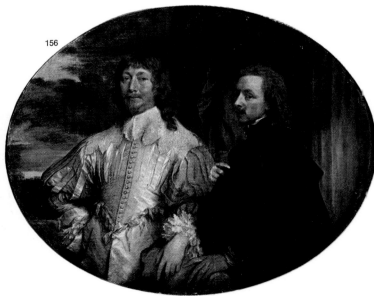

VAN DYCK Portrait of Sir Endymion Porter and Van Dyck

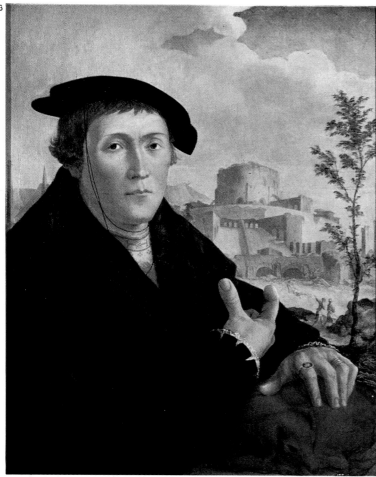

VAN SCOREL PORTRAIT OF A HUMANIST

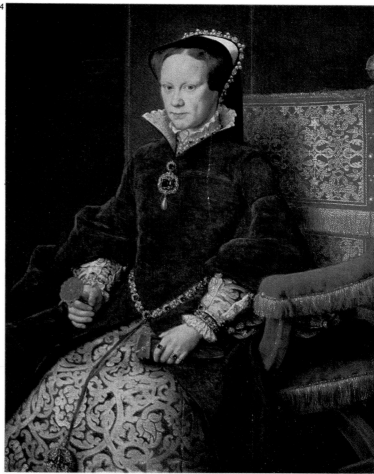

A. MORO PORTRAIT OF QUEEN MARY OF ENGLAND, SECOND WIFE OF PHILIP II OF SPAIN

143 – 144. The art of the portrait was understood quite differently by each of these two sixteenth century Dutch painters. Jan **Van Scorel** died at Utrecht in 1562 at the age of sixty-seven. He painted in the Italian style, and the subject of his *Portrait of a Humanist* – perhaps a commentator of the biblical episode of the Tower of Babel, which can be seen in the background – is rendered with Renaissance monumentality. On the other hand, his pupil Anthonis Mor Van Dashorst, known in Spain as Antonio **Moro**, brings Dutch realism to a very high level of archivement with the penetrating analysis of character and physical features to be found in his *Portrait of Queen Mary of England, Second Wife of Philip II of Spain*. This portrait was painted in 1554, the year in which Mary and Philip were married, and it represents a high point in Moro's career, for he was now a favorite portraitist at the courts of Madrid, London, Brussels and Lisbon.

145. *The Money-Changer and his Wife* is one of the earliest "genre" paintings in Flemish art. It was painted in 1539 by the Dutch artist Marinus **Van Reymerswaele**, who displays an almost obsessive attention to detail in depicting the tools of the money-changer's trade, so intense is his interest in creating an illusion of reality.

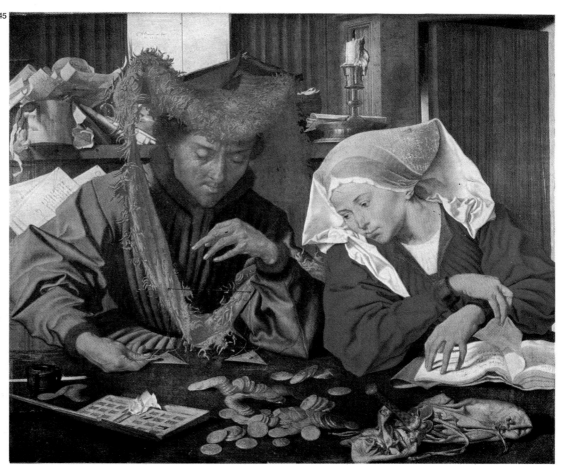

VAN REYMERSWAELE THE MONEY CHANGER AND HIS WIFE

RUBENS

The Flemish artist Peter Paul Rubens was born in Germany in 1577 and died in Antwerp in 1640. The exuberance of his forms, the sweeping movement of his compositions and the intensity of feeling conveyed by his use of color make him one of the creators of the baroque art of the seventeenth century. He went to Italy in 1600 at the age of twenty-three and remained there until the age of thirty. In addition to becoming court painter to Archduke Albert and the Infanta Isabella, Spanish Governors in the Netherlands, he had also been a favorite painter of the Duke of Mantua, for whom he acted as ambassador; and he was a favorite at the courts of Spain, France and England. He cuts a splendid figure in art history, and his magnificent studio in Antwerp was crowded with pupils who helped him to deal with the unending flow of commissions. It became the center of the new art which was now triumphant in Europe.

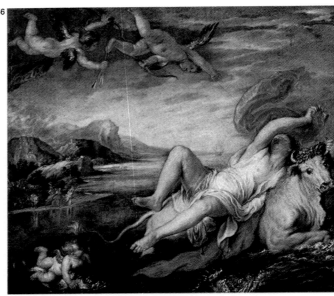

EUROPA AND THE BULL 2457

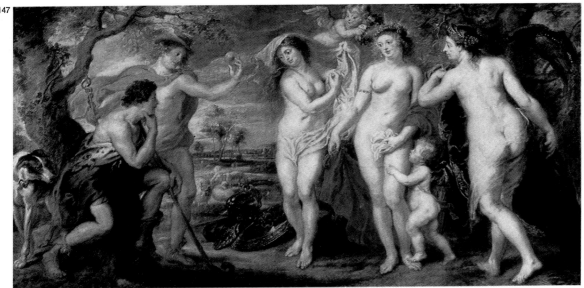

THE JUDGMENT OF PARIS 1669

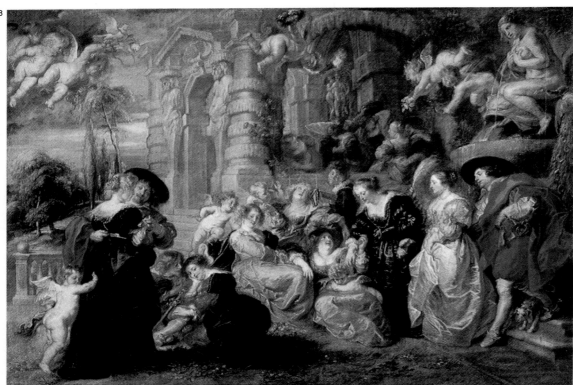

THE GARDEN OF LOVE

146. Rubens' exuberant painting *Europa and the Bull* is a sketch for one of the one hundred and twelve mythological paintings (mostly carried out by pupils) which he supplied to Philip IV of Spain for the embellishment of his new hunting lodge, the Torre de la Parada. The final work was painted by Erasmus Quellin and is also in the Prado.

147 – 148. Rubens' paintings give mythological scenes all the vibrancy of human life, and at the same time his scenes of human life have a mythological tone. All the figures in *The Judgment of Paris* are richly human in their exuberance, whether it is a question of Mercury showing the apple of discord to the goddesses, Paris pondering on the problem of selecting the most beautiful of them, or the three women themselves: Juno, seen from behind, with a peacock, Venus accompanied by Cupid and Minerva with her helmet lying on the ground. The figure of Venus is thought to be a portrait of Hélène Fourment, the beautiful girl who became Rubens' second wife at the age of sixteen in 1630, nine years before this picture was painted. *The Garden of*

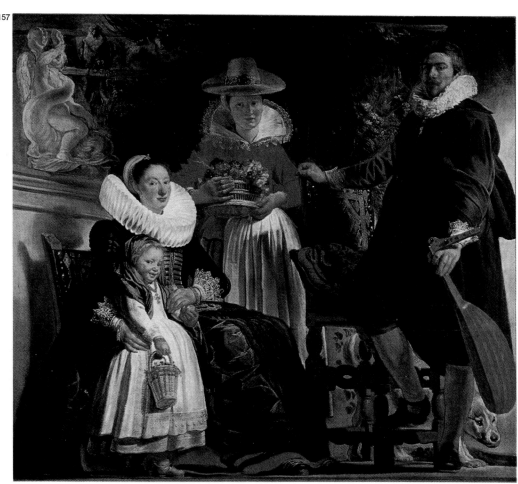

JORDAENS THE ARTIST'S FAMILY IN A GARDEN

156. In the oval *Portrait of Sir En-
dymion Porter and Van Dyck*, **Van
Dyck** has painted himself, in black, and
his best English friend beside a classical
column and against a landscape back-
ground. In addition to being secretary
to the Prime Minister, the Duke of
Buckingham, Sir Endymion Porter was
a poet and man of refined culture, and
the king made use of his services for the
purchase of works of art.

157. *The Artist's Family in a Gar-
den* is an intimate group portrait by
Jacob **Jordaens**, who was a follower of
Rubens and much given to baroque
sensuality. In portraying himself with a
lute, his wife Catherine Van Noort, his
daughter Isabel and a maidservant, he
has used the rich colors of his master
Rubens, but his figures are still rather
static, for this is an early work, painted
about 1621-22, when Jordaens was not
yet thirty.

158. The greatest Dutch painter,
Rembrandt, never had contacts with the
Spanish court. This painting of his did
not make its way to the Royal Palace
until the end of the eighteenth century.
His mysterious use of light, with its
dramatic effects of glitter and darkness,
introduced a note of unease into Dutch
painting, and his followers were called
'the sons of darkness' by contrast with
the orthodox realist style of painting.
Thus in *Queen Artemisia* the deeply
thoughtful figure of the queen emerges
from the darkness as a poetic image of
conjugal love, as she receives from a
maidservant the ashes of her husband,
Mausolus, king of Pergamon. This med-
itative figure is far from being the
queen of Greek history, and her human
grief acquires a new dimension through
the advent of Christianity. She is dress-
ed like a wealthy lady of Rembrandt's
day, and is very like his wife Saskia.
The painting was in fact executed in
1634 – the year of Rembrandt's mar-
riage to Saskia – at an important point
in his career, when he was twenty-eight
years old.

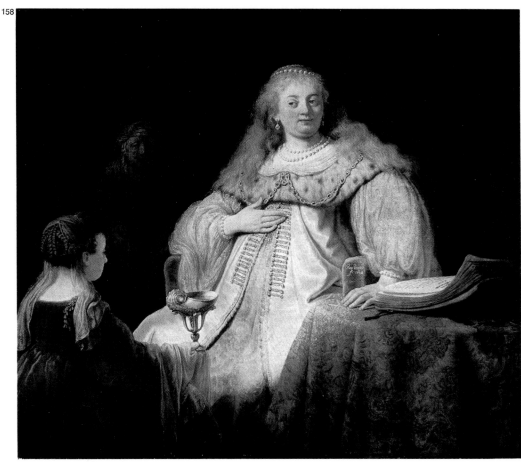

REMBRANDT QUEEN ARTEMISIA

WOUWERMAN Two Horses

HEDA Still Life 2755

VAN OSTADE A Rustic Concert 2121

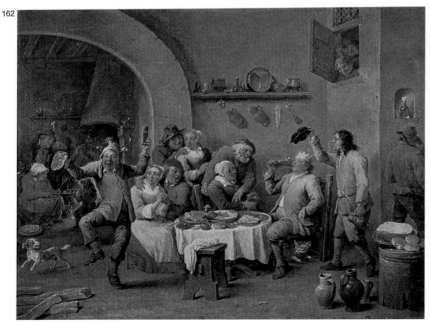

TENIERS II "The King Drinks"

159 – 160. The Dutch artist Philips **Wouwerman** specialized in painting horses. Isabella Farnese, wife of Philip V of Spain, was very fond of his riding and hunting scenes, and she collected a whole series of them for the new palace at La Granja near Segovia. They included *The Two Horses*, painted with a baroque fervor which was unusual in seventeenth century Dutch painting. The *Still Life* painted by Willem **Heda**, a specialist in this genre, in 1657, has an almost abstract, crystalline poetry about it, which derives from a quite different source of inspiration.

161 – 162. Genre paintings, full of the gaiety of working class life, were very popular with the Dutch, including those of the lower classes, but the approach to this kind of painting of the Dutch artist Adriaen **Van Ostade** is quite different from that of the Flemish artist David **Teniers**. In *A Rustic Concert*, painted in 1638, Van Ostade accentuates the boisterous vitality and rapid style of his master Frans Hals, whereas Teniers, who was court painter at Brussels, transposes into a rustic key the baroque orchestration of Rubens and Jordaens in his *"The King Drinks,"* which depicts a peasant feast at which one of the party has been jokingly crowned king.

163. This amazing triptych of *Animals*, painted by Jan **Van Kessel** the Elder at Antwerp in 1660, is a poem in forty stanzas which displays all the Flemish skill at depicting animals. Each picture offers the artist a very limited space to work in, for the paintings are on copper and measure seventeen by twenty-three centimeters, but that does not prevent the artist from combining meticulous realism with liveliness and a feeling of warm interest in the lives of the various animals. Depending on the species of animal depicted, the scenes are set in a variety of landscape. Some are in the plains of the Low Countries, some are in mountainous regions and others offer views of exotic lands, such as the one at the top on the left which shows aquatic birds in a landscape with pyramids, or that on the right (three up in the fourth column) with palm trees behind the elephants.

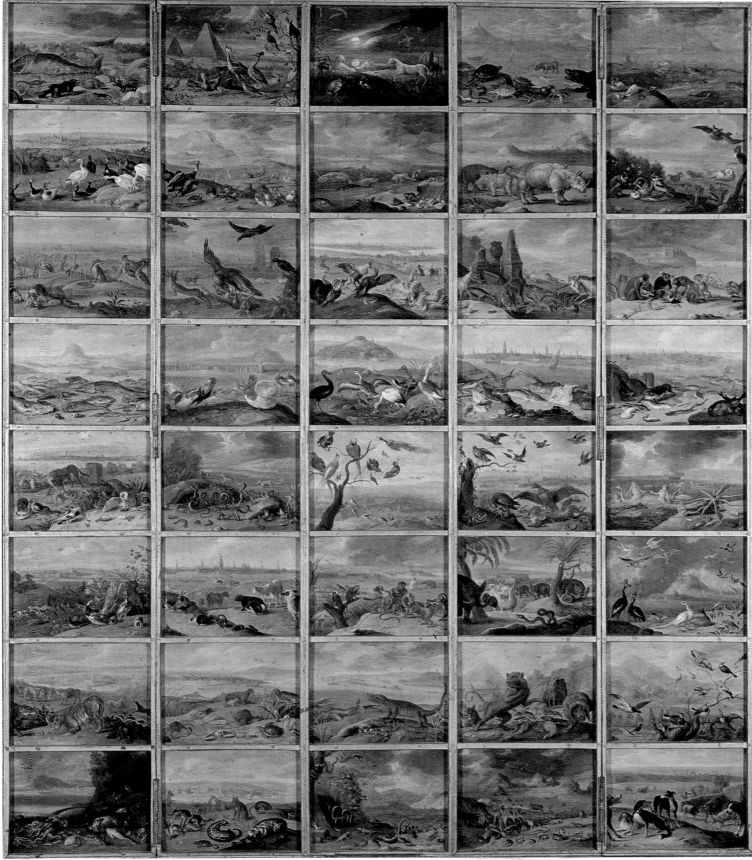

VAN KESSEL THE ELDER Animals

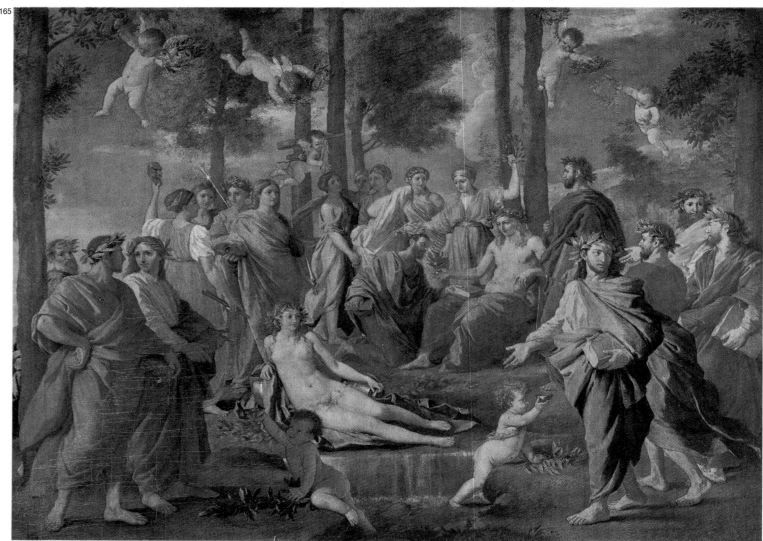

FRENCH, GERMAN AND ENGLISH ARTISTS

164. The *Landscape with the Embarkation of St. Paula of Rome at Ostia* shows the saint about to set off for the Holy Land with her three children. It is a magnificent example of the new kind of classical – romantic landscape created by the French artist Claude **Lorrain**, who drew his inspiration from the country around Rome, where he arrived as a young man and remained until his death in 1682 at the age of eighty-two. The religious subject is merely a pretext for composing a view with classical and medieval buildings, whose poetic effect can be enhanced by varying the time of day and the use of light. In this way Claude completely revolutionized French landscape painting. This painting is one of the "landscapes with saints" which constituted Claude's first major commission in Rome. They were ordered by Philip IV of Spain for the Buen Retiro Palace, and were painted between 1634 and 1638.

165. Nicolas **Poussin** was six years older than Lorrain, and their work brought them into contact, but Poussin was a strictly classical painter who transformed reality into a model of an ideal. He concerned himself not with living human forms but with statues and antique reliefs, and his interpretation of nature is not lyrical but strictly controlled by reason. He too chose Rome as an ideal artistic home, arriving there in 1624 at the age of thirty, and remaining there until his death in 1665. *Parnassus* has all the warm color range of his early period and is chiefly inspired by Raphael's fresco on the same subject in the Vatican Stanze. There are only faint echoes of the baroque style which then held sway. Apollo sits at the top of Mount Parnassus, surrounded by the Muses, and offers divine ambrosia to the poet Homer, who is crowned by Calliope. In the center is the pure spring Castalia, represented as a naked woman. The cupids are inspired by Titian's *Bucchanals*, which Poussin copied before they were sent to Spain.

C. LORRAIN LANDSCAPE WITH THE EMBARKATION OF ST. PAULA OF ROME AT OSTIA

POUSSIN PARNASSUS

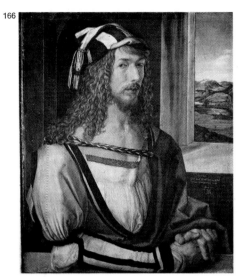

DÜRER Self-portrait

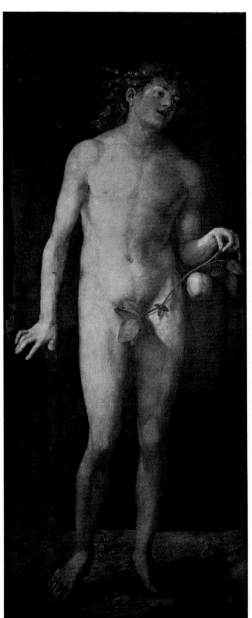

DÜRER Adam

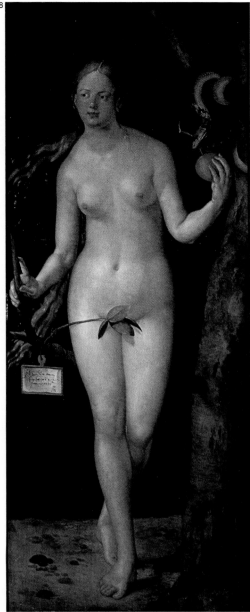

DÜRER Eve

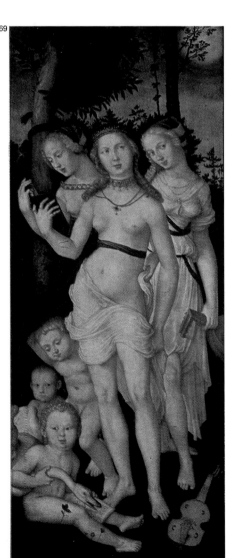

BALDUNG GRÜN The Three Graces

166 – 168. "Modern" art begins in Germany with Albrecht **Dürer**, the first Renaissance painter of the North. During his early visits to Italy, and especially when in Venice, he had absorbed the new concept of art not as a highly skilled craft but as an ideal way of interpreting things, to be achieved by a rational investigation of the real world together with the study of perspective and of the proportions of the human body. His *Self-Portrait* display a typically Italian approach. The artist is seen in a room with a window which reveals a distant landscape — possibly a view in the Trentino, through which Dürer passed on his first visit to Italy in 1494-1495. However, the self-portrait was actually executed three years later, in 1498, when Dürer was twenty-six and had already achieved a con-

siderable early success with his engravings of the Apocalypse. *Adam* and *Eve* were painted in 1507, after his return from his second visit to Italy, and show Dürere at his most classical. They are the first two life-size nudes in German painting, and are painted in accordance with the canons of antique beauty and harmony.

169. Hans **Baldung** Grün was about twenty years younger than Dürer, and worked in his studio, but his art is quite different in conception. *The Three Graces* is painted with refined elegance, but with no sense of relief or separateness of the figures. It recalls both the "flat" refinement of Gothic tapestries and the elegant patterns of curves and folds in the mannerist art of Cranach, another great German artist of the sixteenth century.

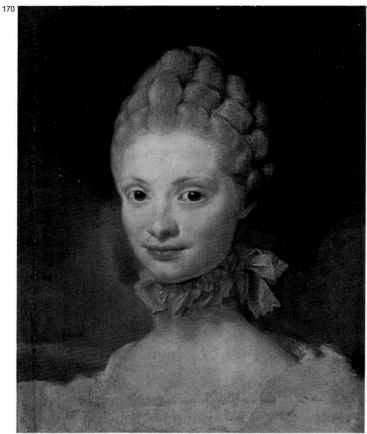

MENGS Portrait of Maria Luisa of Parma 2568

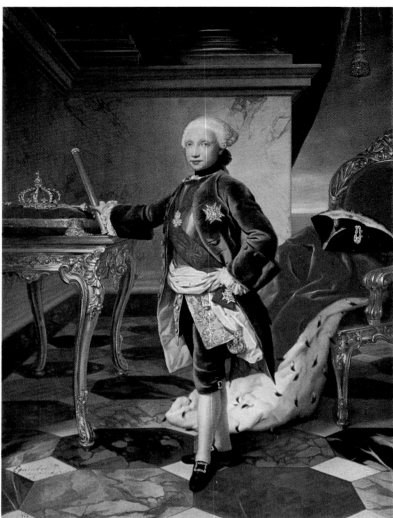

MENGS Portrait of Ferdinand IV of Naples

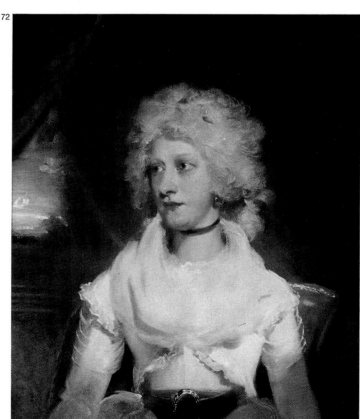

LAWRENCE Portrait of Miss Marthe Carr

170 – 171. This *Portrait of Maria Luisa of Parma* is a small and unfinished but delightfully fresh study from life by Anton Raphael **Mengs** for the large portrait now in the Metropolitan Museum in New York. It represents the princess who in 1765, at the age of fifteen, married the Prince of the Asturias, later to become Charles IV of Spain. No one would recognize in her the woman whom Goya immortalized at the age of fifty in his famous painting of *The Family of Charles IV of Spain*; and it is also astonishing that this essentially rococo portrait should have been painted by an artist who was the first exponent of the anti-rococo ideals of neoclassicism. On the other hand, his *Portrait of Ferdinand IV of Naples*, painted in 1760 when the king was still a boy, is a much more typical example of his work. Mengs was a German who spent most of his life in Rome, where the Greek studies of his compatriot Winckelmann and the rediscovery of Raphael were preparing the way for a classical revival. He arrived there at the age of thirteen and died there in 1779 when he was barely fifty-one. But he was also court painter in Saxony and Madrid where the rococo style held sway, and his portraits show that he was influenced by the prevailing taste of the age, though to a controlled degree. He spent part of the last fifteen years of his life in Spain, where he became the favorit painter of Charles III, who commissioned him to paint frescoes for the new Royal Palace and portraits of his courtiers.

172. Sir Thomas **Lawrence**'s *Portrait of Miss Marthe Carr* shows a typical English beauty with mother-of-pearl flesh tones and delicate blouse. He painted it in 1789, when he was only twenty, using a delicate pictorial style in which rococo gracefulness acquired new life by being fused with an attractive neoclassical clarity. Lawrence was active at the end of the eighteenth century and the early nineteenth century and specialized in portraits of the nobility. He became painter to King George III at the age of twenty-three, and worked during the reign of George IV and the Regency, when a particular English brand of neoclassicism was in fashion. He died in 1830, and his death brings to an end the great period of the English portrait.

Other Important Paintings in the Prado Museum

FRANCESCO ALBANI
The Toilet of Venus

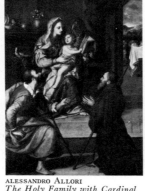

ALESSANDRO ALLORI
*The Holy Family with Cardinal
Ferdinando de' Medici*

DENIS VAN ALSLOOT
Skating Scene

CHRISTOPH AMBERGER
*Portrait of Jörg Zörer,
the Augsburg
Goldsmith* (?)

ANDREA DEL SARTO
The Sacrifice of Isaac

ANDREA DEL SARTO
*Portrait of the
Artist's Wife*

ANONYMOUS SPANISH ARTIST (14th CENTURY)
Altar Frontal from Guills

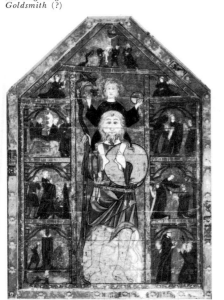

ANONYMOUS SPANISH ARTIST (13th CENTURY)
St. Christopher Altarpiece

ANONYMOUS SPANISH
ARTIST (15th CENTURY)
*The Martyrdom of
St. Vincent* (First Scene)

ANONYMOUS SPANISH ARTIST
(15th CENTURY)
*Portrait of The First Marquis
of Santillana* (?)

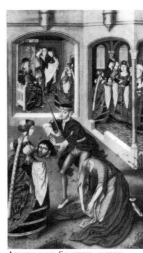

ANONYMOUS SPANISH ARTIST
(15th CENTURY)
*The Beheading of St. John
the Baptist*

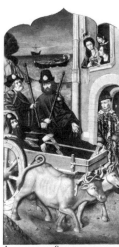

ANONYMOUS SPANISH ARTIST
(15th CENTURY)
*The Translation of the Body
of St. James the Great:
The Journey to Galicia*

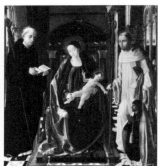

ANONYMOUS SPANISH ARTIST
(15th CENTURY)
*The Madonna of the Knight
of Montesa*

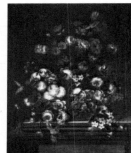

ANONYMOUS SPANISH
ARTIST (17th CENTURY)
*Portrait of Isabella of
Bourbon, Queen of Spain*

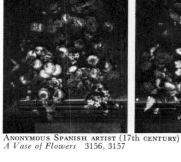

ANONYMOUS SPANISH ARTIST (17th CENTURY)
A Vase of Flowers 3156, 3157

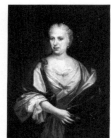

ANONYMOUS FRENCH
ARTIST (18th CENTURY)
Isabella Farnese

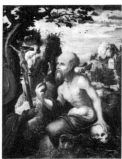

ANONYMOUS ARTIST OF THE
FLEMISH-DUTCH SCHOOL
(16th CENTURY)
St. Jerome

JOSÉ ANTOLÍNEZ
The Ecstasy of the Magdalene

ANTONIAZZO ROMANO
Madonna and Child

JUAN DE ARELLANO
A Vase of Flowers 3139

GIOACCHINO ASSERETO
Moses Striking the Rock

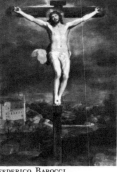
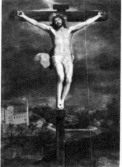

FEDERICO BAROCCI
Christ on the Cross

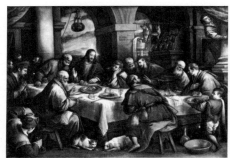

FRANCESCO BASSANO
The Last Supper

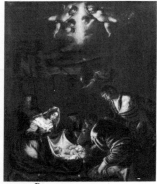

JACOPO BASSANO
The Adoration of the Shepherds

POMPEO GIROLAMO BATONI
*Portrait of Charles Cecil
Roberts*

HANS BALDUNG GRÜN
*The Three Ages of Man
and Death*

FRANCISCO BAYEU
Y SUBÍAS
Feliciana Bayeu

FRANCISCO BAYEU Y SUBÍAS
*The Rebuking of Adam
and Eve*

RAMÓN BAYEU Y SUBÍAS
The Salt Meat Seller

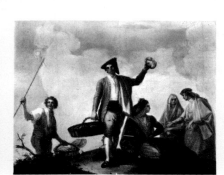

RAMÓN BAYEU Y SUBÍAS
Sellers of Fans and Buns

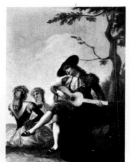

RAMÓN BAYEU Y SUBÍAS
The Guitar Player

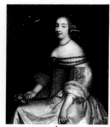

CHARLES and
HENRI BEAUBRUN
*Portrait of Anne Marie
Louise d'Orléans*

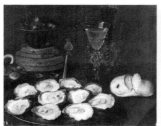

OSIAS BEET
Still Life

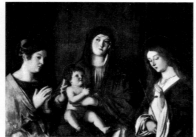

GIOVANNI BELLINI
Madonna and Child with St. Mary
Magdalene and St. Ursula

ANDREA BELVEDERE
A Vase of Flowers 550

GIAN LORENZO BERNINI
Self-Portrait

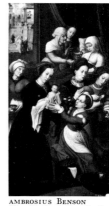

AMBROSIUS BENSON
The Birth of the Virgin

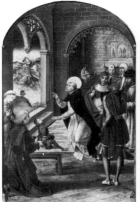

PEDRO BERRUGUETE
St. Dominic Raising up a Young Man;
The Virgin Appearing to a Dominican Community

PEDRO BERRUGUETE
The Death of St. Peter Martyr

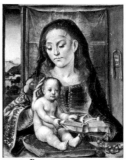

PEDRO BERRUGUETE
St. Dominic of Guzmán
Presiding over an Autodafé

PEDRO BERRUGUETE
Madonna and Child

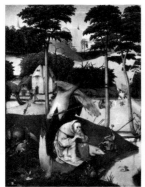

HIERONYMUS BOSCH
The Temptation of
St. Anthony 2049

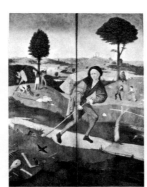

HIERONYMUS BOSCH
The Haywain Triptych (closed):
Life's Pilgrimage

HIERONYMUS BOSCH
The Cure of Folly

GIUSEPPE BONITO
The Turkish Embassy to Naples
in 1741

JUAN DE BORGOÑA
Three Dominican Saints

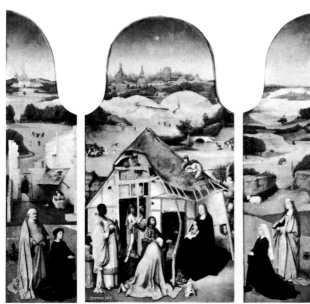

HIERONYMUS BOSCH
The Adoration of the Magi Altarpiece (open)

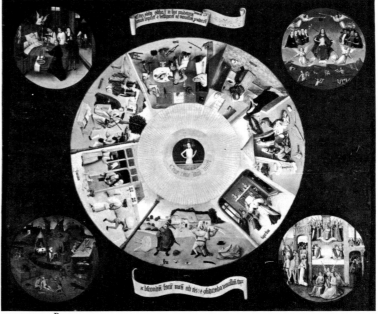

HIERONYMUS BOSCH
The Table of the Seven Deadly Sins

79

DIERIC BOUTS
The Annunciation; The Visitation; The Nativity; The Adoration of the Magi

ADRIAEN BROUWER
Three Men Searching for Lice

PIETER BRUEGHEL THE YOUNGER
The Building of the Tower of Babel

80

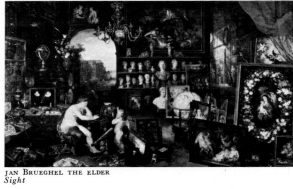

JAN BRUEGHEL THE ELDER
Sight

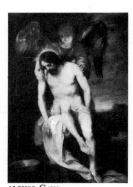

ANDRÉS DE LA CALLEJA
Portrait of a Knight of St. James

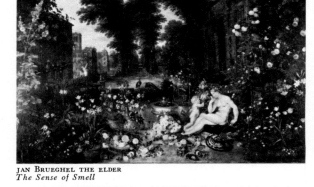

JAN BRUEGHEL THE ELDER
The Sense of Smell

PIETER BRUEGHEL THE ELDER
The Adoration of the Magi

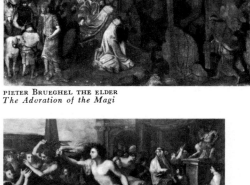

ALONSO CANO
Madonna and Child

ANDREA CAMASSEI
The Feast of Lupercal

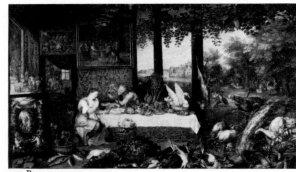

JAN BRUEGHEL THE ELDER
The Sense of Taste

CANALETTO
San Giorgio Maggiore and the Dogana, Venice

ALONSO CANO
The Dead Christ 629

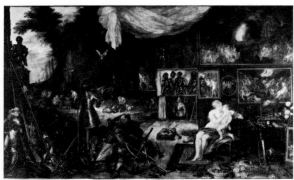

JAN BRUEGHEL THE ELDER
The Sense of Touch

ALONSO CANO
St. Benedict's Vision of the Earthly Sphere

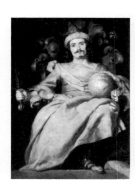

ALONSO CANO
A King of Spain

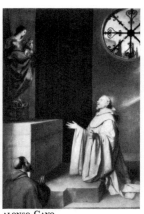

ALONSO CANO
St. Bernard and the Virgin

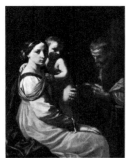

SIMONE CANTARINI
The Holy Family

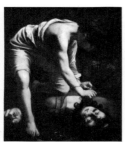

CARAVAGGIO (st?)
*David with the Head
of Goliath*

BARTOLOMÉ CARDUCHO
The Deposition of Christ

VINCENCIO CARDUCHO
The Capture of Rheinfelden

VINCENCIO CARDUCHO
The Miracle of the Water

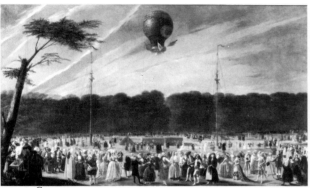

ANTONIO CARNICERO
The Ascent of a Montgolfier Balloon at Madrid

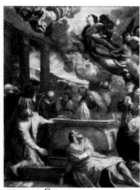

ANNIBALE CARRACCI
The Assumption of the Virgin

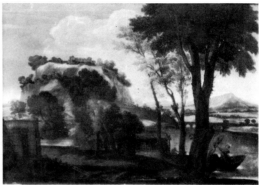

ANNIBALE CARRACCI
Landscape

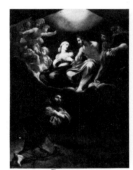

LUDOVICO CARRACCI
*Celebrations at the
Porziuncola*

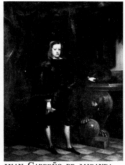

JUAN CARREÑO DE MIRANDA
Charles II of Spain 642

JUAN CARREÑO
DE MIRANDA
The Naked "Giantess"

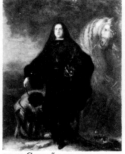

JUAN CARREÑO DE MIRANDA
*Portrait of the Duke
of Pastrana*

GIOVANNI CASTIGLIONE
Diogenes

BERNARDO CAVALLINO
The Marriage of Tobias

EUGENIO CAXÉS
*The Recapture of
San Juan, Porto Rico*

EUGENIO CAXÉS
Madonna and Child

ANTONIO DEL CASTILLO SAAVEDRA
Joseph Sold by his Brothers

MATEO CEREZO
*The Mystical Marriage
of St. Catherine*

MATEO CEREZO
St. Augustine

MICHÉLANGELO CERQUOZZI
The Hut

PETRUS CHRISTUS
Madonna and Child

VIVIANO CODAZZI
St. Peter's Square, Rome

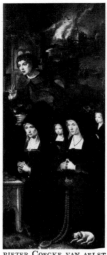

PIETER COECKE VAN AELST
*St. John the Evangelist
with Ladies at Prayer*

CLAUDIO COELLO
*Madonna and Child Worshipped by St. Louis,
King of France*

CLAUDIO COELLO
The Apotheosis of St. Augustine

CLAUDIO COELLO
*The Christ Child at the
Temple Door*

CLAUDIO COELLO
St. Rosa of Lima

82

JUAN CORREA DE VIVAR
The Annunciation

CORNELIS CORNELISZ. VAN HAERLEM
Apollo Before the Tribunal of the Gods

CORREGGIO
*Madonna and Child with
the Infant St. John*

JAN COSSIERS
Prometheus Carrying Fire

FRANCISCO COLLANTES
The Vision of Ezekiel

JACQUES COURTOIS
A Battle Between Christians and Moors

MICHIEL COXCIE
*The Presentation of
Christ in the Temple*

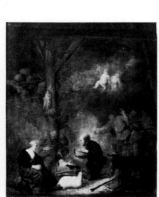

DANIELE CRESPI
Pietà

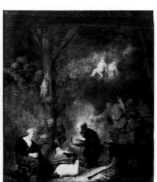

ADRIAEN CRONENBURCH
*Portrait of a Lady with
a Little Girl* 2075

BENJAMIN GERRITSZ. CUYP
The Adoration of the Shepherds

LUCAS CRANACH THE ELDER
Hunting at Torgau Castle in Honor of the Emperor Charles V 2175

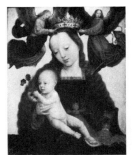

GERARD DAVID
Madonna and Child

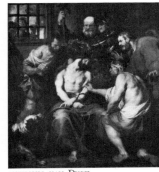

ANTHONIS VAN DYCK
The Crowning of Christ with Thorns

ANTHONIS VAN DYCK
The Betrayal of Christ

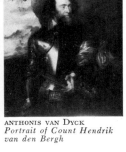

ANTHONIS VAN DYCK
Portrait of Count Hendrik van den Bergh

ANTHONIS VAN DYCK
Portrait of Mary Ruthwen, the Artist's Wife

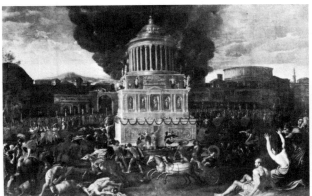

DOMENICHINO
The Funeral of a Roman Emperor

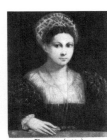

DOSSO DOSSI (attr)
Portrait of a Lady in a Green Turban

GASPARD DUGHET
The Penitent Magdalene 136

83

FRANÇOIS-HUBERT DROUAIS (attr)
Madame du Barry

ALBRECHT DÜRER
Portrait of an Unknown Gentleman

JUAN ANTONIO DE FRÍAS Y ESCALANTE
The Communion of St. Rosa

JERÓNIMO JACINTO ESPINOSA
St. Raymond Nonnatus

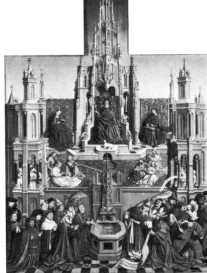

JAN VAN EYCK (school of)
The Fountain of Grace (or of Life) and the Triumph of the Church over the Synagogue

JACOB VAN ES
Still Life

AGUSTÍN ESTEVE
Portrait of Joaquina Téllez-Girón

ANIELLO FALCONE
Elephants at a Circus

MARIANO FORTUNY
A Moroccan Family

ANIELLO FALCONE
Roman Soldiers Entering the Circus

ALEJO FERNÁNDEZ
The Flagellation of Christ

MARIANO FORTUNY
Fantasy on Gounod's 'Faust'

FRANCESCO FURINI
Lot and his Daughters

TADDEO GADDI (attr)
St. Eloy in the Goldsmith's Workshop

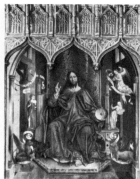

FERNANDO GALLEGO
Christ Enthroned

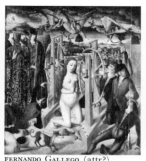

FERNANDO GALLEGO (attr?)
The Martyrdom of St. Catherine

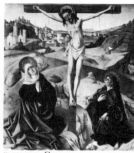

FERNANDO GALLEGO
Calvary

PEDRO GARCÍA
DE BENABARRE (attr)
*The Martyrdom of SS.
Sebastian and Polycarp*

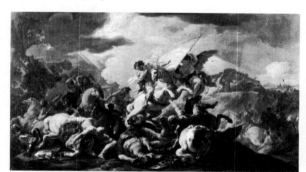

DOMENICO GARGIULO (attr)
The Triumphal Entry of Constantine into Rome

ORAZIO GENTILESCHI
*An Executioner
with the Head of
St. John the Baptist*

ORAZIO GENTILESCHI (attr)
*The Christ Child Asleep
on the Cross*

LUCA GIORDANO
Aeneas Fleeing with his Family

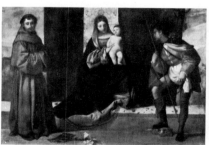

CORRADO GIAQUINTO
The Battle of Clavijo

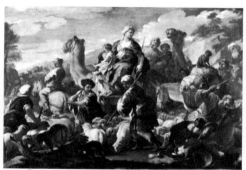

LUCA GIORDANO
Jacob's Journey to Canaan

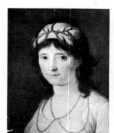

GIORGIONE (attr)
*Madonna and Child with St. Anthony
of Padua and St. Roch*

GIOVANNI DAL PONTE (attr)
The Seven Liberal Arts

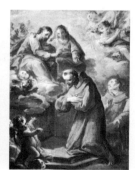

L. GONZÁLEZ VELÁZQUEZ (attr)
*Celebrations at the
Porziuncola*

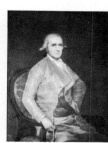

ZACARÍAS GONZÁLEZ
VELÁZQUEZ
*Portrait of
a Young Woman*

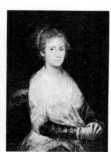

GOYA
*Portrait of
Francisco Bayeu*

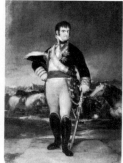

GOYA
*Portrait of the
Artist's Wife (?)*

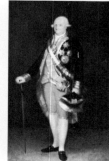

GOYA
*Portrait of Ferdinand VII
of Spain at a Military Camp*

GOYA
*Portrait of Charles IV
of Spain* 727

GOYA
*Maria Luisa,
Queen of Spain* 728

84

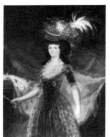

GOYA
*Portrait of Maria Luisa
of Parma, Queen of
Spain 740c*

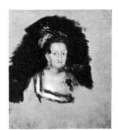

GOYA
*Portrait of the Infanta
Maria Josefa*

GOYA
*Portrait of the Infante
Don Francisco
de Paula Antonio*

GOYA
*Portrait of the Infante
Don Carlos María Isidro*

GOYA
*Portrait of Don Luis
of Bourbon*

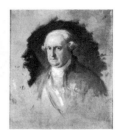

GOYA
*Portrait of the Infante
Don Antonio Pascual*

GOYA
*Portrait of
Isidoro Maiquez*

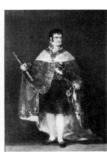

GOYA
*Portrait of
Ferdinand VII of Spain*

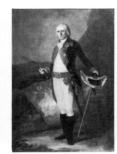

GOYA
*Portrait of
General Urrutia*

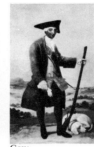

GOYA
*Portrait of
Charles III of Spain*

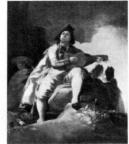

GOYA
A Majo Playing a Guitar

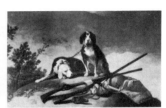

GOYA
Dogs and Hunting Gear

85

GOYA
Destiny

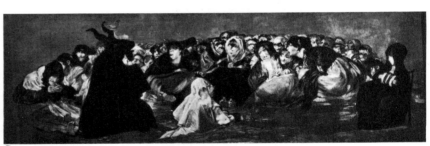

GOYA
The Witches' Sabbath

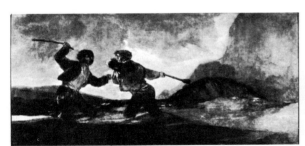

GOYA
Two Men Fighting with Clubs

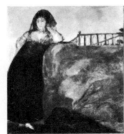

GOYA
*Portrait of Doña
Leocadia Zorrilla (?)*

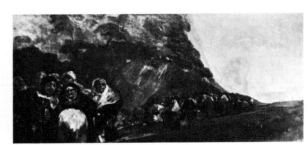

GOYA
A Pilgrimage to the Fountain of St. Isidore

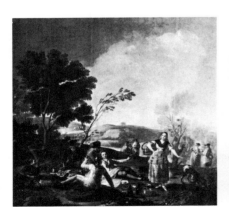

GOYA
A Picnic by the Banks of the Manzanares

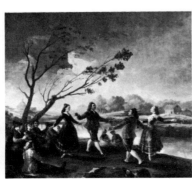

GOYA
A Dance at San Antonio de la Florida

GOYA
*The Maja and the
Cloaked Majos*

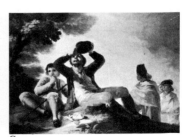

GOYA
The Drinker

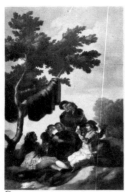

GOYA
The Card Players

GOYA
Boys Blowing up a Balloon

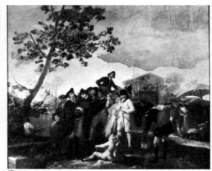

GOYA
The Blind Guitar Player

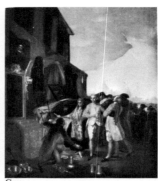

GOYA
The Fair at Madrid

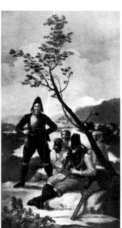

GOYA
*A Boy with
a Bird*

86

GOYA
*The Soldier and
the Lady*

GOYA
The Azarole Seller

GOYA
The Swing

GOYA
The Washerwomen

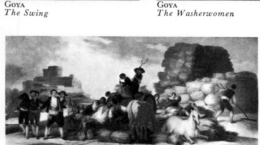

GOYA
The Customs Men

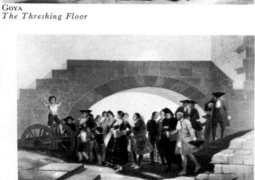

GOYA
The Threshing Floor

GOYA
The Drunken Stonemason

GOYA
Poor People

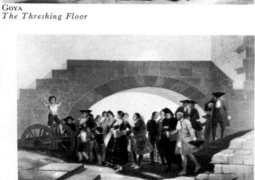

GOYA
The Wedding

GOYA
The Stilt Walkers

GOYA
The Snowstorm

GOYA
Children Playing at Giants

GOYA
The Water Sellers

GOYA
Blind Man's Buff 2781

GOYA
*Portrait of Maria Antonia
Gonzaga, Marchioness of
Villafranca*

GOYA
*Portrait of the
Duke of Alba*

GOYA
*Portrait of
Don Manuel Silvela*

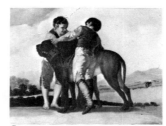

GOYA
Two Boys with Two Mastiffs

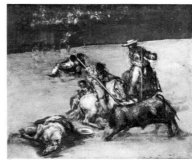

GOYA
The Bull Fight

GOYA
*Portrait of Don Juan
Bautista de Muguiro*

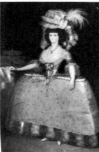

GOYA
*Portrait of Maria Luisa,
Queen of Spain,
in a Hoop Skirt*

GOYA
*Portrait of General
Don Antonio Ricardos*

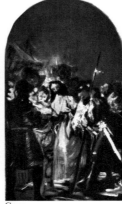

GOYA
The Betrayal of Christ

EL GRECO
*Portrait of an Elderly
Gentleman 806*

EL GRECO
*Portrait of a
Gentleman 810*

87

EL GRECO
*Portrait of a Young
Gentleman 811*

EL GRECO
*Portrait of the Jurist
Jerónimo de Cevallos*

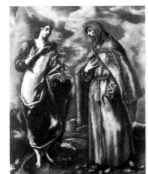

EL GRECO (st)
*St. John the Evangelist
and St. Francis*

EL GRECO
St. Paul 2892

EL GRECO
Christ the Redeemer

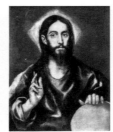

EL GRECO
St. James the Great

EL GRECO
St. Benedict

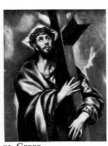

EL GRECO
Christ Carrying the Cross

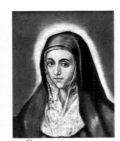

EL GRECO
The Madonna

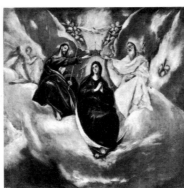

EL GRECO
The Coronation of the Virgin

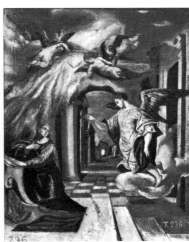

EL GRECO
The Annunciation

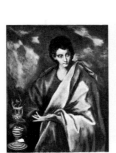

EL GRECO
St. John the Evangelist

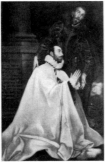

EL GRECO
*Julián Romero
with St. Julian*

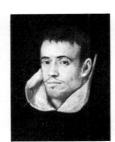

EL GRECO
*A Trinitarian
or Dominican Friar*

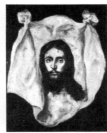

EL GRECO
The Veil of St. Veronica

GREUZE
*A Young Woman Seen
from Behind*

GUERCINO
St. Peter Freed by an Angel

JUAN VAN DER HAMEN Y LEÓN
Still Life

FRANCISCO DE HERRERA THE ELDER
The Head of a Decapitated Saint

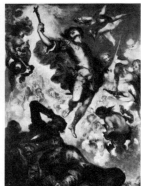

HANS HOLBEIN
THE YOUNGER (attr)
Portrait of an Old Man

JOHN HOPPNER
*Portrait
of Mrs. Thornton*

FRANCISCO DE HERRERA
THE YOUNGER
*The Apotheosis
of St. Hermengild*

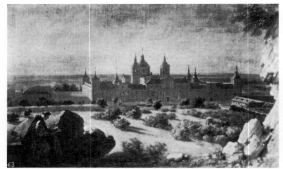

MICHEL-ANGE HOUASSE
A View of the Monastery at El Escorial

JAUME HUGUET
A Prophet

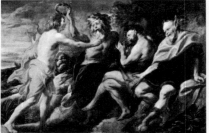

JACOB JORDAENS
Apollo Victorious over Pan

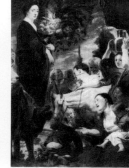

JACOB JORDAENS
Offerings to Pomona

88

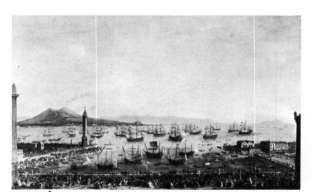

ANTONIO JOLI
The Embarkation of Charles III of Spain at Naples 232

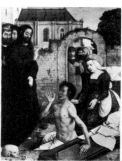

JUAN DE FLANDES
The Raising of Lazarus

IGNACIO IRIARTE
Landscape with Shepherds

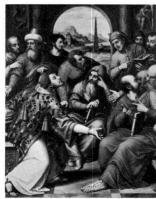

JUAN DE JUANES
St. Stephen in the Synagogue

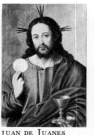

JUAN DE JUANES
Christ the Redeemer

THOMAS LAWRENCE
*Portrait of a Lady
of the Storer Family*

THOMAS LAWRENCE
*Portrait of John Vane,
Tenth Earl of
Westmoreland*

GIOVANNI LANFRANCO
The Funeral of a Roman Emperor

EBERHARD KEIL (attr)
Children's Bacchanal

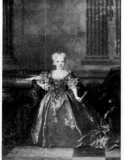

NICOLAS DE LARGILLIÈRE
*Portrait of Anna Maria
Victoria of Bourbon*

ANGELICA KAUFFMAN
*Portrait of Anna
von Escher van Muralt*

GIOVANNI LANFRANCO
Gladiators at a Banquet

JUSEPE LEONARDO
The Surrender of Jülich

BERNARDINO LICINIO
*Portrait of Agnese, the
Artist's Sister-in-law*

JACQUES LINARD
Vanity

LOUIS MICHEL VAN LOO
The Family of Philip V of Spain

VICENTE LÓPEZ PORTAÑA
*Portrait of
Francisco Goya*

VICENTE LÓPEZ PORTAÑA
*Portrait of Maria
Cristina of Naples*

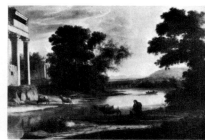

CLAUDE LORRAIN
The Ford

CLAUDE LORRAIN
*Landscape with the Burial
of St. Serapia*

CLAUDE LORRAIN
*Landscape with Tobias and the
Archangel Raphael*

BERNARDINO LUINI
The Holy Family

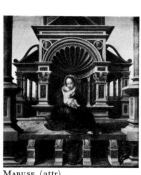

MABUSE (attr)
The Madonna of Louvain

PEDRO MACHUCA
*The Virgin and the Souls
in Purgatory*

MARIANO SALVADOR MAELLA
St. Joseph and *St. Peter*

MASTER OF ARGUIS
*The Legend of St. Michael: St. Michael
Appearing to Pope Gregory* and *St. Michael
Victorious over Antichrist*

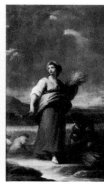

RAIMUNDO DE MADRAZO
*Portrait of the Marchioness
of Manzanedo*

MARIANO SALVADOR
MAELLA
Summer

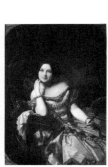

FEDERICO DE MADRAZO
*Portrait of Amalia
de Llano y Dotres*

FEDERICO DE MADRAZO
*Portrait of the Duchess
of Castro Enriquez*

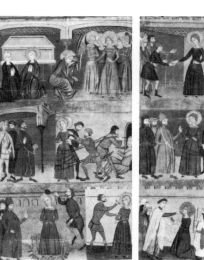

MASTER OF ESTIMARIÚ
The Legend of St. Lucy

89

MASTER
OF FLÉMALLE (attr)
Madonna and Child

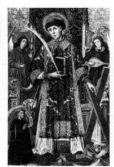

MASTER OF ARCHBISHOP
DALMÁU DE MUR
*St. Vincent, Deacon
and Martyr*

MASTER OF LA SISLA
The Visitation

MASTER OF THE ELEVEN
THOUSAND VIRGINS
*St. Ursula and the
Eleven Thousand Virgins*

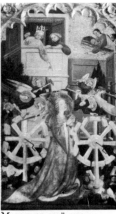

MASTER OF FLÉMALLE
The Annunciation

MASTER OF SIGÜENZA
*Polyptych of St. John the
Baptist and St. Catherine:
The Martyrdom of
St. Catherine*

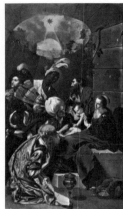

JUAN BAUTISTA MAINO
Portrait of a Gentleman

CARLO MARATTA
*Portrait of the painter
Andrea Sacchi*

QUENTIN MASSYS
*An Old Woman Tearing
her Hair*

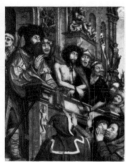

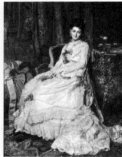

JUAN BAUTISTA MAINO
The Adoration of the Magi

QUENTIN MASSYS
Christ Before the People

JEAN-LOUIS-ERNEST
MEISSONNIER
*Portrait of the Marchioness
of Manzanedo*

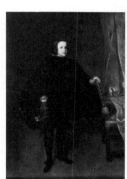

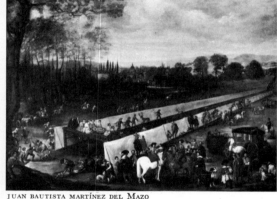

LUIS EUGENIO MELÉNDEZ
*Still Life with a Piece of Salmon,
a Lemon and Three Small Vases*

LUIS EUGENIO MELÉNDEZ
*Still Life with Cheese and a Dish
of Cherries*

JUAN BAUTISTA MARTÍNEZ DEL MAZO
A Hunting Scene at Aranjuez

JUAN BAUTISTA MARTÍNEZ
DEL MAZO
*Portrait of Prince
Baltasar Carlos*

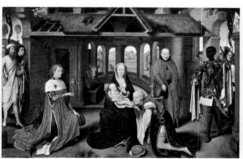

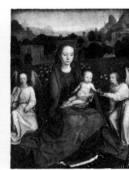

PIERRE MIGNARD (attr)
*Portrait of Henrietta
of England*

HANS MEMLING
The Adoration of the Magi

HANS MEMLING
*Madonna and Child with
Two Angels*

ANTON RAPHAEL MENGS
*Portrait of Charles IV
of Spain*

ANTON RAPHAEL MENGS
*Portrait of the Archduke
Francis of Austria*

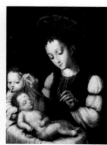

ANTON RAPHAEL MENGS
*Portrait of Maria Luisa
of Bourbon*

ANTON RAPHAEL MENGS
Self-portrait

LUIS DE MORALES
*The Presentation of Christ
in the Temple*

LUIS DE MORALES
St. John of Ribera

LUIS DE MORALES
St. Stephen

LUIS DE MORALES
The Holy Family

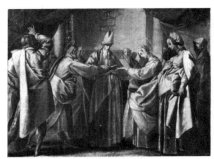

MORAZZONE
The Marriage of the Virgin

ANTONIO MORO
*Portrait of the
Jester Pejerón*

ANTONIO MORO
Portrait of the Artist's Wife

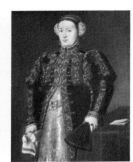

ANTONIO MORO
*Portrait of Catherine
of Austria*

GIOVANNI BATTISTA
MORONI
Portrait of a Soldier (?)

MURILLO
*The Christ Child and St. John
the Baptist as a Child*

MURILLO
The Virgin and St. Anne

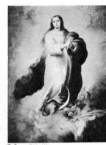

MURILLO
*The Immaculate
Conception 972*

MURILLO
*A Galician Girl with
a Coin in her Hand*

MURILLO
*Portrait of
Nicolás Omazur*

MURILLO
*Portrait of a Gentleman
Wearing a Ruff*

91

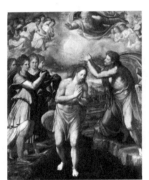

JUAN FERNÁNDEZ NAVARRETE
The Baptism of Christ

PIETER NEEFS THE ELDER
Mass in a Church in Flanders

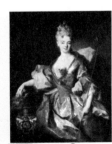

NICOLÁS FRANCÉS
*Altarpiece of the Life of the Virgin
and St. Francis: Madonna and Child*

JOHN OPPIE
Portrait of a Gentleman

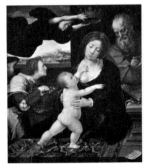

BAREND VAN ORLEY
The Holy Family

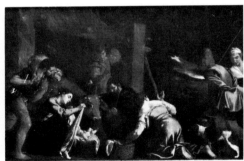

PEDRO DE ORRENTE
The Adoration of the Shepherds

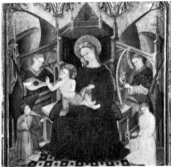

ADRIAEN VAN OSTADE
Peasants Singing

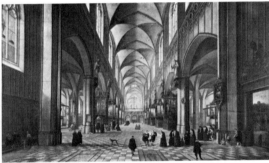

JEAN-BAPTISTE OUDRY
*Portrait of Lady Mary
Josephine Drummond*

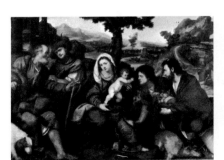

PALMA VECCHIO (attr)
The Adoration of the Shepherds

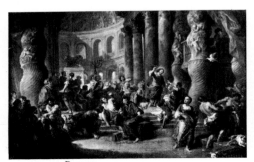

GIOVAN PAOLO PANNINI
Christ Driving the Money-Changers from the Temple

JUAN PANTOJA DE LA CRUZ
*Portrait of a Knight
of St. James*

JUAN PANTOJA DE LA CRUZ
*Portrait of Philip III
of Spain*

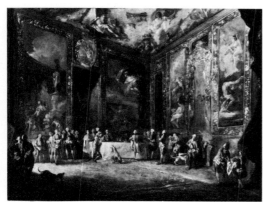

PARMIGIANINO
*Portrait of a Lady with
Three Children*

PARMIGIANINO
*The Holy Family with
an Angel*

JOACHIM PATINIR
The Temptation of St. Anthony Abbot

LUIS PARET Y ALCÁZAR
Charles III of Spain at Table Before his Courties

PENSIONER
OF SARACENI (attr)
The Bird Seller

ANTONIO DE PEREDA
Y SALGADO
St. Jerome

ANTONIO DE PEREDA Y SALGADO
*The Relief of Genoa by the Second Marquis
of Santa Cruz*

JOACHIM PATINIR
The Rest on the Flight to Egypt 1611

BARTOLOMÉ PÉREZ
A Vase of Flowers 1051

LEÓN PICARDO
The Annunciation

PIETRO DA CORTONA (copy?)
The Nativity

PONTORMO (attr)
The Holy Family

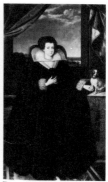

POURBUS THE YOUNGER
*Portrait of Isabella
of Bourbon, Wife of
Philip IV of Spain*

PAULUS POTTER
Animals in a Meadow

NICOLAS POUSSIN
Landscape with Polyphemus and Galatea

NICOLAS POUSSIN (attr)
Landscape with a Hermit Preaching to the Animals

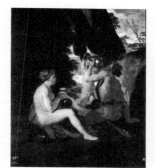

NICOLAS POUSSIN
Bacchanal

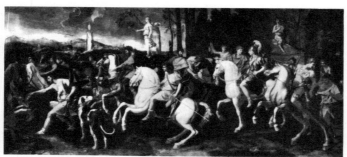

NICOLAS POUSSIN (attr)
Meleager and Atalanta (?)

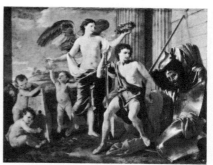

NICOLAS POUSSIN
The Triumph of David

92

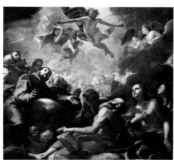

MATTIA PRETI
Christ in Glory with Saints

GIULIO CESARE PROCACCINI
*Madonna and Child with Angels
in a Garland*

HENRY RAEBURN
*Portrait of Mrs. MacLean
of Kinlochline*

RAPHAEL (st)
The Fall on the Road to Calvary

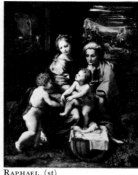

RAPHAEL (st)
The Holy Family ("La Perla")

JEAN RANC
*Portrait of the Cardinal-
Infante Don Luis
Antonio of Bourbon*

GIUSEPPE RECCO
Still Life with Fish and a Tortoise

REMBRANDT
Self-portrait

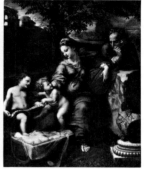

RAPHAEL (st)
The Madonna della rosa

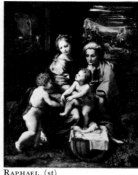

RAPHAEL (st)
*The Holy Family with St. John
under an Oak-tree*

GUIDO RENI
St. Peter and St. Paul

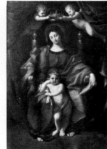

GUIDO RENI
*Portrait of a Girl with
a Rose in her Hand*

GUIDO RENI
*The Madonna
della seggiola*

FRANCISCO RIBALTA
*St. Francis Comforted by
an Angel Playing a Lute*

FRANCISCO RIBALTA (attr)
Christ Embracing St. Bernard

MARINUS VAN REYMERSWAELE
St. Jerome 2100

JOSÉ RIBERA
St. Christopher

JOSÉ RIBERA
Aesop

JOSÉ RIBERA
Isaac and Jacob

JOSÉ RIBERA
The Holy Trinity

JOSÉ RIBERA
Jacob's Dream

JOSÉ RIBERA
An Elderly Money-lender

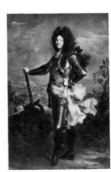

HYACINTHE RIGAUD Y ROS
*Portrait of Louis XIV
of France*

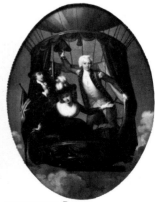

JOHN-FRANCIS RIGAUD
*The Three Favorite
Balloonists*

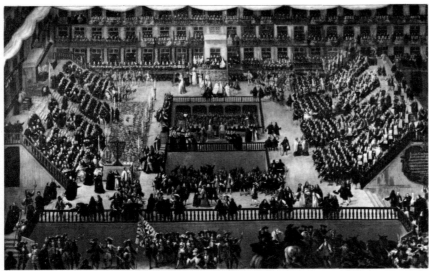

FRANCISCO RIZI DE GUEVARA
An Autodafé in Plaza Mayor at Madrid

JUAN ANDRÉS RIZI DE GUEVARA
St. Benedict's Dinner

FERNANDO RINCÓN DE FIGUEROA
*St. Cosmas and St. Damian
Performing Miracles*

JUAN ANDRÉS RIZI DE GUEVARA
St. Benedict and St. Maurus

GEORGE ROMNEY
Portrait of Master Ward

SALVATOR ROSA
The Gulf of Salerno

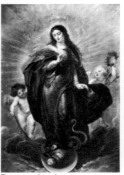

RUBENS (attr)
The Immaculate Conception

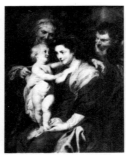

RUBENS
*The Holy Family with
St. Anne*

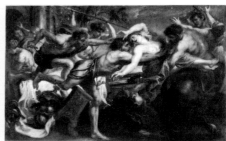

RUBENS
The Rape of Deidamia

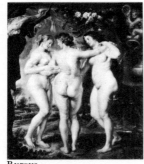

RUBENS
The Three Graces

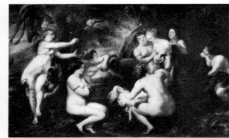

RUBENS
Diana and Callisto

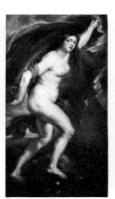

RUBENS
Fortune

RUBENS
*Saturn Devouring
One of his Sons*

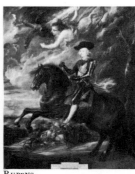

RUBENS
*Portrait of the Cardinal-
Infante Don Ferdinand of
Austria at the Battle
of Nordlingen*

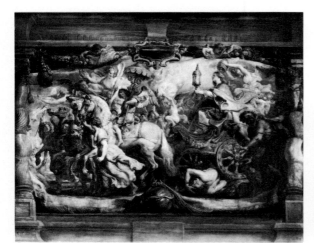

RUBENS
The Triumph of the Church

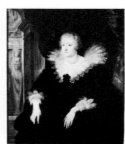

RUBENS
*Portrait of Anne of Austria,
Queen of France*

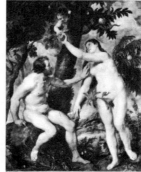

RUBENS
Adam and Eve

RUBENS and
JAN BRUEGHEL THE ELDER
*Madonna and Child
within a Frame of Fruit
and Flowers*

JACOB ISAACKSZ. VAN RUISDAEL
Landscape

ANDREA SACCHI
St. Rosalia of Palermo

CECCHINO DEL SALVIATI
Madonna and Child

ALONSO SÁNCHEZ COELLO
Portrait of Prince Carlos

ALONSO SÁNCHEZ COELLO
*Portrait of a Young
Woman*

FRANS SNIJDERS
The Cook in the Larder

MARTIN ARCHER SHEE
Portrait of Mr. Storer

SEBASTIANO DEL PIOMBO
Christ in Limbo

JAIME and PEDRO SERRA (st)
*Scenes from the Life of St. John the Baptist
and St. Mary Magdalene*

FRANCESCO SOLIMENA
Self-portrait

MASSIMO STANZIONE
St. John the Baptist Preaching in the Desert

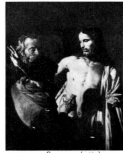

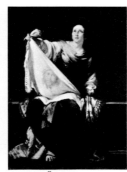

MATTHIAS STOMER (attr)
*The Incredulity of
St. Thomas*

BERNARDO STROZZI
St. Veronica

DAVID TENIERS II
The Archduke Leopold William in his Gallery of Paintings at Brussels

DAVID TENIERS II
The Alchemist

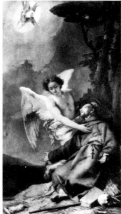

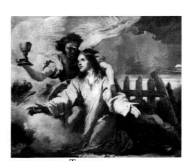

GIAMBATTISTA TIEPOLO
*St. Francis of Assisi
Receiving the Stigmata*

GIAMBATTISTA TIEPOLO
*St. Anthony of Padua with
the Christ Child*

GIAMBATTISTA TIEPOLO
An Angel Carrying the Eucharist

GIAMBATTISTA TIEPOLO
*St. Paschal
Baylón 364a*

GIANDOMENICO TIEPOLO
Christ in the Garden of Gethsemane

95

TINTORETTO (attr)
*Portrait of a Venetian
Senator or Secretary*

TINTORETTO
*Portrait of a Gentleman
with a Gold Chain*

TINTORETTO
*Portrait of a Venetian
Magistrate*

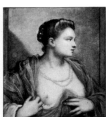

TINTORETTO (attr)
*Portrait of a Lady
Revealing her Breast*

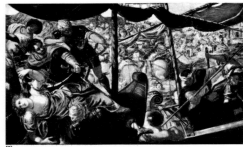

TINTORETTO
Scene of Battle between Turks and Christians

96

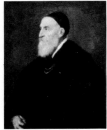

TITIAN
Self-portrait

TITIAN
*Portrait of a Gentleman
with his Hand
on a Watch*

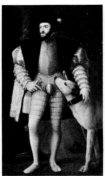

TITIAN
*Portrait of the Emperor
Charles V*

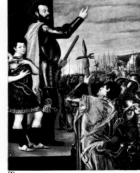

TITIAN
*The Marchese del Vasto
Addressing his Troops*

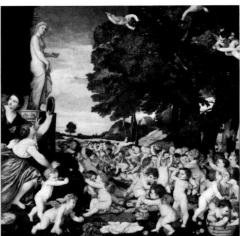

TITIAN
The Worship of Venus

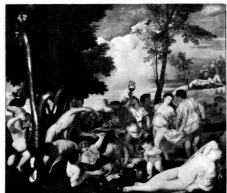

TITIAN
Bacchanal of the Andrians

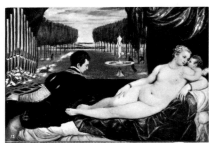

TITIAN
Venus with Cupid and an Organist

TITIAN
The Entombment of Christ 440

TITIAN
St. Margaret and the Dragon

LUIS TRISTÁN
A Female Saint Weeping

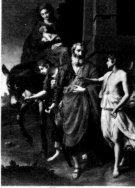

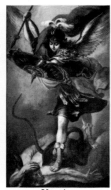

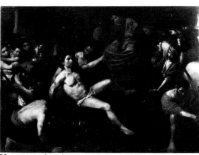

ALESSANDRO TURCHI
The Flight to Egypt

JUAN DE VALDÉS LEAL
St. Michael

VALENTIN (attr)
The Martyrdom of St. Lawrence

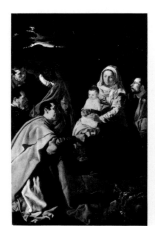

VELÁZQUEZ
The Adoration of the Magi

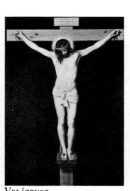

VELÁZQUEZ
Christ on the Cross 1167

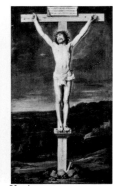

VELÁZQUEZ
Christ on the Cross 2903

VELÁZQUEZ
*Portrait of Philip IV
of Spain* 1182

VELÁZQUEZ
*Portrait of Philip IV
of Spain* 1184

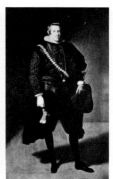

VELÁZQUEZ
*Portrait of the Infante
Don Carlos*

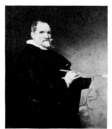

VELÁZQUEZ
Portrait of a Sculptor

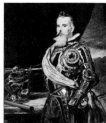

VELÁZQUEZ
*Portrait of Juan
Francisco Pimentel*

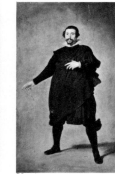

VELÁZQUEZ
*Portrait of Don Diego
de Corral y Arellano*

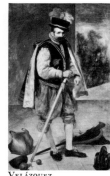

VELÁZQUEZ
*Portrait of Pablo
de Valladolid*

VELÁZQUEZ
*Portrait of the Jester
known as Don John
of Austria*

VELÁZQUEZ
Menippus

VELÁZQUEZ
*The Fountain of the Tritons in the
Gardens at Aranjuez*

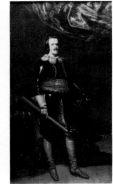

VELÁZQUEZ
*Philip IV
in Armor with
a Lion at his Feet*

VELÁZQUEZ
*Portrait of the Jester
Don Sebastián de Morra*

VELÁZQUEZ
The "Boy of Vallecas"

VELÁZQUEZ
*Portrait of the Jester
Juan Calabazas*

VELÁZQUEZ
Self-portrait (?)

97

VERONESE
Venus and Adonis

VERONESE
*Portrait of a Lady with
a Lapdog*

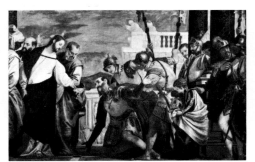

VERONESE
Christ and the Centurion

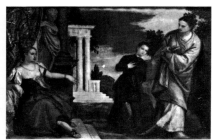

VERONESE
A Young Man between Vice and Virtue

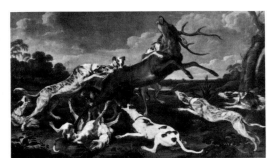

PAUL DE VOS
A Stag Pursued by a Pack of Hounds

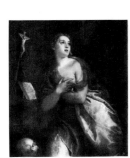

VERONESE
The Penitent Magdalene

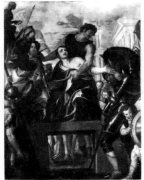

VERONESE
The Martyrdom of St. Mennas

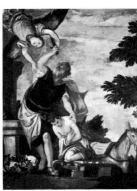

VERONESE
The Sacrifice of Isaac

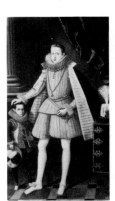

RODRIGO DE VILLANDRANDO
*Philip IV with the
Dwarf called "Soplillo"*

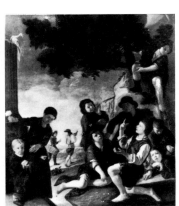

PEDRO NÚÑEZ DE VILLAVICENCIO
Children Playing

CORNELIS DE VOS
The Birth of Venus

SIMON VOUET
Time defeated by Youth and Beauty

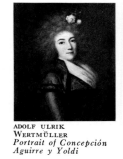

JEAN-ANTOINE WATTEAU
A Marriage Contract and Dancing in the country and *Merrymaking in a Park*

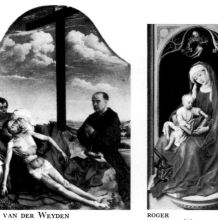

PHILIPS WOUWERMAN
The Hare Hunt

ROGER VAN DER WEYDEN
Pietà

ROGER
VAN DER WEYDEN (attr)
Madonna and Child

ROGER VAN DER WEYDEN
Christ and his Disciples

FERNANDO YÁÑEZ
DE LA ALMEDINA
Madonna and Child

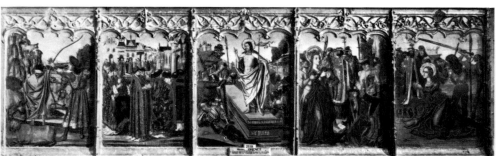

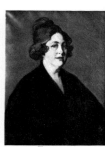

MIGUEL XIMÉNEZ
The Resurrection of Christ with Scenes from the Legend of St. Michael and from the Martyrdom of St. Catherine

ANTONIO ZANCHI
The Penitent Magdalene

IGNACIO ZULOAGA
*Portrait of Mrs. Alice
Lolita Muth Ben Maacha*

FRANCISCO ZURBARÁN
The Defense of Cadiz against the English

FRANCISCO ZURBARÁN
St. Casilda

FRANCISCO ZURBARÁN
*St. Luke Dressed as a Painter before
Christ on the Cross*

FRANCISCO ZURBARÁN
The Immaculate Conception

FRANCISCO ZURBARÁN (st?)
St. Euphemia

Catalogue - in Spanish and English - of the Paintings in the Prado Museum

List of abbreviations

act	active
ar	arched
attr	attributed
c	circa
centr	central
crt	cartoon
cv	canvas
d	dated, date
dip	diptych
drw	drawing
etc	etcetera
ext	exterior
frm	fragment
frs	fresco
ins	inscribed, inscription
int	interior, internal
l	left
min	miniature
mod	modern
mxt	mixed technique
no	number
p	page
pn	panel
pp	paper
prec	preceding
pred	predella
ptg	painting
r	right
repl	replica
res	restored
rv	reverse
sg	signed, signature
st	studio
td	tondo
tmp	tempera
trp	triptych
wat	watercolor
wk	work

Measurements are given in inches and in centimeters: first the height, then the width.

The arrow → indicates the number of a color plate; the asterisk * means that the work is reproduced in black and white in the section "Other important paintings in the Prado" (pages 77-98).

The bar indicates that the support has been changed. For example: cv/pn = transferred from canvas onto panel.

The dash - refers to a double technique.

When no mention is made of the technique, it is understood that it is oil or tempera; when the support is not indicated, it is understood that it is paper if it is about a watercolor or a pastel, and ivory if it is about a miniature.

ADRIAENSSEN Alexander
Antwerp 1587 – 1661
Bodegón
Still life 1341, 1342, 1343
panels 23.6×35.8 (60×91 cm) sg
Bodegón
Still life 1344
pn 23.2×24.0 (59×61 cm) sg

AGÜERO Benito Manuel de
Burgos 1626 (?) – 1670 (?)
Un puerto- fortificado
A fortified harbour
cm 21.3×77.2 (54×196 cm)
Paisaje con una ninfa y un pastor
Landscape with a nymph and a shepherd
cv 22.0×78.3 (56×199 cm)
Paisaje con Dido y Eneas
Paisaje: salida de Eneas de Cartago
Landscape with D. and Aeneas and with the departure of Aeneas from Carthage
canvases 96.9×79.5 and 94.1 ×80.7 (246×202 cm and 239× 205 cm)
Paisaje con Mercurio y Argos
Landscape with Mercury and Argus
cv 97.6×128 (248×325 cm)

ALBANI Francesco
Bologna 1578 – 1660
El tocador de Venus *
El juicio de Paris
The toilet of V.; The judgement of P.
panels 44.9×67.3 and 44.5× 67.3 (114×171 cm and 113×171 cm) the second sg (defaced in 1968); c 1622-3 (?)

ALLORI Alessandro
Florence 1535 – 1607
La Sagrada Familia y el Cardenal Fernando de Médicis *
The Holy Family with Cardinal Ferdinando de' Medici
cv 103.5×19.1 (263×201 cm) sg d 1584; ins

ALLORI Cristofano
Florence 1577 – 1621
Cristina de Lorena, duquesa de Florencia
Portrait of Christine of Lorraine, Duchess of Florence
cv 85.8×55.1 (218×140 cm)

ALSLOOT Denis van
Brussels c 1570 – c 1626
Mascarada patinando *
Masked skaters
cv 22.4×39.4 (57×100 cm)
Fiestas del Ommeganck o Papagayo, en Bruselas:
Procesión de gremios
Procesión de Ntra. Sra. del Sablón
Fiesta de Ntra. Sra. del Bosque
The O. Procession at Brussels:
The P. of the Guilds and Crafts; of Our Lady of the Sands;

The Feast of Our Lady of the Wood
canvases 51.2×149.6 and 61.0 ×93.7 (130×380 and 382 cm; 155×238 cm)
sg d 1616

AMBERGER Christoph
... c 1505 – Augsburg 1561-2
El orfebre de Augsburgo Jörg Zorer (?) *
La esposa de Jörg Zörer
Portraits of J. Z., the Augsburg goldsmith (?) and of his wife
panels 30.7×20.1 and 26.8× 20.1 (78×51 cm and 68×51 cm) d 1531

AMIGONI Jacopo
Naples 1682 (?) – Madrid 1752
La Santa Faz
The Veil of St. Veronica
cv 47.6×61.4 (121×156 cm) sg
La infanta María Isabel
Portrait of the I. M. I.
cv 29.5×24.8 (75×63 cm)
La Infanta María Teresa Antonia
Portrait of the I. M. T. A.
cv 40.6×33.1 (103×84 cm)
El Marqués de la Ensenada
Portrait of Zenón de Somodevilla, Marquis of la E.
cv 48.8×40.9 (124×104 cm)

ANDREA DEL SARTO
(Andrea d'Agnolo)
Florence 1486 – 1530
Lucrecia di Baccio del Fede, mujer del pintor *
Portrait of the artist's wife, Lucrezia di B. del F.
pn 28.7×22.0 (73×56 cm) c 1517 o
La Virgen, el Niño, un Santo y un Ángel → no 100
The Madonna della Scala
pn 69.7×53.1 (177×135 cm) sg c 1522-3
La Sagrada Familia
The Holy Family
pn 55.1×44.1 (140×112 cm)
El Sacrificio de Isaac detenido por un ángel *
The Sacrifice of I.
pn 38.6×27.2 (98×69 cm) c 1529 (?)
La Virgen y el Niño Jesús
Madonna and Child
pn 33.9×26.8 (86×68 cm)
La Virgen, el Niño, San Juan y dos Ángeles
Madonna and Child with St. John and Two Angels
pn 41.7×31.1 (106×79 cm)

ANGELICO Fra
(Fra Giovanni da Fiesole)
Vicchio di Mugello (?) c 1400 – Rome 1455
La Anunciación → no 90
The Annunciation (pred: The Birth of the Virgin, The Marriage of the Virgin, The Visitation, The Adoration of the Magi, The Presentation of Christ in the Temple, The Death of the Virgin)
pn 76.4×76.4 (194×194 cm) c 1430-2 original frame

ANGUISSOLA Lucia
Cremona c 1538 – 1565
Pietro María, médico de Cremona
Portrait of P. M., a Cremonese doctor
pn 37.8×29.9 (96×76 cm) sg

Anónimo see also **MAESTRO**

ANÓNIMO ALEMÁN
[ANONYMOUS GERMAN ARTIST]
Early Sixteenth Century, Rhineland
"Ecce Homo"
pn 17.7×14.6 (45×37 cm) c 1510

ANÓNIMOS ESPAÑOLES
[ANONYMOUS SPANISH ARTISTS]
Early Twelfth Century
Pinturas murales de San Baudelio de Casillas de Berlanga → no 1
Wall paintings from S. B. of C. of B. (Castile) (Stag hunt; Elephant; Soldier or Beater; Bear; Hare hunt; Baldacchino)
frm; frescoes/canvases 72.8× 96.9; 80.7×53.5; 114.2×52.8; 79.5×44.5; 72.8×141.7; 61.0× 44.9 (185×246 cm; 205×136 cm; 290×134 cm; 202×113 cm; 185×360 cm; 155×114 cm)
Pinturas murales de la ermita de la Cruz de Maderuelo (Segovia) → no 2
Wall paintings from the Hermitage of the Cross at M., near Segovia (Castile) (ceiling: Christ Pantocrator; The Annunciation; St. Matthew, St. Luke, St. Mark and St. John the Evangelist; Angels with Censer, Scroll and Book; Archbishop Saint. lunettes: Cain and Abel making Offerings to the Lamb; The Creation of Adam and The Original Sin. walls: Apostles; Mary Magdalene · anointing Christ's Feet; Madonna and Child with one of the Magi)
frescoes/canvases 196.1×177.2 (498×450 cm) (reconstruction of the whole series) c 1125 ins

Late Thirteenth Century, Catalonia
Retablo de San Cristóbal *
Altar of St. Christopher
ar pn 266×184 cm ins original frame

Early Fourteenth Century, Catalonia
Frontal de Guills *
Altar frontal from Guills
pn 36.2×68.9 (92×175 cm)

Early Fifteenth Century, Castile
Retablo del Arzobispo Don Sancho de Rojas
Polyptych of Archbishop D. S. d R. (Madonna and Child

Scenes from the Life and Passion of Christ; The Descent to Limbo; The Ascension; The Descent of the Holy Ghost; The Mass of St. Gregory; etc. Pred: Heads of Saints)
panels between 59.1×32.3 and 6.3×6.3 (150×82 cm and 16× ×16 cm) gold ground c 1415-22 coat of arms

Fifteenth Century
El Martirio de San Vicente, I *-II
panels 98.4×33.1 (250×84 cm) c 1450

Second Half of the Fifteenth Century, Hispano-Flemish School
La Anunciación
El Marqués de Santillana o su hijo el I Duque del Infantado orante *
La Natividad
Tránsito de la Virgen
The Annunciation; Portrait of the First Marquis of S. or his son the First Duke of the I. at prayer; the Nativity; The Death of the Virgin
trp wings; panels 40.6×23.6 (103×60 cm)

Late Fifteenth Century, Hispano-Flemish School
San Miguel Arcángel → no 7
St. Michael
cv/pn 95.3×60.2 (242×153 cm) c 1475; from the Hospital of San Miguel de Zafra
La Virgen de los Reyes Católicos
The Madonna of the Catholic Monarchs
pn 48.4×44.1 (123×112 cm) c 1490
La Visitación
El nacimiento de San Juan Bautista
La predicación de San Juan Bautista
El bautismo de Cristo
Prisión de San Juan Bautista
La degollación del Bautista *
The Visitation; The Birth of St. John the Baptist; St. J. the B. Preaching; The Baptism of Christ; The Arrest of St. J. the B; The Beheading of St. J. the B.
panels c 38.2×c 21.3; the third and the fourth 44.5×27.6; c 97×c 54 cm; the third and the fourth 113×70 cm; from the Carthusian Monastery of Miraflores (Burgos)

Late Fifteenth Century
La Virgen del Caballero de Montesa *
The Madonna of the Knight of M.
pn 40.0×37.8 (102×96 cm) attr. to the school of Rodrigo de Osona (act at Valencia 1476-84) or to Paolo Sancto Leocadio called also Pablo d'Aregio (Arezzo [?] or Reggio [?] act Spain 1471-81)

Translación del cuerpo de Santiago el Mayor: I, Embarque en Jafa; II, La conducción en Galicia *
The Translation of the Body of St. James the Great. Scene I: The Embarkation at Jaffa. Scene II: The Journey to G.
panels 62.6×28.7 (159×73 cm) attr to the school of Miguel Ximénez

Early Sixteenth Century
Un conquistador de Indias (?)
Portrait of a conqueror of the West Indies (?)
pn 13.0×9.4 (33×24 cm) ins
San Gregorio, San Sebastián y San Tirso
St. Gregory, St. S. and St. T.
pn 57.9×48.8 (147×124 cm)

Mid-Sixteenth Century
Don Diego Hurtado de Mendoza (?)
pn 17.7×13.0 (45×33 cm)

Seventeenth Century
El Hermano Lucas Texero ante el cadáver del Venerable P. Bernardino de Obregón
Brother L. T. beqore the body of the V. Father B. de O.
cv 42.5×1 (108×163 cm) d 1627 ins
La Reina Isabel de Borbón, primera mujer de Felipe IV
Portrait of Isabella of Bourbon, first wife of Philip IV of Spain
cv 49.6×35.8 (126×91 cm) attr to Angelo Nardi (Razzo di Mugello 1584 – Spain 1663-5)

Seventeenth Century, Madrid
Florero 3156 *, 3157 *
Vase of flowers
canvases 105×84
Bodegón
Still life
cv 100×127

ANÓNIMOS FLAMENCOS [ANONYMOUS FLEMISH ARTISTS]
Early Sixteenth Century
Milagro en Tolosa de San Antonio de Padua
St. Anthony of P. performing a Miracle at Toulouse
pn 47.6×31.5 (121×80 cm) c 1500
La Adoración de los Magos 2217
The Adoration of the Magi (centr pn: The Adoration of the Magi; wings: St. Joseph and The Negro King)
trp; panels, centr pn 41.3×28.0; wings 41.3×13.4 (105×71 cm; 105×34 cm)
La Crucifixión
The C.
pn 32.7×52.0 (83×132 cm) c 1518
La Sagrada Familia
The Holy Family
pn 15.0×13.0 (38×33 cm) c 1518
La Adoración de los Magos 1361
The Adoration of the Magi (centr pn: The Adoration of the Magi; wings: Herod receiving Gifts sent by the Magi and The Queen of Sheba before Solomon)
trp; panels, centr pn 22.8×11.8; wings 22.8×4.7 (58×30 cm; 58×12 cm) with a symbolic owl (sg (?)) c 1520
Nacimiento e infancia de Cristo
The Birth and Childhood of Christ (int, centr pn: The Adoration of the Magi; wings: The Nativity and The Flight to Egypt. ext: The Annunciation grisaille)
trp; panels, centr pn 53.1×34.3; wings 53.1×13.0 (135×87 cm; 135×33 cm) c 1520
Los desposorios místicos de Santa Catalina
The Mystical Marriage of St. Catherine (centr pn: Madonna and Child with St. Catherine and another Female Saint; wings: Donor (?) and St. Ursula)
trp; panels, centr pn 35.4×24.4 (90×62 cm); wings 36.6×10.2 (93×26 cm) c 1520

ANÓNIMO FLAMENCO HOLANDÉS [ANONYMOUS DUTCH-FLEMISH ARTIST]
Sixteenth Century
San Jerónimo *
St. Jerome
pn 21.6×16.1 (55×41 cm)

ANÓNIMOS FRANCESES [ANONYMOUS FRENCH ARTISTS]
First Half of the Seventeenth Century
La degollación de San Juan Bautista
The Beheading of St. John the Baptist
cv 110.2×374.8 (280×952 cm) c 1650 with portraits of Henry IV of France, Ferdinand II, Wallenstein etc.
La Primavera
El Estío
Spring; Summer
canvases 77.2×43.3 (196×110 cm)

First Half of the Eighteenth Century
Retrato de Isabel de Farnesio *
Portrait of Isabelle Farnese
cv 98×72

Second Half of the Eighteenth Century
El músico Grétry
Portrait of the composer G.
cv 22.4×18.1 (57×46 cm)

ANÓNIMOS ITALIANOS [ANONYMOUS ITALIAN ARTISTS]
Sixteenth Century, Emilian School
El tañedor de viola
Portrait of a v. player
pn 30.3×23.2 (77×59 cm) c 1540; formerly attr to Bronzino

Late Sixteenth Century, Venetian School
Paolo Contarini
cv 46.1×35.8 (117×91 cm) ins; res 1961

Late Seventeenth Century, Neapolitan School
Bodegón de aves
Still life with birds
cv 37.4×32.7 (95×83 cm)

Early Eighteenth Century
Paseo al borde del mar
A walk by the seaside
cv 7.1×8.7 (18×22 cm)

ANTOLÍNEZ Francisco
Seville 1644 – Madrid 1700
La Presentación de la Virgen
Los Desposorios de la Virgen
La Natividad
La huida a Egipto
The Presentation of the Virgin in the Temple; The Marriage of the V.; The Nativity; The Flight to Egypt
canvases 17.7×28.7 (45×73 cm)

ANTOLÍNEZ José
Madrid 1635 – 1675
El tránsito de la Magdalena *
The Ecstasy of the Magdalene
cv 80.7×64.1 (205×163 cm)
La Inmaculada Concepción
The Immaculate Conception
cv 85.0×62.6 (216×159 cm) sg d 1665

ANTONELLO DA MESSINA
Messina c 1430 – 1479
Cristo muerto sostenido por un ángel → no 95
The Dead Christ
pn 29.1×20.1 (75×51 cm) c 1475

ANTONIAZZO ROMANO (Antonio Aquili)
act 1460 – 1508 in Rome and Lazio
La Virgen con el Niño *
Madonna and Child
frs 51.2×43.3 (130×110 cm) attr
Tríptico
Triptych. Int: *The Head of Christ with St. John the Baptist and St. Peter. Ext: St.*

John the Evangelist and St. Columba
panels; centr pn 34.3×24.4 (87×62 cm); wings 37.0×13.8 (94×35 cm) ins attr

Antonio Moro see MORO

ARELLANO Juan de
Santorcaz 1614 – Madrid 1676
Florero 592, 593
A basket of flowers
canvases 32.7×24.8 (83×63 cm)
Florero 594, 595
A vase of flowers
canvases 40.6×30.3 (103×77 cm)
Florero 596, 597
canvases 23.6×18.1 (60×46 cm); the second sg
Florero y paisaje 2507, 2508
Landscape framed in flowers
canvases 22.8×28.7 (58×73 cm); sg d 1652
Floreo 3138, 3139 *
A vase of flowers
canvases 84×100 cm sg

ARIAS FERNÁNDES Antonio
Madrid ... – 1684
La moneda del César
The Tribute Money
cv 75.2×90.6 (191× 230 cm) sg d 1646
La Virgen y el Niño Jesús
Madonna and Child
cv 35.8×50.8 (91×129 cm) sg d 165...

ARPINO Cavalier d' (Giuseppe Cesari)
Arpino 1568 – Rome 1640
La Sagrada Familia con San Juan
The Holy Family with St. John
cv 35.0×26.4 (89×67 cm); attr; recently res

ARTHOIS, Jacques
Brussels 1613 – 1686
Paisaje 1351
Landscape
cv 45.3×56.7 (115×144 cm) sg
Paisaje 1354, 1355
panels 16.1×26.0 (41×66 cm)
Paseo a la orilla de un río
A walk by a river bank
cv 95.3×95.3 (242×242 cm)
Descanso a la orilla de un río
A rest by a river bank
cv 24.0×37.0 (61×94 cm)
the figures attr to Peter Bout

ASSERETO Gioacchino
Genoa 1600 – 1649
Moisés y el agua de la roca *
Moses striking the Rock
cv 96.5×118.1 (245×300 cm)

BACKER Adriaen
Amsterdam 1635-6 – 1684
Un general
Portrait of a general
cv 49.6×41.7 (126×106 cm) sg d 1680

BALDUNG GRÜN Hans
Schwäbisch-Gmünd 1484-5 – Strasbourg 1545
La Armonía o Las Tres Gracias → no 169
Las edades y la Muerte *
Harmony or The three Graces The three ages of man and Death
panels 59.4×24.0 (151×61 cm) rv of the first ins

Balen see under Brueghel Jan, the Elder

BAROCCI Federico
Urbino 1526 – 1612
El Nacimiento
The Nativity
cv 52.8×41.3 (134×105 cm) 1597 (?)
Crucificado *
Christ on the Cross
cv 147.2×96.9 (374×246 cm) 1604 in collaboration with st assistants

Bartolomeo di Giovanni see under Botticelli

BARTOLOMEUS
act in the late Fifteenth Century in Spain
La Virgen de la leche
Madonna and Child
pn 20.5×13.8 (52×35 cm) sg; formerly attr to Bermejo

BASSANO Francesco (F. da Ponte)
Bassano 1549 – Venice 1592
La adoración de los Magos
The Adoration of the Magi
cv 33.9×28.0 (86×71 cm) sg
La Última Cena *
The Last Supper
cv 59.4×84.3 (151×214 cm) sg res

BASSANO Jacopo (J. da Ponte)
Bassano 1516-9 – 1592
La reconvención a Adán
The Rebuking of Adam
cv 75.2×113.0 (191×287 cm) sg
Entrada de los animales en el arca de Noé
The Animals entering Noah's Ark
cv 81.5×104.3 (207×265 cm)
La adoración de los pastores *
The Adoration of the Shepherds
cv 50.4×40.9 (128×104 cm)
Expulsión de los mercaderes del templo 27, 28
Christ driving the Money-Changers from the Temple
canvases 59.1×72.4 (150×184 cm) and 58.7×91.7 (149×233 cm); the second damaged
see also Bassano Leandro

BASSANO Leandro (L. da Ponte)
Bassano 1557 – Venice 1622
El rico avariento y el pobre Lázaro
La vuelta del hijo pródigo
The Rich Man and Lazarus; The Return of the Prodigal Son
canvases 59.1×79.5 (150×202 cm) and 57.9×78.7 (147×200 cm); the first formerly attr to Jacopo Bassano
La Virgen María en el cielo
The Virgin in Glory
cv 68.9×55.1 (175×140 cm) on the l and r hand sides, saints in medallions in a mock frame
Venecia: embarco del Dux
The Embarkation of the Doge at Venice
cv 78.7×234.0 (200×597 cm) sg

BASSANTE or PASSANTE Bartolomeo
Brindisi 1614 – Naples 1656
Adoración de los pastores
The Adoration of the Shepherds
cv 39.0×51.6 (99×131 cm) sg

BATONI Pompeo Girolamo
Lucca 1708 – Rome 1787
Un caballero en Roma: Charles Cecil Roberts *
Portrait of C. C. R.
cv 87.0×61.8 (221×157 cm) sg d 1778

Battistello see CARACCIOLO

BAUDRY Paul
La Roche-sur-Yon 1828 – Paris 1886
La perla y la ola
The pearl and the sea
cv 32.7×68.9 (83×175 cm) sg d 1862

BAYEU Y SUBÍAS Francisco
Saragossa 1734 – Madrid 1795
La Asunción de la Virgen
The Assumption of the Virgin
sketch; cv 53.9×31.9 (137×81 cm)
El triunfo del Cordero de Dios
The Triumph of the Lamb of God
sketch; cv 18.9×22.8 (48×58 cm)
El Olimpo: la batalla con los Gigantes
The Olimpo: the battle with the Gods and Giants
sketch; cv 26.8×48.4 (68×123 cm)

El Paseo de las Delicias, en Madrid
The walk in the Garden of Delights in M.
sketch; cv 14.6×21.7 (37×55 cm)
Merienda en el campo → no 65
A picnic in the country
sketch; cv 14.6×22.0 (37×56 cm) sg
Feliciana Bayeu, hija del pintor *
Portrait of F. B., the artist's daughter
cv 15.0×11.8 (38×30 cm) c 1788 ins
La creación de Adán
Abraham en oración
San Lucas
San Juan Evangelista
San Mateo
San Marco
Adán y Eva reconvenidos por su pecado *
The Creation of Adam; Abraham at Prayer; St. Luke; St. John the Evangelist; St. Matthew; St. Mark; The Rebuking of Adam and Eve The Sacrifice of the Mosaic Law
sketches; canvases; the first two 23.2×13.0 (59×33 cm); the last two 23.2×12.6 (59×32 cm); the others 22.8×22.8 (58×58 cm)
La rendición de Granada
The surrender of G.
sketch; cv 21.3×22.4 (54×57 cm)
La merienda
The picnic
tapestry crt/cv 190.5×68.1 (278×173 cm)
Santa Teresa de Jesús en la gloria
St. Theresa in Glory
sketch; cv 16.9×39.4 (43×100 cm)

BAYEU Y SUBÍAS Ramón
Saragossa 1746 – Aranjuez 1793
El Choricero *
The salt meat seller
tapestry crt/cv 87.4×41.7 (222×106 cm)
Abanicos y roscas *
Sellers of fans and buns
tapestry crt/cv 57.9×73.6 (147×187 cm)
Obsequio campestre
Rustic chivalry
tapestry crt/cv 72.0×57.5 (183×146 cm)
El majo de la guitarra *
The guitar player
tapestry crt/cv 72.4×53.9 (184×137 cm)
El ciego músico
The blind musician
tapestry crt/cv 36.6×57.1 (93×145 cm)
El muchacho de la esportilla
A boy with a basket
tapestry crt/cv 36.6×55.5 (93×141 cm)
Cuadro con trece bocetitos para cartones de tapices
Thirteen sketches for tapestry cartoons (Help for the wayfarer, The salt meat seller, The guitar player, The flower seller, By the well, Pustic chivalry, The bun seller; two listels with: Trees, Boys playing at bull fighting, A game of cards, Christmas night in the Kitchen, The game of skittles)
canvases 17.7×c 39.4 altogether (45×c 100 cm)

BEAUBRUN Charles and Henri
Amboise 1604 and 1603 – Paris 1692 and 1677
Ana María Luisa de Orléans *
Portrait of Anne Marie Louise d'O. ('la Grande Mademoiselle')
cv 42.9×34.6 (109×88 cm) sg d (disappeared) 1655
El Gran Delfín, padre de Felipe V
Portrait of the Dauphin Louis, father of Philip V of Spain
cv 50.8×38.6 (129×98 cm) sg d 1663
Ana de Austria, Reina de Francia
Portrait of Anne of Austria, Queen of France
cv 44.1×34.6 (112×88 cm) sg

BEET or **BEERT Osias**
Antwerp 1622 – Antwerp (?) c 1678
Bodegón *
Still life
pn 16.9×21.3 (43×54 cm) sg

Beke see **CLEVE**

BELLEVOIS or **BELLEBOIS Jacob Adriaensz**
Rotterdam 1621 – 1675
Marina
Seascape
pn 23.2×31.9 (59×81) sg

BELLINI Giovanni
Venice 1426 (?) – 1516
La Virgen y el Niño entre dos Santas *
Madonna and Child with St. Mary Magdalene and St. Ursula
pn 30.3×40.9 (77×104 cm) sg c 1490; in collaboration with st assistants

BELVEDERE Andrea
Naples c 1652 – 1732
Florero 549, 550 *
A vase of flowers
canvases 59.4×39.4 (151×100 cm) sg

BENSON Ambrosius
... – Bruges 1550
Santo Domingo de Guzmán
Santo Tomás (?) y un donador
La Piedad
El entierro de Cristo
El nacimiento de la Virgen *
El abrazo ante la Puerta Dorada
St. Dominic of G.; St. Thomas (?) and a Donor; Pietà; The Entombment of Christ; The Birth of the Virgin; The Meeting at the Golden Gate
panels; the first two 40.9×22.4; 48.8 and 49.2×23.6; the last two 45.3×23.6 (104×57 cm; 124 and 125× 60 cm; 115×60 cm)
Santa Ana, el Niño Jesús y la Virgen
Madonna and Child with St. Anne
pn 49.2×35.4 (125×90 cm) same series as the prec paintings (?)

BERMEJO [RUBEUS] Bartolomé de Cardenas
act 1474–95 Cordova
Santo Domingo de Silos entronizado como abad → no 5
St. Dominic of S.
centr trp pn 95.3×51.2 (242×130 cm); 1474-7 gold ground; see also Bartolomeus

BERNINI Gian Lorenzo
Naples 1598 – Rome 1680
Autorretrato *
Self-portrait
cv 18.1×12.6 (46×32 cm) c 1640

Berrettini see **PIETRO DA CORTONA**

BERRUGUETE Pedro
Paredes de Nava (?) c 1450 – ... 1504
La Adoración de los Reyes → no 3
Dos Reyes Magos
The Adoration of the Magi; Two M.
organ doors; canvases 137.8×81.1 (350×206 cm); two other paintings (St. Peter and St. Paul) are at the Valladolid Museum
Santo Domingo y los Albigenses → no 4
Santo Domingo resucita a un joven *
Aparición de la Virgen a una comunidad *
Santo Domingo ce Guzmán
St. Dominic and the Albigensians; raising up a Young Man; The Virgin appearing to a Religious Community; St. Dominic of G.
polyptych panels, ar; the first two 48.0×32.7; 51.2×33.9; 69.7×35.4 (122×83 cm; 130×86 cm; 177×90 cm)

La prueba del fuego
Trial by Fire
pn 44.5×29.5 (113×75 cm)
Sermón de San Pedro Mártir
San Pedro Mártir en oración
San Pedro Mártir
Muerte de San Pedro Mártir *
El sepulcro de San Pedro Mártir (?)
St. Peter Martyr Preaching; St. P. M. at Prayer; St. P. M.; The Death of St. P. M.; The Tomb of St. P. M. (?)
polyptych panels, ar 52.0×33.1; 52.4×33.9; 69.7×35.4; 50.4×32.3; 51.6×33.5 (132×84 cm; 133×86 cm; 177×90 cm; 128×82 cm; 131×85 cm) ins
Auto de fe presidido por Santo Domingo de Guzmán *
St. Dominic of G. presiding over an Autodafé
ar pn 60.0×36.2 (154×92 cm) ins
La Virgen con el Niño *
Madonna and Child
pn 22.8×16.9 (58×43 cm)
Resurrección de Cristo
The Resurrection of Christ
pn 36.2×22.8 (92×58 cm)

BESCHEY Jacob Andries
Antwerp 1710 – 1786
La elevación de la Cruz
The Elevation of the Cross
pn 18.1×13.8 (46×35 cm) sg

Bike see under **Both Johannes**

BILIVERTI Giovanni
Florence 1576 – 1644
El agradecimiento de Tobías
T. thanking the Archangel Raphael
cv 67.3×58.3 (171×148 cm) c 1622; repl or copy

BLOEMAERT Adriaen
Utrecht c 1609 –1666
El viaje de Jacob
Jacob's Journey
cv 16.9×20.1 (43×51 cm) sg

BLOEMEN (ORIZONTE) Jan Frans
Antwerp 1662 – Rome 1748-9
Paisaje romano
Roman landscape
cv 18.5×22.0 (47×56 cm) sg d 1704

BLOEMEN (STANDAART) Pieter
Antwerp 1657 – 1720
Caravana
The caravan
cv 18.1×19.3 (46×49 cm) sg (disappeared)

BOCANEGRA Pedro Atanasio
Granada 1638 – 1689
La Virgen y el Niño Jesús con Santa Isabel y San Juan
Madonna and Child with St. I. and St. John the Baptist
cv 50.0×65.4 (127×166 cm)
La Virgen María
The Madonna
frm; cv 26.4×18.9 (67×48 cm)

BOEL Pieter
Antwerp 1622 – Paris 1674
Caza y perros
Dead game and dogs
cv 67.7×123.2 (172×313 cm) sg
Bodegón
Still life
cv 66.1×93.3 (168×237 cm) sg
Armas y pertrechos de guerra
Weapons and armour
cv 66.6×123.2 (169×313 cm) sg

BONINI Gerolamo
act in the early Seventeenth Century at Bologna
Nacimiento de la Virgen
The Birth of the Virgin
cv 36.6×20.1 (93×51 cm) copy from Annibale Carracci

BONITO Giuseppe
Castellammare di Stabia 1707 – Naples 1789
La embajada turca en Nápoles, año de 1741 *
The Turkish embassy to Naples in 1741
cv 81.5×66.9 (207×170 cm) d 1741

BONZI Pietro Paolo (Gobbo dei Carracci)
Cortona c 1576 – Rome 1636
Cabeza de viejo
The head of an old man
cv 15.4×12.2 (39×31 cm) formerly attr to Velazquez

BORDONE Paris
Treviso 1500 – Venice 1571
Autorretrato
Self-portrait
cv 40.9×29.9 (104×76 cm)

BORGIANNI Orazio
Rome 1578 – 1616
Autorretrato
Self-portrait
cv 37.4×28.0 (95×71 cm) attr

Borgognone see **COURTOIS**

BORGOÑA Juan de
... – Toledo c 1534
Tres santos dominicos *
Three Dominican Saints (St. Mary Magdalene with St. Peter Martyr, St. Catherine of Siena and the Blessed Margaret of Hungary)
pn 61.4×42.1 (156×107 cm) c 1505-15;frm of a *Crucifixion* (?)

BORKENS or **BORREKENS Jan Baptiste**
Antwerp 1611 – ... 1675
La Apoteosis de Hércules
The apotheosis of H.
cv 74.4×83.5 (189×212 cm) sg

BOSCH Hieronymus van Acken (El Bosco)
's-Hertogenbosch c 1450-60 – 1516
La Adoración de los Magos *
The Adoration of the Magi Altarpiece (Int: centr pn: The Adoration of the Magi; wings: Landscape with a Donor and St. Peter, and Landscape with a Donor's Wife and St. Agnes. Ext: The Mass of St. Gregory, grisaille)
ar panels; centr pn 54.3×28.3; wings 54.3×28.7 (138×72 cm; 138×73 cm) sg c 1510
Las tentaciones de San Antonio 2049 *
The Temptation of St. Anthony
pn 27.6×20.1 (70×51 cm) c 1510
Las tentaciones de San Antonio 2913
pn 27.6×45.3 (70×115 cm) attr (?) copy (?)
Las tentaciones de San Antonio 3085
pn 34.6×20.5 (88×52 cm) by an imitator (?)
El Carro de Heno → no 134 *
The Haywain Triptych (Inside: centr pn: The haywain; wings: The Original Sin, Hell. Outside: Life's pilgrimage)
panels; centr pn 53.1×39.4; wings 53.1×17.7 (135×100 cm; 135×45 cm) sg c 1500-2
Extracción de la piedra de la locura *
The cure of folly
pn 18.9×13.8 (48×35 cm) c 1475-85 ins
Un ballestrero
The head of a crossbowman
pn 11.0×7.9 (28×20 cm) copy (?)
Mesa de los pecados mortales *
The Table of the Seven Deadly Sins
pn 47.2×59.1 (120×150 cm) sg c 1475-80; on loan from the Escorial
El Jardín de las Delicias o La pintura del madroño → no 131
The Garden of Delights Triptych (Int: centr pn: The garden of delights; wings: The Creation of Eve, Hell. Ext: The Creation grisaille ins)
panels, centr pn 86.6×76.8; wings 86.6×38.2 (220×195 cm; 220×97 cm) on loan from the Escorial

BOSMANS Andries
Antwerp 1621 – Rome 1681 (?)

Guirnalda rodeando a Santa Ana, la Virgen y el Niño
The Holy Family with St. Anne in a Flower Garland
pn 32.7×21.7 (83×55 cm) sg figures attr to Schut the Younger

BOTH Andries
... c 1608 – Venice 1641
El jardín Aldobrandini, en Frascati
The garden of the Villa Aldobrandini at Frascati
cv 82.7×61.0 (210×155 cm) in collaboration with Jan Both

BOTH Jan
Utrecht c 1618 – 1652
Bautizo del eunuco de la Reina Candace
The Baptism of the Eunuch of Queen Candace
cv 83.5×61.0 (212×155 cm) figures by Miel van Bike (?)

BOTTICELLI (Sandro Filipepi)
Florence c 1445 – 1510
La historia de Nastagio degli Honesti (Cuadros I, II, III) → no 91-93
The story of Nastagio degli Onesti. Scenes I, II, III
panels 54.3×32.7 and 32.3; 55.9×33.1 (138×83 cm and 82 cm; 142×84 cm) 1483; the third scene in collaboration with Bartolomeo di Giovanni (act late fifteenth century, Florence)

BOUCHER François
Paris 1703 – 1770
Amorcillos jugando con pichones
Amorcillos vendimiando
Cupids playing with pigeons and gathering grapes
canvases 26.4×31.9 (67×81 cm) attr

BOUDEWYNS Adriaan Frans
Brussels 1644 – 1711
Paisajes con pastores 1371, 1375, 1378
Landscapes with shepherds
panels 10.2×15.0; 9.8 and 9.1×13.8 (26×38 cm; 25 and 23×35 cm)
figures attr to Peter Bout
Paisaje
Camino al borde de un río
Landscape; A walk by a river
panels 12.2×16.9 (31×43 cm)
Rebaño
A flock of sheep
pn 12.6×16.9 (32×43 cm)
Un puerto
A harbour
pn 12.6×16.9 (32×43 cm)

Boullogne or **Boulogne** see **VALENTIN**

BOURDON Sébastien
Montpellier 1616 – Paris 1671
Cristina de Suecia a caballo
Portrait of Queen Christine of Sweden on horseback
cv 150.8×114.6 (383×291 cm) 1653-4 (?)
San Pablo y san Bernabé, en Listra
St. Paul and St. Barnabas at L.
cv 18.5×14.2 (47×36 cm)

BOUT Peter
Brussels 1658 – 1719
Los patinadores
Skating scene
pn 10.6×16.9 (27×43 cm) sg d 1678
Plaza de aldea
A village square
pn 10.6×16.9 (27×43 cm) sg d 1678
see also Arthois and Boudewyns

BOUTS Dieric, Dirk or Thierry
Haarlem, act 1432 – Louvain 1475
La Anunciación;
La Adoración de los ángeles;
La Adoración de los Magos *

The Annunciation; The Visitation; The Nativity; The Adoration of the Magi
trp panels; centr pn 31.5×41.3; Wings 31.5×22.0 (80×105 cm; 80×56 cm) c 1445;
two scenes in the centr pn; formerly attr to Petrus Christus

BRAMER Leonard
Delft 1596 – 1674
Abraham y los tres ángeles
A. and the Three Angels
pn 18.5×29.1 (47×74 cm) sg

BREKELENKAM Quiringh Gerritsz van
Zwammerdam c 1620 – Leyden 1668
Una vieja
Portrait of an old woman
pn 18.9×14.2 (48×36 cm) false sg ("D. Ten [iers]") attr

BRIL Paulus
Antwerp 1554 – Rome 1626
Paisaje 1384
Landscape
pn 8.3×13.0 (21×33 cm)
Paisajes 1385, 1388
Landscapes
copper 9.4×7.5 and 9.8×11.4 (24×19 cm and 25×29 cm)
Paisaje con un río
Landscape with a river
copper 9.8×11.4 (25×29 cm)
see also Rubens

BROECK Crispin van der (?)
Malines 1524 – ... 1591
Sacra Familia
The Holy Family
pn 34.6×40.9 (88×104 cm) sg (disappeared) attr

BRONZINO (Agnolo di Cosimo di Mariano)
Florence 1503 – 1572
Don Garcia de Médicis → no 99
Portrait of Don G. de' Medici
pn 18.9×15.0 (48×38 cm) c 1551-2

BROUWER or **BRAUWER Adriaen**
Oudenaarde 1605-6 – Antwerp 1638
La música en la cocina
Music in the kitchen
pn 13.0×21.7 (33×55 cm)
La conversación
The conversation
pn 13.0×22.0 (33×56 cm) also attr to Teniers II
El peinado *
Three men searching for lice
pn 6.7×5.5 (17×14 cm)

BRUEGHEL EL JOVEN (THE YOUNGER) Pieter ('Hell Brueghel')
Brussels 1564 – Antwerp 1637-8
El rapto de Proserpina → no 138
The rape of Proserpine
pn 16.9×25.2 (43×64 cm)
Bosque y casas
A wood and houses
pn 22.4×33.9 (57×86 cm)
Paisaje con caminantes
Landscape with people walking
pn 11.8×18.5 (30×47 cm)
Construcción de la Torre de Babel *
Incendio y saqueo de una población
The Building of the Tower of B.; The burning and sack of a village
panels; tondos converted to squares 17.3×17.3 (44×44 cm) corners added
Ciudad incendiada
A burning city
pn 21.3×30.7 (54×78 cm) also attr to Daniel van Heil (1604-1662)
Paisaje nevado
Snow scene
pn 17.7×29.9 (45×76 cm)
Paso de un río
A river ford
pn 22.4×33.1 (57×84 cm) school formerly attr to Momper II see also Stalbempt

101

BRUEGHEL EL MOZO (THE YOUNGER) Jan
Antwerp 1601 – 1678

Excursión campestre de Isabel Clara Eugenia
La Infanta Isabel Clara Eugenia en el parque de Mariemont
The Infanta I. C. E. in the the country; The I. C. E. in the park at M.
canvases 68.9×93.3 and 69.3 ×92.9 (175×237 cm and 176× 236 cm) attr

BRUEGHEL EL VIEJO (THE ELDER) Jan ('Velvet Brueghel')
Brussels 1568 – Antwerp 1625

El oído → no 139
La vista *
El olfato *
El gusto *
El tacto *
Sight; Hearing; The sense of smell; The sense of taste; The sense of touch (The five senses)
panels 25.6×42.9; 25.6×42.1; 25.6×42.9; 25.2×42.5; 25.6× 43.3 (65×109 cm; 65×107 cm; 65×109 cm; 64×108 cm; 65× 110 cm) the first sg d 1617; the third sg; the fourth sg d 1618
Los cuatro elementos
The four elements
pn 24.4×41.3 (62×105 cm) figures by Hendrick van Balen (Antwerp 1575 – 1632)
La abundancia y los cuatro elementos 1400
Abundance and the four elements
pn 25.6×43.7 (65×111 cm) repl figures painted as above
La abundancia y los cuatro elementos 1401
Abundance and the four elements
copper 20.1×25.2 (51×64 cm) figures attr to Hendrick de Clerck (Brussels 1570 – Brussels [?] c 1629)
La abundancia
Abundance
copper 15.7×22.8 (40×58 cm) figures attr as above
La vista y el olfato
El gusto, el oído y el tacto
Sight and smell; Taste, hearing and touch
canvases 68.9×103.5 and 69.3 ×103.9 (175×263 cm and 176× 264 cm)
El Paraíso Terrenal 1406
La entrada en el arco de Noé
The Earthly Paradise; The Animals entering Noah's Ark
copper 22.4 and 22.0×34.6 (57 and 56×88 cm)
El Paraíso Terrenal 1410
The Earthly Paradise
pn 23.2×16.1 (59×41 cm)
Adán y Eva en el Paraíso: la tentación
The Temptation of Adam and Eve
copper 15.7×19.7 (40×50 cm)
La visión de San Huberto
The V. of St. Hubert
pn 24.8×39.4 (63×100 cm) figures by Rubens (?)
Paisaje con San Juan predicando
Landscape with St. John the Baptist Preaching
copper 17.3×22.4 (44×57 cm)
Cibeles y las Estaciones dentro de un festón de frutas
Cybele and the Seasons in a garland of fruit
pn 41.7×28.7 (106×73 cm) figures attr to van Balen
Guirnalda de flores y frutos con la Virgen y el Niño 1416
Madonna and Child in a Garland of Flowers and Fruit
pn 18.9×16.1 (48×41 cm)
Guirnalda rodeando a la Virgen María 1419
The Madonna in a Garland
copper 31.9×25.6 (81×65 cm) ins
Florero 1421, 1424
A vase of flowers
the first on copper, the second a pn: 18.9×13.8 and 18.5 ×13.8 (48×35 cm and 47×35 cm)
Florero 1422
pn 17.3×26.0 (44×66 cm)
Florero 1423
pn 19.3×15.4 (49×39 cm)

Florero 1426
pn 16.1×13.0 (41×33 cm)
Flores sobre un plato
Flowers on a dish
cv 16.9×13.0 (43×33 cm)
Camino en un bosque
A path through a wood
pn 18.1×29.5 (46×75 cm)
Paisaje con molinos de viento
Landscape with windmills
pn 13.4×19.7 (34×50 cm)
Paisaje
Landscape
pn 15.7×24.4 (40×62 cm)
Recua y gitanos en un bosque
Beasts of burden and gypsies in a wood
copper 14.2×16.9 (36×43 cm) sg 1614
Paisaje con galeras
Landscape with carriages
pn 13.0×16.9 (33×43 cm) sg d 1603
Molinos de viento
Camino en la montaña
Windmills; A mountain journey
copper 6.3×10.6 (16×27 cm)
Banquete de bodas
Baile campestre ante los Archiduques
A wedding feast; A country dance before the Archduke and Archduchess
canvases 51.2×104.3 and 51.2 ×65.4 (130×265 cm and 266 cm) the first sg d 1623
La vida en el campo
Country life
cv 65.0×65.0 (165×165 cm)
Boda campestre
Banquete de bodas presidido por los Archiduques
A village wedding; A w. feast presided over by the Archduke and Archduchess
canvases 33.1×49.6 (84×126 cm)
Mercado y lavadero en Flandes
A market and washing place in Flanders
cv 65.4×76.4 (166×194 cm)
La vida campesina
Country life
cv 51.2×115.4 (130×293 cm)
Puerto
A harbour
pn 5.5×7.5 (14×19 cm)
see also Momper II, Procaccini Giulio Cesare and Rubens

BRUEGHEL EL VIEJO (THE ELDER) Pieter
Bruegel (?) c 1525-30 – Brussels 1569

El Triunfo de la Muerte → no 137
The triumph of death
pn 46.1×63.8 (117×162 cm) c 1560-4
La Adoración de los Magos *
The Adoration of the Magi
cv 46.9×65.0 (119×165 cm) c1556; res damaged attr

Brugghen see under **Stomer**

CABEZALERO Juan Martín
Almadén 1633 – Madrid 1673

Pasaje de la vida de San Francisco
A Scene from the Life of St. Francis
cv 91.3×76.78 (232×195 cm)

CALLEJA Andrés de la
La Rioja 1705 – Madrid 1785

Retrato de Caballero de Santiago *
Portrait of a Knight of St. James
cv 34.3×30.7 (87×78 cm) attr

CALLET Antoine-François
Paris 1741 – 1825

Luis XVI
Portrait of Louis XVI of France
cv 108.3×76.0 (275×193 cm) 1779; original frame with an ins

CAMARÓN José
Segorbe 1730 – Valencia 1803

La Dolorosa
The Madonna of Sorrows
cv 63.8×45.3 (162×115 cm)

CAMASSEI Andrea
Bevagna 1602 – Rome 1649

Fiestas lupercales *
The feast of Lupercal
cv 93.3×143.7 (237×365 cm) c 1635; attr
see also Domenichino

CAMBIASO Luca (Luchetto)
Moneglia 1527 – El Escorial 1585

La Sagrada Familia
The Holy Family
cv 51.6×40.6 (131×103 cm)

CAMILO Francisco
Madrid ... – 1673

El martirio de San Bartolomé
The Martyrdom of St. Bartholomew
cv 80.7×98.0 (205×249 cm)

CAMPI Antonio
Cremona ... – c 1591

San Jerónimo meditando
St. Jerome
pn/cv 72.0×48.0 (183×122 cm) sg

CAMPI Vincenzo
Cremona 1536 – 1591

La Crucifixión
The C.
cv 82.7×55.5 (210×141 cm) sg d 1577

Campin see **MAESTRO DE FLÉMALLE**

CANALETTO (Giovanni Antonio Canal)
Venice 1697 – 1768

El Gran Canal de Venecia con el puente de Rialto
The Grand C. and R. Bridge, Venice
cv 14.6×21.3 (37×54 cm) attr
San Giorgio Maggiore y la Aduana de Venecia *
St. G. M. and the Dogana, Venice
cv 24.8×18.9 (63×48 cm) attr
La Plaza de San Marcos de Venecia, desde la Piazzetta
St. Mark's Square from the P., Venice
cv 12.6×18.9 (32×48 cm) attr

CANO Alonso
Granada 1601 – 1667

San Benito en la visión del globo y los tres ángeles *
St. Benedict's V. of the Earthly Sphere and Three Angels
cv 65.4×48.4 (166×123 cm)
San Jerónimo penitente
St. Jerome listening to the Last Trump
cv 69.7×82.3 (177×209 cm)
La Virgen y el Niño *
Madonna and Child
cv 63.8×42.1 (162×107 cm)
Cristo muerto sostenido por un ángel 629 *
The Dead Christ
cv 70.1×47.6 (178×121 cm)
Cristo muerto sostenido por un ángel 2637
The Dead Christ
cv 53.9×39.4 (137×100 cm) sg repl
Un Rey de España *
A King of Spain
Dos Reyes de España *
A king of Spain; Two kings of Spain
canvases 65.0×49.2 and 50.0 (165×125 cm and 127 cm) from a design by Carducho; also attr to Jusepe Leonardo
El milagro del pozo → no 57
The Miracle of the Well
cv 85.0×58.7 (216×149 cm)
San Antonio de Padua
The Virgin appearing to St. Anthony of P.
sketch; cv 11.0×7.5 (28×19 cm)
San Bernardo y la Virgen *
St. Bernard and the Virgin
cv 105.1×72.8 (267×185 cm)
Cristo en la Cruz
Christ on the Cross
cv 86.6×49.6 (220×126 cm)

CANTARINI Simone
Pesaro 1612 – Verona (?) 1648

Sacra Familia *
The Holy Family
cv 29.5×21.7 (75×55 cm) c 1645

CARACCIOLO Giovanni Battista (Battistello)
Naples c 1570 – 1637

Los santos médicos Cosme y Damián
St. Cosmas and St. Damian
cv 37.8×47.6 (96×121 cm)

CARAVAGGIO (Michelangelo Merisi)
Caravaggio 1573 – Porto Ércole 1610

David vencedor de Goliat *
D. with the Head of Goliath
cv 43.3×35.8 (110×91 cm) st wk (?)

CARDUCHO or CARDUCCI Bartolomé
Florence c 1554 – El Pardo 1608

El Descendimiento *
The Deposition of Christ
cv 103.5×71.3 (263×181 cm) sg d 1595
La Última Cena
The Last Supper
cv 100.8×96.1 (256×244 cm) sg d 1605

CARDUCHO or CARDUCCI Vincencio
Florence 1576 – Madrid 1638

Victoria de Fleurus
Socorro de la plaza de Constanza
Expugnación de Rheinfelden *
The battle of F.; The relief of Constance; The capture of R.
canvases 116.9×143.7 147.2 140.6 (297×365 cm 374 cm 357 cm) sg d 1634 ins
for other paintings in the same series, see Carés, Leonardo Jusepe, Maino, Pereda, Velázquez and Zurbarán
Muerte del venerable Odón de Novara
El milagro de las aguas *
San Bruno se aparece a un cartujo
San Bruno renuncia a la mitra de regio
The Death of the V. Odo of N.; The Miracle of the Water; St. B. appearing to a Carthusian Monk; St. B. refusing the Archbishop's Mitre
canvases 134.7×118.9 (342× 302 cm) sq; the first and the third d 1632
La Sagrada Familia
The Holy Family
cv 59.1×44.9 (150×114 cm) sg d 1631
see also Cano, Titian

CARNICERO Antonio
Salamanca 1748 – Madrid 1814

Ascensión de un globo Montgolfier en Madrid *
The ascent of a M. balloon at M.
cv 66.9×111.8 (170×284 cm)
Doña Tomasa de Aliaga, viuda de Salcedo
Portrait of D. T. de A., widow of Don Manuel Pablo de S.
cv 36.6×27.2 (93×69 cm) ins formerly attr to Goya

CARRACCI Agostino
Bologna 1557 – Parma 1602

La Santa Cena
The Last Supper
cv 67.7×93.3 (172×237 cm) c 1596-7
see also Carracci Ludovico

CARRACCI Annibale
Bologna 1560 – Rome 1609

La Asunción *
The Assumption of the Virgin
cv 51.2×38.2 (130×97 cm) c 1590
Apoteosis de San Francisco
Apoteosis de Santiago el Mayor
Apoteosis de San Lorenzo
San Diego de Alcalá recibe el hábito franciscano
La refacción milagrosa
San Diego salva al muchacho dormido dentro del horno
The Apotheosis of St. Francis; of St. James the Great; of St. Laurence; St. D. of A.

receiving the Franciscan Habit; The Miraculous Meal; St. D. saving a Child asleep in an Oven
frescoes/canvases; the first three oval 61.0×41.3 (155× 105 cm), the others trapezoidal 49.2×86.6 (125×220 cm) c 1604-1607
Paisaje *
Landscape
cv 44.1×58.7 (112×149 cm) c 1600
Venus, Adonis y Cupido → no 118
V., A. and C.
cv 83.5×105.5 (212×268 cm) c 1595
Virgen con el Niño y San Juan
Madonna and Child with St. John
pn; td 11.4 (29 cm)
see also Bonini

CARRACCI Ludovico
Bologna 1555 – 1619

San Francisco de Asís
St. Francis of Assisi
cv 78.7×57.9 (200×147 cm) c 1587 (?) attr
Oración del huerto
Christ in the Garden of Gethsemane
cv 18.9×21.7 (48×55 cm) 1590-1600
Jubileo de la Porciúncula *
Celebrations at the Porziuncola
cv 78.7×57.9 (200×147 cm) 1595-7; formerly attr to Agostino Carracci

CARREÑO DE MIRANDA Juan
Avilés 1614 – Madrid 1685

Carlos II 642 *
Portrait of Charles II of Spain
cv 79.1×55.5 (201×141 cm) c 1673
Carlos II 648
Portrait of Charles II of Spain
cv 29.5×23.6 (75×60 cm) c 1680
La Reina Doña Mariana de Austria → no 58
Portrait of M. of A., Queen of Spain
cv 83.1×49.2 (211×125 cm) 1669 (?)
Pedro Iwanowitz Potemkin, embajador de Rusia
Portrait of Peter Ivanovich P., Russian Ambassador to Spain
cv 80.3×47.2 (204×120 cm) 1681 (?)
Eugenia Martínez Vallejo, "La monstrua"
La monstrua desnuda *
Portrait of E. M. V., "the giantess"; The naked "g."
canvases 65.0×42.1 and 42.5 (165×107 cm and 108 cm)
El bufón Francisco Bazán
Portrait of the jester F. B.
cv 78.7×39.8 (200×101 cm)
San Sebastián
St. S.
cv 67.3×44.5 (171×113 cm) sg d 1656
El Duque de Pastrana *
Portrait of the Duke of P.
cv 85.4×61.0 (217×155 cm)
Santa Ana dando lección a la Virgen
St. Anne teaching the Virgin
cv 77.2×66.1 (196×168 cm) sg d (illegible)
El festín de Herodes
The Feast of Herod
sketch; cv 31.5×23.2 (80×59 cm)

CASTIGLIONE Giovanni Benedetto (IL GRECHETTO)
Genoa c 1610 – Mantua 1665

Diógenes *
cv 38.2×57.1 (97×145 cm) sg

CASTILLO SAAVEDRA Antonio del
Cordova 1616 – 1668

José y sus hermanos
José vendido por sus hermanos
La castidad de José
José explica los sueños del Faraón
El triunfo de José en Egipto

José ordena la prisión de Gedeón
Joseph and his Brothers; J. sold by his B.; The Chastity of J.; J. interpreting Pharaoh's Dreams; The Triumph of J. in Egypt; J. ordering the Arrest of Gideon
canvases 42.9×57.1 (109×145 cm); the last one 42.9×56.3 (109×143 cm)
San Jerónimo penitente
St. Jerome in Penitence
cv 55.1×41.3 (141×105 cm) sg d 1635

CATENA Vincenzo
Venice c 1480 – 1531
Cristo dando las llaves a San Pedro
Christ giving the Keys to St. Peter
pn 33.9×53.1 (86×135 cm) c 1517; res in 1944

Cavalier d'Arpino see ARPINO

CAVALLINO Bernardo
Naples 1616 – c 1656
Curación de Tobías
Desposorios de Tobías *
T. cured of his Blindness; The Marriage of T.
canvases 29.9×40.6 (76×103 cm) recently res attr

CAVAROZZI Bartolomeo
Viterbo c 1590 – Rome 1625
La Sagrada Familia y Santa Catalina
The Mystical Marriage of St. Catherine
cv 100.8×66.9 (256×170 cm) c 1617-9; formerly attr to Orazio Gentileschi (q.v.)

CAVEDONE Giacomo
Sassuolo 1577 – Bologna 1660
La Adoración de los pastores
The Adoration of the Shepherds
cv 94.5×71.7 (240×182 cm) c 1613-4 repl

CAXES or CAJÉS (DA CASCESE) Eugenio
Madrid c 1577 – 1634
Recuperación de San Juan de Puerto Rico *
Recuperación de la isla de san Cristóbal
The recapture of San Juan, Porto Rico and of the island of San C.
canvases 114.2×135.4 and 116.9×122.4 (290×344 cm and 297×311 cm) formerly attr to Félix Castelo (... – ... 1656); for other paintings in the same series, see Carducho Vincencio, Leonardo Jusepe, Maino, Pereda, Velázquez and Zurbarán
La Virgen con el Niño y ángeles *
Madonna and Child with Angels
cv 63.0×53.1 (160×135 cm) d

CECCO DEL CARAVAGGIO
act in the Seventeenth Century
Mujer con paloma → no 121
Portrait of a lady with a dove
cv 26.0×18.5 (66×47 cm) attr; formerly thought to me a self-portrait of A. Gentileschi

Cerano see CRESPI Giovanni Battista

CEREZO Mateo
Burgos 1626 – Madrid 1666
Los desposorios místicos de Santa Catalina *
The Mystical Marriage of St. Catherine
cv 81.5×64.1 (207×163 cm) sg d 1660
San Agustín *
St. Augustine
cv 81.9×49.6 (208×126 cm) sg d 1663
see also van Dijck

CERQUOZZI Michelangelo
Rome 1602 – 1660
Cabaña *
The hut
cv 20.1×16.1 (51×41 cm)

Cesari see ARPINO

Ceulen see JOHNSON

CHAMPAIGNE Philippe de
Brussels 1602 – Paris 1674
Luis XIII de Francia
Portrait of Louis XIII of France
cv 42.5×33.9 (108×86 cm) sg d 1655 (disappeared)

CHRISTUS or CHRISTI Petrus
Baerle ... – Bruges 1472-3
La Virgen con el Niño Jesús *
Madonna and Child
pn 19.3×13.4 (49×34 cm) see also Bouts

CIEZA Vicente
act 1677-1701 in Granada and Madrid
El juicio de Salomón
The Judgement of Solomon
cv 43.3×55.1 (110×140 cm) attr

CIGNAROLI Giambettino
Verona 1706 – 1770
La Virgen y el Niño Jesús, con varios santos
Madonna and Child with Saints
cv 123.6×67.3 (314×171 cm) sg

CIMA DA CONEGLIANO Giambattista
Conegliano c 1459 – Venice c 1518
La Virgen y el Niño
Madonna and Child
pn 24.8×17.3 (63×44 cm) sg

CLAESZOON Pieter
Steinfurt c 1597-8 – Haarlem 1661
Bodegón
Still life
pn 32.7×26.0 (83×66 cm) sg d 1637

Clerk see under Brueghel el Viejo Jan and Colyn

CLEVE or DER BEKE Joos van (Maestro de la Muerte de María [Master of the Death of the Virgin])
Cleve (?) c 1495 – Antwerp 1540-1
El Salvador
Christ the Redeemer
pn 23.6×18.5 (60×47 cm) late or st wk
see also Holbein el Joven

CODAZZI Viviano
Bergamo 1604 – Rome 1670
Exterior de San Pedro, en Roma *
St. Peter's Square, Rome
cv 66.1×86.6 (168×220 cm) c 1630 (?)

COECKE VAN AELST Pieter
Aelst 1502 – Brussels 1550
Santiago el Mayor y once orantes
San Juan Evangelista con dos damas y dos niñas orantes *
St. James the Great and Eleven Monks at Prayer (ext: St. George); St. John the Evangelist with Two Ladies and Two Girls at Prayer (ext: St. Adrian)
trp wings; panels 44.1×17.3 (112×44 cm) attr
La Anunciación; La Adoración de los Magos; La Adoración de los ángeles y de los pastores
The Annunciation; The Adoration of the Magi; The A. of the Angels and Shepherds
trp; panels, centr pn 31.9×26.4 (81×67 cm); wings 31.9×12.2 81×31 cm) attr

COELLO Claudio
Madrid 1642 – 1693
La Virgen y el Niño entre las Virtudes teologales y Santos
Madonna and Child with the Theological Virtues and Saints
cv 91.3×107.5 (232×237 cm) sg d 1669; with an ins on a shield
La Virgen y el Niño adorados por San Luis, rey de Francia *
Madonna and Child worshipped by St. Louis, King of France
cv 90.2×98.0 (229×249 cm) sg
El triunfo de San Agustín *
The Apotheosis of St. Augustine
cv 106.7×79.9 (271×203 cm) d 1664
Doña Mariana de Austria, Reina de España
Portrait of M. of A., Queen of Spain
cv 38.2×31.1 (97×79 cm) attr
Jesús Niño en la puerta del templo *
The Christ Child at the Temple Door
cv 66.1×48.0 (168×122 cm) sg d 1660
Santo Domingo de Guzmán → no 60
Santa Rosa de Lima *
St. Dominic of G.; St. R. of L.
ar canvases 94.5×63.0 (240×160 cm)
the second has an ins on a book

COFFERMANS Marcellus
Antwerp c 1535 – c 1575
La Flagelación; El Descendimiento; La Anunciación; San Jerónimo; Descanso en la huida a Egipto
The Flagellation of Christ; The Deposition of C.; The Annunciation; St. Jerome; The Rest on the Flight to Egypt
panels 13.0×9.1 (33×23 cm); the last 8.3×5.5 (21×14 cm); in the Twentieth Century the panels were put together to form a polyptych

COLLANTES Francisco
Madrid 1599 – 1656
Visión de Ezequiel: la resurrección de la carne *
The V. of Ezekiel: the Resurrection of the Flesh
cv 69.7×80.7 (177×205 cm) sg d 1630
Paisaje
Landscape
cv 29.5×36.2 (75×92 cm) sg

COLYN David
Rotterdam c 1582 – c 1668
El banquete de los dioses
The feast of the gods
copper 14.6×20.5 (37×52 cm) sg d 16[?]0; also attr to Hendrick de Clerck (c 1570 – c 1629)

CONCA Sebastiano
Gaeta 1680 – Naples 1764
Alejandro Magno en el templo de Jerusalén
La idolatría de Salomón
Alexander the Great in the Temple at Jerusalem; Solomon worshipping Idols
sketches; canvases 20.5×27.6 and 21.3×28.0 (52×70 cm and 54×71 cm) c 1735

CONTE Jacopino del
Florence 1510 – Rome 1598
La Sagrada Familia
The Holy Family
pn 41.3×39.4 (105×100 cm) formerly attr to Francesco Salviati

COOSEMANS or COASEIMAS Alexander
Antwerp 1627 – 1689
Bodegón
Still life
pn 28.7×30.3 (73×77 cm) sg

COOSEMANS J. D.
... – ...
Frutero
Still life with a tray of fruit
pn 19.3×15.7 (49×40 cm) sg

CORNEILLE DE LYON or DE LA HAYE
The Hague c 1500-10 – Lyon (?) c 1574
Caballero
Portrait of a gentleman
pn 11.0×8.3 (28×21 cm)

CORNELISZ VAN HAERLEM Cornelis
Haarlem 1562 – 1638
Apolo ante el tribunal de los dioses *
Apollo before the tribunal of the gods
pn 17.3×38.6 (44×98 cm) sg d 1594

CORREA DE VIVAR Juan
act 1539 – 52 in Castile
El tránsito de la Virgen
The Death of the Virgin
pn 100.0×57.9 (254×147 cm)
La Virgen, el Niño y Santa Ana San Benito bendiciendo a San Mauro
Madonna and Child with St. Anne; St. Benedict blessing St. Maurus
panels 37.0×35.4 and 38.2 (94×90 cm and 97 cm)
La presentación de Jesús en el templo
La Visitación
The Presentation of Christ in the Temple; The V. (rv: St. Jerome in Penitence)
trp wings; panels 86.2×30.7 and 85.8×30.3 (219×78 cm and 218×77 cm)
La Natividad
The Nativity
pn 89.8×72.0 (228×183 cm)
La Anunciación *
The Annunciation
pn 88.6×57.5 (225×146 cm)
Aparición de la Virgen a San Bernardo
The Virgin appearing to St. Bernard
pn 66.9×51.2 (170×130 cm)

CORREGGIO (Antonio Allegri)
Correggio 1493 – 1534
"Noli me tangere" → no 101
pn/cv 51.2×40.6 (130×103 cm) c 1518
on rv two seals, one with the monogram AR and the other a seal of Charles I of England
La Virgen, el Niño Jesús y san Juan *
Madonna and Child with St. John
pn 18.9×14.6 (48×37 cm) c 1515-17

Cortona see PIETRO DA CORTONA

COSSIERS or COETSIERS or CAUSSIERS Jan
Antwerp 1600 – 1671
Júpiter y Licaón
J. and Lycaon
cv 49.6×45.3 (126×115 cm) sg
Prometeo trayendo el fuego *
Prometheus carrying fire
cv 71.7×44.5 (182×113 cm) from a sketch by Rubens
Narciso
Narcissus
cv 38.2×36.6 (97×93 cm) sg

COSTER Adam de
Malines c 1586 – Antwerp 1643
Judith
cv 56.7×61.0 (144×155 cm) attr

COURTOIS Jacques (Borgognone)
St.-Hippolyte 1621 – Rome 1676
Batalla entre Cristianos y Musulmanes *
A battle between Christians and Moors
cv 37.8×59.8 (96×152 cm)
Lucha por la posesión de una fortaleza
A battle for possession of a fortress
cv 29.9×61.0 (76×155 cm)
Carga de caballería
Escaramuza de caballería
A cavalry charge; A c. skirmish
copper 9.8×12.6 (25×32 cm)

Couwenberg see THIELEN

COXCIE or COXIE Michiel
Malines 1499 – 1592
Santa Cecilia
St. C.
pn 53.5×40.9 (136×104 cm) sg
La vida de la Virgen *
Triptych of the Life of the Virgin (Int: centr pn: The Death of the Virgin and The Assumption of the V.; wings: The Birth of the V. and The Presentation of Christ in the Temple. Ext: l hand side: The Annunciation and The Adoration of the Shepherds; r hand side: The Visitation and The Adoration of the Magi grisaille)
panels 81.9×30.3; 81.9×71.3; 81.9×30.3 (208×77 cm; 208×181 cm; 208×77 cm)
Jesús con la cruz a cuestas
Christ carrying the Cross
pn 31.9×19.7 (81×50 cm) sg

COYPEL Antoine
Paris 1661 – 1722
Susana acusada de adulterio
Susanna and the Elders
cv 58.7×8.3 (149×204 cm) attr

CRAESBEECK Joost van
Neerlinter c 1606 – Brussels 1654-61
Terceto burlesco
Three men singing
pn 11.8×9.4 (30×24 cm) sg

Cranach el Joven see under Cranach el Viejo

CRANACH EL VIEJO (THE ELDER) Lucas (L. Sunder or Muller)
Kronach 1472 – Weimar 1553
Cacería en honor de Carlos V en el Castillo de Torgau 2175 *, 2176
Hunting at T. Castle in honour of the Emperor Charles V
panels 44.9×68.9 and 46.5×69.7 (114×175 cm and 118×177 cm) sg d 1544 and 1545
also attr to Lucas Cranach el Joven (the Younger) (Wittenberg 1515 – Weimar 1586)

CRAYER Gaspar de
Antwerp 1584 – Ghent 1669
El Infante Don Fernando de Austria, vestido de Cardenal
Portrait of the Infant Don Ferdinand of A., in cardinal's robes
cv 86.2×49.2 (219×125 cm) sg d 1639

CRESPI Daniele
Busto Arsizio c 1600 – Milan 1630
La Piedad *
Pietà
cv 68.9×56.7 (175×144 cm) sg c 1626 (?)

CRESPI Giovanni Battista (Il Cerano)
Cerano c 1575 – Milan 1632
San Carlos Borromeo y Cristo muerto
St. Charles B. and the Dead Christ
cv 82.3×61.4 (209×156 cm) c 1610

CRONENBURCH Adriaen (formerly thought to be Anna)
Pietersbierun (Friesland) c 1540 – ... c 1604
Dama con una flor amarilla
Portrait of a lady with a yellow flower
pn 42.1×31.1 (107×79 cm) sg
Dama y niña 2074
Portrait of a lady with a little girl
pn 40.9×30.7 (104×78 cm) sg
Dama y niña 2075 *
pn 41.3×30.7 (105×78 cm) sg d 1587 ins
Dama holandesa
Portrait of a Dutch lady
pn 39.4×31.1 (100×79 cm) sg

CUYP Benjamin Gerritsz
Dordrecht 1612 – 1652
La Adoración de los pastores *
The Adoration of the Shepherds
pn 31.9×25.6 (81×65 cm) false
sg ("R.f." [Rembrandt fecit])

DALEM or **DALE Cornelis van**
act 1545 at Antwerp
Paisaje con pastores
Landscape with shepherds
pn 18.5×26.8 (47×68 cm) c
1550 – 60; formerly attr to Lucas van Valckenborch

**DANIELE DA VOLTERRA
(D. Ricciarelli)**
Volterra 1509 – Rome 1566
La Anunciación
The Annunciation
pn 66.1×49.2 (168×125 cm)
attr

Da Ponte see BASSANO

Daret see under Maestro de Flémalle

104

DAVID Gerard
Oudewater 1450-60 – Bruges 1523
La Virgen, el Niño y dos ángeles que la coronan *
Madonna and Child with Two Angels
pn 13.4×10.6 (34×27 cm)
Descanso en la huida a Egipto
→ no 141
The Rest on the Flight to Egypt
pn 23.6×15.4 (60×39 cm)

**Diepenbeck see under
Seghers Daniel**

**DOMENICHINO
(Domenico Zampieri)**
Bologna 1581 – Naples 1641
Aparición de los ángeles a San Jerónimo
Angels appearing to St. Jerome
cv 72.4×50.8 (184×129 cm)
formerly attr to Lucio Massari
(Bologna 1569 – 1633)
El sacrificio de Abraham
The Sacrifice of Isaac
cv 57.9×55.1 (147×140 cm) c
1630
Exequias de un Emperador romano
The funeral of a Roman emperor
cv 89.4×142.9 (227×363 cm)
1635 formerly attr to Camassei

DORIGNY Michel
Saint-Quentin 1617 – Paris 1665
El triunfo de la Prudencia
The Triumph of Prudence
cv 101.2×116.1 (257×295) attr

**DOSSO DOSSI
(Giovanni Luteri)**
Ferrara 1489-90 – 1542
La dama del turbante verde *
Portrait of a lady in a green turban
cv 25.2×19.7 (64×50 cm) attr
now attr to Niccoló dell'Abate (Modena 1509 [?] - Paris or Fontainebleau 1571 [?])

**DROOCHSLOOT
Joost Cornelisz**
Utrecht (?) 1586 – 1666
Patinadores
Skating scene
cv 29.5×43.7 (75×111 cm) sg
d 1629 (1639?)

DROUAIS François-Hubert
Paris 1727 – 1775
Madame du Barry *
cv oval 24.4×20.5 (62×52 cm)
sg d 1770 attr

DUBBELS Hendrick Jacobsz
Amsterdam 1620-1 – 1676
Patinadores
Skating scene
cv 26.4×35.8 (67×91 cm) sg

Dubois see LIGNIS

DUGHET Gaspard (Le Guaspre Poussin, or Pusino)
Rome 1615 – 1675
La tempestad
The storm
cv 19.3×26.0 (49×66 cm)
El huracán
The hurricane
cv 29.1×38.6 (74× 98 cm)
La Magdalena, penitente 136 *
The Penitent Magdalena
cv 29.9×51.2 (76×130 cm) c
1660-70
La Magdalena penitente 552
cv 24.0×29.5 (61×75 cm) damaged; figures by Maratta
Paisajes 137,138
Landscapes
canvases 28.7×37.8 (73×96 cm) and 29.1×38.6 (74×98 cm)

DUPRA' or **DUPRAT Domenico**
Turin 1689 – 1770
Doña Bárbara de Braganza, Reina de España
Portrait of B. of B., Queen of Spain
cv 29.5×23.6 (75×60 cm) sg
(disappeared?)

DÜRER Albrecht
Nuremburg 1471 – 1528
Adán → no 167
Eva → no 168
Adam; Eve
panels 82.3×31.9 and 31.5
(209×81 cm and 80 cm) sg;
the second d 1507
Autorretrato → no 166
Self portrait
pn 20.5×16.1 (52×41 cm) sg
d 1498
Desconocido *
Portrait of an unknown gentleman
pn 19.7×14.2 (50×36 cm) sg
d 1524

DYCK (DIJCK) Anthonie van
Antwerp 1599 – London 1641
San Jerónimo penitente
St. Jerome in Penitence
cv 39.4×28.0 (100×71 cm)
formerly attr to Cerezo
La coronación de espinas *
The Crowning of Christ with Thorns
cv 87.8×77.2 (223×196 cm)
La Piedad
Pietà
cv 44.9×39.4 (114×100 cm)
El prendimiento *
The Betrayal of Christ
cv 135.4×98.0 (344×249 cm)
San Francisco de Asís
St. Francis of Assisi
cv 48.4×41.7 (123×106 cm) c
1627-32
El pintor manco Martín Ryckaert → no 153
Portrait of the one-handed painter, M. R.
pn 58.3×44.5 (148×113 cm) c
1630
El Cardenal-Infante Don Fernando de Austria
Portrait of the Cardinal I Don Ferdinand of A.
cv 42.1×41.7 (107×106 cm)
1634 (?); also attr to Rubens
Diana Cecil, condesa de Oxford → n 154
Portrait of Diana Cecil, Countess of O.
cv 42.1×33.9 (107×86 cm) sg
d 1638
Federico Enrico de Nassau, Príncipe de Orange
Amelia de Solms-Braunfels
Portrait of Frederick Henry of N., Prince of O.; Portrait of A. of S-B. Princess of Orange
canvases/panels 43.3×37.4 and 41.3×35.78 (110×95 cm and 105×91 cm) 1628
Carlos I de Inglaterra → no 155
Portrait of Charles I of England on horseback
cv 48.4×33.5 (123×85 cm) c
1635-40
Desconocida
Portrait of an unknown lady
cv 41.7×29.5 (106× 75 cm) c
1628
El Conde Enrique de Bergh *
Portrait of Count Hendrik van den B.
cv 44.9×39.4 (114×100 cm)
c 1629-32

El músico Jacobo Gaultier (?)
Portrait of the composer Jacques G. (?)
cv 50.4×39.4 (128×100 cm) c
1622-7
El grabador Paul du Pont (?)
Portrait of the engraver P.d. P. (?)
cv 44.1×39.4 (112×100 cm) c
1635
Sir Endymion Porter y Van Dyck → no 156
cv, oval 46.9×56.7 (119×144 cm)
El músico Enrique Liberti
Portrait of the composer Hendrick L.
cv 42.1×38.2 (107×97 cm) c
1627-32
Cabeza de viejo 1491
The head of an old man
cv 18.5×14.2 (47×36 cm)
Cabeza de anciano 1694
The head of an old man
pp/pn 17.7×13.4 (45×34 cm)
formerly attr to Rubens
Diana y Endimión sorprendidos por un sátiro
D. and Endymion surprised by a satyr
cv 56.7×64.1 (144×163 cm) c
1626
Doña Policena Spínola, marquesa de Leganés
Portrait of P. S., Marchioness of L.
cv 80.3×51.2 (204×130 cm)
1621-22
Santa Rosalía
St. R.
cv 41.7×31.9 (106×81 cm)
damaged and repainted
María Ruthwen *
Portrait of Mary R., the artist's wife
cv 40.9×31.9 (104×81 cm)
formerly attr to Sir Peter Lely (Pieter van der Faest [Soest 1618 – London 1680])
La serpiente de metal
The bronze serpent
cv 80.7×92.5 (205×235 cm)
false sg (?) ("P. P. Rubens fecit") attr
El Conde de Arundel y Tomás, nieto suyo
Portrait of Thomas Howard, Earl of A. and his grandson Thomas
cv 73.6×63.8 (187×162 cm) c
1635
Carlos II de Inglaterra
Portrait of Charles II of England
cv 53.9×43.7 (137×111 cm) attr
repl or copy of a ptg at Windsor, Royal collections
Santa Rosalía de Palermo
St. R.
cv 50.0×42.5 (127×108 cm)
attr see also Jordaens, Rubens

ELSHEIMER Adam
Frankfurt 1578 – Rome 1610
Ceres en casa de Bécuba
C. at the house of B.
copper 11.8×9.8 (30×25 cm)

ES or **ESCH Jacob Fopens van**
... c 1596 – Antwerp 1666
Ostras y limones
Bodegón *
Still life with oysters and lemons; Still life
panels 10.6×12.6 (27×32 cm)
Flores y frutas
Still life with flowers and fruit
pn td 11.8 (30 cm)

**ESCALANTE
Juan Antonio de Frías y**
Cordova 1630 – Madrid 1670
La prudente Abigail
Triunfo de la Fe sobre los sentidos
The Prudent A; The Triumph of Faith over the Senses
canvases 44.5×59.8 (113×152 cm) sg d 1667; the second has an ins
La comunión de Santa Rosa de Viterbo *
The Communion of St. R. of V.
cv 84.6×74.8 (215×190 cm) sg
c 1660
"Ecce Homo"
cv 41.3×32.3 (105×82 cm) sg

ESPINOSA Jerómino Jacinto
Cocentaina 1600 – Valencia 1667
Santa María Magdalena
San Juan Bautista
St. Mary Magdalena; St. John the Baptist
canvases 44.1×35.8 (112×91 cm)
San Ramón Nonato *
St. Raymond Nonnatus
cv 96.5×70.9 (245×180 cm)

ESPINOSA Juan de
act 1624 – 1645-6 in Spain
Manzanas, ciruelas, uvas y peras
Still life with apples, plums, grapes and pears
cv 29.9×23.2 (76×59 cm)
Uvas y manzanas
Still life with grapes and apples
cv 19.7×15.4 (50×39 cm) attr

ESQUIVEL Antonio
Seville 1806 – Madrid 1857
Doña Pilar de Jandiola
cv 48.8×37.4 (124×95 cm) sg
d 1838

ESTEVE Agustín
Valencia 1753 – ... c 1820
Doña Joaquina Téllez-Girón, hija de los Duques de Osuna *
Portrait of J. T. G., daughter of the Duke and Duchess of O.
cv 74.8×45.7 (190×116 cm) sg
1798
Don Mariano San Juan y Pinedo, Conde consorte de la Cimera
Portrait of M. S. J. y P., Count Consort de la C.
cv 50.4×35.0 (128×89 cm) c
1813

EYCK Gaspard van
Antwerp 1613 – Brussels 1679
Marina 1507
Seascape
cv 31.9×42.1 (81×107 cm)
Combate naval entre Turcos y Malteses
Marina 1509
A naval battle between the Turks and the Maltese; Seascape
canvases 34.3×46.5 (87×118 cm); the first sg d 1649

EYCK or **AEYC Jan** or **YCK Hans**
act 1627-33 and subsequently, at Antwerp
La caída de Faetón
The fall of Phaethon
cv 76.8×70.9 (195×180 cm) sg
Apolo persiguiendo a Dafne
Apollo pursuing Daphne
cv 76.0×81.5 (193×207 cm)

EYCK Jan van
Bruges c 1385 – 1441
La fuente de la gracia y triunfo de la Iglesia sobre la Sinagoga *
The Fountain of Grace (or of Life) and the Triumph of the Church over the Synagogue
cv 51.6 (centr curved top 71.3 [181 cm]) × 45.7 (131×116 cm) school
La Virgen con el Niño
Madonna and Child
pn 7.1×5.9 (18×15 cm)
school see also Mabuse

**EZQUERRA
Jerónimo Antonio de**
First half of the Eighteenth Century, Madrid
El Agua
Water
cv 97.6×63.0 (248×160 cm)

FALCONE Aniello
Naples 1607 – 1656
Elefantes en un circo *
Elephants at a circus
cv 90.2×90.9 (229×231 cm) c
1630-5
Gladiadores
Gladiators
cv 73.2×72.0 (186×183 cm) c
1630-5

Soldados romanos en el circo *
Roman soldiers entering the circus
cv 36.2×72.0 (92×183 cm) c
1630-5
La expulsión de los mercaderes del templo
Christ driving the Money-Changers from the Temple
cv 39.8×53.5 (101×136 cm)
Batalla
Battle scene
cv 52.4×84.6 (133×215 cm)
Noé después del diluvio
Noah after the Flood
cv 39.4×50.0 (100×127 cm)
Concierto
A concert
cv 42.9×50.0 (109×127 cm) c
1640; the fruit and flower decorations by his pupil Paolo Porpora (?) (Naples 1617 – 1673)

FERNÁNDEZ Alejo
Cordova c 1475 – Granada 1545-6
La flagelación *
The Flagellation of Christ
pn 18.9×13.8 (48×35 cm) attr

**FERNÁNDEZ CRUZADO
Joaquín Manuel**
Jerez de la Frontera 1781 – Cadiz 1856
Dama escotada
Portrait of a lady in a low-cut dress
cv 34.3×31.1 (87×79 cm) c
1840; attr

FERRO Gregorio
Santa María de Lamas 1742 – Madrid 1812
El Conde de Floridablanca (?), protector del comercio
Portrait of the Count of F. (?), Protector of Trade
sketch; cv 13.8×10.6 (35×27 cm) false sg Francisco Goya

FINSON or **FINSONIUS Louis**
Bruges c 1580 – Amberes 1617 or Arles 1632
Anunciación
The Annunciation
cv 68.1×85.8 (173×218 cm) sg
c 1612 (?)

Flandes see JUAN DE F.

FLAUGIER José Bernat
Martigues 1757 – Barcelona 1813
Joven desconocido
Portrait of a young man
cv 26.4×10.6 (67×27 cm) mutilated

FLIPART Charles-Joseph
Paris 1721 – Madrid 1797
La rendición de Sevilla a San Fernando
The surrender of Seville to St. Ferdinand (Ferdinand III of Castile)
sketch; cv 23.3×22.0 (72×56 cm)

FORTUNY Mariano
Reus 1838 – Rome 1874
Fantasía sobre "Fausto" *
Fantasy on Gounod's 'Faust'
cv 15.7×27.2 (40×69 cm) sg
d 1866
Desnudo en la playa de Portici
Nude figure on the beach at P.
pn 5.1×7.5 (13×19 cm) 1874
Marroquíes *
A Moroccan family
pn 5.1×7.5 (13×19 cm) sg
Un marroquí
A Moroccan
wat 12.6×7.9 (32×20 cm) sg
d 1869
Idilio
Idyll
wat 12.2×8.7 (31×22 cm) sg
d 1868
Flores
Flowers
cv 48.4×25.6 (123×65 cm)
Viejo desnudo al sol
An old man, naked, in the sun
cv 29.1×22.8 (74×58 cm) sg

Paisaje
Landscape
sketch; wat 15.7×12.2 (40×31 cm)
Los hijos del pintor María Luisa y Mariano
Portrait of the artist's children, M. L. and M.
cv 17.3×36.6 (44×93 cm) 1874
Jardín de la casa de Fortuny
The garden of the artist's house
pn 15.7×10.6 (40×27 cm) sg ("R. Madrazo") finished by Madrazo after 1874

FOSSE Charles de la
Paris 1636 – 1716
Acis y Galatea
A. and G.
copper 40.9×35.4 (104×90 cm) 1704 (?)

FRACANZANO Cesare
Bisceglie c 1600 – Barletta 1651
Dos luchadores
Two wrestlers (Hercules and Antaeus?)
cv 61.4×50.4 (156×128 cm) sg c 1637

FRANCIA Giacomo
(G. Raibolini)
Bologna c 1486 – 1557
San Jerónimo, Santa Margarita y San Francisco
St. Jerome, St. Margaret and St. Francis
pn 61.4×57.1 (156×145 cm) sg d 1518
in collaboration with his brother Giulio (Bologna 1487-1540)

Francia Giulio see under
Francia Giacomo

FRANCK II EL MOZO
(THE YOUNGER) Frans
Antwerp 1581 – 1642
Neptuno y Anfitrite
Neptune and Amphitrite
copper 11.8×16.1 (30×41 cm) sg
El pecado original
Caín matando a Abel
Noé dirige la entrada en el arca
La construcción de la Torre de Babel
Abraham y Melquísedec
Agar y el ángel
Abraham y los tres ángeles
Lot y sus hijas
El sacrificio de Isaac
Rebeca y Eliecer
La escala de Jacob
La lucha de Jacob con el ángel
The Original Sin; C. killing A.; Noah guiding the Animals into the Ark; The Building of the Tower of B.; A. and Melchizedek; Hagar and the Angel; A. and the Three Angels; L. and his Daughters; The Sacrifice of I.; Rebecca and Eleazar; Jacob's Ladder; J. wrestling with the Angel
copper 26.8×33.9 (68×86 cm)
see also Franck el Viejo

FRANCK EL VIEJO
(THE ELDER) Frans
Herenthals 1542 – Antwerp 1616
"Ecce Homo"
copper 13.0×9.1 (33×23 cm) sg
El prendimiento
The Betrayal of Christ
copper 17.3×9.1 (44×23 cm) sg
Interior de una iglesia flamenca
The interior of a Flemish church
pn 13.0×18.9 (33×48 cm) sg
La sentencia de Jesús
Christ condemned
pn 22.8×31.9 (58×81 cm) sg; copy by Frans Franck II the Younger
La predicación de San Juan Bautista
St. John the Baptist Preaching
pn 22.0×35.8 (56×91 cm) d 1623;
copy by Frans Franck II the Younger
see also Neefs el Viejo

Franck III see under
Neefs Ludwig

FRIS or **FRIST Pieter**
Amsterdam 1627-8 – Delft 1708
Orfeo en los infiernos
Orpheus in the underworld
cv 24.0×30.3 (61×77 cm) sg d 1652

FURINI Francesco
Florence c 1600 – 1646
Lot y sus hijas *
L. and his Daughters
cv 48.4×47.2 (123×120 cm)

FYT Jan
Antwerp 1611 – 1661
Un milano
A kite
cv 37.4×52.8 (95×134 cm)
Caza muerta con un perro
Dead game and a dog
cv 28.3×47.6 (72×121 cm) sg d 1649
Bodegón con un perro y un gato
Still life with a dog and a cat
pn 30.3×44.1 (77×112 cm) sg (damaged)
Ánades y gallinas de agua 1531
Ducks and water-hens
cv 50.0×64.1 (127×163 cm) sg
Ánades y gallinas de agua 1533
cv 46.9×66.9 (119×170 cm)
Concierto de aves
A concert of birds
cv 53.1×68.5 (135×174 cm) sg d 1661; ins

GADDI Taddeo
act 1332-1366 in Florence
San Eloy antes el Rey Clotario
San Eloy en el taller de orfebrería *
St. E. before King Clotaire; St. E. in the Goldsmith's Workshop
panels 13.8×15.4 (35×39 cm) attr

GAGLIARDI Filippo
... – Rome 1659
Interior de San Pedro en Roma
The interior of St. Peter's, Rome
cv 82.7×61.4 (210×156 cm) sg d 1640

GAINSBOROUGH Thomas
Sudbury 1727 – London 1788
El médico Isaac Henrique Sequeira
Portrait of Dr. I. H. S.
cv 50.0×40.2 (127×102 cm)
Mr. Robert Butcher of Walttamstan
cv 29.5×24.4 (75×62 cm) repl

GALLEGO Fernando
act 1466-7 –
1507 at Salamanca and Zamora
Cristo bendiciendo *
Christ Enthroned
centr pn of a polyptych; ogee pn 66.6×52.0 (169×132 cm) c 1492
El Calvario *
Calvary
pn 36.2×32.7 (92×83 cm)
La piedad, o Quinta Angustia
→ no 60
Pietá
pn with curved top 46.5×40.2 (118×102 cm) sg ins two donors on the l
El martirio de Santa Catalina *
The Martyrdom of St. Catherine
pn 49.2×42.9 (125×109 cm) attr (?)

GARCÍA DE BENABARRE
Pedro
Benabarre (Lérida) ... –
... act 1455-6
San Sebastián y San Policarpo destruyen los ídolos. El primero habla a Marcos y Marceliano
Martirio de los Santos Sebastián y Policarpo *
St. S. and St. Polycarp destroying idols. St. S. is talking to Marcus and Marcelli-

nus; *The Martyrdom of St. S. and St. P.*
panels 63.0×26.8 (160×68 cm)

García de Miranda see under
Titian

GARGIULO Domenico
(Micco Spadaro)
Naples 1612 – 1675
Entrada triunfal de Vespasiano en Roma
Entrada triunfal de Constantino en Roma *
The triumphal entry of Vespasian and Constantine into Rome
canvases 61.0×142.9 and 139.8 (155×363 cm and 355 cm) attr

Gellée see **LORRAIN**

GENTILESCHI Artemisia
Rome 1597 –
Naples (?) after 1651
El nacimiento de San Juan Bautista
The Birth of St. John the Baptist
cv 72.4×101.6 (184×258 cm) sg c 1635

GENTILESCHI Orazio Lomi de
Pisa 1565 (?) – London 1639 (?)
Moisés salvado de las aguas del Nilo → no 120
The Finding of Moses
cv 95.3×110.6 (242×281 cm) sg c 1633
El Niño Jesús dormido sobre la cruz *
The Christ Child asleep on the Cross
cv 29.5×39.4 (75×100 cm) attr fomerly attr to Zurbarán or Cavarozzi
San Francisco sostenido por un ángel
St. Francis supported by an angel
cv 49.6×38.6 (126×98 cm) c 1605 attr
Verdugo con la cabeza de San Juan *
An Executioner with the Head of St. John the Baptist
cv 32.3×24.0 (82×61 cm) sg

GHERING Antoon Gunther
... – Antwerp 1668
La iglesia de los Jesuitas, de Amberes
The Jesuit church at Antwerp
cv 33.1×47.6 (84×121 cm)

GIACOMOTTI Félix-Henri
Quingey 1828 – Besançon 1909
La Marquesa de San Carlos de Pedroso
Portrait of the Marchioness of San Carlos de Pedroso
cv 83.5×53.5 (212×136 cm)

Giambellino see
BELLINI Giovanni

GIAQUINTO Corrado
Molfetta 1703 – Naples 1765
El nacimiento del Sol y el triunfo de Baco
The Sun ascending and the triumph of Bacchus
sketch; cv 66.1×55.1 (168×140 cm)
La Paz y la Justicia 582, 104
Peace and Justice
canvases 82.7×126.0 (210×320 cm) and 82.7×127.9 (210×325 cm) the second sg and repl of the first
La Batalla de Clavijo *
The Battle of C.
sketch; cv 30.3×53.5 (77×136 cm)
La oración del huerto
El descendimiento de la Cruz
Christ in the Garden of Gethsemane; The Deposition of Christ
canvases 30.3×53.5 and 57.9×42.9 (77×136 cm and 147×109 cm)
San Lorenzo en la gloria
St. Laurence in Glory
sketch; cv 38.2×53.9 (97×137 cm)

El triunfo de San Juan de Dios
The Apotheosis of St. John of God
sketch; cv 83.9×38.6 (213×98 cm)

GILARTE Mateo
Valencia c 1620 – Murcia 1690
El nacimiento de la Virgen
The Birth of the Virgin
cv 89.8×57.9 (228×147 cm) sg ins

GIORDANO Luca
(L. Jordán)
Naples 1634 – 1705
Lot embriagado por sus hijas
L. made drunk by his Daughters
cv 22.8×60.6 (58×154 cm)
Viaje de Jacob a Canaán *
Jacob's Journey to C.; The Song of the Prophetess Miriam
copper 23.2 and 22.8×33.1 (59 and 578×84 cm)
La derrota de Sísara
Victoria de los Israelitas y cántico de Dévora
The Defeat of Sisera; The Victory of the Israelites and the Song of Deborah
sketches; canvases 40.2×51.2 and 60.6 (102×130 cm and 154 cm)
Hércules en la pira
H. on the Pyre
cv 88.2×35.8 (224×91 cm)
Bethsabé en el baño
Bathsheba at her Bath
cv 86.2×83.5 (219×212 cm)
La prudente Abigail
The Prudent A.
cv 85.0×142.5 (216×362 cm)
San Antonio de Padua con el Niño Jesús
St. Anthony of P. with the Christ Child
cv 47.6×36.6 (121×93 cm) c 1655-60
San Francisco Javier
St. Francis Xavier
cv 38.2×28.0 (97×71 cm)
Santa salvada de un naufragio
A Female Saint saved from a Shipwreck
cv 24.4×30.3 (62×77 cm)
Toma de una plaza fuerte
The capture of a stronghold
cv 92.5×135.0 (235×343 cm)
La batalla de San Quintín 184, 185, 186
Prisión del Condestable de Montmorency en la batalla de San Quintín
Prisión del Almirante de Francia en la batalla de San Quintín
The Battle of San Quentin (three scenes); The capture of the Constable d. M. at the B. of S. Q.; The capture of Admiral Coligny at the B. of S. Q.
sketches; canvases 20.9×66.1 (53×168 cm)
Rubens, pintando: Alegoría de la Paz
Rubens painting: an allegory of peace
cv 132.7×163.0 (337×414 cm)
El aire
Air
cv 76.4×30.3 (194×77 cm)
La muerte del centauro Neso
The death of the centaur Nessus
cv 44.9×31.1 (114×79 cm)
Perseo vencedor de Medusa
Perseus with the head of M.
cv 87.8×35.8 (223×91 cm)
Andrómeda
cv 30.7×25.2 (78×64 cm)
Eneas, fugitivo con su familia *
Aeneas fleeing with his family
cv 109.8×49.2 (279×125 cm)
Carlos II, niño 197
Doña María Ana de Neuburg, Reina de España, a cabello 198
Portrait of Charles II of Spain on horseback; Portrait of Mariana of Neuburg, Queen of Spain, on horseback
canvases 31.9×24.0 (81×61 cm)

Carlos II, a caballo 2762
Doña María Ana de Neuburg, Reina de España, a caballo 2763
Portrait of Charles II of Spain on horseback; Portrait of Mariana of N., Queen of Spain, on horseback
sketches; canvases 31.5×24.4 (80×62 cm) replicas of the preceding paintings
Carlos II, a caballo 2761
Portrait of Charles II of Spain on horseback
sketch; cv 26.8×21.3 (68×54 cm)
Orfeo
Orpheus
cv 78.0×122.4 (198×311 cm) attr
San Carlos Borromeo
St. Charles B.
cv 49.6×40.9 (126×104 cm)
Degollación de los inocentes
The Massacre of the Innocents
cv 92.5×127.9 (235×325 cm) c 1692 recently res
Sacrificio de Abraham
The Sacrifice of Isaac
cv 33.1×48.0 (84×122 cm) sg c 1692
Sueño de Salomón
Juicio de Salomón
The Dream and The Judgement of Solomon
sketches; canvases 96.5×142.1 and 98.4×141.7 (245×361 cm and 250×360 cm) c 1693

GIORGIONE
(Giorgio da Castelfranco)
Castelfranco Veneto c 1477 –
Venice 1510
La Virgen, con el Niño en brazos, entre San Antonio de Padua y San Roque *
Madonna and Child with St. Anthony of P. and St. Roch
cv 36.2×52.4 (92×133 cm) attr also attr to Titian

GIOVANNI DAL PONTE
(Giovanni di Marco da Santo Stefano al Ponte)
Florence 1385 – c 1437
Las siete Artes Liberales *
The seven Liberal Arts
pn for a chest 22.0×61.0 (56×155 cm) gold ground c 1435 attr

GIULIO ROMANO
(G. Pippi)
Rome c 1499 – Mantua 1546
"Noli me tangere"
pn 86.6×63.0 (220×160 cm) in collaboration with Gianfrancesco Penni (Il Fattore, Florence c 1488 – Naples 1528)
Sagrada Familia
The Holy Family
pn 18.9×14.6 (48×37 cm) school

GLAUBER Jan (Polidoro)
Utrecht 1646 –
Shoonhoven c 1726
Paisaje con pastores y ganado
Landscape with shepherds and their flocks
cv 16.5×24.0 (42×61 cm)
Descanso en el camino
A rest on the journey
cv 16.9×24.8 (43×63 cm)
Paisaje con ruinas
Landscape with ruins
cv 16.9×27.2 (43×69 cm)
Parada en un camino
A halt on the journey
cv 16.9×24.4 (43×62 cm)

Gobbo dei Carracci see
BONZI

GOBERT Pierre
Fontainebleau 1662 – Paris 1744
Luis XV, niño
Portrait of Louis XV of France as a child
cv 50.8×38.6 (129×98 cm) sg d 1714
La segunda Mademoiselle de Blois, en figura de Leda
The second M. de B. as L.
cv 85.0×105.5 (216×268 cm)

GÓMEZ PASTOR Jacinto
San Ildefonso 1746 – 1812

Adoración del Espíritu Santo
por los ángeles
*Angels worshipping the Holy
Ghost*
sketch; cv 18.1×17.7 (46×45
cm)

GONZÁLEZ Bartolomé
Valladolid 1564 – Madrid 1627

La Reina Doña Margarita de
Austria
*Portrait of Margaret of A.
Queen of Spain*
cv 45.7×39.4 (116×100 cm) sg
d 1609

GONZÁLEZ
VELÁZQUEZ Luis
Madrid 1715 – 1764

Jubileo de la Porciúncula *
*Celebrations at the Porziun-
cola*
cv 27.6×20.5 (70×52 cm) attr

GONZÁLEZ
VELÁZQUEZ Zacarías
Madrid 1763 – 1834

Don Antonio González Veláz-
quez
cv 31.5×22.8 (80×58 cm)
Pescador
A fisherman
cv 43.3×77.2 (110×196 cm)
1785
Retrato de Señora *
Portrait of a young woman
cv 17.7×13.8 (45×35 cm)

Gossart or Gossaert see
MABUSE

GOWY Jacob Peter
act 1636-61 at Antwerp

Hipómenes y Atalanta
Hippomenes and A.
cv 71.3×86.6 (181×220 cm) sg
from a sketch by Rubens
La derrota de los Titanes
The fall of the Titans
cv 67.3×112.2 (171×285 cm)
from a sketch by Rubens
La caída de Ícaro
The fall of Icarus
cv 76.8×70.9 (195×180 cm) sg
from a sketch by Rubens

GOYA Francisco de
*Fuendetodos 1746 –
Bordeaux 1828*

Carlos IV a caballo
La Reina María Luisa a ca-
ballo
*Portrait of Charles IV of
Spain on horseback; Portrait
of Marie Louise of Parma,
Queen of Spain, on horse-
back*
canvases 132.5 and 133.2×
111.1 (336 and 338×282 cm)
1799
El pintor Francisco Bayeu *
Portrait of F. B.
cv 44.1×33.1 (112×84 cm) 1795
Josefa Bayeu de Goya (?) *
*Portrait of J. B. de G., the
artist's wife (?)*
cv 31.9×22.0 (81×56 cm)
c 1798
Autorretrato → no 83
Self-portrait
cv 18.1×13.8 (46×35 cm) sg
1815 (?)
Fernando VII en un campa-
mento *
*Portrait of Ferdinand VII of
Spain at a military camp*
cv 81.5×55.1 (207×140 cm) sg
El general Don José de Palafox
a caballo
*Portrait of G. D. J. d. P. on
horseback*
cv 97.6×88.2 (248×224 cm) sg
d 1814
Carlos IV 727 *
*Portrait of Charles IV of
Spain*
cv 79.5×49.6 (202×126 cm)
c 1789
Carlos IV 740a
cv 49.6×37.0 (126×94 cm)
c 1789
La Reina María Luisa 728 *
*Portrait of M. L. of Parma,
Queen of Spain*
cv 82.3×49.2 (209×125 cm)
1799

La Reina María Luisa 740c *
*Portrait of M. L. of Parma,
Queen of Spain*
cv 44.9×31.9 (114×81 cm)
La Infanta Doña María Josefa *
El Infante Don Francisco de
Paula Antonio *
El Infante Don Carlos María
Isidro *
Don Luis de Borbón, Príncipe
de Parma y rey de Etruria *
El Infante Don Antonio Pas-
cual *
*Portrait of the I. M. J.; Por-
trait of the I. Don F. de P. A.;
Portrait of the I. Don C. M. I.;
Portrait of Don L de B. Prin-
ce of P. and King of E.; Por-
trait of the I. Don A. P.*
canvases 29.1×23.6 (74×60
cm) studies for the next ptg
La familia de Carlos IV → no
80
*The family of Charles IV of
Spain*
cv 110.2×132.3 (280×336 cm)
1800 recently res
Isidro Maiquez *
cv 30.3×22.8 (77×58 cm) sg
d 1807
Fernando VII con manto real *
*Portrait of Ferdinand VII of
Spain in royal robes*
cv 83.5×57.5 (212×146 cm)
1814-5 (?)
El general Urrutia *
Portrait of G. U.
cv 78.7×53.1 (200×135 cm) sg
Carlos III cazador *
*Portrait of Charles III of
Spain in hunting dress*
cv 82.7×50.0 (210×127 cm)
El cardenal Don Luis María de
Borbón y Vallabriga
*Portrait of Cardinal Don L.
M. of Bourbon and V.*
cv 84.3×53.5 (214×136 cm)
Los Duques de Osuna y sus hi-
jos → no 81
*Portrait of the Duke and Du-
chess of Osuna and their chil-
dren*
cv 88.6×68.5 (225×174 cm)
1790
Doña Tadea Arías de Enríquez
Portrait of D. T. A. de E.
→ no 82
cv 74.8×41.7 (190×106 cm)
La degollación
La hoguera
The execution; The pyre
pencil/crt 11.4×16.1 and 12.6×
16.9 (29×41 cm and 32×43
cm) c 1808
La Maja vestida → no 79
La Maja desnuda → no 78
*The clothed maja; the naked
m.*
canvases 37.4 and 38.2×74.8
(95 and 97×190 cm)
El majo de la guitarra *
A m. playing a guitar
tapestry crt/cv 53.1×43.3
(135×110 cm) 1778-9
Un garrochista a caballo
A mounted picador
cv 22.0×18.5 (56×47 cm) c
1797-9
Cristo crucificado
Christ on the Cross
cv 100.4×60.2 (255×153 cm)
1780
La Sagrada Familia
The Holy Family
cv 78.7×58.3 (200×148 cm)
El exorcizado
The exorcism
cv 18.9×23.6 (48×60 cm) c
1808
El 2 de mayo de 1808 en Ma-
drid: la lucha con los Mame-
lucos → no 85
El 3 de mayo de 1808 en Ma-
drid: los fusilamientos en la
montaña del príncipe Pío
→ no 86
*The citizens of M. fighting
Murat's cavalry, 2nd May 1808;
The executions of 3rd May
1808*
canvases 104.7×135.8 (266×
345 cm) 1814; the first ptg
has an ins, now covered up
and is mutilated
La pradera de San Isidro → no
74
The meadow of St. Isidore
sketch; cv 17.3×37.0 (44×94
cm) 1788
Un pavo muerto
Aves muertas
A dead turkey; Dead birds
canvases 17.7×24.8 and 18.1×
25.2 (45×63 cm and 46×64
cm) the first sg

Perros y útiles de caza *
Dogs and hunting gear
tapestry crt/cv 44.1×66.9
(112×170 cm) 1775

FOURTEEN "BLACK PAINT-
INGS" FROM THE "HOUSE
OF THE DEAF", BELONGING
TO THE PERIOD 1820-23

Una manola: doña Leocadia
Zorrilla (?) *
*Portrait of Dona L. Z. (?), a
lady of Madrid*
frs/cv 57.9×52.0 (147×132 cm)
Peregrinación a la fuente de
San Isidro (El Santo Oficio) *
*A pilgrimage to the Fountain
of St. Isidore*
frs/cv 48.4×104.7 (123×266
cm)
El Aquelarre (Asmodeo) 756
→ no 89
The witches' sabbath
frs/cv 48.4×104.3 (123×265
cm)
Aquelarre (Escena Sabática)
761 *
The witches' sabbath
frs/cv 55.1×172.4 (140×438
cm)
El destino (Atropos) *
Destiny (or The Fates)
frs/cv 48.4×104.7 (123×266
cm)
Duelo a garrotazos *
Two men fighting with clubs
frs/cv 48.4×104.7 (123×266
cm)
Dos frailes
Two friars
frs/cv 56.7×26.0 (144×66 cm)
La romería de San Isidro *
The Hermitage of St. Isidore
frs/cv 55.1×172.4 (140×438
cm)
Dos viejos comiendo
Two old men eating
frs/cv 20.9×33.5 (53×85 cm)
Saturno devorando a un hijo
→ no 88
*Saturn devouring one of his
sons*
frs/cv 57.5×32.7 (146×83 cm)
Judith y Holofernes
J. and H.
frs/cv 57.5×33.1 (146×84 cm)
Dos mujeres y un hombre
Two women and a man
frs/cv 49.2×26.0 (125×66 cm)
La lectura
The reading
frs/cv 49.6×26.0 (126×66 cm)
Perro semihundido
A half-submerged dog
frs/cv 52.8×31.5 (134×80 cm)

La merienda a orillas del Man-
zanares *
*A picnic by the banks of the
M.*
tapestry crt/cv 107.1×116.1
(272×295 cm) 1776
El baile de San Antonio de la
Florida *
A dance at S. A. de la F.
tapestry crt/cv 107.1×116.1
(272×295 cm) 1777
La riña en la Venta Nueva
→ no 67
The fight at the 'V. N.'
tapestry crt/cv 108.3×163.0
(275×414 cm) 1777
La maja y los embozados *
The m. and the cloaked majos
tapestry crt/cv 108.3×74.8
(275×190 cm) 1777
El bebedor *
The drinker
tapestry crt/cv 42.1×59.4
(107×151 cm) 1777
El quitasol → no 66
The parasol
tapestry crt/cv 40.9×59.8
(104×152 cm) 1777
La cometa → no 68
Flying a kite
tapestry crt/cv 105.9×112.2
(269×285 cm) 1778
Los jugadores de naipes *
The card players
tapestry crt/cv 106.3×65.7
(270×167 cm) 1778
Niño inflando una vejiga *
Boys blowing up a balloon
tapestry crt/cv 45.7×48.8 (116
×124 cm) 1778
Muchachos cogiendo fruta
Boys picking fruit
tapestry crt/cv 46.9×48.0
(119×122 cm) 1778

El ciego de la guitarra *
The blind guitar player
tapestry crt/tv 102.4×122.4
(260×311 cm) 1778
La feria de Madrid *
The fair at M.
tapestry crt/cv 101.6×85.8 (258
×218 cm) 1778
El cacharrero → no 69
The crockery seller
tapestry crt/cv 102.0×86.6
(259×220 cm) 1778
El militar y la señora *
The soldier and the lady
tapestry crt/cv 102.0×39.4
(259×100 cm) 1778
La acerolera *
The azarole seller
tapestry crt/cv 102.0×39.4
(259×100 cm) 1778
Muchachos jugando a los sol-
dados
Boys playing at soldiers
tapestry crt/cv 57.5×37.0
(146×94 cm) 1778
El juego de la pelota a pala
The ball game
tapestry crt/cv 102.8×185.0
(261×470 cm) 1779
El columpio *
The swing
tapestry crt/cv 102.4×65.0
(260×165 cm) 1779
Las lavanderas *
The washerwomen
tapestry crt/cv 85.8×65.4
(218×166 cm) 1780
La novillada
The amateur bull-fight
tapestry crt/cv 102.0×53.5
(259×136 cm) 1780
El resguardo de tabacos *
The customs men
tapestry crt/cv 103.1×53.9
(262×137 cm) 1780
El niño del árbol
A boy up a tree
tapestry crt/cv 103.1×15.7
(262×40 cm) 1780
El muchacho del pájaro *
A boy with a bird
tapestry crt/cv 103.1×15.7
(262×40 cm) 1780
Los leñadores
The woodcutters
tapestry crt/cv 55.5×44.9
(141×114 cm) 1780
La cita
The rendezvous
tapestry crt/cv 39.4×59.4
(100×151 cm) 1780
Las floreras → no 70
The flower-girls
tapestry crt/cv 109.1×75.6
(277×192 cm) 1786
La era *
The threshing floor
tapestry crt/cv 108.7×252.4
(276×641 cm) 1786
La vendimia → no 71
The grape harvest
tapestry crt/cv 108.3×74.8
(275×190 cm) 1786
El albañil herido → no 72
The injured stonemason
tapestry crt/cv 105.5×43.3
(268×110 cm) 1786
El albañil borracho *
The drunken stonemason
cv 13.8×5.9 (35×15) 1799 a
variation on the prec ptg, on
a small scale
Los pobres en la fuente *
Poor people at the fountain
tapestry crt/cv 109.1×45.3
(277×115 cm) 1786
La nevada *
The snowstorm
tapestry crt/cv 108.3×115.4
(275×293 cm) 1786
La boda *
The wedding
tapestry crt/cv 105.1×115.4
(267×293 cm) 1791-2
Las mozas del cántaro *
The water sellers
tapestry crt/cv 103.1×63.0
(262×160 cm) 1791-2
Las gigantillas *
Children playing at giants
tapestry crt/cv 53.9×40.9
(137×104 cm) 1791-2
Los zancos *
The stilt walkers
tapestry crt/cv 105.5×126.0
(268×320 cm) 1791-2
El pelele → no 75
The puppet
tapestry crt/cv 105.1×63.0
(267×160 cm) 1791-2
Muchachos trepando a un árbol
Boys climbing a tree
tapestry crt/cv 55.5×43.7
(141×111 cm) 1791-2

La gallina ciega 804 → no 76
Blind man's buff
tapestry crt/cv 105.9×137.8
(269×350 cm) 1787
La gallina ciega 2781 *
Blind man's buff
cv 16.1×17.3 (41×44 cm) 1799
(?) a variation on the prec
ptg, on a small scale
El cazador con sus perros
The huntsman and his dogs
tapestry crt/cv 103.1×28.0
(262×71 cm) 1775
Cornelio van der Gotten
Portrait of Correlis v. d. G.
cv 24.4×18.5 (62×48 cm) sg
d 1782
Doña María Antonia Gonzaga,
marquesa de Villafranca *
*Portrait of M. A. G., Marchio-
ness of V.*
cv 34.3×28.3 (87×72 cm)
Doña María Tomasa Palafox,
marquesa de Villafranca
*Portrait of M. T. P., Marchio-
ness of V.*
cv 76.8×49.6 (195×126 cm) sg
d 1804, ins
El Duque de Alba *
Portrait of the Duke of A.
cv 76.8×49.6 (195×126 cm)
1795
Don Manuel Silvela *
Portrait of Don M. S.
cv 37.4×26.8 (95×68 cm) c
1809
Dos niños con dos mastinos *
Two boys with two mastiffs
tapestry crt/cv 44.1×57.1
(112×145 cm) 1786 (?)
El Comercio
La Agricultura
La Industria
Trade; Agriculture; Industry
round canvases 89.4 (227 cm)
Santa Justa y Santa Rufina
St. J. and St. R.
sketch; pn 18.5×11.4 (47×29
cm) 1817 (?)
La ermita de San Isidro el día
de la fiesta *
*The Hermitage of St. Isidore
on a festival day*
sketch; cv 16.5×17.3 (42×44
cm) 1788
El general don Antonio Ricar-
dos *
Portrait of G. Don A.
cv 44.1×33.1 (112×84 cm)
1793-4
El coloso, o El pánico → no 87
The colossus or Panic
cv 45.7×41.3 (116×105 cm) c
1808
Caza con reclamo
Hunting with decoys
cv 43.7×69.3 (111×176 cm)
1775
Partida de caza
The hunt
cv 114.2×89.0 (290×226 cm)
1775
La reina María Luisa con ton-
tillo *
*Portrait of M. L., Queen of
Spain, in a hoop skirt*
cv 86.6×55.1 (200×140 cm)
1797 (?)
Pastor tocando la dulzaina
Cazador al lado de una fuente
*A shepherd playing a pipe;
A huntsman by fountain*
tapestry cartoons/canvases
51.6×51.2 (131×130 cm) 1786
(?)
Don Juan Bautista de Muguiro *
Portrait of Don J. B. de M.
cv 40.6×33.1 (103×84 cm) sg
and d 1827 ins
La lechera de Burdeos → no 84
The milkmaid of Bordeaux
cv 29.1×26.8 (74×68 cm) sg
Don Joaquín Company, arzobis-
po de Zaragoza y Valencia
*Portrait of Don J. C., Archbi-
shop of Saragossa and V.*
sketch; cv 17.3×12.2 (44×31
cm) 1797 – 1800
Los cómicos ambulantes
→ no 77
The wandering players
metal 16.9×12.6 (43×32 cm)
1794 or 1798 ins
Corrida de toros *
The bull fight
cv 15.0×18.1 (38×46 cm) 1824
(?)
Prendimiento de Cristo *
The Betrayal of Christ
sketch; cv 15.7×9.1 (40×23
cm) 1788 (?) see also Carni-
cero

GOYEN Joseph van
Leyden 1596 – The Hague 1656
Paisaje
Landscape
cv 15.0×22.8 (38×58 cm) c
1636 repl of a ptg in a private
collection in Sarasota

GREBER Pieter Frans
Haarlem c 1600 – 1652-3
Ofrenda
The offering
pn 35.0×28.0 (89×71 cm) attr

Grechetto see **CASTIGLIONE**

**GRECO (Domenico
Theotocopoulos or
Theotocopuli)**
Candia 1540 – Toledo 1614
Un caballero 806 *
*Portrait of an elderly gentle-
man*
cv 18.1×16.9 (46×43 cm) sg
1584 – 94
Un caballero 810 *
Portrait of a gentleman
cv 25.2×20.1 (64×51 cm) sg
1604 – 14
Caballero Joven 811 *
Portrait of a young gentleman
cv 21.7×19.3 (55×49 cm) sg
1604 – 14
Un caballero 813 *
Portrait of a gentleman
cv 25.6×21.7 (65×55 cm)
1584 – 94 damaged
El médico (Dr. Rodrigo de la
Fuente?) → no 21
*Portrait of a doctor (R. de la
F. ?)*
cv 36.6×32.3 (93×82 cm)
1577 – 84
Don Rodrigo Vázquez, presi-
dente de los Consejos de
Hacienda y de Castilla
Portrait of Don R. V.
cv 24.4×15.7 (62×40 cm)
1594 – 1604 ins
El caballero de la mano al pe-
cho → no 20
*Portrait of a gentleman with
his hand at his breast*
cv 31.9×26.0 (81×66 cm) sg
1577 – 84
El licenciado Jerónimo de Ce-
vallos *
Portrait of the jurist J. de C.
cv 25.2×21.3 (64×54 cm)
1604 – 14
San Pablo 814
St. Paul
cv 27.6×22.0 (70×56 cm)
1594 – 1604; st wk (?)
San Pablo 2892 *
El Salvador *
Santiago el Mayor *
San Felipe o Santo Tomás
*St. Paul; Christ the Redee-
mer; St. James the Great; St.
Philip or St. Thomas*
canvases 28.3×21.7 (72×55
cm) 1610 – 14; with st assis-
tants; the first ptg res 1936-38
incomplete 'Apostolado' of
Almadrones
San Antonio de Padua
St. Anthony of P.
cv 40.9×31.1 (104×79 cm) sg
San Benito *
St. Benedict
cv 45.7×31.9 (116×81 cm)
formerly thought to represent
St. Basil
San Francisco de Asís *
*St. Francis of Assisi and
Brother Leo meditating on
death*
cv 59.8×44.5 (152×113 cm)
c 1585 – 90; res
San Juan Evangelista y San
Francisco de Asís *
*St. John the Evangelist and
St. Francis*
cv 25.2×19.7 (64×50 cm)
1600 – 5 (?); st wk; damaged
El bautismo de Cristo → no 18
The Baptism of Christ
cv 137.8×56.7 (350×144 cm)
sg 1596 – 1600
Cristo abrazado a la Cruz *
Christ carrying the Cross
cv 42.5×30.7 (108×78 cm) sg
1594 – 1605
La Crucifixión → no 19
*The Crucifixion, with the Vir-
gin, St. Mary Magdalene, St.
John the Evangelist and An-
gels*
cv 122.8×66.6 (312×169 cm)
sg c 1584 – 94

La Trinidad → no 15
The Holy Trinity
cv 118.1×70.5 (300×179 cm)
1577
La Resurrección → no 23
La Pentecostés → no 24
*The Resurrection of Christ;
The Descent of the Holy
Ghost*
canvases 108.3×50.0 (275×127
cm) sg
La Sagrada Familia → no 16
The Holy Family
cv 42.1×27.2 (107×69 cm) sg
1594 – 1604
La Anunciación *
The Annunciation
pn 10.2×7.5 (26×19 cm) 1570
80
La Virgen María *
The Madonna
cv 42.1×27.2 (107×69 cm) sg
1594 – 1604
San Juan Evangelista *
St. John the Evangelist
cv 35.4×30.3 (90×77 cm)
1594 – 1604
Julián Romero y su santo pa-
trono *
*Portrait of J. R. de las Azañas
with St. Julian*
cv 81.5×50.0 (207×127 cm) ins
(erroneous and added later?);
c 1580 – 90
Un fraile trinitario o dominico *
*A Trinitarian or Dominican
Friar*
cv 13.8×10.2 (35×26 cm) 1600 –
14 fr or study (?)
La Coronación de la Virgen *
The Coronation of the Virgin
cv 35.4×39.4 (90×100 cm) sg
frm 1590 – 95
San Andrés y San Francisco
→ no 25
St. Andrew and St. Francis
cv 65.7×44.5 (167×113 cm) sg
1590 – 1600
La Santa Faz *
The Veil of St. Veronica
cv 28.0×21.3 (71×54 cm) 1590 –
5; res and damaged
La Adoración de los pastores
→ no 17
*The Adoration of the She-
pherds*
cv 125.6×70.9 (319×180 cm)
1612 – 14
San Sebastián → no 22
St. S.
frm; cv 45.3×33.5 (115×85 cm)
1610 – 14

COPIES from El Greco made
BY HIS SON Jorge Manuel
THEOTOCÓPULI (Toledo
1578 – 1631)
El entierro del Señor de Orgaz
*The burial of the Lord of Or-
gaz (lower part)*
cv 74.4×98.4 (189×250 cm)
copy of the lower part of the
ptg at Toledo, Santo Tomé
El Expolio
The Disrobing of Christ
cv 47.2×25.6 (120×65 cm) sg
c 1595 – 1604
copy of a ptg in Toledo, Ca-
thedral

GREUZE Jean-Baptiste
Tournus 1725 – Paris 1805
Joven de espaldas *
*A young woman seen from
behind*
cv 18.1×15.0 (46×38 cm)
repl of a ptg in Montpellier,
Musée Fabre

**GUERCINO (Giovanni
Francesco Barbieri)**
Cento 1591 – Bologna 1666
San Pedro libertado por un án-
gel *
St. Peter freed by an Angel
cv 41.3×53.5 (105×136 cm)
c 1620-3; recently res
Susana y los viejos → no 122
S. and the Elders
cv 68.9×81.5 (175×207 cm)
1617
San Agustín meditando sobre
la Trinidad
*St. Augustine meditating on
the Mystery of the Trinity*
cv 72.8×65.4 (185×166 cm)
1636;
recently res

HAMEN Y LEÓN Juan van der
Madrid 1596 – 1631
Bodegón *
Still life
cv 20.5×34.6 (52×88 cm) sg
d 1622
Frutero
A basket of fruit
cv 22.0×43.3 (56×110 cm) sg
d 1623
Ofrenda a Flora
An offering to F.
cv 85.0×55.1 (216×140 cm) sg
d 1627

Haarlem see **CORNELISZ.
VAN HAERLEM**

Haye see
CORNEILLE DE LYON

HAYES Edwin
Bristol 1819 – London 1904
Marina
Seascape
cv 35.4×59.4 (90×151 cm) sg
d 1884

HEDA Willem Claesz
Haarlem 1594 – 1680
Bodegón 2754, 2755 → no 162,
2756
Still life
canvases 21.3×28.0; 20.5×
29.1; 20.5×28.7 (54×71 cm;
52×74 cm and 73 cm) the
first sg d 1657; the third sg

HEEM Jan Davidsz. de
Utrecht 1606 – Antwerp 1683-4
Mesa 2089
Still life with a table of food
cv 16.9×31.9 (43×81 cm)
Mesa 2090
cv 19.3×25.2 (49×64 cm) sg

HEERE Lucas de
Ghent 1534 – Paris 1584
Felipe II
Portrait of Philip II of Spain
pn 16.1×12.6 (41×32 cm) 1553

Heil see under
Bruegel el Joven Pieter

HEMESEN Jan Sanders van
*Hemixen c 1500 –
Haarlem 1564-6*
El cirujano
The surgeon
pn 39.4×55.5 (100×141 cm)
c 1555
La Virgen y el Niño
Madonna and Child
pn 53.1×35.8 (135×91 cm)
sg (?) d 1543 attr

**HERRERA EL MOZO
(THE YOUNGER) Francisco de**
Seville 1622 – Madrid 1685
El triunfo de San Hermenegil-
do *
*The Apotheosis of St. Her-
mengild*
cv 129.1×90.2 (328×229 cm)
see also Herrera el Viejo

Inglés see **JORGE INGLÉS**

**HERRERA EL VIEJO
(THE ELDER) Francisco de**
Seville c 1576 – Madrid 1656
El Papa San León I "El Magno"
Pope Leo I (Leo the Great)
oval pn; 64.6×41.3 (164×105
cm)
formerly attr to Herrera the
Younger
San Buenaventura recibe el
hábito de san Francisco →
no 28
*St. Bonaventura received into
the Franciscan Order*
cv 90.9×84.6 (231×215 cm)
1628
Cabeza de un Apóstol (?) 2773,
2774
Head of an Apostle (?)
sketches; canvases 15.0×12.6
and 15.4×12.6 (38 and 39×32
cm)
Cabeza de Santo degollado *
*The Head of a decapitated
Saint*
cv 20.1×25.6 (51×65 cm) sg

HOBBEMA Meindert
Amsterdam 1638 – 1709
Paisaje
Landscape
pn 16.5×22.0 (42×56 cm) sg

**HOLBEIN EL JOVEN
(THE YOUNGER) Hans**
Augsburg 1497-8 – London 1543
Retrato de anciano *
Portrait of an old man
pn 24.4×18.5 (62×47 cm)
also attr to Joos van Cleve
see also Rubens

HOPPNER John
Whitechapel 1758 – London 1810
Mrs. Thornton *
cv 24.0×29.1 (61×74 cm)

HOUASSE Michel-Ange
Paris 1680 – Arpajon 1730
La Sagrada Familia con San
Juan Bautista niño
*The Holy Family with St.
John the Baptist*
cv 24.8×33.1 (63×84 cm) sg
d 1726
Bacanal
Sacrificio a Baco
*Bacchanal; The offering to
Bacchus*
canvases 49.2×70.9 (125×180
cm) sg d 1719 and 1720
Vista del Monasterio de El
Escorial *
*A view of the monastery at
El E.*
cv 19.7×32.3 (50×82 cm)
Luis I
*Portrait of Luis of Bourbon,
Prince of Asturias*
cv 67.7×44.1 (172×112 cm) d
1717 ins attr

Houte see **LIGNIS**

HUGUET Jaume
*Valls 1414-5 –
... act 1434-87 at Barcelona*
Un Profeta *
A Prophet
pn 11.8×10.2 (30×26 cm)
Fragmento de un retablo de la
Virgen
Fragment of an altarpiece
pn 66.9×22.0 (170×56 cm) attr;
damaged

HUTIN Charles-François
Paris 1715 – Dresden 1776
Aldeana sajona en la cocina
Un aldeano
*A Saxon peasant in the kit-
chen; A peasant*
canvases 32.7×21.7 and 32.7
×22.4 (83×55 cm and 83×57
cm) the second sg d 1756

HUYS Peeter
*... 1519 (?) –
... 1581 (?) act at Antwerp*
El Infierno
Hell
pn 33.9×32.3 (86×82 cm) sg
d 1570

Ijkens see **YKENS**

Inglés see **JORGE INGLÉS**

INZA Joaquín
1763 – ... 1808 act in Spain
Don Tomás Iriarte
cv 32.3×23.2 (82×59 cm)
c 1792

IRIARTE Ignacio
Azcoitia 1621 – Seville 1685
Paisaje con un torrente
Paisaje con pastores →
Landscape with a stream and
with shepherds
canvases 44.1×78.0 and 41.7
×76.4 (112×198 cm and 106×
194 cm) the second sg d 1665
Paisaje con ruinas
Landscape with ruins
cv 38.2×39.8 (97×101 cm)

**ISENBRANDT or
YSENBRANDT Adriaen**
... act c 1500 – Bruges 1551
La misa de San Gregorio
The Mass of St. Gregory
cv 28.3×22.0 (72×56 cm) attr

La Virgen, el Niño, San Juanito
y tres ángeles
*Madonna and Child with St.
John and Three Angels*
pn 6.5×4.8 (16.5×12.3 cm) res

Jiménez Miguel see **XIMÉNES**

JIMÉNEZ DONOSO José
Consuegra 1628 – Madrid 1690
Visión de San Francisco de
Paula
*The Vision of St. Francis of
Paola*
cv 67.7×64.1 (172×163 cm)

**JOHNSON Cornelius
(Janssen van Ceulen)**
*London 1593 –
... c 1662, act in Holland*
Joven con la mano ante el pe-
cho
*Portrait of a young man with
his hand before his breast*
cv 29.1×23.6 (74×60 cm) attr

JOLI Antonio
Modena c 1700 – 1777
Embarco de Carlos III, en Ná-
poles 232 *, 233
*The Embarkation of Charles
III of Spain at Naples*
canvases 50.4×80.7 (128×205
cm) sg d 1759

JORDAENS Jacob
Antwerp 1593 – 1678
Los desposorios místicos de
Santa Catalina de Alejandría
*The Mystical Marriage of St.
Catherine*
cv 47.6×68.1 (121×173 cm) al-
so attr to Van Dyck
El Niño Jesús y San Juan
The Christ Child and St. John
pn 51.2×29.1 (130×74 cm) attr
Meleagro y Atalanta
Meleager and A.
cv 59.4×94.9 (151×241 cm)
c 1628 part of the I hand side
added later
Ofrendas a Pomona *
Offerings to P.
cv 65.0×44.1 (165×112 cm)
1618 (?)
Diosas y Ninfas después del
baño
*Goddesses and nymphs after
a bathe*
cv/pn (partly painted direc-
tly on to the pn) 51.6×50.0
(131×127 cm)
La familia de Jordaens en un
jardín → no 157
*The artist's family in a gar-
den*
cv 71.3×73.6 (181×187 cm)
1621-2 (?)
Tres músicos ambulantes
Three wandering musicians
pn 19.3×25.2 (49×64 cm) attr
Apolo vencedor de Pan *
Apollo victorious over P.
cv 71.3×105.1 (181×267 cm) sg
c 1637; from a sketch by Ru-
bens; copy painted by Mazo
see also Rubens

Jordán see **GIORDANO**

JORGE INGLÉS
*act in the mid-Fifteenth Century,
Castile*
La Trinidad rodeada de ángeles
*The Holy Trinity surrounded
by Angels*
pn 38.2×33.9 (97×86 cm) attr

JOUVENET Jean-Baptiste
Rouen 1644 – Paris 1717
El "Magnificat"
The M.
sketch; cv 40.6×39.4 (103×
100 cm)

**JUAN DE FLANDES
(Juan Sallaert?)**
... c 1475 – Palencia (?) 1519
La resurrección de Lázaro *
La oración del huerto
La Ascensión del Señor
La venida del Espíritu Santo
*The Raising of Lazarus;
Christ in the Garden of Geth-
semane; The Ascension of
Christ; The Descent of the
Holy Ghost*
panels 43.3×33.1 (110×84 cm)

Column 1

MADRAZO Luis de
Madrid 1825 – 1897
La Señora de Creus
Portrait of a lady
cv, oval 21.7×18.9 (55×48 cm)
sg d 1870

MADRAZO Raimundo de
Rome 1841 – Versailles 1920
Doña Josefa Manzanedo e Intentas de Mitjans, Marquesa de Manzanedo *
Portrait of J. M. e I. de M., Marchioness of M.
pn 89.4×50.0 (227×127 cm) sg d 1875
Don Ramón de Errazu
pn 85.0×34.6 (216×88 cm) sg d 1879
Después del baño (desnudo de mujer)
After the bath (female nude)
cv 72.4×43.3 (184×110 cm) sg
El pabellón de Carlos V, en los jardines del Alcázar de Sevilla
Estanque en el Alcázar de Sevilla
The pavilion of Charles V in the A. gardens at Seville; A lake in the A. gardens at Seville
panels 3.5×6.3 (9×16 cm) the first sg
El patio de San Miguel, en la Catedral de Sevilla
The Courtyard of S. Michael at Seville Cathedral
pn 5.9×3.5 (15×9 cm) sg
Doña María Cristina de Habsburgo, reina regente de España
Portrait of Maria Christina of Austria, Queen Regent of Spain
cv 22.8×16.5 (58×42 cm) sg d 1887
Una gitana
A gypsy woman
cv 25.6×19.3 (65×49 cm)
see also Fortuny

MAELLA Mariano Salvador
Valencia 1739 – Madrid 1819
Carlota Joaquina, Infanta de España, reina de Portugal
Portrait of C. J., I. of Spain and Queen of P.
cv 69.7×45.7 (177×116 cm)
Visión de San Sebastián de Aparicio
A vision of St. S. of A.
cv 67.3×47.6 (171×121 cm)
Las Estaciones: la Primavera
Las Estaciones: el Verano *
Las Estaciones: el Otoño
Las Estaciones: el Invierno
The seasons: Spring; Summer; Autumn; Winter
canvases 56.3×30.3; the fourth 56.3×32.7 (108×84 cm) and c 35.3×
83 cm)
San José *
San Pedro *
St. Joseph; St. Peter
canvases 10.6×7.5 (27×19 cm) d

Maestro see also **Anonymous**

MAESTRO DE ARGUIS
(MASTER OF A.)
act c 1450 in Aragon
La Leyenda de San Miguel *
The Legend of St. Michael (I panels: St. Michael appearing on Mount Gargano; St. Michael appearing to Pope Gregory; St. Michael victorious over Antichrist; r panels: St. Michael fighting the Fallen Angels; St. Michael receiving the Souls of the Dead; The Wounding of Gargano; In the pred: St. Paul, St. Catherine, St. Laurence, St. Vincent, St. Barbara, and St. Peter
panels: from an unfinished polyptych, measuring between 42.5×33.1 (108×84 cm) and 35×33.1 (c 89×84 cm); pred c 26.4×19.3 (c 67×49 cm)

MAESTRO DE ESTIMARIU
(MASTER OF E.)
act in the Fourteenth Century in Catalonia
Leyenda de Santa Lucía *
The Legend of St. Lucy (St. L. and her mother before St. A-

Column 2

gatha's tomb; St. A. appears to St. L.; St. L. sells her property; is accused of being a Christian; is locked up in a brothel; is threatened by two oxes: is put on a pyre; is beheaded; is brought back to life; receives Holy Communion; is buried)*
two panels 63.4×38.2 (161×97 cm) including the frame, which is original

MASTER DE FLÉMALLE
(MASTER OF F.)
(Robert Campin?)
... c 1378 – Tournai 1444
San Juan Bautista y el maestro franciscano Enrique de Werl → no 130
Santa Bárbara
St. John the Baptist and Heinrich of W., a Franciscan Theologian from Cologne; St. B.
trp wings; panels 39.8×18.5 (101×47 cm) 1438 ins
Los desposorios de la Virgen → no 129
The Marriage of the Virgin (rev: St. James the Great and St. Clare grisaille)
centr pn from a trp; pn 30.3×34.6 (77×88 cm); c 1428 also attr to Roger van der Weyden
La Anunciación *
The Annunciation
pn 29.9×27.6 (76×70 cm) c 1482; also attr to Jacques Daret (Tournai c 1410 - c 1468)
La Virgen con el Niño *
Madonna and Child
pn 70.9×51.2 (180×130 cm) attr

MAESTRO DE FRANCFORT
(MASTER DE FRANKFURT)
... c 1460 –... c 1515-20 act at Antwerp (?)
Santa Catalina
Santa Bárbara
St. Catherine; St. B.
trp wings; panels 31.1×10.6 (79×27 cm)

MAESTRO DEL ARZOBISPO DALMÁU DE MUR
(MASTER OF ARCHBISHOP D. DE M.)
(Jaime Romeu?, 1440-1475?)
act in the Fifteenth Century in Catalonia
San Vincente, Diácono y mártir *
St. Vincent, Deacon and Martyr
pn 72.8×46.1 (185×117 cm) with an ins on a scroll

Maestro de la Muerte de Masía
(Master of the death of the Virgin) see **CLEVE**

MAESTRO DE LA SANTA SANGRE
(MASTER OF THE HOLY BLOOD)
act at the beginning of the Sixteenth Century at Bruges
"Ecce Homo"
(centr pn. *Christ before Pontius Pilate*; wings: *A Donor with the Virgin* and *St. John, The Mocking of Christ*)
trp; panels; pn 49.2×35.0; wings 49.2×15.4 (109×89 cm; 109×39 cm)
La Anunciación
San Jerónimo
San Juan Bautista
centr pn; *The Annunciation*; wings; *St. Jerome* and *St. John the Baptist*
trp; panels; centr pn 15.4×13.0 (39×33 cm); wings: 16.9×5.9 (43×15 cm)

MAESTRO DE LAS MEDIAS FIGURAS
(MASTER OF THE HALF FIGURES)
act 1530 – 40 in the southern Low Countries
La Adoración de los Reyes Magos
The Adoration of the Magi
pn 21.3×14.2 (54×36 cm) c 1525

Column 3

La Anunciación y La Presentación en el templo. La Natividad
Triptych of the Nativity (wings: The Annunciation and The Presentation of Christ in the Temple)
panels; centr pn; 32.7×27.6; wings 32.7×13.0 (83×70 cm; 83×33 cm)

MAESTRO DE LA SISLA
(MASTER OF LA S.)
act c 1500 in Castile
La Anunciación
La Visitación
La Adoración de los Magos
La Presentación del Niño Dios en el templo
La Circuncisión del Señor
El Tránsito de la Virgen
The Annunciation; The Visitation; The Adoration of the Magi; The Presentation of Christ in the Temple; The Circumcision of C.; The Death of the Virgin
panels/canvases 78.7×39.4; 78.7×44.9; 84.3×42.9; 79.9×39.4; 83.9×40.2; 83.5×44.5 (200×100 cm; 200×114 cm; 214×109 cm; 203×100 cm; 213×102 cm; 212×113 cm); from the Monastery of Jeronimos de la Sisla (Toledo); the first, third and sixth derive from engravings by Martin Schongauer (Colmar c 1430 - Bresaich 1491)

MAESTRO DE LAS ONCE MIL VIRGINES
(MASTER OF THE ELEVEN THOUSAND VIRGINS)
act c 1490 in Castile
La coronación de la Virgen
Santa Úrsula con las once mil Vírgenes *
La Descención de la Virgen para premiar a San Ildefonso
The Coronation of the Virgin; St. Ursula and the Eleven Thousand Virgins; The V., appearing to St. Ildefonso
panels 50.8×36.2; 44.1×31.1; 65.0×35.8 (129×92 cm; 112×79 cm; 165×91 cm)

MAESTRO DE LA VIRGO INTER VIRGINES
(MASTER OF THE V. I. V.)
act 1470 – c1500 at Delft (?)
La Piedad
Pietá
pn 33.1×30.7 (84×78 cm) attr

MAESTRO DEL PAPPAGAYO
(MASTER OF THE PARROT)
act in the Sixteenth Century in Flanders
La Virgen dando el pecho al Niño Jesús
Madonna and Child
pn 23.6×18.5 (60×47 cm) attr

MAESTRO DE PEREA
(MASTER OF P.)
act at the end of the Fifteenth Century at Valencia
La Visitación
The Visitation
pn 69.3×61.0 (176×155 cm) attr

MAESTRO DE ROBREDO
(MASTER OF R.)
act in the Fifteenth Century at Burgos
La cena en casa del Fariseo
The Feast in the House of the Pharisee
frm; pn 15.4×20.1 (39×51 cm)

MAESTRO DE SAN ILDEFONSO
(MASTER OF ST. I.)
act at the end of the Fifteenth Century at Valladolid
Los Apóstoles Santos Felipe, Bartolomé, Matías; Simón, Judas y Tomás
The Apostles Philip, Bartholomew, Matthias; S., J. and Thomas
two pred panels 9.8×15.7 (25×40 cm) the altarpiece is in the Louvre

Column 4

MAESTRO DE SAN NICOLÁS
(MASTER OF ST. NICHOLAS)
act in the Fifteenth Century in Spain (Catalonia?)
San Agustín, de pontifical
St. Augustine in Pontifical Robes
pn 50.0×20.9 (127×53 cm)

MAESTRO DE SIGÜENZA
(MASTER OF S.)
act in the second quarter of the Fifteenth Century at Siguenza
Retablo de San Juan Bautista y Santa Catalina *
Polyptych of St. John the Baptist and St. Catherine (centr pn: St. John the Baptist and St. Catherine; l hand panels: Salome before Herod and The Beheading of St. John the Baptist; r hand panels: The Martyrdom of St. Catherine and The Beheading of St. Catherine)
five panels; centr pn 63.4×50.0 (161×127 cm); side panels 53.1×25.2 (135×64 cm)

MAGNASCO Alessandro
Genoa 1667 – 1749
Cristo servido por los ángeles → no 126
Christ accompanied by Angels
cv 76.0×55.9 (193×142 cm) c 1730

MAINERI Gian Francesco
act 1489 – 1504 in Emilia
La Virgen y San José adorando al Niño
The Virgin and St. Joseph worshipping the Christ Child
pn 24.8×18.9 (63×48 cm)

MAINO Fray (Friar) Juan Bautista
Pastrana 1578 – Madrid 1649
Recuperación de Bahía del Brasil → no 30
The recapture of the port of B. in Brazil
cv 121.6×150.0 (309×381 cm) c 1635 ins (on a coat of arms)
La Adoración de los Magos *
La venida del Espíritu Santo
The Adoration of the Magi; The Descent of the Holy Ghost
canvases 124.0×68.5 (315×174 cm) and 112.2×64.1 (285×163 cm); the first sg; the second d 1611 from the church of St. Peter Martyr in Toledo
Caballero *
Portrait of a gentleman
cv 37.8×28.7 (96×73 cm) sg

MALAINE Joseph-Laurent
Tournai 1745 – 1809
Florero 2286
A vase of flowers
pn 15.0×11.0 (38×28 cm) sg
Florero 2287
pn 18.9×13.0 (48×33 cm) sg

MALOMBRA Pietro
Venice 1556 – 1618
La Sala del Colegio de Venecia
The Sala del Collegio in the Doge's Palace in Venice
cv 66.9×84.3 (170×214 cm)

MANETTI Rutilio
Siena 1571 – 1639
Visión de San Bruno
The Vision of St. B.
cv, divided into two 26.0 and 47. 2×33.1 (66 and 120×84 cm)

MANFREDI Bartolomeo
Ostiano 1580 (?) – Rome c 1620
Soldado portador de la cabeza del Bautista
A Soldier carrying the Head of St. John the Baptist
cv 52.4×37.4 (133×95 cm) attr

MANTEGNA Andrea
Island of Carturo 1430-1 – Mantua 1506

Column 5

El tránsito de la Virgen → no 94
The Death of the Virgin
pn 21.3×16.5 (54×42 cm) c 1459 (?); mutilated

MARATTA or **MARATTI Carlo**
Camerano 1625 – Rome 1713
El pintor Andrea Sacchi *
Portrait of the painter A. S.
cv 26.4×19.7 (67×50 cm) c 1650
El Papa Clemente XI
Portrait of Pope Clement XI
cv 11.8×9.4 (30×24 cm) sg
Huida a Egipto
The Flight to Egypt
cv 27.2×21.3 (69×54 cm) c 1664; repl on a reduced scale
Magdalena en el desierto
St. Mary Magdalene in the Desert
cv 5.5×7.9 (14×20 cm) sketch of the figure added to a landscape by Dughet (see)

MARCH Esteban
... – ... 1660 act in Spain
Viejo bebedor
Vieja bebedora
An old man and *An old woman drinking*
canvases 28.7×24.4 (73×62 cm)
Vieja con unas sonajas
An old woman with bells
cv 31.5×24.4 (80×62 cm)
El paso del Mar Rojo
The Crossing of the Red Sea
cv 50.8×69.3 (129×176 cm) sg

MASIP Juan Vicente
Fuente de la Higuera c 1475 – Valencia 1545-50
El martirio de Santa Inés
La Visitación
The Martyrdom of St. I.; The Visitation
panels; tondos 22.8 and 23.6 (58 and 60 cm)
Cristo con la cruz a cuestas
Christ carrying the Cross
pn 36.6×31.5 (93×80 cm) formerly attr to Juan de Juanes

Masip Vicente Juan see **JUANES**

Massari see under **Domenichino**

MASSYS Jan
Antwerp c 1509 – 1575
El Salvador
La Virgen María
Christ the Redeemer; The Madonna
panels 17.3×13.8 (44×35 cm); on rv of the first ptg is an ins ("Opus Quintini Metsys MDXXIX") in gold letters see also Lombard

MASSYS or **METSYS Quentin**
Lauvain 1465 – Antwerp 1530
Cristo presentado al pueblo *
Christ before the People
pn 63.0×47.2 (160×120 cm)
Vieja mesándose los cabellos *
An old woman tearing her hair
pn 21.7×15.7 (55×40 cm) ins on rv
see also Patinir

Master see **MAESTRO**

MAZO Juan Bautista Martínez del
Beteta (?) ... – Madrid 1667
La Emperatriz Doña Margarita de Austria → no 29
Portrait of the Empress Margaret Theresa of A.
cv 82.3×57.9 (209×147 cm) 1666 (?) ins
La calle de la Reina, en Aranjuez
"C. de la R." at A.
cv 96.5×79.5 (245×202 cm)
Un estanque del Buen Retiro
A lake at the "B. R."
cv 57.9×44.9 (147×114 cm)

Jardín palatino
The palace garden (The Al-cazar gardens in Madrid from the "jardín de la Priora"?)
cv 58.3×43.7 (148×111 cm)
Paisaje con un templo
Landscape with a temple
cv 58.3×43.7 (148×111 cm)
Edificio clásico con paisaje
Landscape with a classical building
cv 58.3×43.7 (148×111 cm)
El Príncipe Don Baltasar Carlos *
Portrait of Prince B. C.
cv 82.3×56.7 (209×144 cm) 1645 ins
La cacería del tabladillo, en Aranjuez *
A hunting scene at A.
cv 98.0×73.6 (249×187 cm)
Apolo vecedor de Pan
Apollo victorious over P.
cv 71.3×87.8 (181×223 cm) copy of a ptg by Jordaens see also Velázquez

MECKENEM Israhel van
act at the end of the Fifteenth Century and at the beginning of the Sixteenth Century in Germany
San Jerónimo
St. Jerome
pn 20.9×27.6 (53×70 cm)

MEISSONNIER Jean-Louis-Ernest
Lyons 1815 – Paris 1891
Doña Josefa Manzanedo e Intentas de Mitjans, Marquesa de Manzanedo *
Portrait of J. M. e I. de M., Marchioness of M.
cv 18.1×19.3 (46×49 cm) sg d 1872

MELÉNDEZ or **MENÉNDEZ Luis Eugenio**
Naples 1716 – Madrid 1780
Bodegón: un trozo de salmón, un limón, y tres vasijas *
Still life with a piece of salmon, a lemon and three small vases and with fish and oranges
canvases 16.5×24.4 (42×62 cm) sg d 1772
Bodegón: caja de dulce
Still life with a box of sweetmeats
cv 19.3×14.6 (49×37 cm) sg d 1770
Bodegón: plato de cerezas, queso *
Still life with cheese and a dish of cherries
cv 15.7×24.4 (40×62 cm) sg d 1771
Bodegón: peritas, pan, jarro, frasco y tartera
Still life with pears, bread, a jug, a flask and a cake-dish
cv 18.5×13.4 (47×34 cm) sg d 1760
Sandía, pan, roscas → no 61
Water-melon, bread, cakes
cv 13.4×18.5 (34×47 cm) sg
Bodegón: peras, melón, barril
Still life with pears, a melon and a barrel
cv 18.9×13.8 (48×35 cm) sg d 1764
Bodegón: servicio de chocolate
Still life with a drinking chocolate set
cv 18.9×14.2 (48×36 cm) sg d 1770
Bodegón: pepinos y tomates
Still life with cucumbers and tomatoes
cv 16.1×24.4 (41×62 cm) sg d 1772
Ciruelas, uvas y manzana
Still life with cherries, grapes and an apple
cv 18.9×13.8 (48×35 cm) sg d 1762
Manzanas, nueces y tarro y cajas de dulce
Still life with apples, nuts, a jar and boxes of sweetmeats
cv 14.2×19.3 (36×49 cm) sg d 1769
Bodegón: plato de higos y granadas
Still life with a dish of figs and pomegranates
cv 14.2×19.3 (36×49 cm) sg d (the d is illegible)

Bodegón: trozo de carne etc.
Still life with a joint of meat etc.
cv 16.1×24.8 (41×63 cm)

MELÉNDEZ Miguel Jacinto
Oviedo 1679 – c 1731
San Agustín conjurando una plaga de langosta
St. Augustine driving away a plague of locusts
sketch; cv/pn 33.5×57.9 (85×147 cm)
El entierro del Señor de Orgaz
The burial of the Lord of O.
sketch; cv/pn 33.5×57.9 (85×147 cm)

MELOZZO DA FORLÌ (M. degli Ambrosi)
Forlì 1438 – 1494
Angel músico
An Angel playing a musical instrument
frg 24.8×20.5 (63×52 cm)

MEMLING or **MEMLINC Hans**
Mömling c 1433 – Bruges 1494
La Natividad → no 140
La Adoración de los Magos *
La Purificación
centr pn *The Adoration of the Magi*; wings *The Nativity* and *The Purification of the Virgin*
trp; panels; centr on 37.4×57.1; wings 37.4×24.8 (95×145 cm; 95×63 cm) c 1470
La Virgen y el Niño entre dos ángeles *
Madonna and Child with Two Angels
pn 14.2×10.2 (36×26 cm) attr; damaged and repainted

MENGS Anton Raphael
Aussig 1728 – Rome 1779
María Josepha de Lorena, Archiduquesa de Austria
Portrait of M. J. of Lorraine, Archduchess of A.
cv 50.4×38.6 (128×98 cm)
El Infante Don Antonio Pascual de Borbón
Portrait of the I. Don A. P. of Bourbon
cv 33.1×26.8 (84×68 cm)
Carlos IV, siendo Príncipe *
María Luisa de Parma, Princesa de Asturias 2189
Portrait of Charles IV of Spain as Prince of the Asturias; Portrait of M. L. of P., Princess of the A.
canvases 59.8×43.3 (152×110 cm)
María Luisa de Parma 2568 → no 170
Portrait of M. L. of Parma
sketch; cv 18.9×15.0 (48×38 cm)
Fernando IV, Rey de Nápoles → no 171
Portrait of Ferdinand IV of Naples
cv 70.5×51.2 (179×130 cm) sg d 1760
El Archiduque Francisco de Austria, después Emperador *
Portrait of the Archduke Francis of Austria, later Emperor Francis II
cv 56.7×38.2 (144×97 cm) 1770
Los Archiduques Fernando y María Ana de Austria
Portrait of Ferdinand and Mariana, Archduke and Archduchess of A.
cv 57.9×37.8 (147×96 cm) 1770
La Archiduquesa Teresa de Austria
Portrait of the Archduchess Theresa of A.
cv 56.7×41.3 (144×105 cm) 1770
Leopoldo de Lorena, Gran Duque de Toscana, después Emperador
Portrait of Leopold of Lorraine, Grand Duke of Tuscany, later Emperor Leopold II of Austria
cv 37.4×28.3 (95×72 cm) 1770
María Luisa de Borbón, Gran Duquesa de Toscana, después Emperatriz *
Portrait of M. L. of Bourbon, Grand Duchess of Tuscany, later Empress of Austria
cv 45.7×42.1 (116×107 cm) 1770

María Carolina de Lorena, Reina de Nápoles
Portrait of M. C. of Lorraine, Queen of Naples
cv 51.2×60.2 (130×153 cm)
El Infante Don Javier de Borbón
Portrait of the I. Don J. of Bourbon
cv 32.3×27.2 (82×69 cm)
El Infante Don Gabriel de Borbón
Portrait of the Infante Don G. of Bourbon
cv 32.3×27.2 (82×69 cm)
Autorretrato *
Self-portrait
pn 24.4×19.7 (62×50 cm)
Carlos III
La Reina María Amalia de Sajonia
Portrait of Charles III of Spain; Portrait of M. A. of Saxony, Queen of Spain
canvases 60.6×43.3 (154×110 cm) 1761 (?)
Un Apóstol 2202, 2203
An Apostle
sketches; canvases 24.8×19.7 (63×50 cm) 1752 (?)
La Adoración de los pastores
The Adoration of the Shepherds
pn 101.6×75.2 (258×191 cm) 1770
La Magdalena penitente
The Penitent Magdalene
cv 43.3×35.0 (110×89 cm)
San Pedro, predicando
St. Peter Preaching
cv 52.8×38.6 (134×98 cm)

METSU Gabriël
Leyden 1629 – Amsterdam 1667
Gallo muerto
A dead cockerel
pn 22.4×15.7 (57×40 cm) sg

Metsys see **MASSYS**

MEULEN Adan Frans van der
Brussels 1632 – Paris 1690
General saliendo a campaña
A g. leaving for a military campaign
cv 25.2×31.5 (64×80 cm) sg d 1660 (?)
Choque de caballería
A cavalry encounter
cv 33.9×47.6 (86×121 cm) sg d 1657

Meulener see **MOLENAER**

Micco Spadaro see **GARGIULO**

MICHAU Theobald
Tournai 1676 – Antwerp 1765
Río con gente y ganado
Caseríos junto a un río
A river with people and cattle; Farmhouses by a r.
panels 11.4×15.7 (29×40 cm)

A pupil of MICHELANGELO BUONARROTI
act mid Sixteenth Century Central Italy
La Flagelación
The Flagellation of Christ
pn 39.0×28.0 (99×71 cm)

MICHELI or **MICHIELI Parrasio**
... c 1516 – Venice 1578
Alegoría: nacimiento del Infante Don Fernando, hijo de Felipe II
Allegory: the birth of the I. Ferdinand, son of Philip II of Spain
cv 71.7×87.8 (182×223 cm) 1575
Cristo yacente adorado por el Papa San Pío V
Pope Puis V worshipping the Dead Christ
copper 16.5×11.8 (42×30 cm) sg ins (on the bed)

MIEL VAN BIKE Jan ("Cavaliere Gioo", Miele or della Vita)
Antwerp c 1599 – Turin 1663
La merienda
The picnic
cv 19.3×26.8 (49×68 cm)

Escenas populares
Scenes of everyday life
cv 19.7×26.4 (50×67 cm)
Conversación en el camino
A conversation on the journey
cv 18.9×14.6 (48×37 cm)
El carnaval en Roma
The Carnival at Rome
cv 26.8×19.7 (68×50 cm) sg d 1653 see also Both Johannes

MIEREVELD Michiel Jansz. van
Delft 1567 – 1641
Retrato de dama
Retrato de caballero
Portrait of a Lady; Portrait of a gentleman (Husband and wife?)
canvases 24.8×20.1 and 24.8×18.9 (63×51 cm and 63×48 cm) the first sg

MIGNARD Pierre
Troyes 1612 – Paris 1693
San Juan Bautista
St. John the Baptist
cv 57.9×42.9 (147×109 cm) 1688
Felipe de Francia, Duque de Orléans
Portrait of Philip Duke of O.
cv 41.3×33.9 (105×86 cm) 1659 (?)
Enriqueta de Inglaterra, Duquesa de Orléans *
Portrait of Henrietta of England, Duchess of O.
cv 29.5×23.6 (75×60 cm) repl attr

MINDERHOUT Hendrick van
Rotterdam 1632 – Antwerp 1696
Desembarco
Embarco para una fiesta
The disembarkation; Embarkation for a party
canvases 27.6×65.7 (70×167 cm) sg d 1668

MIROU Anton
Frankenthal c 1587 – ... c 1653
Paisaje con Abraham y Agar
Landscape with A. and Hagar
copper 20.5×16.9 (52×43 cm)

MITELLI Agostino
Bologna 1609 – Madrid 1660
Modelo para un techo del palacio del Buen Retiro
Sketch for a ceiling in the B. R. Palace
cv 73.6×110.6 (187×281 cm) c 1659 in collaboration with Angelo Michele Colonna (Como 1600 – Bologna 1687)

MOHEDANO Antonio
Lucena c 1569 – 1625
San Juan Evangelista
St. John the Evangelist
frs 91.7×51.2 (223×130 cm) attr

MOL Pieter van
Antwerp 1599 – Paris 1650
San Marcos
San Juan Evangelista
St. Mark; St. John the Evangelist
panels 25.2×19.3 and 24.0×19.3 (64 and 61×49 cm) attr

MOLA Pier Francesco
Coldrerio 1612 – Rome 1666
San Juan Bautista niño
St. John the Baptist as a Child
octagonal pn 5.1×6.7 (13×17 cm)

MOLENAER or **MEULENER Pieter**
Antwerp 1602 – 1654
Defensa de un convoy
Combate de caballería
The defence of a convoy; A cavalry engagement
panels 20.5×31.1 (52×79 cm) sg d 1644

MOMPER II [THE YOUNGER] Joos de
Antwerp 1564 – 1635
Paisaje con patinadores
Skating scene
pn 22.8×33.1 (58×84 cm) figures by Jan ('Velvet') Brueghel (?)
Paisaje
Landscape
pn 22.8×33.1 (58×84 cm) figures as prec ptg
Paisaje de mar y montañas
Landscape with sea and mountains
cv 68.5×100.8 (174×256 cm) figures as prec ptg see also Brueghel el Joven Pieter

Monsù Bernardo see **KEIL**

MORALES Luis de (El Divino)
Badajcz 1510-25 (?) – 1586
La presentación del Niño Dios *
The Presentation of Christ in the Temple
pn 57.5×44.9 (146×114 cm)
La Virgen y el Niño 944
Madonna and Child
pn 22.4×15.7 (57×40 cm)
La Virgen y el Niño 946
pn 16.9×12.6 (43×32 cm)
La Virgen y el Niño 2656 → no 11
pn 33.1×25.2 (84×64 cm)
San Juan de Ribera *
St. John of R.
pn 15.7×11.0 (40×28 cm) formerly thought to represent St. Ignatius Loyola or the Blessed Alonso de Villegas
San Estéban *
St. Stephen
pn 26.4×19.7 (67×50 cm)
La Anunciación
The Annunciation
pn 42.9×32.7 (109×83 cm)
"Ecce Homo"
pn 15.7×11.0 (40×28 cm)
Sagrada Familia *
The Holy Family
pn 27.6×22.4 (70×57 cm)

MORAZZONE (Pier Francesco Mazzucchelli)
Morazzone 1573 – 1626
Desposorios de la Virgen *
The Marriage of the Virgin
sketch; pp/cv 12.2×16.1 (31×41 cm) c 1602-5

MORENO José
Burgos ... – 1674
La Visitación
The Visitation
cv 72.8×52.0 (185×132 cm) sg d 1662

MORO Antonio (Anthonis Mor van Dashorst)
Utrecht 1519 – Antwerp 1575
Pejerón, bufón del Conde de Benavente y del Gran Duque de Alba *
Portrait of P., jester of the Count of B. and the Grand Duke of A.
pn 71.3×36.2 (181×92 cm)
La Reina María Túdor de Inglaterra, segunda mujer de Felipe II → no 144
Portrait of Queen Mary of England, second wife of Philip II of Spain
pn 42.9×33.1 (109×84 cm) sg d 1554
Doña Catalina de Austria, mujer de Juan III de Portugal *
Portrait of Catherine of A., wife of John III of P.
pn 42.1×33.1 (107×84 cm) 1552
La Emperatriz Doña María de Austria, mujer de Maximiliano II
*El Emperador Maximiliano II
Portrait of the Empress M. of A., wife of the Emperor Maximilian II; Portrait of the Emperor Maximilian II*
canvases 71.3×35.4 and 72.4×35.4 (181×90 cm and 184×100 cm) sg d 1551 and 1550
Doña Juana de Austria, madre del Rey Don Sebastián de Portugal
Portrait of Dona I. of A., mother of King Don S. of P.
cv 76.8×40.9 (195×104 cm) c 1554-60

La dama del Joyel
Portrait of a lady with a jewel
cv 42.1×32.7 (107×83 cm)
Metgen, mujer del pintor *
Portrait of the artist's wife
pn 39.4×31.5 (100×80 cm)
c 1554
La Duquesa de Feria (?)
Portrait of the Duchess of F. (?)
cv 37.4×29.9 (95×76 cm)
c 1567 or c 1575
Dama con cruz al cuello
Portrait of a lady wearing a cross at her neck
cv 37.0×29.9 (94×76 cm)
c 1567 or c 1575
Doña María de Portugal, mujer de Alejandro Farnesio
Margarita de Parma
Portrait of M. of P., wife of Alessandro Farnese; Portrait of Margaret of P.
trp wings; panels 15.4×5.9 39×15 cm) c 1570
Felipe II
Portrait of Philip II of Spain
pn 16.1×12.2 (41×31 cm)

MORONI Giovanni Battista
Bondio (near Albino) c 1520-25 – Bergamo 1578
Un militar (?) *
Portrait of a soldier (?)
cv 46.9×35.8 (119×91 cm)

MUÑOZ Sebastián
Segovia (?) c 1654 – Madrid 1690
Autorretrato
Self-portrait
cv 13.8×13.0 (35×33 cm)

MURILLO Bartolomé Esteban
Seville 1618 – 1682
La Sagrada Familia del pajarito → no 63
The Holy Family with a Bird
cv 56.7×74.0 (144×183 cm) c 1650
La Adoración de los pastores
The Adoration of the Shepherds
cv 73.6×89.8 (187×228 cm) c 1655 – 60
El Buen Pastor → no 64
San Juan Bautista Niño
The Good Shepherd; St. John the Baptist as a Child
canvases 48.4×39.8 and 47.6× 39.0 (123×101 cm and 121×99 cm) 1665 (?)
Los Niños de la concha *
The Christ Child and St. John the Baptist as a Child
cv 40.9×48.8 (104×124 cm) c 1670
"Ecce Homo"
La Dolorosa
E. H.; Our Lady of Sorrows
canvases 20.5×16.1 (52×41 cm)
Cristo en la Cruz 966
Christ on the Cross
cv 7.20×42.1 (183×107 cm)
Cristo en la Cruz 967
Christ on the Cross
cv 28.0×21.3 (71×54 cm)
Santa Ana y la Virgen *
The Virgin and St. Anne
cv 86.2×65.0 (219×165 cm) c 1674
La Anunciación 969
The Annunciation
cv 72.0×88.6 (183×225 cm) c 1648 – 55
La Anunciación 970
cv 49.2×40.6 (125×103 cm)
La Concepción de El Escorial 972 *
The Immaculate Conception
cv 81.1×56.7 (206×144 cm)
La Concepción 973
cv 35.8×27.6 (91×70 cm)
1660 – 70
La Concepción de Aranjuez 974
cv 87.4×46.5 (222×118 cm)
La Virgen del Rosario
The Madonna of the Rosary
cv 64.6×43.3 (164×110 cm)
La Virgen con el Niño
Madonna and Child
cv 59.4×40.2 (151×103 cm)
Aparición de la Virgen a San Bernardo
The Virgin appearing to St. Bernard
cv 122.4×98.0 (311×249 cm) c 1665 – 70

La descención de la Virgen para premiar los escritos de San Ildefonso
The Virgin rewarding St. Ildefonso for his Writings
cv 121.6×98.8 (309×251 cm)
San Agustín entre Cristo y la Virgen
St. Augustine between Christ and the Virgin
cv 107.9×76.8 (274×195 cm) 1663-4
Visión de San Francisco en la Porciúncula
The Vision of St. Francis in the Porziuncola (first chapel)
cv 81.1×57.5 (206×146 cm) 1667 (?)
El martirio de San Andrés
The Martyrdom of St. Andrew
cv 48.4×63.8 (123×162 cm)
La conversión de San Pablo
The C. of St. Paul
cv 49.2×66.6 (125×169 cm)
San Jerónimo
St. Jerome
cv 73.6×52.4 (187×133 cm) c 1650-2
Santiago, apóstol
St. James the Apostle
cv 52.8×42.1 (134×107 cm)
La fundación de Santa María Maggiore de Roma
I: El sueño del Patricio Juan
II: El patricio revela su sueño al Papa
The Founding of Santa M. M. in Rome – I: Patrician John's Dream. – II: Patrician John describes his Dream to the Pope
canvases 91.3×205.5 (232×522 cm) c 1665
Rebeca y Eliecer → no 62
Rebecca and Eleazar
cv 42.1×67.3 (107×171 cm) c 1650
El Hijo Pródigo recoge su legítima
La despedida del Hijo Pródigo
La disipación del Hijo Pródigo
El Hijo Pródigo, abandonado
The Prodigal Son receives his Portion; The Departure of the P. S.; The P. S. wastes his Substance; The P. S. employed to feed Swine
sketches; canvases 10.6×13.4 (27×34 cm)
La vieja, hilando
An old woman spinning
cv 24.0×20.1 (61×51 cm)
La Gallega de la moneda *
A Galician girl with a coin in her hand
cv 24.8×16.9 (63×43 cm) c 1645 – 50
Paisaje 1005, 1006
Landscape
canvases 37.4×48.4 (95×123 cm) attr
Paisaje 3008
cv 76.4×51.2 (194×130 cm)
Desconocido
Portrait of an unknown man
cv 19.3×16.1 (49×41 cm)
La Inmaculada de Soult
The Immaculate Conception
cv 107.9×74.8 (274×190 cm) c 1678
Caballero de golilla *
Portrait of a gentleman wearing a ruff
cv 78.0×77.6 (198×197 cm) c 1670 – 82
Nicolás Omazur *
cv 32.7×28.7 (83×73 cm) 1672
Autorretrato
Self-portrait
cv 40.6×30.3 (103×77 cm) ins attr

NANI Giacomo
Naples 1707 – 1770
Caza 263
Still life with dead game
cv 26.4×18.1 (67×46 cm)
Caza 264, 265
canvases 28.3×18.9 (72×48 cm)

Nardi see under **Anónimos Españoles,**
Seventeenth Century

NATTIER Jean-Marc
Paris 1685 – 1766
María Leczinska, Reina de Francia (?)
Portrait of Marie Leszczynski, Queen of France (?)
cv 24.0×20.1 (61×51 cm) attr

NAVARRETE Juan Fernández (El Mudo) [The Mute])
Logrono c 1526 – Toledo 1579
El bautismo de Cristo *
The Baptism of Christ
pn 19.3×14.6 (49×37 cm) sg c 1574

NEEFS Ludwig
Antwerp 1617 – ... c 1648
Interior de iglesia: el Viático
The interior of a church: the Viaticum
pn 11.0×9.8 (28×25 cm) sg d 1646 ("ffranck") in collaboration with Frans Franck III (Antwerp 1607 – 1667)
Interior de iglesia
The interior of a church
pn 11.0×9.8 (28×25 cm) sg d 1646 as the prec ptg

NEEFS EL VIEJO (THE ELDER) Pieter
Antwerp 1577-8 – 1656-61
El viático en el interior de una iglesia
The Viaticum inside a church
pn 20.1×31.5 (51×80 cm) sg d 1636
Interior de iglesia: adoración de una reliquia
The interior of a church: a relic shown to the congregation
pn 10.6×15.4 (27×39 cm) sg
Iglesia de Flandes: la misa *
Mass in a church in Flanders
pn 22.8×38.6 (58×98 cm) sg d 1618
Interior de la Catedral de Amberes 2726, 2727
The interior of Antwerp Cathedral
panels 15.0×24.8 and 15.4× 24.8 (38 and 39×63) sg; the first has an ins ("ffranck"); possibly based on a sketch by Franck the Elder

NEER Eglon Hendrik van der
Amsterdam 1634 – Düsseldorf 1703
Choque de caballería
A cavalry encounter
cv 24.0×19.7 (61×50 cm)

NEUFCHATEL Nicolas de (Lucidel)
Mons 1527 – Nuremburg c 1590
Dama con perrito
Portrait of a lady with a dog
pn 30.3×22.4 (77×57 cm) attr

Niccoló dell'Abate see under **Dosso Dossi**

NICOLÁS FRANCÉS
... – ... 1468 act at León
Retablo de la vida de la Virgen y de San Francisco *
Altarpiece of the Life of the Virgin and St. Francis (centr pn: Madonna and Child with Angels; The Assumption of the Virgin; Calvary. r hand pn: The Annunciation; The Nativity; The Purification of the Virgin. l hand pn: St. Francis before the Sultan; The Dream of Honorius III and the Foundation of the Franciscan Order; The Stigmata); Pred Busts of Saints
panels ogival 219.3×219.7 (altogether) (557×558 cm) original frame

NOCRET Jean
Nancy 1615 – Paris 1672
Felipe de Francia, Duque de Orléans 2298
Portrait of Philip, Duke of O.
cv 41.3×33.9 (105×86 cm)
Felipe de Francia, Duque d'Orléans 2380
cv 29.5×23.6 (75×60 cm) forms a pair with the portrait of his wife Henrietta by Minard (q.v.)

NOGARI Giuseppe
Venice 1669 – 1763
Vieja con una muleta
Portrait of an old woman with a crutch
cv 21.3×16.9 (54×43 cm) attr

NOLPE Pieter
Amsterdam 1613-4 – 1651-3
Paisaje de costa
Seaside landscape
pn 20.5×32.7 (52×83 cm) attr

NOVELLI Pietro ('Il Monrealese')
Monreale 1603 – Palermo 1647
La Resurrección del Señor
The Resurrection of Christ
cv 64.1×71.3 (163×181 cm) attr

NUZZI Mario (M. dei Fiori)
Penna Fermana 1603 – Rome 1673
Florero de plata volcado sobre un paño
A silver flower vase lying on a piece of cloth
cv 33.1×61.8 (84×157 cm) intended to be placed above a door
Floreros y cebollas
Vases of flowers and onions
cv 32.7×60.6 (83×154 cm) as the prec ptg

OOSTSANEN Jacob Cornelius van
Oostsanen c 1470 – Amsterdam 1533
San Jerónimo
St. Jerome
pn 18.9×16.9 (48×43 cm)

OPPIE John
St. Agnes 1716 – London 1807
Retrato de caballero *
Portrait of a gentleman
cv 39.4×35.4 (100×90 cm)

Orizzonte see **BLOEMEN Jan Frans**

ORLEY Barend or **Bernard van**
Brussels c 1492 – 1542
La Virgen de la leche
Madonna and Child
pn 21.3×11.8 (54×30 cm) attr
La Virgen con el Niño
pn 38.6×28.0 (98×71 cm) attr
La Sagrada Familia *
The Holy Family
pn 35.4×29.1 (90×74 cm) sg d 1522 see also Mabuse

ORRENTE Pedro de
Murcia 1588 – Valencia 1645
La Adoración de los pastores *
The Adoration of the Shepherds
cv 43.7×63.8 (111×162 cm)
La vuelta al aprisco
The return to the fold
cv 29.1×35.0 (74×89 cm)
Un caballo con vasijas de cobre y de barro
A horse with copper and earthenware jugs
cv 13.8×20.1 (35×51 cm)

Osona see under **Anónimos Españoles**
Late Fifteenth Century

OSTADE Adriaen van
Haarlem 1610 – 1684
Concierto rústico 2121 → no 160
A rustic concert
pn 10.6×11.8 (27×30 cm) sg
Concierto rústico 2126
pn 7.9×15.7 (20×40 cm) sg d 1638
Cocina aldeana
A peasant kitchen
pn 9.1×11.4 (23×29 cm) sg
Aldeanos cantando *
Peasants singing
pn 9.4×11.4 (24×29 cm) sg d 1672

OUDRY Jean-Baptiste
Paris 1686 – Beauvais 1755
Lady María Josefa Drumond, Condesa de Castelblanco *
Don José de Rozas y Meléndez de la Cueva, il conde de Castelblanco
Portrait of Lady Mary Josephine Drummond, Countess of C.; Portrait of Don J. de

R. y M. de la C., 1st Count of C.
(husband and wife)
canvases 53.9×41.3 (137×105 cm); the first sg; the second has a coat of arms

PACHECO Francisco
Sanlúcar de Barrameda 1564 – Seville 1654
Santa Inés
Santa Catalina
San Juan Evangelista
San Juan Bautista
St. I.; St. Catherine; St. John the Evangelist; St. J. the Baptist
panels 41.0×17.3; 40.2×16.9; 39.0×17.7; 39.0×17.7 (103×44 cm; 102×43 cm; 99×45 cm; 99×45 cm); the first is sg d 1608

PADOVANINO (Alessandro Varotari)
Padua 1588 – Venice 1648
Orfeo
Orpheus
cv 65.0×42.5 (165×108 cm) attr

PALAMEDESZ. Anthonie (Stevers)
Delft 1601 – Amsterdam 1673
Escena de soldadesca
The soldier and the lady
pn 17.3×13.0 (44×33 cm) attr

PALMA GIOVANE (Jacopo Negreti)
Venice 1544 – 1628
David vencedor de Goliat
La conversión de San Pablo
David with the Head of Goliath; The Conversion of St. Paul
canvases 81.5×92.5 (207×235 cm)

PALMA VECCHIO (Jacopo Negreti)
Serina c 1480 – Venice 1528
La Adoración de los pastores *
The Adoration of the Shepherds
pn 46.5×66.1 (118×168 cm) attr; also attr to Bonifacio Veronese (Verona 1487-Venice 1553)

PALOMINO Acisclo Antonio de
Bujalance 1655 – Madrid 1726
La Inmaculada Concepción
The Immaculate Conception
cv 76.0×53.9 (193×137 cm) sg

PALTHE Gerard Jan
Degenkamp 1681 – ... 1750
Joven dibujante
A young man sketching
pn 7.9×9.4 (20×24 cm) sg (?)

PANNINI Giovan Paolo
Piacenza 1691-2 – Rome 1765
Ruinas con una mujer dirigiendo la palabra a varias personas
Ruins with a woman addressing a group of people
cv 24.8×18.9 (63×48 cm)
La disputa de Jesús con los Doctores
Jesús y los mercaderes del templo *
Christ among the Doctors; C. driving the Money-Changers from the Temple
sketches; canvases 15.7×24.4 and 15.7×24.8 (40×62 cm and 40×63 cm) sg

PANTOJA DE LA CRUZ Juan
Valladolid 1553 – Madrid 1608
Margarita de Austria, mujer de Felipe III
Portrait of Margaret of A., wife of Philip III of Spain
cv 44.1×38.2 (112×97 cm) sg d 1607
Un Santiaguista *
Portrait of a Knight of St. James
cv 20.1×18.5 (51×47 cm) sg d 1601

111

El nacimiento de la Virgen
The Birth of the Virgin
cv 102.4×67.7 (260×172 cm)
sg d 1603
San Agustín
San Nicolás de Tolentino
St. Augustine; St. Nicholas of T.
canvases 103.9×45.3 and 53.1 (264×115 and 135 cm) sg d 1601
Felipe III *
La Reina Doña Margarita
Portrait of Philip III of Spain; Portrait of Queen Margaret of Spain
canvases 80.3×48.0 (204×122 cm) sg; the second d 1606

PARCELLIS or **PORCELLIS Johannes**
Ghent c 1548 – Leyden 1632
Un puerto de mar
A harbour
copper 27.6×33.9 (70×86 cm) sg attr; also attr to J. Peeters I (Antwerp 1624 – c 1677)

PAREJA Juan de
Seville c 1610 – Madrid 1670
La vocación de San Mateo
The Calling of St. Matthew
cv 88.6×127.9 (225×325 cm) sg d 1661

PARET Y ALCÁZAR Luis
Madrid 1746 – 1798-9
Ramo de flores 1042, 1043
Bunch of flowers
canvases 15.4×14.6 (39×37 cm) sg
Las parejas reales
The royal horse races
cv 91.3×143.7 (232×365 cm) sg d 1773
Jura de Fernando VII como príncipe de Asturias
Ferdinand VII of Spain taking the oath as Prince of the A.
cv 93.3×62.6 (237×159 cm) sg d 1791
Carlos III, comiendo ante su corte *
Charles III of Spain at table before his courtiers
pn 19.7×25.2 (50×64 cm) sg
Baile en máscara
A masked ball
pn 15.7×20.1 (40×51 cm)

PARMIGIANINO (Francesco Mazzola)
Parma 1503 – 1540
Pedro María Rossi, o Roscio, Conde de San Segundo
Portrait of Pier M. R., Count of San Secondo
pn 52.4×38.6 (133×98 cm)
Dama con tres niños *
Portrait of a lady with three children
pn 50.4×38.2 (128×97 cm) c 1530 formerly thought to portray the Countess of San Secondo
Cupido
Cupid
pn 58.3×25.6 (148×65 cm) repl of a ptg in the Kunsthistorisches Museum, Vienna
Santa Bárbara
St. B.
pn 19.3×15.4 (49×39 cm) 1522
La Sagrada Familia con un ángel *
The Holy Family with an Angel
pn 43.3×35.0 (110×89 cm) c 1524

Parrasio see **MICHELI**

Parrocel see under **Rigaud y Ros**

Passante see **BASSANTE**

PATINIR or **PATENIER Joachim**
Bouvignes-le-Dinant c 1480 – Antwerp 1524
Descanso en la huida a Egipto 1611 *
The Rest on the Flight to Egypt
pn 47.6×69.7 (121×177 cm) mature work

Descanso en la huida a Egipto 1612
pn 26.8×44.1 (68×112 cm) attr
Descanso en la huida a Egipto 1613
painted by a follower
pn 24.8×44.1 (63×112 cm) attr
Paisaje con san Jerónimo
Landscape with St. Jerome
pn 29.1×35.8 (74×91 cm) sg
El paso de la Laguna Estigia
→ no 136
Crossing the Styx
pn 25.2×40.6 (64×103 cm)
Las tentaciones de San Antonio Abad *
The Temptation of St. Anthony Abbot
pn 61.0×68.1 (155×173 cm) sg; figures attr to Quentin Massys

PEETERS Clara
Antwerp c 1589 – 1676
Bodegón 1619, 1620
Still life
panels 20.1×28.0 and 19.7×28.3 (51×71 cm and 50×72 cm) d 1611
Mesa 1620, 1622
Still life with a table of food
panels 20.5 and 21.7×28.7 (52 and 55×73 cm) sg; the first d 1611

Peeters I Jan see under **Parcellis**

Pencz see under **Lombard**

Penni see under **Giulio Romano**

"PENSIONANTE DE SARACENI" ("PENSIONER OF S.")
act in the first third of the Seventeenth Century in Rome
Vendedor de aves *
The bird seller
cv 37.4×28.0 (95×71 cm) attr

PEREDA Y SALGADO Antonio de
Valladolid c 1608 – Madrid 1678
San Jerónimo *
St. Jerome
cv 41.3×33.1 (105×84 cm) sg d 1643
Cristo, varón de dolores
Christ of Sorrows
cv 38.2×30.7 (97×78 cm) sg d 1641
El socorro de Génova por el segundo Marqués de Sta. Cruz *
The relief of Genoa by the Second Marquis of Santa C.
cv 114.2×145.7 (290×370 cm) sg 1634
for other paintings in the same series see Carducho Vincencio, Caxés, Leonardo Jusepe, Maino, Velázquez and Zurbarán
Aparición de la Virgen a San Félix de Cantalicio
The Virgin appearing to St. F. of Cantalice
cv 30.3×21.7 (77×55 cm) sg d 1665
San Pedro libertado por un ángel
St. Peter freed by an Angel
cv 57.1×43.3 (145×110 cm) sg d 1643
La Anunciación
The Annunciation
cv 52.8×30.3 (135×77 cm) sg d 1637

PÉREZ Bartolomé
Madrid 1634 – 1693
Florero 1048, 1049
A vase of flowers
cv 33.9×22.9 (86×76 cm)
Florero 1051*
cv 44.1×28.0 (112×71 cm)
San Francisco Javier dentro de una guirnalda
Santa Teresa de Jesús dentro de una guirnalda
St. Francis Xavier in a Garland; St. Theresa in a Garland
cvs 37.4×28.7 (95×73 cm); the first ptg was formerly thought to represent St. Ignatius

PERUZZI Baldassarre
Siena 1481 – Rome 1536
El rapto de las Sabinas
La continencia de Escipión
The rape of the Sabines; The continence of Scipio
pns 18.5 and 18.1×61.8 (47 and 46×157 cm) wedding-chest panels; attr

PHILIPS John
Aberdeen 1817 – London 1867
Don Gonzalo de Vilches I Conde de Vilches (?)
Portrait of G. de V., 1st Count of V. (?)
cv 29.5×25.2 (75×64 cm) attr

PICARDO Léon
act in the Early Sixteenth Century in Castile
La Anunciación*
La Purificación
The Annunciation; The Purification of the Virgin
pns 67.3 and 66.9×54.7 (171 and 170×139 cm)

PIERIN or **PERIN DEL VAGA (Pietro Buonaccorsi)**
Florence 1500-1 – Rome 1547
"Noli me tangere"
pn 24.0×18.5 (61×47 cm) attr

PIETRO DA CORTONA (P. Berrettini)
Cortona 1596 – Rome 1669
La Natividad*
The Nativity
agate 20.1×15.7 (51×40 cm) copy(?)

PILLEMENT Jean
Lyons 1728 – 1808
Paisaje 2302, 2303
Landscape
cv 22.0×29.9 (56×76 cm); the first sg d 1773
Paisaje con un castillo y guerreros
Landscape with a castle and soldiers
pn 18.5×26.0 (47×66 cm)

PINO Marco dal (Marco da Siena)
Siena c 1525 – Naples 1587-8
Jesucristo, muerto, sostenido por ángeles
The Dead Christ
pn 16.9×11.0 (43×28 cm) attr

Piombo see **SEBASTIANO DEL PIOMBO**

POELENBURGH Cornelius van
Utrecht c 1586 – 1667
El baño de Diana
D. and Actaeon
copper 17.3×22.0 (44×56 cm)
Las termas de Diocleciano
The Baths of Diocletian
pn 16.5×22.0 (42×56 cm)

Ponte see **BASSANO** and **GIOVANNI DAL PONTE**

PONTORMO (Jacopo Carrucci)
Pontormo 1494 – Florence 1557
La Sagrada Familia*
The Holy Family
pn 51.2×39.4 (130×100 cm) attr

PORPORA Paolo
Naples 1617 – 1673
Florero
A vase of flowers
cv 30.3×25.6 (77×65 cm) attr
see also Falcone

POTTER Paulus
Enkhuizen 1625 – Amsterdam 1654
En el prado*
Animals in a meadow
pn 11.8×13.8 (30×35 cm) sg d 1652

POURBUS EL JOVEN (THE YOUNGER) Frans
Antwerp 1569-70 – Paris 1622
María de Médicis, Reina de Francia
Portrait of Marie de' Medici, Queen of France
cv 84.6×45.3 (215×115 cm) sg d 1617
Isabel de Francia, mujer de Felipe IV *
Portrait of Isabella of Bourbon, wife of Philip IV of Spain
cv 76.0×42.1 (193×107 cm) c 1621

Poussin Gaspare see **DUGHET**

POUSSIN Nicolas
Les Andelys 1594 – Rome 1665
Paisaje con San Jerónimo
Paisaje con un anacoreta predicando a los animales
Landscape with St. Jerome and with a hermit preaching to the animals
cvs 61.0×92.1 and 62.6×91.7 (155×234 cm and 159×233 cm) c 1637-8
Paisaje 2307, 2309
Landscape
cvs 28.3×37.4 (72×95 cm)
El triunfo de David
The Triumph of D.
cv 39.4×51.2 (100×130 cm) c 1627-30
Bacanal
Bacchanal
cv 48.0×66.6 (122×169 cm) c 1632-6
El Parnaso → no 165
Parnassus
cv 57.1×77.6 (145×197 cm) c 1625-31
Anacoreta entre ruinas*
A hermit amidst ruins
cv 63.8×94.5 (162×240 cm) attr
Escena báquica*
Bacchic scene
cv 29.1×23.6 (74×60 cm) c 1632-6
La caza de Meleagro (?)*
The hunt of Meleager
cv 63.0×141.8 (160×360 cm) attr
Paisaje: Polifemo y Galatea*
Landscape with Polyphemus and G.
cv 19.3×24.8 (49×63 cm) c 1649
see also Lanfranco

PRADO Blas del
Toledo c 1545 – c 1592
La Sagrada Familia, San Ildefonso, San Juan Evangelista y el Maestro Alonso de Villegas
The Holy Family with St. I., St. John the Evangelist and Master A. de V.
cv 82.3×65.0 (209×165 cm) sg d 1589 ins

PRETI Mattia (Cavalier Calabrese)
Taverna di Calabria 1613 – Malta 1699
El agua de la peña
Moses striking the Rock
cv 69.3×82.3 (176×209 cm) attr
Cristo glorioso y Santos*
Christ in Glory with Saints
cv 86.6×99.6 (220×253 cm) c 1660

PREVOST or **PROVOST Jan**
Mons c 1465 – Antwerp(?) 1529
Zacarías
Zacharias
polyptych wing; pn 48.4×17.7 (123×45 cm)

PROCACCINI Andrea
Rome 1671 – La Granja de San Ildefonso 1734
El cardenal Borja
Portrait of Cardinal Carlos B. Centellas Ponce de León
cv 97.6×69.3 (248×176 cm) c 1720

PROCACCINI Camillo
Bologna c 1550 – Milan 1629
La Sagrada Familia del racimo
The Holy Family
pn 53.1×42.5 (135×108 cm) attr

PROCACCINI Giulio Cesare
Bologna c 1570 – Milan 1625
La Virgen del gorrión
The Madonna del passero
pn 36.5×29.5 (93×75 cm)
Virgen con el Niño y ángeles, en una guirnalda*
Madonna and Child with Angels in a Garland
copper 18.9×14.2 (48×36 cm) the garland is by Jan ('Velvet') Brueghel
Sansón destruyendo a los Filisteos
Samson slaying the Philistines
cv 103.5×103.5 (263×263 cm) damaged

PUGA Antonio (?)
Orense 1602 – Madrid 1648
La madre del pintor
Portrait of the artist's mother
cv 57.9×42.9 (147×109 cm) attr

PULIGO Domenico
Florence 1492 – 1527
La Sagrada Familia
The Holy Family
pn 51.2×38.6 (130×98 cm)

QUELLIN or **QUELLINUS Erasmus**
Antwerp 1607 – 1678
El rapto de Europa
E. and the bull
cv 49.6×34.3 (126×87 cm) sg based on a sketch by Rubens
Baco y Ariadna
Bacchus and Ariadne
cv 70.9×37.4 (180×95 cm) sg
La muerte de Eurídice
The death of Eurydice
cv 70.5×76.8 (179×195 cm) sg
Jasón con el vellocino de oro
J. with the Golden Fleece
cv 71.3×76.8 (181×195 cm) sg
Cupido navegando sobre un delfín
Cupid riding on a dolphin
cv 38.5×38.6 (98×98 cm) based on a sketch by Rubens in the Musées Royaux des Beaux-Arts, Brussels
La persecución de las Harpías
Calais and Zethes pursuing the Harpies
cv 39.0×38.6 (99×98 cm) based on a sketch by Rubens (q.v.)

RAEBURN Henry
Stockbridge 1756 – Edinburgh 1823
Retrato de Mrs. MacLean of Kinlochline*
Portrait of Mrs. M. of K.
cv 29.5×24.8 (75×63 cm)

RAFFAELLO SANZIO
Urbino 1483 – Rome 1520
La Sagrada Familia del cordero → no 96
The Holy Family
pn 11.4×8.3 (29×21 cm) sg d 1507
La Virgen del pez → no 97
The Madonna del pesce
pn/cv 34.6×62.2 (215×158 cm) c 1513-4; in collaboration with st assistants
Caída en el camino del Calvario*
The Fall on the Road to Calvary
pn/cv 125.2×90.2 (318×229 cm) sg 1517; largely painted by st assistants (Giulio Romano?); recently res from Santa Maria dello Spasimo in Palermo
El Cardenal → no 98
Portrait of a cardinal
pn 31.1×24.0 (79×61 cm) c 1510-1
La Visitación
The Visitation
pn/cv 78.7×57.1 (200×145 cm) sg 1519 ins st wk

La Sagrada Familia, llamada
"La Perla"*
The Holy Family ("La P.")
pn 56.7×45.3 (144×115 cm)
1522-3 st wk; attr to Giulio
Romano
La Virgen de la rosa*
*The Madonna della r. (The
Holy Family with St. John)*
pn/cv 40.6×33.1 (103×84 cm)
c 1518 st wk
La Sagrada Familia del roble*
*The Holy Family with St. John
under an oak tree*
pn 56.7×43.3 (144×110 cm)
c 1518 st wk

RAMÍREZ Felipe
*act in the Early Seventeenth
Century in Spain*
Bodegón
Still life
cv 28.0×36.2 (71×92 cm) sg d
1628

RANC Jean
Montpellier 1674 – Madrid 1735
El Infante Cardenal Don Luis
Antonio de Borbón *
*Portrait of the Cardinal-I. Don
L. A. of Bourbon; Portrait of
M. T. A., Dauphine of France*
cvs 41.3×33.1 (105×84 cm)
Felipe V, a caballo
*Portrait of Philip V of Spain
on horseback*
cv 131.9×106.3 (335×270 cm)
damaged
Felipe V
La Reina Isabel Farnesio
*Portrait of Philip V of Spain;
Portrait of Isabella Farnese,
Queen of Spain*
cvs 56.7×45.3 (114×115 cm)
Fernando VI, niño
Carlos III, niño
*Ferdinand VI of Spain as a
child; Charles III of Spain as
a child*
cvs 56.7×45.7 and 55.9×45.3
(114×116 cm and 142×115 cm)
Fernando VI, siendo Príncipe
de Asturias
*Portrait of Ferdinand VI of
Spain as Prince of the A.*
cv 29.5×24.4 (75×62 cm) sg d
1725
La familia de Felipe V
*The Family of Philip V of
Spain*
sketch; cv 17.3×25.6 (44×65
cm) 1722-3

RECCO Giuseppe
Naples 1634 – Alicante 1694
Bodegón de peces y tortuga*
*Still life with fish and a tor-
toise*
cv 29.5×35.8 (75×91 cm) sg
c 1680

**REMBRANDT HARMENSZ.
VAN RIJN**
Leyden 1606 – Amsterdam 1669
Artemisia → no 158
Queen A.
cv 55.9×60.2 (142×153 cm) sg
d 1634
Autorretrato*
Self-portrait
cv 31.9×25.6 (81×65 cm)
c 1661-2

RENI Guido
Bologna 1575 – 1642
La Virgen de la silla*
The Madonna della seggiola
cv 83.5×53.9 (212×137 cm)
San Sebastián
St. S.
cv 66.9×52.4 (170×133 cm)
El Apóstol Santiago el Mayor
St. James the Great
cv 53.1×35.0 (135×89 cm)
Asunción y Coronación de la
Virgen
*The Assumption and Corona-
tion of the Virgin*
pn 30.3×31.9 (77×81 cm)
c 1602-3
San Pedro*
San Pablo*
St. Peter; St. Paul
cvs 29.9×24.0 (76×61cm)
c 1617

Hipómenes y Atalanta
→ no 123
Hippomenes and A.
cv 81.1×116.9 (206×297 cm)
c 1612; recently res
Muchacha con una rosa*
*Portrait of a girl with a rose
in her hand*
cv 31.9×24.4 (81×62 cm); re-
cently res

REYMERSWAELE Marinus van
*... c 1493 – ... 1567(?) act in the
Low Countries*
San Jerónimo 2100*
St. Jerome
pn 29.5×39.8 (75×101 cm) sg
d 1551
San Jerónimo 2653
pn 31.5×42.5 (80×108 cm) sg
d 1547
La Virgen amamantando al Niño
Madonna and Child
pn 24.0×18.1 (61×46 cm) false
sg and d ("1511 A D") (Al-
brecht Dürer or Anno Domi-
ni?)
El cambista y su mujer
→ no 145
*The money-changer and his
wife*
pn 32.7×38.2 (83×97 cm) sg
d 1539

REYN or VAN RYN Jan
Dunkirk 1610 – 1678
Las bodas de Tetis y Peleo
*The marriage of Thetis and
Peleus*
cv 71.3×113.4 (181×288 cm)
sg d 163...; based on a sketch
by Rubens

REYNOLDS Sir Joshua
*Plympton-Earl's 1723 – London
1792*
Retrato de un eclesiástico
Portrait of a clergyman
cv 30.3×25.2 (77×64 cm)
Retrato de Mr. Bourdieu
Portrait of Mr. J. B.
cv 49.6×24.0 (126×61 cm) 1765

RIBALTA Francisco
Solsona 1565 – Valencia 1628
San Francisco confortado por
un ángel músico*
*St. Francis comforted by an
Angel playing a lute*
cv 80.3×62.2 (204×158 cm)
San Mateo y San Juan Evange-
lista
San Marcos y San Mateo
*St. Matthew and St. John the
Evangelist; St. Mark and St.
M.*
part of a pred (?); cvs 26.0×
40.2 and 26.8×40.6 (66×102
cm and 68×103 cm)
Cristo abrazando a San Ber-
nardo*
Christ embracing St. Bernard
cv 62.2×44.5 (158×113 cm)
attr

RIBALTA Juan
Madrid 1596-7 – Valencia 1628
San Juan Evangelista
St. John the Evangelist
cv 71.7×44.5 (182×113 cm) sg

RIBELLES Y HELIP José
Valencia 1778 – Madrid 1835
Don Manuel José Quintana
cv 26.0×19.7 (66×50 cm)
1806 (?)

**RIBERA José or Jusepe de
(El Españoleto)**
Játiva 1591 – Naples 1652
El Salvador
San Pedro 1071
San Pablo
San Andrés 1077
Santiago el Mayor 1082
Santo Tomás
San Mateo
San Felipe
Santiago el Menor
San Simón 1090
San Judas Tadeo
San Bartolomé
*Christ the Redeemer; St. Pe-
ter; St. Paul; St. Andrew; St.
James the Great; St. Thomas;
St. Matthew; St. Philip; St.*

*James the Less; St. Simon;
St. Jude; St. Bartholomew*
canvases 30.3×25.6
29.5×25.2; 29.5×24.8;
29.9×24.8; 30.7×25.2;
29.5×24.4; 30.3×25.6;
29.9×25.2; 30.7×25.6;
29.1×24.4; 29.9×25.2;
30.3×25.2 (77×65 cm;
75×64 cm; 75×63 cm;
76×63 cm; 78×64 cm;
75×62 cm; 77×65 cm;
76×64 cm; 78×65 cm;
74×62 cm; 76×64 cm;
77×64 cm) the fourth sg d
41 (?) "Apostolado" (Series of
paintings of the Apostles),
unfinished
La Trinidad*
The Holy Trinity
cv 89.0×71.3 (226×181 cm)
c 1636
La Inmaculada Concepción
The Immaculate Conception
cv 86.6×63.0 (220×160 cm)
San Pedro 1072
St. Peter
cv 50.4×39.4 (128×100 cm)
c 1636 (?)
San Pedro libertado por un án-
gel
St. Peter freed by an Angel
cv 69.7×91.3 (177×232 cm) sg
d 1639
San Pablo, Ermitaño 1075
St. Paul the Hermit
cv 56.3×56.3 (143×143 cm) sg
d 1640
San Pablo, Ermitaño 1115
cv 46.5×38.6 (118×98 cm)
c 1636
San Andrés 1076
St. Andrew
cv 29.9×25.2 (76×64 cm) st
work with final touches by R.
San Andrés 1078
cv 48.4×37.4 (123×95 cm)
c 1635
San Andrés 1079
cv 50.0×39.4 (127×100 cm)
res
Santiago el Mayor 1083
St. James the Great
cv 79.5×57.5 (202×146 cm) sg
d 1651 (1631?)
San Simón 1091
St. S.
cv 42.1×35.8 (107×91 cm)
c 1632
San Agustín, en oración
St. Augustine at Prayer
cv 79.9×59.1 (203×150 cm)
San Sebastián
St. S.
cv 50.0×39.4 (127×100 cm)
San Jerónimo
St. Jerome
cv 42.9×35.4 (109×90 cm) sg
d 1644
San Jerónimo penitente
St. Jerome in Penitence
cv 30.3×28.0 (77×71 cm) sg d
1652
San Bartolomé 1100
La Magdalena, o Santa Tais
1103 → no 26
Santa María Egipciaca
San Juan Bautista en el de-
sierto
*St. Bartholomew; St. Mary
Magdalene or St. Thais; St.
Mary of Egypt; St. John the
Baptist in the Desert*
cvs 72.0×77.6; 71.3×76.8; 72.0
×77.6; 72.4×78.0 (183×197
cm; 181×195 cm; 183×197 cm;
184×198 cm) c 1644-7
El martirio de San Bartolomé
→ no 27
*The Martyrdom of St. Bartho-
lomew*
cv 92.1×92.1 (234×234 cm) sg
d 1630 (1639?)
San José y el Niño Jesús
*St. Joseph with the Infant Je-
sus*
cv 49.6×39.4 (126×100 cm)
La Magdalena, penitente 1104
The Penitent Magdalene
cv 38.2×26.0 (97×66 cm)
La Magdalena, penitente 1105
cv 60.2×48.8 (153×124 cm)
attr; formerly attr to Murillo
Visión de San Francisco de
Asís
*A Vision of St. Francis of As-
sisi*
cv 47.2×38.6 (120×98 cm)
c 1632
San Roque
St. Roch
cv 83.5×56.7 (212×144 cm) sg
d 1631

San Cristóbal*
St. Christopher
cv 50.0×39.4 (127×100 cm) sg
d 1637
El escultor ciego Gambazo
*Portrait of the blind sculptor
Gambassi*
cv 49.2×38.6 (125×98 cm) sg
d 1632
Ticio
Ixión
Tityus; Ixion
cvs 89.4×118.5 (227×301 cm)
the second sg d 1632
Un anacoreta
A hermit
cv 50.4×36.6 (128×93 cm)
El sueño de Jacob*
J.'s Dream
cv 70.5×91.7 (179×233 cm) sg
d 1639
Isaac y Jacob *
I. and J.
cv 50.8×113.8 (129×289 cm)
sg d 1637
Esopo*
Aesop
cv 46.5×37.0 (118×94 cm)
Arquímedes
Archimedes
cv 49.2×31.9 (125×81 cm) sg
d 1630
Fragmentos de El Triunfo de
Baco 1122, 1123
*Fragments of The triumph of
Bacchus*
cvs 26.4×20.9 and 21.7×18.1
(67×53 cm and 55×46 cm)
Combate de mujeres
A duel between two women
cv 92.5×83.5 (235×212 cm) sg
d 1636
Vieja usurera*
An elderly money-lender
cv 29.9×24.4 (76×62 cm) sg d
1638
Estigmatización de San Fran-
cisco
*San Francis receiving the
Stigmata*
cv 89.4×68.9 (227×175 cm) sg
(repainted?) d 1644; copy or
repl by the st

Rici or Ricci see RIZI

RICO Martín
Madrid 1833 – Venice 1908
Desembocadura del Bidasoa
*The mouth of the River Bi-
dassoa*
cv 15.4×28.0 (39×71 cm) sg
Venecia
Venice
cv 16.1×28.0 (41×71 cm) sg

RIGAUD John Francis
*Turin 1742 – Packington Hall
1810*
"Los tres viajeros aéreos favo-
ritos"*
*The three favourite balloon-
ists*
copper; oval 14.2×12.2 (36×
31 cm) c 1785

RIGAUD Y ROS Hyacinthe
Perpignan 1659 – Paris 1743
Felipe V
Portrait of Philip V of Spain
cv 51.2×35.8 (130×91 cm) sg
d 1701 on rv
Luis XIV*
*Portrait of Louis XIV of
France*
cv 93.7×58.7 (238×149 cm)
1701 (?) the battle scene in
the background by Charles
Parrocel (Paris 1688-1752)

Rigoults see THIELEN

**RINCÓN DE FIGUEROA
Fernando**
Guadalajara ... – ... c 1517
Don Francisco Fernández de
Córdova y Mendoza
*Portrait of Don F. F. de C. y
M. (Bishop of Oviedo and Pa-
lencia)*
pn 20.1×15.7 (51×40 cm) ins
original frame with the arch-
bishop's coat of arms
Milagros de los Santos Médi-
cos Cosme y Damián*
*St. Cosmas and St. Damian
performing Miracles*
cv 74.0×61.0 (188×155 cm)
mutilated (?)

**RIZI or RICCI DE GUEVARA
Francisco**
Madrid 1608 – El Escorial 1685
Auto de Fe en la Plaza Mayor
de Madrid*
An autodafé in P. M. at M.
pn 109.1×172.4 (277×438 cm)
sg d 1683
La Adoración de los Reyes
La Presentación en el templo
*The Adoration of the Magi;
The Presentation of Christ in
the Temple*
polyptych panels; canvases
21.3×22.4 (54×57 cm)
La Purísima Concepción
The Immaculate Conception
cv 113.8×68.5 (289×174 cm) sg

**RIZI or RICCI DE GUEVARA
(Fray) (Friar) Juan Andrés**
*Madrid 1595 – Montecassino
1681*
Don Tiburcio de Redín y Cru-
zat
Portrait of Don T. de R. y C.
cv 79.9×48.8 (203×124 cm) ins
(of a later date)
San Benito bendiciendo un pan
La cena de San Benito*
*St. Benedict blessing a Loaf
of Bread; St. Benedict's Din-
ner*
canvases 66.1×58.3 and 72.8
×85.0 (168×148 cm and 185×
216 cm)
San Benito y San Mauro *
St. Benedict and St. Maurus
cv 74.0×65.4 (188×166 cm)

ROBERT Hubert
Paris 1733 – 1808
El Coliseo
The Colosseum
cv 94.5×88.6 (240×225 cm)

ROBERTS David
Edinburgh 1796 – London 1864
El castillo de Alcalá de Gua-
daira
*The Castle of A. on the River
G.*
cv 15.7×18.9 (40×48 cm)
La Torre del Oro
The T. del O.
cv 15.4×18.9 (39×48 cm) sg d
1833

**Rodrigo de Osona see under
Anónimos Españoles,**
Late Fifteenth Century

**Roemerswaele see
REYMERSWAELE**

ROMANELLI Gian Francesco
Viterbo c 1610 – 1662
San Pedro y San Juan en el se-
pulcro de Cristo
*St. Peter and St. John at the
Sepulchre*
copper 18.5×15.4 (47×39 cm)
Gladiadores
Gladiators
cv 92.5×140.2 (235×356 cm)
damaged

Romano see GIULIO ROMANO

**ROMBOUTS ROELANDS
Theodor**
Antwerp 1597 – 1637
El charlatán sacamuelas
The quack dentist
cv 45.7×87.0 (116×221 cm)
Jugadores de naipes
The card players
cv 39.4×88.6 (100×225 cm)

ROMNEY George
*Dalton-in-Furness 1734 – Kendal
1802*
Un caballero inglés
*Portrait of an English gentle-
man*
cv 29.9×25.2 (76×64 cm)
Retrato de Master Ward*
Portrait of M. W.
cv 49.6×40.2 (126×102 cm)

**ROOS Philipp Peter
(Rosa da Tivoli)**
Frankfurt 1655 – Rome 1705-6
Pastor con ganado
A shepherd with his flock
cv 37.0×51.2 (94×130 cm)

Pastora con cabras y ovejas
A shepherdess with goats and sheep
cv 77.2×114.2 (196×290 cm)

ROSA Salvator
Arenella 1615 – Rome 1673
El golfo de Salerno*
The Gulf of S.
cv 66.9×102.4 (170×260 cm)
sg ins (damaged) c 1640-5

Rossi Francesco see SALVIATI

RUBENS Peter Paul
Siegen 1577 – Antwerp 1640
El juicio de Salomón
The Judgement of Solomon
cv 72.4×85.4 (184×217 cm)
attr
La Concepción*
The Immaculate Conception
cv 78.0×52.8 (198×134 cm)
1628-9; attr; formerly attr to
Erasmus Quellin
La Adoración de los Magos
The Adoration of the Magi
cv 136.2×192.1 (346×488 cm)
1609; enlarged and repainted
1628-9
La Sagrada Familia con Santa Ana*
The Holy Family with St. Anne
cv 45.3×35.4 (115×90 cm)
c 1626-30
Descanso en la huida a Egipto
The Rest on the Flight to Egypt
pn 34.3×49.2 (87×125 cm)
La Piedad
Pietà
cv 79.1×67.3 (201×171 cm)
La cena en Emaús
The Supper at Emmaus
cv 56.3×61.4 (143×156 cm)
c 1638
Lucha de San Jorge con el dragón
St. George and the Dragon
cv 119.7×100.8 (304×256 cm)
c 1606-10
Acto de devoción de Rodolfo I de Habsburgo
An act of devotion by Rudolph I of Hapsburg
cv 78.0×111.4 (198×283 cm)
c 1636; also attr to Jan Wildens (Antwerp 1586 – 1653)
San Pedro
San Juan Evangelista
Santiago el Mayor
San Andrés
San Felipe
San Mateo 1651
San Bartolomé
San Matías
Santo Tomás 1654
San Simón
San Judas Tadeo
San Pablo
St. Peter; St. John the Evangelist; St. James the Great; St. Andrew; St. Philip; St. Matthew; St. Bartholomew; St. Matthias; St. Thomas; St. Simon; St. Jude; St. Paul
panels 105×25.2 (108×64 cm)
"Apostolado" (series of painting of the Apostles), unfinished
El rapto de Deidamia, o Lapitas y Centauros
El rapto de Proserpina
The rape of D. or Lapithae and Centaurs; The rape of Proserpine
canvases 71.7×114.2 and 70.9×106.3 (182×290 cm and 180×270 cm) 1636-8
El banquete de Tereo
The banquet of Tereus
cv 76.8×105.1 (195×267 cm)
Atalanta y Meleagro cazando el jabalí de Calidonia
A. and Meleager hunting the Calydonian boar
cv 63.0×102.4 (160×260 cm)
c 1636
Andrómeda libertada por Perseo
Perseus and A.
cv 104.3×63.0 (265×160 cm)
1639 (?); completed by Jordaens
Diana y sus Ninfas sorprendidas por Faunos
D. and her nymphs surprised by fauns
cv 50.4×123.6 (128×314 cm)
c 1638-40; landscape and animals attr to Jan Wildens (Antwerp 1586 – 1653)

Ninfas y Sátiros
Nymph and satyrs
cv 53.5×65.0 (136×165 cm)
c 1637-40
Orfeo y Eurídice
Orpheus and Eurydice
cv 76.4×96.5 (194×245 cm) st
wk retouched by Rubens
El Nacimiento de la Vía Láctea
The origin of the Milky Way
cv 71.3×96.1 (181×244 cm)
in collaboration with the st assistants
El Juicio de Paris 1669
→ no 147
The judgement of P.
cv 78.3×149.2 (199×379 cm)
1639; Venus is a portrait of Hélène Fourment
El Juicio de Paris 1731
pn 35.8×44.9 (91×114 cm)
c 1605
Las Tres Gracias*
The three Graces
pn 87.0×71.3 (221×181 cm)
c 1639; recently res
Diana y Calisto*
D. and Callisto
cv 79.5×127.2 (202×323 cm)
c 1638-40; the landscape by Lucas van Uden
La Fortuna*
Fortune
cv 70.5×37.4 (179×95 cm)
Vulcano forjando los rayos de Júpiter
Vulcan forging Jupiter's thunderbolts
cv 71.3×38.2 (181×97 cm)
Saturno devorando a un hijo*
Saturn devouring one of his sons
cv 70.9×34.3 (180×87 cm)
El rapto de Ganimedes
Ganymede carried off by the eagle
cv 71.3×34.3 (181×87 cm)
c 1636
Heráclito, el filósofo que llora
Demócrito, el filósofo que ríe
Heraclitus, the mournful philosopher; Democritus, the laughing ph.
canvases 71.3×24.8 and 70.5×26.0 (181×63 cm and 179×66 cm) 1603
Sileno, o un fauno
Silenus or a faun
cv 71.3×25.2 (181×64 cm)
María de Médicis, Reina de Francia → no 149
Portrait of Marie de' Medici, Queen of France
cv 51.2×42.5 (130×108 cm)
c 1622-5
Felipe II, a caballo
Portrait of Philip II of Spain on horseback
cv 123.6×89.8 (314×228 cm)
1628
El Cardenal Infante Don Fernando de Austria, en la batalla de Nordlingen*
Portrait of the Cardinal I. Don Ferdinand of A. at the Battle of N.
cv 131.9×101.6 (335×258 cm)
c 1636 ins
Ana de Austria, Reina de Francia*
Portrait of Anne of A., Queen of France
cv 50.8×41.7 (129×106 cm)
c 1622
El jardín del Amor → no 148
The Garden of Love
cv 78.0×111.4 (198×283 cm)
c 1638
Danza de aldeanos
Peasants dancing
pn 28.7×41.7 (73×106 cm)
c 1636-40

"APOTHEOSIS OF THE EUCHARIST" SERIES
Santa Clara entre Padres y Doctores de la Iglesia
Abraham ofrece el diezmo a Melquísedec
Triunfo de la Verdad Católica
El triunfo de la Iglesia*
Triunfo de la Eucaristía sobre la Idolatría
El triunfo del Amor Divino
Triunfo de la Eucaristía sobre la Filosofía
Los cuatro Evangelistas
St. Clare with the Fathers and Doctors of the Church; Abraham offering tribute to Melchizedek; The Triumph of the Catholic Truth; of the Church; of the Eucharist over Idolatry; of Divine Love; of the Eucha-

rist over Philosophy; The Four Evangelists
panels; the first three and the last three 33.9×35.8 (86×91 cm); the others 33.9×41.3 (86×105 cm) c 1628; the last one is unfinished
Diana, de caza
D. the huntress
cv 71.7×76.4 (182×194 cm) the dogs by Paul de Vos (?)

SKETCHES FOR PAINTINGS FOR THE TORRE DE LA PARADA
El gigante Polifemo
Atlas sosteniendo el mundo
Apolo y la serpiente Pitón
Deucalión y Pirra
Prométeo con el fuego
Hércules y el Cancerbero
Vertunno y Pomona
El rapto de Europa 2457
→ no 146
La persecución de las Harpías
Céfalo y Procris
El rapto de Deyanira
La muerte de Jacinto
Polyphemus; A. holding up the world; Apollo and Python; D. and Pyrrha; Prometheus carrying fire; H. and Cerberus; Vertumnus and P.; E. and the bull; Calais and Zethes pursuing the Harpies; Cephalus and P.; The rape of Deyanira; The death of Hyacinthus
panels 10.6×5.9; 9.8×6.7; 10.6×16.5; 9.8×6.7; 9.8×6.7; 11.4 12.6; 11.4×12.6; 7.1×5.1; 5.5× 5.5; 11.4×12.6; 7.1×5.1; 5.5× 5.5 (27×15 cm; 25×17 cm; 27 ×42 cm; 25×17 cm; 25×17 cm; 29×32 cm; 29×32 cm; 18 ×13 cm; 14×14 cm; 29×32 cm; 18×13 cm; 14×14 cm) 1603
San Agustín meditando sobre el misterio de la Trinidad
St. Augustine meditating on the Mystery of the Trinity
cv 82.3×62.6 (209×159 cm)
La educación de Aquiles
Aquiles descubierto por Ulises
Briseida, devuelta a Aquiles por Néstor
The education of Achilles; A. discovered by Ulysses; Briseis brought to A. by N.
canvases 43.3×34.6; 42.1× 55.9; 41.7×63.8 (110×88 cm; 107×142 cm; 106×162 cm) 1630 or 1630-5; possibly st works
La muerte del cónsul Decio Mus
The death of the consul Decius M.
pn 39.0×54.3 (99×138 cm)
El Duque de Lerma → no 150
Portrait of the Duke of L.
cv 111.4×78.7 (283×200 cm)
sg d 16.. (1603)

COPIES BY RUBENS OF WORKS BY OTHER ARTISTS
Santo Tomás More, Gran Canciller de Inglaterra
Portrait of St. Thomas M., Lord Chancellor of England
pn 41.3×28.7 (105×73 cm)
1629-30 (?)
from the original painted by Holbein the Younger in 1527, now in the E. Huth Collection in London
Adán y Eva *
Adam and Eve
cv 93.3×72.4 (237×184 cm)
1628-9 from the original by Titian in the Prado (q.v.) ...
El rapto de Europa 1693
E. and the bull
cv 71.3×78.7 (181×200 cm)
1628-9 from the original by Titian in the Gardner Museum in Boston

WORKS IN COLLABORATION WITH OTHER PAINTERS
Paisaje con Hebe y Júpiter
Landscape with H. and J.
cv 36.6×50.4 (93×128 cm) d 1610; the landscape attr to Bril or Lucas van Uden
La Virgen y el Niño en un cuadro rodeado de flores y frutas *
Madonna and Child within a frame surrounded by fruit and flowers
pn 31.1×25.6 (79×65 cm)
garland, animals and background by Jan Brueghel the Elder

El Archiduque Alberto de Austria
Portrait of the Archduke Albert of A.
cv 44.1×68.1 (112×173 cm)
landscape by Jan Brueghel the Elder
La Infanta Isabel Clara Eugenia
Portrait of the I C. E.
cv 40.2×68.1 (102×173 cm) as the prec ptg
Ceres y dos ninfas
C. and two nymphs
cv 87.8×63.8 (223×162 cm) c 1620-8; animals and fruit by Snijders
Ceres y Pan
C. and P.
cv 69.7×109.8 (177×279 cm)
c 1630; animals and fruit attr to Snijders
Aquiles descubierto
Achilles discovered
cv 96.9×105.1 (246×267 cm)
1618 in collaboration with van Dyck
Mercurio y Argos
Mercury and Argus
cv 70.5×116.9 (179×297 cm) in collaboration with van Uden

School of
RUBENS
Eolo, o El aire
Vulcano, o El fuego
Aeolus or Air; Vulcan or Fire
canvases 55.1×49.6 (140×126 cm) see also Cossiers, Dyck, Gowy, Quellin, Symons, Utrecht, Cornelis de Vos

RUISDAEL Jacob Isaacksz. van
Haarlem 1628-9 – Amsterdam (?) 1682
Bosque
A forest
pn 21.7×24.0 (55×61 cm)
Paisaje
Landscape
pn 24.0×24.0 (61×61 cm) sg

RUIZ DE LA IGLESIA Francisco Ignacio
Madrid ... – 1704
Retrato de una monja anciana
Portrait of an elderly nun
cv 31.9×23.6 (81×60 cm) sg ins

RUIZ GONZÁLES Pedro
Arandilla 1640 – Madrid 1706
Cristo en la noche de la Pasión
Christ on the Night of the Passion
cv 48.4×32.7 (123×83 cm) sg d 1673

RUOPPOLO Giovanni Battista
Naples 1629 – 1685
Bodegón
Still life
cv 30.7×59.4 (78×151 cm) attr recently res

RYCKAERT III David
Antwerp 1612 – 1661
El alquimista
The alchemist
pn 22.8×33.9 (58×86 cm) sg d 1640

SACCHI Andrea
Nettuno 1599 – Rome 1661
El nacimiento de San Juan Bautista
The Birth of St. John the Baptist
cv 103.1×67.3 (262×171 cm)
El pintor Francesco Albani
Portrait of F. A.
cv 28.7×21.3 (73×54 cm) c 1635
San Pablo y San Antonio, ermitaños
Santa Rosalía de Palermo *
St. Anthony the Great and St. Paul the Hermit; St. R. of P.
canvases 55.5×55.5 and 55.1× 55.1 (141×141 cm and 140× 140 cm) 1630-40; the second res in 1970; ins

SALVIATI Cecchino del (Francesco Rossi)
Florence 1510 – 1563

La Virgen, el Niño y dos ángeles *
Madonna and Child with two Angels
pn 44.9×39.0 (114×99 cm) c 1545; res 1945-5 formerly attr to Vasari; see also Conte

SÁNCHEZ COELLO Alonso
Alquería Blanca 1531-2 – Madrid 1588
Felipe II → no 13
Portrait of Philip II of Spain
cv 34.6×28.3 (88×72 cm)
c 1572-80 attr
El Príncipe Don Carlos *
Portrait of Prince C.
cv 42.9×37.4 (109×95 cm) mutilated
La Infanta Isabel Clara Eugenia
Portrait of the I. I. C. E.
cv 45.7×40.2 (116×102 cm) sg d 1579
Las Infantas Isabel Clara Eugenia y Catalina Micaela →
no 14
Portrait of the I. I. C. E. and Catherine M.
cv 53.1×58.7 (135×149 cm)
c 1571
Joven desconocida *
Portrait of a young woman
pn 10.2×11.0 (25×28 cm)
Desposorios míst cos de Santa Catalina
The Mystical Marriage of St. Catherine
cork 64.6×31.5 (164×80 cm)
sg d 1578
Autorretrato (?)
Self-portrait (?)
pn 15.0×12.6 (38×32 cm) enlarged
San Sebastián entre San Bernardo y San Francisco
St. S. between St. Bernard and St. Francis
pn 116.1×77.2 (295×196 cm)
sg d 1582

Sancto Leocadio see under Anónimos Españoles,
Late Fifteenth Century

SANI Domenico Maria
Cesena 1690 – ... c 1772, act in Spain
El charlatán de aldea
Reunión de mendigos
The village quack; Two beggars talking
canvases 41.3×49.6 (105×126 cm)

Sarto see ANDREA DEL SARTO

SASSOFERRATO (Giovanni Battista Salvi)
Sassoferrato 1609 – Rome 1685
La Virgen en meditación
The Virgin in Meditation
cv 18.9×15.7 (48×40 cm)
La Virgen con el Niño dormido
Madonna and Child
cv 18.9×15.0 (48×38 cm)

SAUTS Theodor (?)
act in the Seventeenth Century in Holland
Mesa revuelta
Still life with a table of food
pn 10.2×13.8 (26×35 cm) sg;
the sg has also been interpreted as that of Theodorus Harcamp Smits (.. – 1707 (?) act in London and Dublin)

SCARSELLINO (Ippolito Scarsella)
Ferrara 1550 (?) – 1620
Virgen con el Niño
Madonna and Child
cv 7.9×11.0 (20×28 cm)

SCHALCKEN Godfried
Made 1643 – The Hague 1706
Efecto de luz artificial
The effects of artificial light
cv 22.8×18.5 (58×47 cm) sg

SCHOEFF Johannes Pietersz.
The Hague (?) 1608 – Bergen c 1666
Marina
Seascape
pn 19.3×27.6 (49×70 cm) sg

114

School of
SCHOEVAERDTS Mathieu
Brussels (?) c 1665 – c 1694
Paisaje
Landscape
copper 18.5×28.7 (47×73 cm)

Schongauer see under
Maestro de la Sisla

SCHUT EL MOZO
(THE YOUNGER) Cornelis
Antwerp c 1629 – Seville c 1694
La Concepción
The Immaculate Conception
cv 32.3×21.3 (82×54 cm) sg d
1667 see also Bosmans

Schut el Viejo see under
Seghers Daniel

SCOREL Jan van
Schoorl 1495 – Utrecht 1562
El Diluvio Universal
The Flood
pn 42.9×70.1 (109×178 cm)
c 1530 (?)
Un humanista → no 143
Portrait of a humanist
pn 26.4×20.5 (67×52 cm)

SEBASTIANO DEL PIOMBO
(S. Luciani or Veneziano)
Venice c 1485 – Rome 1547
Jesús con la cruz a cuestas
Christ carrying the Cross
cv 47.6×39.4 (121×100 cm)
Bajada de Cristo al Limbo *
Christ in Limbo
cv 89.0×44.9 (226×114 cm)

SEGHERS Daniel
(The Theatine)
Antwerp 1590 – 1661
La Virgen y el Niño, dentro de
una guirnalda
*Madonna and Child in a Gar-
land*
copper 33.1×21.7 (84×55 cm)
Guirnalda de rosas
A garland of roses
pn 15.4×25.6 (39×65 cm)
Guirnalda
A garland of flowers
pn 36.6×27.6 (93×70 cm)
Guirnalda con la Virgen y el
Niño
*Madonna and Child with a
Garland of Flowers*
cv 33.9×24.4 (86×62 cm) fi-
gures att- to Schut the Elder
(Antwerp 1597-1655) or to Die-
penbeek ('s-Hertogenbosch
1596 – Antwerp 1675)

SEGHERS Gerard
Antwerp 1591 – 1651
Jesús, en casa de Marta y Ma-
ría
*Christ at the House of Martha
and Mary*
cv 80.7×84.6 (205×215 cm)

SELLITTO Carlo
(C. Napoletano)
Naples 1581 – 1614
Magdalena
St. Mary Magdalene
cv 24.0×17.7 (61×45 cm)
copy of a wk by Lanfranco
painted in 1608

SERODINE Giovanni
Ascona c 1600 – Rome 1630
Santa Margarita resucita a un
joven
St. Margaret healing a Boy
cv 55.5×40.9 (141×104 cm)
c 1620-5 attr

SERRA Jaime and **Pedro**
*act in the Late Fourteenth Cen-
tury in Catalonia*
Histórias de San Juan Bauti-
sta *
*Historias de la Magdalena *
*Scenes from the Life of St.
John the Baptist; Scenes from
the Life of St. Mary Magda-
lene*
trp wings; ar panels 110.2×
36.2 (280×92 cm) c 1373 ori-
ginal frame studio work

SEVILLA ROMERO Juan de
Granada 1643 – 1695
El epulón y el pobre Lázaro
The Rich Man and Lazarus
cv 43.3×63.0 (110×160 cm) sg

SHEE Sir Martin Archer
Dublin 1769 – Brighton 1850
Mr. Storer *
*Anthony Gilbert Storer Esq.
Portrait of Mr. S.; Portrait of
A. G. S. Esq.*
canvases 94.1×58.3 and 94.5
×58.3 (239×148 cm and 240×
148 cm) the second sg d
1815 on rv

SILVESTRE LE JEUNE
(THE YOUNGER) Louis
Paris 1675 – 1760
María Amalia de Sajonia, Reina
de España
*Portrait of M. Amelia of Sa-
xony, Queen of Spain*
cv 102.4×71.3 (260×181 cm)
attr

SNAYERS or **SNYERS Peeter**
Antwerp 1592 - Brussels c 1666
Cacería del Cardenal-Infante
*The Cardinal-I. hunting (Don
Ferdinand of Austria)*
cv 76.8×118.9 (195×302 cm)
sg
Cacería de Felipe IV 1734
Philip IV of Spain hunting
cv 71.3×226.8 (181×576 cm)
Cacería de Felipe IV 1736
cv 70.9×58.7 (180×149 cm) sg
Cacería de Felipe IV 1737
cv 63.8×57.1 (162×145 cm) sg
Choque de caballería
A cavalry encounter
cv 31.1×40.9 (79×104 cm) sg
d 1646
El sitio de Gravelinas
The siege of Gravelines
cv 74.0×102.4 (188×260 cm) ins
Ataque nocturno a Lila
A night attack on Lille
cv 71.3×105.1 (181×267 cm)
sg d 1650 ins
Toma de Breda
The capture of B.
cv 72.4×103.5 (184×263 cm)
sg d 1650 ins
Socorro de Saint-Omer
The relief of S. O.
cv 72.4×103.5 (184×263 cm) sg
d 16...
Asedio de Aire-sur-la-Lys
The siege of A.-s.-l.-L.
cv 72.4×103.5 (184×263 cm)
sg d 1653
Socorro de la plaza de Lérida
The relief of the fortress of L.
cv 76.8×113.4 (195×288 cm)
sg (sg concealed by the fra-
me)
Vista caballera del sitio de
Breda
*Bird's eye view of the siege
of B.*
cv 55.1×89.0 (140×226 cm)
sg d

SNIJDERS Frans
Antwerp 1579 – 1675
Fábula de la liebre y el galá-
pago
Fábula del león y el ratón
*The fable of the hare and the
tortoise; of the lion and the
mouse*
canvases 44.1×33.1 (112×84
cm) the first sg; the second
sg (?)
Aves acuáticas, armiños, etc.
*Aquatic birds, stoats and
other animals*
cv 71.3×31.1 (181×79 cm) sg
La zorra y la gata
The fox and the cat
cv 71.3×40.6 (181×103 cm) sg
La frutera
The basket of fruit
cv 60.2×84.3 (153×214 cm) sg
Concierto de aves 1758
→ no 152
A concert of birds
pn 38.6×53.9 (98×137 cm)
Concierto de aves 1761
→ no 151
cv 31.1×59.4 (79×151 cm) sg
Jabalí acosado 1759
Dogs pursuing a boar
cv 38.6×39.8 (98×101 cm) sg
Jabalí acosado 1762
cv 31.1×57.1 (79×145 cm)

La cocinera en la despensa *
The cook in the larder
cv 74.0×100.0 (188×254 cm)
Bodegón
Still life
cv 47.6×72.0 (121×183 cm) sg
Despensa
The larder
cv 46.1×114.6 (117×291 cm)
false sg ("P. de Vos")
see also Rubens

SOLIMENA Francesco
(Abate Ciccio)
*Canale di Serino 1657 –
Barra 1747*
San Juan Bautista
St. John the Baptist
cv 32.7×7.9 (83×20 cm)
Autorretrato *
Self-portrait
cv 15.0×13.4 (38×34 cm)
San Joaquín, Santa Ana y la
Virgen
*St. Joachim, St. Anne and the
Virgin*
cv 16.9×15.0 (43×38 cm)

SOMER EL VIEJO
(THE ELDER) Paul van
Antwerp c 1576 – London 1621
Jacobo I de Inglaterra
Portrait of James I of England
cv 77.2×47.2 (196×120 cm)
c 1600 attr

SON Joris van
Antwerp 1623 – 1667
Bodegón 1774, 1775
Still life
canvases 16.9×13.0 (43×33
cm) sg d 1664
Guirnalda de frutas rodeando a
San Miguel
*St. Michael in a Garland of
Fruit*
cv 49.9×34.6 (119×88 cm) sg
d 1657
La Virgen con el Niño dentro
de un festón de frutas
*Madonna and Child in a Gar-
land of Fruit*
cv 47.2×33.1 (120×84 cm)

SPADA Lionello
Bologna 1576 – Parma 1622
Santa Cecilia
St. C.
cv 50.4×39.4 (128×100 cm) attr

STALBEMPT Adriaen van
Antwerp 1580 – 1662
Las Ciencias y las Artes
The sciences and the arts
pn 36.6×44.9 (93×114 cm) attr
El geógrafo y el naturalista
*The geographer and the na-
turalist*
pn 15.7×16.1 (40×41 cm) attr
El triunfo de David sobre Go-
liat
D. with the Head of Goliath
pn 34.6×85.0 (88×216 cm) sg
d Stalbempt 1619 and Brue-
ghel 1618
in collaboration with Pieter
Brueghel the Younger

Standaart see **BLOEMEN Pieter**

STANZIONE Massimo
Orta d'Atella 1585 – Naples 1656
El nacimiento del Bautista
anunciado a Zacarías
El Bautista se despide de sus
padres
Predicación del Bautista en el
desierto*
La degollación del Bautista
*An Angel announcing the
Birth of St. John the Baptist
to Zacharias; St. J. the B.
taking leave of his Parents;
St. J. the B. preaching in the
Desert; The Beheading of St.
J. the B.*
canvases 74.0×132.7; 71.3×
103.5; 73.6×131.9; 72.4×101.6
(188×337 cm; 181×263 cm; 187
×335 cm; 184×258 cm); the
second sg; c 1634
as to paintings of the same
series see Artemisia Genti-
leschi
Sacrificio a Baco
Offerings to Bacchus
cv 93.3×140.9 (237×358 cm)
sg c 1634

STEENWIJCK EL JOVEN
(THE YOUNGER) Hendrick van
*Antwerp or Frankfurt c 1580 –
London c 1650*
Jesús en el atrio del Pontífice
La negación de San Pedro
*Christ at the House of the
High Priest; St. Peter denying
Christ*
copper 16.1 and 16.5×19.9 (41
and 42×50 cm)

STEENWIJCK Pieter
*act in 1632-54 at Leyden, Delft
and The Hague*
Emblema de la muerte
A symbol of death
pn 13.4×18.1 (34×46 cm) sg

STOCK Ignatius van der
Brussels (?) c 1640 – ... c 1665
Paisaje
Landscape
cv 27.6×33.1 (70×84 cm)
sg d 1660

STOMER Matthias
*Amersfoort c 1600 – Messina (?)
1650 or 1672?*
La caridad romana
Roman charity
cv 50.4×56.7 (128×144 cm)
sg (?) ins attr
Incredulidad de Santo Tomás*
The Incredulity of St. Thomas
cv 49.2×39.0 (125×99 cm) attr
copy (?) formerly attr to Hen-
drick ter Brugghen (Deventer
1588 – Utrecht 1629)

STROZZI Bernardo
**(Cappuccino or
Prete genovese)**
Genoa 1581 – Venice 1644
La Verónica*
St. V.
cv 66.1×46.5 (168×118 cm)
c 1625-30

SUSTERMAN Justus
Antwerp 1597 – Florence 1681
María Magdalena de Austria,
Gran Duquesa de Toscana
*Portrait of M. Maddalena of
A., Grand Duchess of Tuscany*
cv 30.3×24.8 (77×63 cm)
Fernando II, Gran Duque de
Toscana
*Portrait of Ferdinand II, Grand
Duke of Tuscany*
cv 30.3×24.8 (77×63 cm)
c 1627

SYMONS Peeter
Antwerp c 1615 – ... c 1637
Céfalo y Procris
Cephalus and P.
cv 68.5×80.3 (174×204 cm) sg
from a sketch by Rubens (q.
v.)

TENIERS Abraham
Antwerp 1629 – 1670
Un cuerpo de guardia 1783,
1784
A guardroom
copper 19.3×26.8 (49×68 cm)

TENIERS David I
Antwerp 1582 – 1649
Armida ante Godofredo de
Bouillon
Consejo convocado por Godo-
fredo sobre el socorro a Ar-
mida
El Mago descubre a Carlos y
Ubaldo el paradero de Rei-
naldo
Reinaldo, enamorado de Armi-
da, en la isla de Orontes
Reinaldo llevado en sueños a
las Islas Afortunadas
Carlos y Ubaldo en las Islas
Afortunadas
El jardín de Armida
Separación de Armida y Rei-
naldo
Huida de Reinaldo de las Islas
Afortunadas
Proezas de Reinaldo
Armida animando a los Moros
en la Batalla
Reconciliación de Reinaldo y
Armida
A. before Godfrey of Bou-

logne; G. summons a council
to decide on aid for A.; The
magician reveals to Carlo and
U. where Rinaldo is hidden;
R., enamoured of A., on the
island of O.; R. is taken,
while asleep, to the Fortunate
Isles; Carlo and U. in the F.
I.; The garden of A.; The se-
paration of A. and R.; The
flight of R. from the F. I.; The
prowess of R.; A. urging on
the Moors in battle; The re-
conciliation of R. and A.
copper 10.6×15.4 (27×39 cm)
all sg except the sixth and the
ninth; formerly attr to Teniers
the Younger

TENIERS David II
(The Younger)
Antwerp 1610 – Brussels 1690
Fiesta aldeana
The village fête
copper 27.2×33.9 (69×86 cm)
sg
Fiesta campestre
A country fête
cv 29.5×44.1 (75×112 cm)
sg d 1647
Fiesta y comida aldeanas
A village fête and feast
cv 47.2×74.0 (120×188 cm)
sg d 1637
El soldado alegre
The gay soldier
pn 18.5×14.2 (47×36 cm) sg
Fumadores
The smokers
cv 15.7×24.4 (40×62 cm) sg
"Le Roi boit" → no 161
"The king drinks"
copper 22.8×27.6 (58×70 cm)
sg
La cocina
The kitchen
pn 13.8×19.7 (35×50 cm) sg
El viejo y la criada
*The old man and the maid-
servant*
copper 19.3×25.2 (49×64 cm)
Operación quirúrgica 1803
El alquimista*
*The surgical operation; The
alchemist*
canvases 13.0 and 12.6×9.8
(33 and 32×25 cm) sg
Operación quirúrgica 1802
The surgical operation
pn 15.0×24.0 (38×61 cm) sg
El mono pintor
The monkey painter
pn 9.4×12.6 (24×32 cm) sg
El mono escultor
The monkey sculptor
pn 9.1×12.6 (23×32 cm) sg
Monos en una bodega
Monkeys in a tavern
pn 8.3×11.8 (21×30 cm) sg
Monos en la escuela
Monkeys at school
copper 9.8×13.4 (25×34 cm)
sg
Monos fumadores y bebedores
*Monkeys smoking and drink-
ing*
pn 8.3×11.8 (21×30 cm) sg
Banquete de monos
The monkeys' banquet
pn 9.8×13.4 (25×34 cm) sg
El Archiduque Leopoldo Gui-
llermo en su galería de pin-
turas en Bruselas*
*The Archduke Leopold Wil-
liam in his gallery of paint-
ings at Brussels*
copper 41.7×50.8 (106×129
cm) sg c 1647
Aldeanos conversando
Villagers in conversation
pn 16.1×24.8 (41×63 cm) sg
Paisaje con gitanos
Landscape with gypsies
tapestry crt (?); cv 69.7×94.1
(177×239 cm) sg
Las tentaciones de San Antonio
Abad 1820
*The Temptation of St. Antho-
ny Abbot*
pn 20.1×28.0 (51×71 cm) sg
Las tentaciones de San Antonio
Abad 1821
cv 31.1×43.3 (79×110 cm) sg
Las tentaciones de San Antonio
Abad 1822
copper 21.7×27.2 (55×69 cm)
sg
San Pablo, primer ermitaño, y
San Antonio Abad
*St. Paul the Hermit and St.
Anthony Abbot*
cv 24.8×37.0 (63×94 cm) sg
(the sg is damaged)

Los fumadores
The smokers
pn 7.1×6.7 (18×17 cm)
see also Brekelenkam, Brouwer and Teniers I

Terbrugghen see under Stomer

Theotocópuli Jorge Manuel
see under Greco

THIELEN or RIGOULTS or COUWENBERG Jan Philips van
Malines 1618 – Boisschot 1667
San Felipe en una Hornacina rodeada de flores
St. Philip in a Niche surrounded by Flowers
copper 49.6×37.8 (126×96 cm)
sg d 1651

Thulden see TULDEN

TIEL or TILENS Justus
act in the Late Sixteenth and Early Seventeenth Centuries in Flanders
Alegoría de la Educación de Felipe III
Allegory of the education of Philip III of Spain
pn 62.2×41.3 (158×105 cm) sg

TIEPOLO Giambattista
Venice 1696 – Madrid 1770
La Purísima Concepción
→ no 127
Angel portador de la Eucaristía*
San Pascual Baylón 364 a*
San Francisco de Asís recibiendo los estigmas*
Angel con corona de azucenas
San Antonio de Padua con el Niño Jesús*
The Immaculate Conception; An Angel carrying the Eucharist; St. Paschal B.; St. Francis of Assisi receiving the Stigmata; An Angel with a Crown of Lilies; St. Anthony of P. with the Christ Child
canvases 109.8×59.8; 72.8×70.1; 60.2×44.1; 109.5×60.2; 15.7×20.9; oval 88.6×69.3 (279×152 cm); 185×178 cm; 153×112 cm; 278×153 cm; 40×53 cm; oval 225×176 cm) the first and the fourth sg 1767-9; the second and third are fragments of the same ptg; the fifth is a fr; the fourth res in 1914
El Olimpo
Olympus or The triumph of Venus
sketch; cv 33.9×24.4 (86×62 cm) c 1761-4
Abraham y los ángeles
A. and the Three Angels
cv 77.6×59.4 (197×151 cm) c 1767-70
San Pascual Baylón 2900
St. Paschal B.
sketch; cv 15.4×10.2 (39×26 cm) attr

TIEPOLO Giandomenico
Venice 1727 – 1804
La Oración del huerto*
Cristo a la columna
La Coronación de espinas
Caída en el camino del Calvario
El Expolio
La Crucifixión
El Descendimiento
El Entierro de Cristo
Christ in the Garden of Gethsemane; The Scourging of C.; C. crowned with Thorns; The Fall on the Road to Calvary; The Disrobing of C.; The Crucifixion; The Deposition of C.; The Entombment of C.
canvases; the first 49.2×55.9 (125×142 cm); the seventh 48.8×55.9 (124×142 cm); the others 48.8×56.7 (124×144 cm); the eighth sg d 1772

TINTORETTA (Marietta Robusti)
Venice 1550-60 – 1590 (?)
Autorretrato
Self-portrait
cv 23.6×20.1 (60×51 cm) attr

Joven veneciana
Portrait of a young Venetian woman
cv 30.3×25.6 (77×65 cm) attr

TINTORETTO (Jacopo Robusti)
Venice 1518 – 1594
General veneciano
Portrait of a Venetian general
cv 32.3×26.4 (82×67 cm) c 1569
El arzobispo Pedro
Portrait of Archbishop Peter
cv 28.0×21.3 (71×54 cm) ins attr
Un Jesuita
Portrait of a Jesuit
cv 19.7×16.9 (50×43 cm) attr
Un Senador, o secretario veneciano*
Portrait of a Venetian senator or secretary
cv 40.9×30.3 (104×77 cm) attr
Magistrado veneciano 373, 374
Portrait of a Venetian magistrate
canvases 21.3×16.9 (54×43 cm) attr
Un patricio veneciano
Portrait of a Venetian patrician
cv 30.7×25.6 (78×65 cm) attr
El caballero de la cadena de oro*
Portrait of a gentleman with a gold chain
cv 40.6×29.9 (103×76 cm) 1550-60
Un Procurador de la República de Venecia*
Portrait of a Venetian magistrate
cv 30.3×24.8 (77×63 cm) c 1580
La dama que descubre el seno*
Portrait of a lady revealing her breast
cv 24.0×21.7 (61×55 cm) attr
Marieta Robusti "La Tintoretta" (?)
Portrait of Marietta R. "La T." (?)
cv 25.6×20.1 (65×51 cm) attr
Susana y los viejos → no 113
Esther and Asuero
Judith y Holofernes 389
→ no 114
Visita de la Reina de Saba a Salomón
José y la mujer de Putifar
→ no 115
Moisés sacado del Nilo
→ no 116
La purificación del botín de las vírgenes Madianitas
Susanna and the Elders; E. before Ahasuerus; J. and H.; The Queen of Sheba before Solomon; Joseph and Potiphar's wife; The finding of Moses; The Purification of the captured Midianite Virgins
ceiling; canvases 22.8×45.7; 23.2×79.9; 22.8×46.9; 22.8×80.7; 21.3×46.1; 22.0×49.9; the last one, oval 116.1×71.3 (58×116 cm; 59×203 cm; 58×119 cm; 58×205 cm; 54×117 cm; 56×119 cm; 295×181 cm) c 1555
Judith y Holofernes 391
J. and H.
cv 74.0×98.8 (188×251 cm) c 1579; with collaboration of st assistants
La muerte de Holofernes 390
The Death of H.
cv 38.6×127.9 (98×325 cm) c 1570 (?) attr
La violencia de Tarquino
The rape of Lucretia
cv 74.0×106.7 (188×271 cm) damaged attr
El Bautismo de Cristo
The Baptism of Christ
cv 53.9×41.3 (137×105 cm) attr
El Paraíso
Paradise
cv 66.1×214.2 (168×544 cm) attr
Episodio de una batalla entre Turcos y Cristianos*
Scene of battle between Turks and Christians (The rape of Helen?)
cv 73.2×120.9 (186×307 cm) 1588-9
El lavatorio → no 112
Christ washing the Apostles' Feet
cv 82.7×209.8 (210×533 cm) 1547

TINTORETTO Domenico (D. Robusti)
Venice 1560 – 1635
La Prosperidad o la Virtud ahuyentando los Males
Prosperity or Virtue driving away Evil
ceiling; cv 81.5×55.1 (207×140 cm) attr

TITIAN (Tiziano Vecellio)
Pieve di Cadore c 1488-90 – Venice 1576
Autorretrato*
Self-portrait
cv 33.9×25.6 (86×65 cm) c 1567
Federico Gonzaga, I Duque de Mantua
Portrait of F. G., 1st Duke of M.
pn 49.2×39.0 (125×99 cm) sg c 1525
El Emperador Carlos V*
Portrait of the Emperor Charles V
cv 75.6×43.7 (192×111 cm) 1532-3
El Emperador Carlos V, a caballo en Mühlberg → no 103
Portrait of the Emperor Charles V on horseback at M.
cv 130.7×109.8 (332×279 cm) 1548 recently res
Felipe II
Portrait of Philip II of Spain
cv 76.0×43.7 (193×111 cm) 1551
El caballero del reloj*
Portrait of a gentleman with his hand on a watch (thought to be a Knight of Malta)
cv 48.0×39.8 (122×101 cm) c 1550
Daniello Barbaro, patriarca de Aquileya
Portrait of D. B., Patriarch of Aquileia
cv 31.9×27.2 (81×69 cm) 1545 or 1550 (?)
La Emperatriz Doña Isabel de Portugal → no 105
Portrait of the Empress Isabella of P.
cv 46.1×38.6 (117×98 cm) 1548
Alocución del Marqués del Vasto a sus soldados*
The Marchese del V. (Alfonso d'Avalos) addressing his troops
cv 87.8×65.0 (223×165 cm) 1540-1
La Bacanal*
Ofrenda a la diosa de los Amores*
Bacchanal of the Andrians; The worship of Venus
canvases 68.9×76.0 and 67.7×68.9 (175×193 cm and 172×175 cm) sg 1518-9; the first has an ins
Venus recreándose en la música
V. with an organist and a small dog
cv 53.5×86.6 (136×220 cm) c 1550; in collaboration with studio assistants (?)
Venus recreándose con el Amor y la música *
V. with Cupid and an organist
cv 58.3×85.4 (148×217 cm) 1548
Venus y Adonis → no 110
V. and A.
cv 73.2×81.5 (186×207 cm) 1553
Danae recibiendo la lluvia de oro → no 109
D. and the shower of gold
cv 50.8×70.9 (129×180 cm) 1553-4
Sísifo
Ticio
Sisyphus; Tityus
canvases 93.3×85.0 and 99.6×85.4 (237×216 cm and 253×217 cm) 1549; the first recently res
Salomé con la cabeza del Bautista → no 106
S. with the Head of St. John the Baptist
cv 34.3×31.5 (87×80 cm) c 1560
Adán y Eva → no 111
Adam and Eve (The Original Sin)
cv 94.5×73.2 (240×186 cm) sg c 1570; res and repainted after a fire in 1734 by Juan García de Miranda (Madrid 1677-1749); a copy by Rubens (q.v.)

La Religión socorrida por España
Spain coming to the aid of Religion
cv 66.1×66.1 (168×168 cm) sg c 1571
Felipe II, después de la victoria de Lepanto, ofrece al cielo al Príncipe Don Fernando
Philip II of Spain offering Prince Ferdinand to Heaven after the Battle of L.
cv 131.9×107.9 (335×274 cm) sg 1571-5 ins st wk (?) enlarged and repainted in 1625 by Vincencio Carducho
La Gloria
Glory (The Adoration of the Holy Trinity)
cv 136.2×94.5 (346×240 cm) sg 1551-4
La Adoración de los Magos
The Adoration of the Magi
cv 55.5×86.2 (141×219 cm) repl by st assistants (?)
La Virgen y el Niño con San Jorge y Santa Catalina (?)
Madonna and Child with St. George and St. Catherine (or St. Ulf and St. Bridget)
cv 33.9×51.2 (86×130 cm) c 1516
La oración del huerto
Christ in the Garden of Gethsemane
cv 69.3×53.5 (176×136 cm) 1559-62 (?) damaged res
"Ecce Homo" 437
slate 27.2×22.0 (69×56 cm) sg 1547 (?)
"Ecce Homo" 42
cv 39.4×39.4 (100×100 cm) c 1570 studio work (?) repainted
Cristo y el Cireneo 438
Christ and the Cyrenian
cv 26.4×30.3 (67×77 cm) sg 1560-70
Jesús y el Cireneo 439
Christ and the Cyrenian
cv 38.6×45.7 (98×116 cm) sg c 1560; st wk (?)
El entierro de Cristo 440*
The Entombment of Christ
cv 53.9×68.9 (137×175 cm) sg 1559
El entierro de Cristo 441
cv 51.2×66.1 (130×168 cm) sg c 1566
El Salvador, de hortelano
Christ the Redeemer dressed as a Gardener
cv 26.8×24.4 (68×62 cm) 1553-4; frm of a "Noli me tangere"
La Dolorosa 443 → no 107
The Madonna of Sorrows
pn 26.8×24.0 (68×61 cm) 1550
La Dolorosa 444 → no 108
marble 26.8×20.9 (68×53 cm) sg 1554
Santa Margarita*
St. Margaret and the Dragon
cv 95.3×71.7 (242×182 cm) sg (c 1565?)
El Elector Juan Federico, Duque de Sajonia
Portrait of the E. John Frederick, Duke of Saxony
cv 50.8×36.6 (129×93 cm) 1548
Santa Catalina
St. Catherine
cv 53.1×38.6 (135×98 cm) c 1550 attr
see also Giorgione and Rubens

TOLEDO Capitán Juan de
Lorca 1611 – Madrid 1665
Combate naval entre Españoles y Turcos
Naufragio
Desembarco y combate
Abordaje
A naval battle between Spaniards and Turks; The shipwreck; The disembarkation and battle; Boarding the enemy
canvases 24.4×43.3 and (the last) 18.9×33.1 (62×110 cm and 48×84 cm)
Batalla 2775, 2776
Battle scene
canvases 24.4×57.5 and 24.8×57.5 (62 and 63×146 cm)

Tournier see under Valentin

TRAINI Francesco
act in the First Half of Fourteenth Century at Pisa
La Virgen con el Niño
Madonna and Child
pn 18.9×16.5 (48×42 cm) ins gold ground attr

TRAVERSE Charles-François de la
Paris ... – ... 1787 act at Naples and Madrid
Montería
The hunt
cv 47.6×60.6 (121×154 cm)

TRISTÁN Luis
... – Toledo 1624
Anciano
Portrait of an old man
cv 18.5×13.4 (47×34 cm) attr
Santa Mónica
Santa llorosa *
St. M.; A Female Saint Weeping
canvases 16.5×15.7 (42×40 cm) frm from the Yepes altarpiece of 1616
El Calabrés
Portrait of a man from Calabria
cv 42.5×37.4 (108×95 cm) attr
La Piedad
Pietà
cv 24.0×18.9 (61×48 cm) attr

TRONO or TRONUS Giuseppe
Turin 1739 – ... 1810 act at Lisbon
Carlota Joaquina, Reina de Portugal
Portrait of C. J., Queen of P.
cv 67.7×50.4 (172×128 cm) sg d 1787

TULDEN or THULDEN Theodore van
's-Hertogenbosch 1606 – 1669
El descubrimiento de la púrpura
The discovery of purple
cv 74.4×83.5 (189×212 cm) sg

TURCHI Alessandro
Verona 1588-90 – Rome 1649
La huida a Egipto*
The Flight to Egypt
cv 111.8×78.7 (284×200 cm) c 1633

UDEN Lucas van
Antwerp 1595 – 1672
Paisaje
Landscape
pn 19.3×26.8 (49×68 cm)
see also Rubens

UTRECHT Adriaen van
Antwerp 1599 – 1652-3
Filopémenes descubierto
Philopoemen discovered
cv 79.1×122.4 (201×311 cm) from a sketch by Rubens
Una despensa
A larder
cv 87.0×120.9 (221×307 cm) sg d 1642
Festón de frutas y verduras
A garland of fruit and vegetables
cv 73.2×23.6 (186×60 cm) sg d 1638

UYTENWAEL or WITENWAEL Joachim Antonisz.
Utrecht c 1566 – 1638
La Adoración de los pastores
The Adoration of the shepherds
pn 24.4×39.0 (62×99 cm) sg d 1625

VACCARO Andrea
Naples 1604 – 1670
San Cayetano ofrecido a la Virgen por su madre
Muerte de San Cayetano
St. Gaetano offered to the Virgin by his Mother; The Death of St. G.
canvases 48.4×29.9 (123×76 cm) sg
La Magdalena, pen tente
The Penitent Magdalene
cv 70.5×50.4 (179×128 cm)
Encuentro de Rebeca e Isaac
The meeting of Rebecca and Isaac
cv 76.8×96.9 (195×246 cm) sg
El tránsito de San Jenaro
The Death of St. Januarius
cv 81.5×60.6 (207×154 cm) sg
Santa Rosalía de Palermo
St. R. of P.
cv 89.8×70.5 (228×179 cm) sg

116

Vaga see **PERIN DEL VAGA**

VALCKENBORCH Lucas van
Louvain (?) c 1535 – Frankfurt-am-Main 1597
Paisaje con la curación del poseso
Landscape with Christ casting out devils
pn 14.6×22.8 (37×58 cm)
Paisaje con ferrerías 1854
Landscape with forges
pn 16.1×25.2 (41×64 cm) sg d 1595
Paisaje con ferrerías 1855
Landscape with forges
pn 16.1×23.6 (41×60 cm) sg
see also Dalem

VALDÉS LEAL Juan de
Seville 1622 – 1690
Jesús, disputando con los Doctores
Christ among the Doctors
cv 78.7×34.6 (200×215 cm) sg d 1686
Un mártir de la orden de San Jerónimo
San Jerónimo → no 59
A Martyr of the Hieronymite Order; St. Jerome
canvases 98.0×51.2 and 83.1× 51.6 (249×130 cm and 211×131 cm); the second sg
San Miguel *
St. Michael
cv 81.0×42.9 (205×109 cm) sg

VALENTIN
(Jean Boulogne or Boullogne)
Coulommiers 1591 – Rome 1632
El martirio de San Lorenzo*
The Martyrdom of St. Lawrence
cv 76.8×102.8 (195×261 cm) attr
La negación de San Pedro
St. Peter denying Christ
cv 67.7×99.2 (172×252 cm) in collaboration with Nicolas Tournier (?) (Montbéliard 1590 – Toulouse c 1660)

Vanvitelli see **WITTEL**

A pupil of
VASARI Giorgio
act second half of the Sixteenth Century, Tuscany
La oración del huerto
Christ in the Garden of Gethsemane
cv 47.2×49.2 (120×125 cm)
see also Salviati

VECCHIA (Pietro Mutoni della)
Vienna 1603 – Venice 1678
Dionisio de Siracusa enseñando matemáticas
Dennis of Syracuse teaching mathematics
cv 40.6×47.2 (103×120 cm)

VEEN or VENIUS Otto van
Leyden 1556 – Brussels 1629
Don Alonso de Idiaquez, Duque de Ciudad Real
Doña Juana de Robles, Duquesa de Ciudad Real
Portrait of Don A. de I., Duke of Civita Reale; Portrait of Doña J. de R., Duchess of Civita Reale
trp wings; panels 46.8×14.6 (119×37 cm) c 1589 attr

VELÁZQUEZ
Diego Rodríguez de Silva y
Seville 1599 – Madrid 1660
La Adoración de los Reyes Magos*
The Adoration of the Magi
cv 79.9×49.2 (203×125 cm) d 1619 (or 1617)
Cristo crucificado 1167*
Christ on the Cross
cv 97.6×66.6 (248×169 cm) c 1632 ins
Cristo en la cruz 2903*
Christ on the Cross
cv 39.4×22.4 (100×57 cm) sg d 1631 ins
La Coronación de la Virgen
The Coronation of the Virgin
cv 69.3×48.8 (176×124 cm) c 1641-2

San Antonio Abad y San Pablo primer ermitaño
St. Anthony Abbot and St. Paul the Hermit
cv 101.2×74.0 (257×188 cm) c 1634 or 1660
Los Borrachos o El triunfo de Baco → no 31
The topers or The triumph of Bacchus
cv 65.0×88.6 (165×225 cm) 1628-9
La fragua de Vulcano → no 32
The forge of Vulcan
cv 87.8×114.2 (223×290 cm) 1630
Las Lanzas o La rendición de Breda → no 39
The surrender of B.
cv 120.9×144.5 (307×367 cm) 1634-5
as to paintings of the same series see Carducho Vincencio, Caxés, Leonardo Jusepe, Maino, Pereda and Zurbarán
Las Hilanderas o La fábula de Aragne → no 53
The spinners or the story of Arachne
cv 86.6×113.8 (220×289 cm) c 1657
Las Meninas o La familia de Felipe IV → no 49
Las Meninas or The family of Philip IV of Spain
cv 125.2×108.7 (318×276 cm) 1656; in the background is Mazo's copy of Jordaens' "Apollo victorious over Pan"
Mercurio y Argos
Mercury and Argus
cv 50.0×97.6 (127×248 cm) c 1659
Felipe III, a caballo
La Reina Margarita de Austria, mujer de Felipe III
Portrait of Philip III of Spain on horseback; Portrait of Queen Margaret, wife of Philip III of Spain, on horseback
canvases 118.1×123.6 and 116.9×121.6 (300×314 cm and 297×309 cm) 1628-9 and 1635 (?); with collaboration of st assistants
Felipe IV ecuestre 1178 → no 37
La Reina Doña Isabel de Francia, mujer de Felipe IV
Portrait of Philip IV of Spain on horseback; Portrait of Isabella of Bourbon, wife of Philip IV of Spain, on horseback
canvases 118.5×123.6 (301× 314 cm); the first c 1635-6; the second 1628-9 and 1635-6; in collaboration with st assistants
El Príncipe Baltasar Carlos 1180 → no 40
Portrait of Prince B. C.
cv 82.3×68.1 (209×173 cm) 1635 or 1636
El Príncipe Baltasar Carlos 1189 → no 47
cv 75.2×40.6 (191×103 cm) 1635 or 1636 ins
Don Gaspar de Guzmán, Conde-Duque de Olivares → no 38
Portrait of G. de G., Count-Duke of O., on horseback
cv 123.2×94.1 (313×239 cm) c 1634
Felipe IV 1182*
Portrait of Philip IV of Spain
cv 79.1×40.2 (201×102 cm) 1628 (?)
Felipe IV 1183
cv 22.4×17.3 (57×44 cm) 1625-8 (?); frm of an equestrian portrait?
Felipe IV 1184*
cv 75.2×49.6 (191×126 cm)
Felipe IV 1185 → no 42
cv 27.2×22.0 (69×56 cm) 1655-60
El Cardenal-Infante Don Fernando de Austria → no 46
Portrait of the Cardinal-I. Don Ferdinand of A.
cv 75.2×42.1 (191×107 cm) 1632-6
Doña María de Austria, Reina de Hungría → no 41
Portrait of M. de A., Queen of Hungary
cv 22.8×17.3 (58×44 cm) 1630
El Infante Don Carlos*
Portrait of the I. Don C.
cv 82.3×49.2 (209×125 cm) c 1626-7
La Reina Doña Mariana de Austria → no 45
Portrait of M. de A., Queen of Spain
cv 90.9×51.6 (231×131 cm) c 1652-3

La Infanta Doña Margarita de Austria → no 48
Portrait of the I. Margaret of A.
cv 83.5×57.9 (212×147 cm)
Don Juan Francisco Pimentel, X Conde de Benavente*
Portrait of J. F. P., Tenth Count of B.
cv 42.9×34.6 (109×88 cm) 1648 mutilated on all four sides
Juan Martínez Montañés (?)*
Portrait of a sculptor (J. M. M. ?)
cv 42.9×42.1 (109×107 cm) 1635-6
Don Diego de Corral y Arellano, oidor del Consejo Supremo de Castilla*
Portrait of Don D. de C. y A., judge of the Supreme Council of Castile
cv 84.6×43.3 (215×110 cm) c 1631
Doña Antonia de Ipeñarrieta y Galdós, y su hijo don Luis → no 36
Portrait of Doña A. de I. y G. and her son L. (Luis Vicente)
cv 84.6×43.3 (215×110 cm) c 1631
Doña Juana Pacheco (?), mujer del autor, caracterizada como Sibila → no 33
Portrait of J. P. (?), the artist's wife, dressed as a Sybil
cv 24.4×19.7 (62×50 cm) c 1632
Pablo de Valladolid*
cv 82.3×48.4 (209×123 cm) c 1633
El bufón Barbarroja, Don Cristóbal de Castañedas y Pernia → no 44
Portrait of the jester B., Don C. de C. y P.
cv 78.0×47.6 (198×121 cm) c 1636
El bufón llamado Don Juan de Austria*
Portrait of the jester known as Don John of A.
cv 82.7×48.4 (210×123 cm) c 1636
El bufón Don Diego de Acedo, El Primo → no 43
Portrait of the jester Don D. de A. (the artist's 'cousin')
cv 42.1×32.2 (107×82 cm) 1643
El bufón Don Sebastián de Morra*
Portrait of the jester Don S. de M.
cv 41.7×31.9 (106×81 cm) c 1643-4
Bufón mal supuesto Don Antonio El Inglés
Portrait of a dwarf formerly thought to be Don A. El I., with a dog
cv 55.9×42.1 (142×107 cm)
El niño de Vallecas Francisco Lezcano*
Portrait of F. L., the "boy of V."
cv 42.1×32.7 (107×83 cm) c 1637
El bufón Calabacillas, llamado erróneamente El bobo de Coria*
Portrait of the jester Juan Calabazas, wrongly called "El b. de C."
cv 41.7×32.7 (106×83 cm) c 1639
Esopo → no 34
Aesop
cv 70.5×37.0 (179×94 cm) c 1639-40 ins
Menipo*
Menippus
cv 70.5×37.0 (179×94 cm) c 1639-40 ins
El dios Marte
Mars
cv 70.5×37.4 (179×95 cm) c 1640-2
Francisco Pacheco (?)
cv 15.7×14.2 (40×36 cm) c 1619
Vista del jardín de la Villa Médicis en Roma 1210 → no 50
The gardens of the V. Medici in Rome
cv 18.9×16.5 (48×42 cm) 1650-1 (?)
Vista del jardín de la Villa Médicis en Roma 1211 → no 51
cv 17.3×15.0 (44×38 cm) 1650-1 (?)
La Fuente de los Tritones en el jardín de la isla de Aranjuez*
The Fountain of the Tritons in the gardens at A.
cv 97.6×87.8 (248×223 cm) ins

Felipe IV, armado, con un león a los pies*
Portrait of Philip IV of Spain in military dress with a lion at his feet
cv 90.9×51.6 (231×131 cm) c 1653; in collaboration with st assistants
Autorretrato (?)*
Self-portrait (?)
cv 22.0×15.4 (56×39 cm) c 1623
La venerable madre Jerónima de la Fuente → no 35
Portrait of the Venerable Mother J. de la F.
cv 63.0×43.3 (160×110 cm) sg d 1620 ins
Vista de la ciudad de Zaragoza → no 52
A view of Saragossa
cv 71.3×130.3 (181×331 cm) sg (by Mazo) d 1647; in collaboration with Bonzi
see also Bonzi

VERNET Claude-Joseph
Avignon 1714 – Paris 1789
Paisaje con una cascada
Paisaje romano a la puesta del sol
La Cometa
Landscape with a waterfall; Roman landscape at sunset; The kite
canvases 61.0×22.0, 22.4 and 13.4 (155×56 cm, 57 cm and 34 cm); the first sg d 1782
Marina: vista de Sorrento
Coastal scene at S.
cv 23.2×42.9 (59×109 cm)

VERONESE (Paolo Caliari)
Verona 1528 – Venice 1588
Venus y Adonis *
V. and A.
cv 83.5×75.2 (212×191 cm) c 1580
Susana y los viejos
Susanna and the Elders
cv 59.4×69.7 (151×177 cm) st wk
Livia Colonna*
Portrait of a lady with a lap-dog (L. C.)
cv 47.6×38.6 (121×98 cm) formerly attr to B. Zelotti
Lavinia Vecellio
Portrait of a lady (L. V.?)
cv 46.1×36.2 (117×92 cm)
La disputa con los Doctores en el templo
Christ among the Doctors
cv 92.9×169.3 (236×430 cm) d (falsely?) 1548
Jesús y el centurión*
Christ and the Centurion
cv 75.6×116.9 (192×297 cm) c 1571
Las bodas de Caná
The Wedding at C.
cv 50.0×82.3 (127×209 cm)
Martirio de San Mena*
The Martyrdom of St. Menas
cv 97.6×71.7 (248×182 cm) ins; formerly thought to represent the martyrdom of St. Genesius
La Magdalena, penitente*
The Penitent Magdalene
cv 48.0×41.3 (122×105 cm) d 1583
El joven entre la Virtud y el Vicio*
A young man between Vice and Virtue
cv 40.2×60.2 (102×153 cm)
El sacrificio de Abraham*
The Sacrifice of Isaac
cv 50.8×37.4 (129×95 cm)
La familia de Caín, errante
C. and his Family in the Desert
cv 41.3×60.2 (105×153 cm)
Moisés salvado de las aguas del Nilo → no 117
The Finding of Moses
cv 19.7×16.9 (50×43 cm) c 1575-80
La Virgen y el Niño, Santa Lucía y un mártir
Madonna and Child with St. Lucy and a Martyr Knight (wearing the Cross of St. Stephen)
cv 38.6×53.9 (98×137 cm) attr

VERONESE Carletto
(Carlo Caliari)
Venice 1570 (?) – 1596
Santa Águeda
St. Agatha
cv 45.3×33.9 (115×86 cm)

VILADOMAT Antonio
Barcelona 1678 – 1755
San Agustín y la Sagrada Familia
The Holy Family with St. Augustine
cv 42.1×28.3 (107×72 cm)

VILLAFRANCA Pedro de
Alcolea de Calatrava ... – ... c 1690; act 1632-78
Felipe IV
Portrait of Philip IV of Spain
cv 79.9×49.2 (203×125 cm) ins
the head is copied from the ptg 1185 by Velázquez

VILLANDRANDO Rodrigo de
... – Madrid c 1637
Felipe IV y el enano Soplillo *
Portrait of Philip IV of Spain with the dwarf called "S."
cv 80.3×43.3 (204×110 cm)
Isabel de Francia, mujer de Felipe IV
Portrait of Isabella of Bourbon, wife of Philip IV of Spain
cv 79.1×45.3 (201×115 cm) sg

VILLAVINCENCIO
Pedro Núñez de
Seville 1644 – 1700
Juegos de niños *
Children playing
cv 93.7×81.5 (238×207 cm) sg; a strip has been added at the top of the cv

Vitelli see **WITTEL**

VOLLARDT or VOLLAERT or
VOLLERDT Jan Christian
Leipzig 1709 – Dresden 1769
Paisaje 2820, 2821
Landscape
canvases 15.0×20.1 (38×51 cm) sg d 1758

Volterra see
DANIELE DA VOLTERRA

VOS Cornelis de
Hulst c 1585 – Antwerp 1657
El triunfo de Baco
The triumph of Bacchus
cv 70.9×116.1 (180×295 cm) sg
Apolo y la serpiente Pitón
Apollo and Python
cv 74.0×104.3 (188×265 cm) sg; based on a sketch by Rubens (q.v.)
El nacimiento de Venus *
The birth of V.
cv 72.4×81.9 (184×208 cm) sg; based on a sketch by Rubens in Brussels; Musées Royaux des Beaux-Arts

VOS Paul de
Hulst c 1596 – Antwerp 1678
Zorra corriendo
A fox running
cv 33.1×31.9 (84×81 cm) sg
Pelea de gatos en una despensa
Cats fighting in a larder
cv 45.7×67.7 (116×172 cm) sg
Un perro
A dog
cv 45.7×32.3 (116×82 cm) sg
Cacería de corzos
The deer hunt
cv 83.5×136.6 (212×347 cm) sg
Ciervo acosado por la jauría *
A stag pursued by a pack of hounds
cv 83.5×136.6 (212×347 cm) sg
Un galgo blanco
A white greyhound
cv 41.3×41.3 (105×105 cm) sg
see also Rubens

VOUET Simon
Paris 1590 – 1649
El Tiempo vencido por la Juventud y la Belleza *
Time defeated by Youth and Beauty
cv 42.1×55.9 (107×142 cm) sg d 1627

117

WATTEAU Jean-Antoine
Valenciennes 1684 –
Nogent-sur-Marne 1721
Capitulación de bodas y baile
 campestre *
Fiesta en un parque *
 A marriage contract and
 dancing in the country;
 Merrymaking in a park
 canvases 18.5×21.7 and
 18.9×22.0 (47×55 cm and
 48×56 cm) attr

WATSON GORDON Sir John
Edinburgh 1788 or 1790 – 1864
Un caballero inglés
 Portrait of an English gentle-
 man
 cv 50.0×40.2 (127×102 cm) sg
 d 1828

WERTINGER Hans von
(Schwabmaler)
Landshut or Wertingen 1465-70 –
Landshut 1533
Fedrico III, Emperador de Ale-
 mania
 Portrait of the Emperor
 Fredrick III
 pn 18.5×12.6 (47×32 cm) attr

WERTMÜLLER Adolf Ulrik
Stockholm 1751 – U.S.A.
(Wilmington) 1811
El Conde Jacobo de Rechteren
Doña Concepción Aguirre y
 Yoldi *
 Portrait of Count Jacob van
 R.; Portrait of C. A. y Y.,
 Countess van Rechteren
 canvases 24.4×20.5
 (62×52 cm) sg d 1790

WEYDEN Roger van der
(R. de la Pasture)
Tournai c 1399 – Brussels 1464
La Redención - La moneda del
 César → no 133 *
 Triptych of the Redemption
 (Int.: The Redemption; centr
 pn: Christ on the Cross with
 the Virgin and St. John aga-
 inst a background of a Gothic
 Church with Scenes from the
 Passion and Sacraments; I -
 hand wing: The Expulsion of
 Adam and Eve from the Gar-
 den of Eden; r - hand wing:
 The Last Judgment. Ext: The
 Tribute Money grisaille *I*
 hand wing: Christ and his
 Disciples; r hand wing: Three
 Pharisees)
 panels; centr pn 76.8×67.7;
 wings 76.8×30.3 (195×172 cm;
 195×77 cm) 1455-9 (?)
La Piedad *
 Pietà
 ar pn 18.5×13.8 (47×35 cm)
La Virgen con el Niño *
 Madonna and Child
 pn 39.4×20.5 (100×52 cm) attr
El descendimiento de la cruz
 → no 132
 The Deposition of Christ
 pn 59.8 (centr arch 80.3)×103.1
 (152[204]×262 cm) c 1435 see
 also Maestro de Flémalle

Wildens see under **Rubens**

WITTEL Gaspar van (Vitelli,
Vanvitelli or degli Occhiali)
Amersfoort 1653 – Rome 1736
Venecia, vista desde la isla de
 San Giorgio → no 124
 Venice, from the island of
 San G.
 cv 38.6×68.5 (98×174 cm) sg
 d 1697

WOLFORDT Artus
Antwerp 1581 – 1641
La huida a Egipto
Descanso en la huida a Egipto
 The Flight to Egypt; The Rest
 on the F. to E.
 copper 22.8×30.3
 (58×77 cm) sg

WOUWERMAN Philips
Haarlem 1619 – 1668
Un montero
 A beater
 pn 12.6×13.8 (32×35 cm) sg
Los dos caballos → no 159
 Two horses
 pn 13.0×12.6 (33×32 cm) sg

Cacería de liebres *
 The hare hunt
 cv 30.3×41.3 (77×105 cm) sg
Partida para una cetrería
 The hawking expedition
 cv 31.5×27.6 (80×70 cm) sg
Salida de la posada
 The departure from the inn
 pn 14.6×18.5 (37×47 cm) sg
Parada en la venta
 The halt at the inn
 cv 24.0×28.7 (61×73 cm) sg
Choque de caballería
 A cavalry encounter
 cv 19.3×21.7 (49×55 cm) sg
Refriega entre tropas enemigas
 An affray between enemy
 troops
 cv 23.6×28.0 (60×71 cm) sg

XIMÉNEZ or JIMÉNEZ Miguel
act 1466 – 1503 at Saragossa
La Resurrección del Señor en-
 tre pasajes de la leyenda de
 San Miguel y del martirio de
 Santa Catalina *
 The Resurrection of Christ
 with Scenes from the Legend
 of St. Michael and from the
 Martyrdom of St. Catherine
 pred; five panels 27.6×15.7
 (70×40 cm) sg
 see also Anónimos Españo-
 les, Late Fifteenth Century

YÁÑEZ DE LA ALMEDINA
Fernando
Almedina (?) ... – ... act 1505-36
at Valencia and Cuenca
San Damián
 St. D
 frm of a polyptych; pn octa-
 gonal 37.4×28.7 (95×73 cm)
Santa Ana, la Virgen, Santa Isa-
 bel, San Juan y Jesús Niño
 St. Anne, the Virgin, St. Isa-
 bella, St. John and the Christ
 Child
 polyptych pn 55.1×46.9
 (140×119 cm)
Santa Catalina → no 9
 St. Catherine
 pn 83.5×44.1 (212×112 cm)
 c 1520
Virgen con el Niño *
 Madonna and Child
 pn 22.8×18.1 (58×46 cm)
 copy from a lost original by
 Leonardo da Vinci
 (Vinci 1452 – Cloux 1519)

YKENS or IJKENS Frans
Antwerp 1601 – Brussels (?)
c 1693
Despensa
 A larder
 cv 42.1×68.1 (107×173 cm) sg
 d 1646
Mesa
 Still life with a table of food
 pn 29.1×41.3 (74×105 cm) sg
 d 1646

Ysenbrandt see **ISENBRANDT**

ZANCHI Antonio
Este 1631 – Venice 1722
La Magdalena penitente *
 The Penitent Magdalene
 cv 44.1×37.4 (112×95 cm)

ZELOTTI Battista
Verona 1526 – Mantua 1578
Rebeca y Eliecer
 R. and Eleazar
 cv 86.2×106.3 (219×270 cm)
 false sg and d ("P. Caliar.
 Ver. F. 1553")
 see also Veronese

ZORN André
Mora 1860 – Stockholm 1920
Cristina Morphy
 Portrait of Christine M.
 wat 26.8×17.7 (68×45 cm) sg
 d 1884

ZULOAGA Ignacio
Eibar 1870 – Madrid 1945
Mrs. Alice Lolita Muth Ben
 Maacha *
 cv 29.5×22.0 (75×56 cm)

ZURBARÁN Francisco
Fuente de Cantos 1598 –
Madrid 1664
Defensa de Cádiz contra los
 Ingleses *
 The defence of C. against the
 English

 cv 118.9×127.2 (302×323 cm)
 1634 much res formerly attr
 to Caxés; for other paintings
 in the same series see Car-
 ducho Vincencio, Caxés, Leo-
 nardo Jusepe, Maino, Pereda
 and Velázquez
Visión de San Pedro Nolasco
 → no 55
Aparición del Apóstol San Pe-
 dro a San Pedro Nolasco →
 no 56
 St. Peter N. dreaming of the
 Heavenly Jerusalem; St. Peter
 the Apostle appearing to St.
 P. N.
 canvases 70.5×87.8 (179×223
 cm); the first sg; the second
 sg d 1629
Santa Casilda *
 St. C.
 cv 72.4×35.4 (184×90 cm)
 c 1638-42; mutilated on the l
 hand side
Hércules separa los montes
 Calpe y Abyla
Hércules vence a Gerión
Lucha de Hércules con el león
 de Nemea
Lucha de Hércules con el
 jabalí de Erimanto
Hércules y el toro de Creta
Lucha de Hércules con Anteo
Hércules y el Cancerbero
Hércules detiene el curso del
 Río Alfeo
Lucha de Hércules con la Hidra
 de Lerna
Hércules abrasado por la
 túnica del Centauro Neso
 Hercules separating Mount
 Calpe and Mount Abyla; H.
 killing Geryon; H. fighting the
 Nemean lion; H. catching the
 Erymanthian boar; H. slaying
 the Cretan bull; H. lifting up
 Antaeus; H. fighting the three-
 headed Cerberus; H. chan-
 ging the course of the river
 Alpheus; H. killing the Hydra
 of L.; H. seared by the poiso-
 ned tunic of Nessus
 canvases 53.5×65.7;
 53.5×65.7; 59.4×65.4;
 52.0×60.2; 52.4×59.8;
 53.5×60.2; 52.0×59.4;
 52.4×60.2; 52.4×65.7;
 53.5×65.7 (136×167 cm;
 136×167 cm; 151×166 cm;
 132×153 cm; 133×152 cm;
 136×153 cm; 132×151 cm;
 133×153 cm; 133×167 cm;
 136×167 cm) 1634
San Diego de Alcalá
 St. D. of A.
 pred (?); cv 36.6×39.0
 93×99 cm)
San Jacobo de la Marca
 St. James of the Marches
 cv 114.6×65.0 (291×165 cm sg
San Lucas como pintor (au-
 torretrato de Zurbarán?) ante
 Cristo en la Cruz *
 St. Luke dressed as a painter
 (self-portrait of Z.?) before
 Christ on the Cross
 cv 41.3×33.1 (105×84 cm
 c 1660
Bodegón → no 54
 Still life
 cv 18.1×33.1 (46×84 cm)
Florero
 A vase of flowers
 cv 17.3×13.4 (44×34 cm)
La Inmaculada Concepción *
 The Immaculate Conception
 cv 54.7×40.9 (139×104 cm)
 c 1630-5
Fray Diego de Deza, Arzobispo
 de Sevilla
 Portrait of F. D. de D.,
 Archbishop of Seville
 cv 83.1×63.4 (211×161 cm)
 c 1631 much res
San Antonio de Padua con el
 Niño Jesús
 St. Anthony of P. with the
 Christ Child
 cv 58.3×42.5 (148×108 cm)
 c 1635-40 in collaboration with
 st assistants (?)
Santa Eufemia *
 St. Euphemia
 cv 32.7×28.7 (83×73 cm)
 st wk (?)
Santa Clara
 St. Clare
 cv 59.8×31.1 (152×79 cm)
 studio work (?)
Un clérigo (?) difunto
 Portrait of a dead
 ecclesiastic (?)
 cv 19.7×26.8 (50×68 cm)
 studio work (?); see also
 Gentileschi Orazio